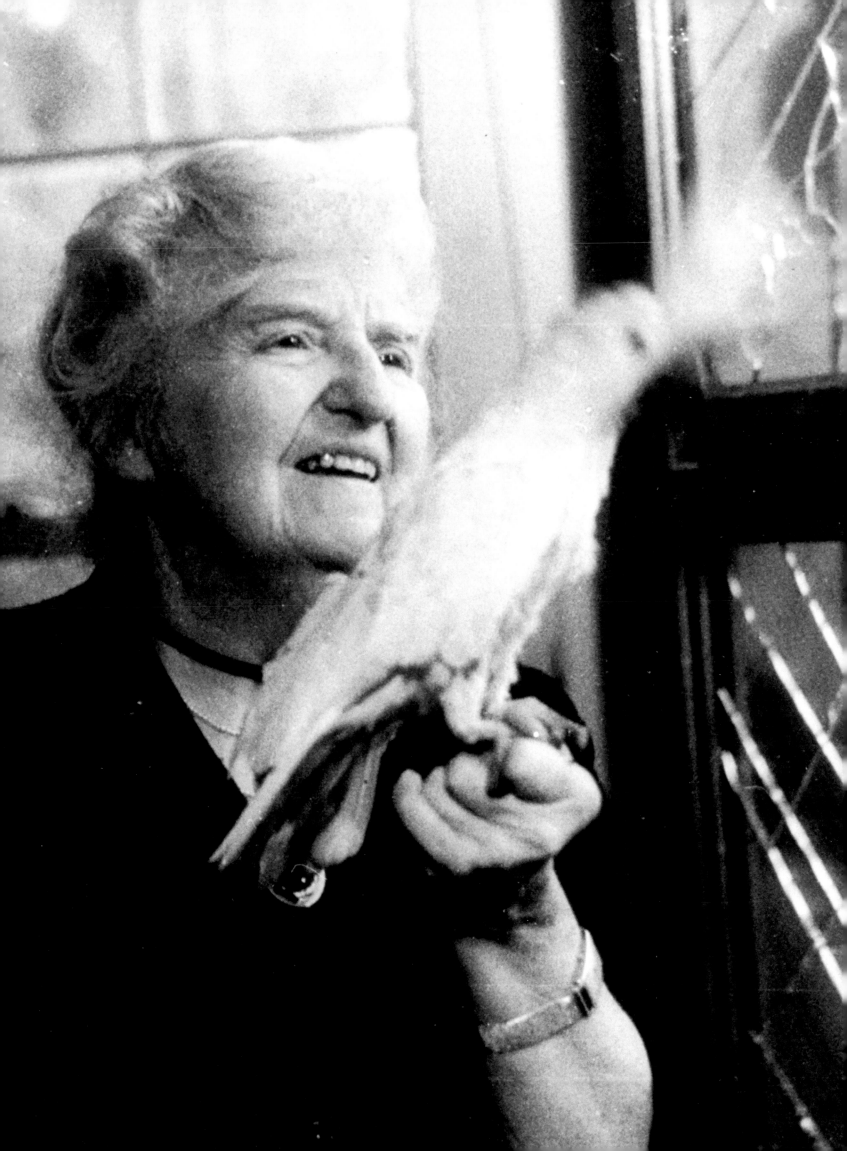

with contributions by

Ruth L. Bohan
Susan Greenberg
David Joselit
Elise K. Kenney
Dickran Tashjian
Kristina Wilson

The Société Anonyme
Modernism for America

edited by Jennifer R. Gross

YALE UNIVERSITY PRESS, NEW HAVEN AND LONDON
IN ASSOCIATION WITH THE YALE UNIVERSITY ART GALLERY

In memory of George Heard Hamilton
(1910–2004)

Exhibition Dates

Hammer Museum, Los Angeles
April 23–August 20, 2006

The Phillips Collection, Washington, D.C.
October 14, 2006–January 21, 2007

Dallas Museum of Art
June 10–September 16, 2007

Frist Center for the Visual Arts, Nashville
October 26, 2007–February 3, 2008

Yale University Art Gallery
2010

**The exhibition was organized
by the Yale University Art Gallery,
New Haven**

NATIONAL
ENDOWMENT
FOR THE ARTS

At time of publication, the exhibition is supported in part
by an award from the National Endowment for the Arts,
with additional support provided by Mr. and Mrs. James
H. Clark, Jr., B.A. 1958; Mr. and Mrs. James Howard
Cullum Clark, B.A. 1989; Ms. Helen Runnells DuBois,
B.A. 1978, and Mr. Raymond F. DuBois, Jr.; Mr. Leonard
F. Hill, B.A. 1969; Mr. and Mrs. George T. Lee, Jr., B.A.
1957; Dr. and Mrs. Edmund P. Pillsbury, B.A. 1965;
Mr. Mark H. Resnick, B.A. 1978; Ms. Cathy R. Siegel
and Mr. Kenneth Weiss; Mr. and Mrs. Joseph B. Smith,
B.A. 1950; Michael Sullivan, B.A. 1973; and Mr. and
Mrs. John Walsh, B.A. 1961.

Published by Yale University Press in association with
the Yale University Art Gallery.

All artworks reproduced in this book are in the
collection of the Yale University Art Gallery unless
otherwise indicated. All of the Yale works are featured
in the exhibition.

First Edition

Designed by Daphne Geismar, daphnegeismar.com

Set in Electra and Univers type by Amy Storm

Printed in Singapore by CS Graphics

Library of Congress Cataloging-in-Publication Data
The Société Anonyme: modernism for America/Jennifer
R. Gross, editor; Ruth L. Bohan...[et al.].
 p. cm.
Includes bibliographical references and index.
ISBN-13: 978-0-300-10921-4 (cloth: alk. paper)
ISBN-10: 0-300-10921-0 (cloth: alk. paper)
ISBN-13: 978-0-89467-961-2 (paper: alk. paper)
ISBN-10: 0-89467-961-9 (paper: alk. paper)
1. Modernism (Art)—Exhibitions. 2. Société Anonyme—
Art collections—Exhibitions. 3. Dreier, Katherine
Sophie, 1877–1952—Art collections—Exhibitions. 4.
Art—Connecticut—New Haven—Exhibitions. 5. Yale
University. Art Gallery—Exhibitions. I. Gross, Jennifer R.
II. Bohan, Ruth L. III. Yale University. Art Gallery.
N6487.N34S66 2006
709'.04'0747468—dc22
2005019917

A catalogue record for this book is available from the
British Library.

The paper in this book meets the guidelines for perma-
nence and durability of the Committee on Production
Guidelines for Book Longevity of the Council on Library
Resources.

10 9 8 7 6 5 4 3 2 1

Front Cover Jacques Villon, *Color Perspective (Perspec-
tive colorée).* 1922. Oil on canvas, 23$^{11}/_{16}$ x 36$^{1}/_{4}$ in.
(60.2 x 92.1 cm). Gift of Collection Société Anonyme,
©2005 Artists Rights Society (ARS), New York/ADAGP,
Paris.

Page i Marcel Duchamp, "Laughing Ass" from Société
Anonyme stationery, n.d. Katherine S. Dreier Papers/
Société Anonyme Archive. Yale Collection of American
Literature, Beinecke Rare Book and Manuscript Library.

Pages iii and xvii Roberto Matta Echaurren, letter to
Dreier, n.d.'(c. 1940). Box 23, Folder 682, Katherine S.
Dreier Papers/Société Anonyme Archive. Yale Collection
of American Literature, Beinecke Rare Book and Manu-
script Library. Transcribed in part on page xxi.

Page v Katherine S. Dreier with Koko, her sulfur-crested
cockatoo. The Schlesinger Library, Radcliffe Institute,
Harvard University.

Contents, page ix Marcel Duchamp in Katherine
Dreier's New York apartment, c. 1918. Katherine S.
Dreier Papers/Société Anonyme Archive. Yale Collection
of American Literature, Beinecke Rare Book and Manu-
script Library.

Page xix Marcel Duchamp and Koko, c. 1926–28. The
photograph may have been taken by Katherine S. Dreier.
Katherine S. Dreier Papers/Société Anonyme Archive.
Yale Collection of American Literature, Beinecke Rare
Book and Manuscript Library.

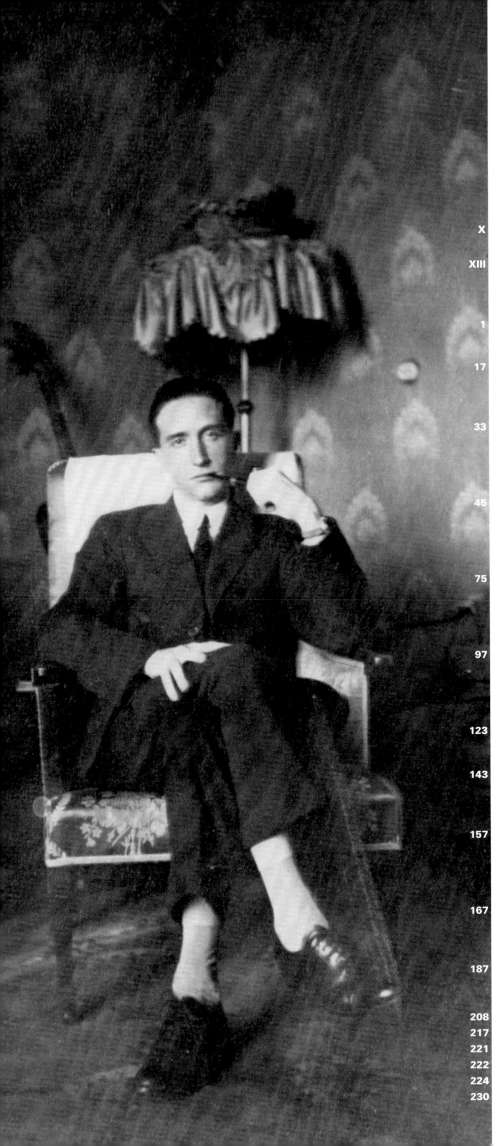

Contents

Director's Foreword

For more than sixty years the Yale University Art Gallery has had the good fortune of housing the Société Anonyme Collection of modern art as part of its permanent collection. Generations of Yale students, scholars, and members of our public audience have been fascinated by this unique assemblage of more than one thousand works. Canonical paintings and sculpture by such artists as Marcel Duchamp, Kurt Schwitters, Wassily Kandinsky, Constantin Brancusi, Piet Mondrian, Arthur Dove, and Joseph Stella have long played a key role in our permanent collection display. Important drawings, prints, and photographs by Man Ray, El Lissitzky, and a host of others have drawn twentieth-century art scholars and students to Yale for decades. *The Société Anonyme: Modernism for America* marks the first time since the donation of the collection to the Gallery in 1941 that a selection from this stellar group of objects will travel outside New Haven. The present exhibition and scholarly catalogue not only feature the most celebrated artists and objects in this collection but also probe the work of such lesser-known but equally compelling artists as the Futurist painter Erika Giovanna Klien, the Belgian cubist Marthe Donas, and the Hungarian artist Béla Kádár. Through what has been a wonderfully stimulating endeavor, both for myself and for my colleagues here at the Gallery, we hope to share with a broader audience the impressive history of the Société Anonyme and its artworks that have long been an admired part of the university's cultural holdings.

It was the Société Anonyme's founders, artists Katherine S. Dreier and Marcel Duchamp, who chose the Yale University Art Gallery as the home for the extraordinary collection they assembled. The Société Anonyme gift established the modern art collection at Yale, and it compares in importance to the university's Mabel Brady Garvan Collection of American art and the James Jackson Jarves Collection of early Italian paintings. Dreier's commitment to the Société Anonyme Collection did not end with the initial gift, for throughout the 1940s and early 1950s she supplemented the collection with more than one hundred new works, many of them gifts to the Collection from the artists themselves. The full scope of Dreier's generosity was made evident after her death, in 1953, when more than three hundred additional works, including many modern masterpieces such as Constantin Brancusi's *Yellow Bird* (1919), came from her estate to the Gallery. Dreier and Duchamp's devotion to living artists of all nationalities presciently anticipated the global conditions of artistic practice extant today. The two friends also pioneered a form of patronage that valued artistic commitment over critical and commercial popularity as their standard for collecting, one that remains as a challenge to today's impulse toward scholarly categorization and commercial success. Their dedication — especially that of Dreier — to the progressive value that art and artists offer to society has, we hope, continued in our active use of the collection as a means to help students, faculty, and our public understand new approaches to art making and creativity in the twenty-first century.

To introduce this wonderfully varied collection of modern art to audiences beyond Yale University is the goal of this exhibition, which has been very thoughtfully organized by Jennifer R. Gross, the Seymour H. Knox, Jr., Curator of Modern and Contemporary Art. Dreier and Duchamp have a devoted contemporary champion of

the artist in Jennifer, a curator dedicated to broadening the modernist narrative to include artists of all approaches and backgrounds. The project could not have come to such gratifying fruition without the enthusiasm, scholarship, and hard work of Susan Greenberg, the Horace W. Goldsmith Assistant Curator of Modern and Contemporary Art, who not only worked closely with Jennifer on the development of the project but was instrumental in coordinating the complex publication that accompanies the exhibition. Helen A. Cooper, the Holcombe T. Green Curator of American Paintings and Sculpture, has generously supported the exhibition by enabling the inclusion of some her department's major American paintings by Société Anonyme artists. The similarly enthusiastic support of Suzanne Boorsch, curator of prints, drawings, and photographs, which enabled the presentation of so many works on paper in the exhibition, was also greatly appreciated.

This exhibition was made possible by an endowment created with a challenge grant from the National Endowment for the Arts. We are also extremely grateful to John Walsh, B.A. 1961, director emeritus of the J. Paul Getty Museum and chairman of the Gallery's Governing Board Education Committee, who was immediately supportive of our efforts to make this exhibition available to other institutions throughout America while Yale renovated its three historic art buildings in downtown New Haven. John and his wife, Jill, also provided the first leadership gift of funds to become principal sponsors of the exhibition, and have been joined by other principal sponsors, Mr. and Mrs. James H. Clark, Jr., B.A. 1958; Mr. and Mrs. James Howard Cullum Clark, B.A. 1989; Ms. Helen Runnells DuBois, B.A. 1978, and Mr. Raymond F. DuBois, Jr.; Mr. Leonard F. Hill, B.A. 1969; Mr. and Mrs. George T. Lee, Jr., B.A. 1957; Dr. and Mrs. Edmund P. Pillsbury, B.A. 1965; Mr. Mark H. Resnick, B.A. 1978; Ms. Cathy R. Siegel and Mr. Kenneth Weiss; Mr. and Mrs. Joseph B. Smith, B.A. 1950; and Mr. Michael Sullivan, B.A 1973. The four museums hosting the tour of the exhibition have also been wonderfully supportive of our project, and I warmly thank Ann Philbin, director of the Hammer Museum; Jay Gates, director of The Phillips Collection; John R. Lane, the Eugene McDermott Director, Dallas Museum of Art; and Susan Edwards, director of the Frist Center for the Visual Arts, for their enthusiastic commitment to the fascinating history of the Société Anonyme. Their many highly capable and cooperative museum colleagues have also been a great pleasure to work with on this cultural endeavor. In addition, we are greatly indebted to the institutions whose generous loans were essential to the realization of this exhibition: The Cleveland Museum of Art, The J. Paul Getty Museum, the Solomon R. Guggenheim Museum, and the Beinecke Rare Book and Manuscript Library and the Arts Library at Yale.

The life of the Société Anonyme Collection at Yale began under the precocious and enlightened advisement of Dr. George Heard Hamilton (1910–2004), a long-standing professor of the history of art at Yale (1936–66) and curator of modern art at the Yale University Art Gallery (1940–66). Professor Hamilton's collaboration with Dreier and Duchamp after their first gift in 1941 and his efforts to document the Collection, which resulted in the first catalogue in 1950, are the foundations supporting

the curatorial efforts of the subsequent generation of scholars who have further illuminated this Collection. Of these scholars, Robert L. Herbert, Eleanor S. Apter, and Elise K. Kenney, authors of the essential 1984 Société Anonyme catalogue raisonné, must be mentioned. Professor Hamilton's passing in March 2004 prevented him from sharing our pleasure in realizing this ambitious exhibition of the history of the Société Anonyme Collection. We fondly dedicate this book to him. We also would like to recognize Theodore Sizer, former director of the Yale University Art Gallery (1928–47), whose prescience in recognizing the value of these modernist artworks confirmed the importance of following up on Katherine Dreier's offer of the Société Anonyme Collection. In turn, the diplomacy of Charles Seymour, former president of Yale University (1917–56), was instrumental in securing this fabled collection for our university. It was through their efforts that modernism came to the Yale University Art Gallery, where it continues to enrich the central mission of this dedicated teaching museum.

Jock Reynolds
The Henry J. Heinz II Director
Yale University Art Gallery

Acknowledgments

It is the ambition of this exhibition and its accompanying publication to clarify the place of the Société Anonyme in the development of modernism in America and to increase the visibility of the Société Anonyme Collection and its archives for future use by artists and scholars. The loyalty, passion, and effort of Katherine S. Dreier (1877–1952) and Marcel Duchamp (1887–1968) provided the foundation for our work. It has been a pleasure and a privilege to dive into the wake of their ambitious enterprise.

The conception and organization of this exhibition and publication rest firmly on the pioneering scholarship of Eleanor S. Apter, Elise K. Kenney, and, most profoundly, Robert L. Herbert. Their work is beautifully contained in their ambitious and thorough catalogue raisonné of the Société Anonyme Collection, published in 1984. Their research left little room for correction and the need for only modest updates on the artists and artworks. It remains the definitive resource on the Société Anonyme Collection, along with the Katherine S. Dreier Papers/Société Anonyme Archive at the Beinecke Rare Book and Manuscript Library at Yale. In addition to their groundbreaking work, Professor Herbert, Ms. Apter, and Ms. Kenney have continued in their role as zealous advocates for the Société Anonyme, providing generous counsel and insight throughout the development of this project. For this assistance we have been extremely grateful.

Patricia Willis and her colleagues at the Beinecke Library gave generously of their time and support to our own research, and we are most appreciative. Miriam B. Spectre's meticulous organization of the Beinecke archives expedited and enriched our experience of these documents. In addition to our colleagues at Yale, the librarians and archivists of The Museum of Modern Art, the Schlesinger Library at Radcliffe College, Harvard University, The New School, and particularly the Philadelphia Museum of Art, in the person of archivist Susan K. Anderson, provided us with invaluable assistance. Russell Stockman's vivid translation of letters by a number of Société Anonyme artists, including Wassily Kandinsky and Kurt Schwitters, was also most helpful to our better understanding of the period.

It was the late George Heard Hamilton, in his role as curator of modern art and professor of art history at Yale, who stewarded the arrival and first presentation of these works at the Yale University Art Gallery. He also assisted Dreier and Duchamp in the publication of the first catalogue of the collection, in 1950. The archives record his patience and valiant diplomacy in both of these endeavors, and we are grateful for the imprint of his wisdom and knowledge of modernism on the formation of the legacy of the Société Anonyme.

A number of institutions are presenting this exhibition in addition to its installation at the Yale University Art Gallery. Our colleagues at these institutions — Russell Ferguson, deputy director for exhibitions and programs and chief curator, Hammer Museum; Dorothy Kosinski, senior curator, painting and sculpture, and the Barbara Thomas Lemmon Curator of European Art, Dallas Museum of Art; Elizabeth Turner, senior curator, The Phillips Collection, Washington, D.C.; and Susan H. Edwards, director, Frist Center for the Visual Arts — have bettered the presentation of this collection through their expertise and shared knowledge of modernism in America.

A special thank-you is reserved for John Walsh for his early support of the tour, a further manifestation of his perpetual willingness to facilitate both art and art-historical scholarship in the United States.

Jock Reynolds, Henry J. Heinz II Director at the Yale University Art Gallery, can always be relied on for passionate support of artists and the exhibition of art, and I am most appreciative. His tireless efforts to give voice to creativity in America, and to elevate the exhibition, care, and educational presentation of the Société Anonyme Collection, have fulfilled the originating hope of the Société's founding artists. Without his enthusiasm this exhibition tour, publication, and program could not have been realized.

The sage and generous guidance of Susan B. Matheson, chief curator and Molly and Walter Bareiss Curator of Ancient Art at the Yale University Art Gallery, smoothed the path of this project as it traveled first through its planning phases at its home base and then across America. Her professionalism provided a signpost for the many decisions that helped bring this exhibition to fruition. Louisa Cunningham, deputy director of finance and administration; Carol DeNatale, director of collections and technology; Anna Hammond, deputy director for education, programs, and public affairs; and their staffs always mediated the transition of our ideas into actualities to their betterment. Their constancy and hard work in attending to the myriad details vital to the project's realization encouraged us along the way.

John ffrench, manager of digital imaging, and his staff logged countless hours beautifully recording the Société Anonyme Collection for publication and future reference. Burrus Harlow, installation manager, and his excellent team painstakingly prepared the works for shipment and exhibition, and their care is greatly appreciated. In particular, senior associate registrar L. Lynne Addison and associate director of communications Amy Jean Porter provided humor and focus in organizing the details of the exhibition tour and of the publication of the catalogue.

Patricia S. Garland, senior conservator, was extremely generous and creative in her thoughtful consideration of Société Anonyme Collection works in terms of their conservation. Susan Schussler, conservator, also provided expert object care. Suzanne Boorsch, curator of prints, drawings, and photographs, and her staff were also gracious in sharing much of their collections for this exhibition. Helen Cooper, Holcombe T. Green Curator of American Painting and Sculpture, also kindly made available works traditionally seen in the Gallery's permanent-collection display of American art that were vital to telling the Société Anonyme story.

The spirit of this publication owes its energy to the vision of its publisher, Patricia Fidler of Yale University Press, assisted by associate editor Michelle Komie and Mary Mayer, John Long, Dan Heaton, and special assistant Starsha Pyr. Their commitment to publishing art-historical scholarship as an artistic form encouraged the work of its authors. In the book's design, Daphne Geismar's embrace of the modernist spirit with contemporary clarity has transformed scholarship into a beautiful object.

Tiffany Sprague, the Gallery's associate editor, guided our words with care and expediency toward publication. Editor David Frankel refined the impressive

scholarly efforts of a wonderful team of art historians and archivists. It was a distinct pleasure to work with and learn from Ruth L. Bohan, Elise K. Kenney, Susan Greenberg, David Joselit, Dickran Tashjian, and Kristina Wilson. All of these colleagues were generous with their expertise and contributed vital commentary in the formative stages of the publication as well as in the final review of the assembled research.

Francis Naumann's comments and factual knowledge refined all our efforts and enlivened our understanding of the period, as did the insights of Leah Dickerman, Naomi Sawelson-Gorse, and Ingrid Schaffner. I am especially grateful to Sylvia and Robert Mangold for their willingness to share their insights and response to the history of this collection and the lives of the artists whose advocacy for modernism in America, as well as for each other, built the lived history of the Société Anonyme.

The meticulous and thoughtful work of the students in the Department of Modern and Contemporary Art at Yale University, who shared our enthusiasm for the Société Anonyme and its artists, has been immediately vital to the orderly realization of the project. My principal thanks are due to curatorial assistant Kristin P. Henry, who beautifully and effectively selected and narrated the ephemera sections of the exhibition. Her knowledge of the artists represented in the exhibition, and of the histories of its objects — a trove she was able to immediately recall and poetically pen — helped refine its every aspect. Liena Vayzman's scholarship on Katherine Dreier's Country Museum whetted our curiosity about the contents of the Dreier archives and set the standard for our research. Gabrielle Gopinath, Alyssa Phoebus, Bryony W. Roberts, Lydia Shook, and Katherine Wyman were all most helpful in the exhibition's organization. Yvonne Morant, senior administrative assistant in the Department of Modern and Contemporary Art at the outset of this project, provided a solid foundation for all of our labors, while in the same capacity Valerie Richardson brought these efforts to closure with care and enthusiasm.

My deepest gratitude is reserved for the most deserving of colleagues, Susan Greenberg, Horace W. Goldsmith Assistant Curator, Modern and Contemporary Art, at the Yale University Art Gallery. Without her this exhibition would not have come to fruition. Her engaging mind and diligent attention to every detail of scholarship and presentation relating to the book and exhibition have made our work a pleasurable expedition and profoundly shaped the contours of our effort to recognize the work of artists whom we deeply admire.

We devote this volume and exhibition to the Knights of the Société Anonyme: long may their vision inspire the making of art in America.

Jennifer R. Gross
Seymour H. Knox, Jr., Curator, Modern and Contemporary Art

I received it) If you send it
before to the /Prevoot does not
surprise me the last since we
have not received any mail
forwarded by them.

I did't know that you have
allready given the Collection.

Several reactions happen in me
by knowing it appart from the ~~scholar~~
— the interst of which will put them closer to the object and not the foot notes.
interests, and some are concerning you
having to part from pictures as
La Mariée etc. wich I think is
a Presence Zodial (an astral (in the sense of sphrical space)
mirror. to live with

More than before) I want to see
to talk some action wich should be printed concerning the structural intention of
you now, and I hope you (du the collection
manage to let me know as soon
as possible. when

love

the red
and red marka
tissue ● the lay out
A the catalogue should be in the same proportion

a very clean-oyut
catalog we
wonder if
I could get
Find a few
use.

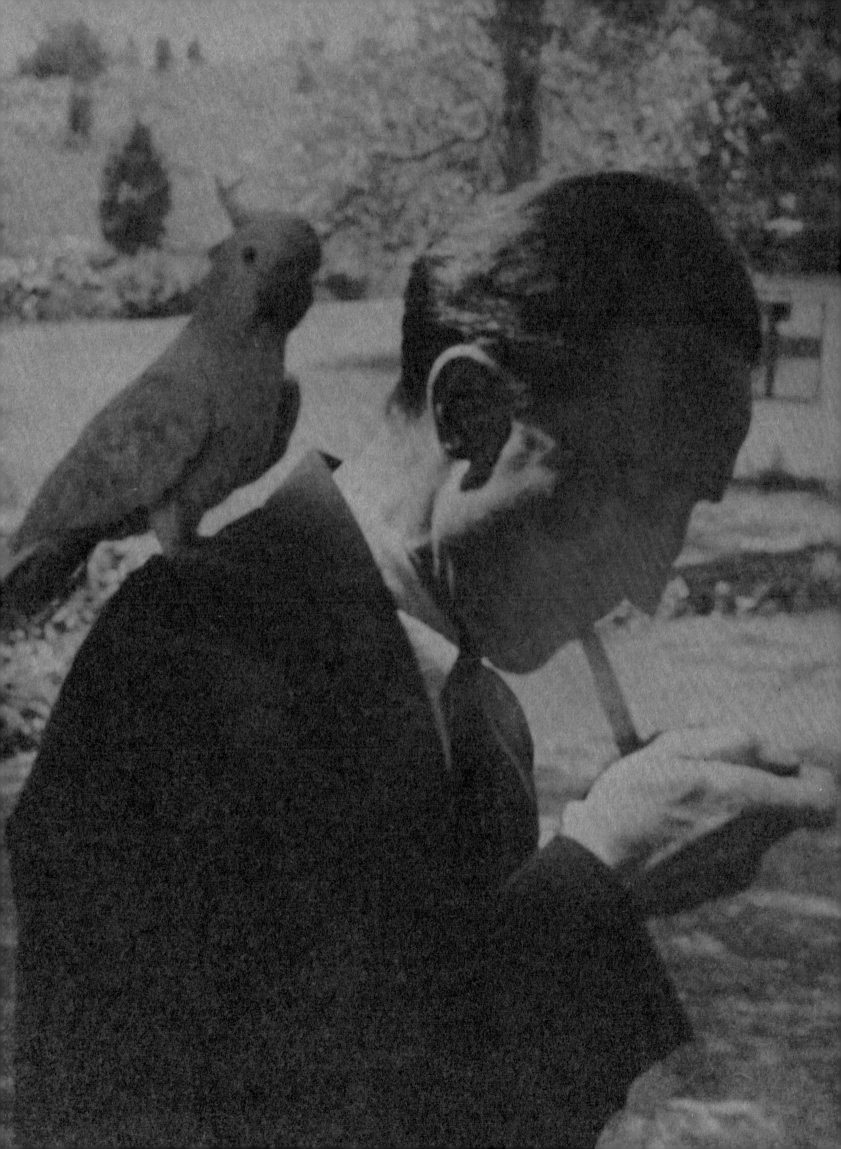

My <u>dear</u> Miss Dreier,

I'm so sorry that my not mentioning the Société Anonyme collection could be interpreted as a lack of interest of my part.

I considered your collection as I told you before one of the most important: <u>as Structures!</u> Not only in so far as the relating of pictures which we know (Duchamp – Picabia – …) but of those very little known star artist of Germany France (D. Villon) and America. I think is the only just document which exist[s] of collecting the good pictures of the unknown artist which it will be a priceless document of the future.

At the time I received your letter telling me about your intention of Giving the Collection to Yale, but I have to say for by that the announcement (——) the printed letter you send me now is <u>the first time I received it,</u> If you send it before to the Brevoort does not surprise me the least since we have not received any mail forwarded by them.

I didn't know that you have already given the collection . . .

An Artists' Museum

Jennifer R. Gross

It is the goal of this exhibition and publication to bring to light the extraordinary history of the Société Anonyme, which was founded in 1920 by the artists Katherine Dreier, Marcel Duchamp, and Man Ray as America's first "experimental museum" for contemporary art.[1] At the conception of the organization its membership was broad, including critics, museum directors, and patrons of art as well as artists; as time passed, however, its profile evolved to focus on the artists who participated in its exhibitions and whose work was included in the Dreier and Société Anonyme collections.[2] Under the leadership of Dreier and Duchamp, advised and assisted by other society members, the Société Anonyme ultimately amassed a collection that is a time capsule of modern art practice from 1920 to 1950, unmediated by traditional art-historical and curatorial analysis.[3] In clarifying the contribution of the Société Anonyme to the definition of modernism in America, this exhibition enriches our understanding of the lives and work of the artists of the period. It is also an endeavor of the project to make familiar the art of many artists whose works are not otherwise represented in American collections. Some, such as Carl Buchheister and Ivo Pannaggi, are well-known in Europe but remain virtually unknown to American audiences; others, such as Angelika Hoerle, Hélène Perdriat, Käte Traumann Steinitz, and Erika Giovanna Klien, have been poorly recognized on both sides of the Atlantic. All deserve closer scholarly examination.

The essays in this volume illuminate aspects of the history of the Société Anonyme as an artist-conceived and -driven institution that markedly distinguish it from other collections and exhibition initiatives of the period. David Joselit's essay on Duchamp reveals this well-known artist's curatorial contributions to the organization, while Ruth Bohan's essay on Duchamp, Dreier, and Joseph Stella explores the influence of their involvement in the organization on their respective artistic practices. Dickran Tashjian's research into the Russian roots of the Société Anonyme articulates the turbulent social and political backdrop that imbued modernism with urgency and relevance during this period. His research also illuminates the connection between Dreier's spiritual beliefs and her faith in modern art, a link that motivated her work as a patron and educator.

My own essay on the rich correspondence among Société Anonyme members, and particularly between Dreier and Duchamp, reveals the web of intimacy that the organization fostered. These letters record the transformation of professional relationships into friendships and collaborations. Kristina Wilson's contextualization of the Société Anonyme's 1926 Brooklyn exhibition within the larger landscape of modernist exhibition practice explores the distinctions between the approach of these artists to the exhibition of modern art and that of their institutional and private predecessors. Susan Greenberg's essay establishes Dreier's prescience as an educator and cultural collaborator in the field of modern art, while Elise Kenney's concise explication of the Collection's integration into Yale University resolves the history of the organization within the image of its ongoing legacy. Sylvia and Robert Mangold's response to their experience of the Société Anonyme legacy both questions and affirms the influential role that museums play in defining the history of art and preserving and interpreting

fig. 1
Société Anonyme signboard (detail), n.d. Paint on panel, 36 x 24 in. (91.44 x 60.96 cm)

that history for their audiences. The Mangolds' comments are challenging to consider in a new period of cultural conservatism and reduced public funding for the living artist in America.

The book concludes with brief biographies of each of the Société Anonyme artists whose works are included in the exhibition. Their lives' itinerant courses, and the web of cultural and aesthetic influences that are recorded in these narratives, testify to the complex image of early modernism in America that was defined by the work of the Société Anonyme.

AN ANONYMOUS SOCIETY OF ARTISTS

Katherine Dreier, Marcel Duchamp, and Man Ray's satirical incorporation in 1920 of an "anonymous society" that would exhibit modern art — its emblem Duchamp's signature laughing ass (fig. 2) — has proved more ironic than these Dadaist aspirants could possibly have conceived. For the work of this incongruous convocation of artists ultimately resulted in the presentation of more than eighty exhibitions of contemporary art, the introduction of more than seventy artists to American audiences, at least eighty-five public programs, and approximately thirty publications — a tour de force campaign to bring modernism to America and nurture an international artistic exchange.

These staggering numbers pale, however, in light of what time has revealed as the organization's crowning achievement: the creation, out of rather modest means, of an inimitable collection of more than one thousand works of modern art. In 1941 the Société Anonyme gave part of this collection to Yale University, to be followed in 1953 by the remainder, through Dreier's estate. Unique to the collection, in contrast to those assembled and exhibited during the same period by Louise and Walter Arensberg, Alfred H. Barr, Jr., and A. E. Gallatin, is its breadth. Dreier and Duchamp (figs. 3 and 4) amassed it without consideration of renown, nationality, or alignment with a particular movement; their criterion was individual merit, and they often acted on the recommendations of other artists involved with the organization. Many of these artists have otherwise been lost to art history, whether because of the peripatetic lifestyle that many of them shared during the economically and politically tumultuous period of 1920–40 or, in some cases, because of early deaths due to illness, persecution, or military service.

When the curator Katherine Kuh reviewed the recently published catalogue of the Collection in the April 1951 issue of the *Magazine of Art*, Dreier wrote back to her, "What pleased both Marcel Duchamp and me especially was that you emphasized that — 'Perhaps even most useful are those many lesser known artists who supported the new movement, for, in a sense, they form the broad base from which the most progressive art of our times evolved since there are few, if any, publications where their work is adequately documented, this catalogue becomes doubly valuable.'"[4] This vision of the value of the Collection as a record that would help rectify the vagaries of art history was shared by the Société's peripheral contributors, as is attested to in a letter to Dreier from Roberto Matta Echaurren, undated but from the 1940s (see pages iii, xxiv, xxi):

> I considered your collection as I told you before one of the most important: <u>as Structures!</u> Not only in so far as the relations of pictures which we know (Duchamp — Picabia — …) but those very little known star artist of Germany, France (D. Villon) and America. I think is the only just document which exist[s] of the unknown artist which it will be a priceless document of the future.[5]

fig. 2
Société Anonyme membership cards for Marcel Duchamp (1923) and Man Ray (1921). Katherine S. Dreier Papers/Société Anonyme Archive. Yale Collection of American Literature, Beinecke Rare Book and Manuscript Library

Dreier and Duchamp did not assume that all of these artists would one day come to be appreciated as modern masters. Rather, they felt that the Collection represented and embodied the modernist spirit in art, and the artists' commitment to creativity — the resolute spirit of the modern art movement. In response to another review of the 1950 catalogue, Dreier wrote to Aline Louchheim of the *New York Times* to correct her evaluation of the source of the energy behind the Collection: "You have overlooked the point that it is 'the many' who create a movement — not the isolated leaders. It is this we have emphasized which makes the Collection of such historical value."[6]

Beyond the tangible achievements of the Société Anonyme — its exhibition record and Collection — what may be the group's greatest contribution to modern art remains unquantifiable, although it is the organization's most enviable accomplishment in the eyes of curators and historians of contemporary art: that is, its creation of an international community of artists who cross-pollinated ideas and resources. Much in keeping with the founding principles behind the Society of Independent Artists (the artists' cooperative responsible for the 1917 exhibition), and with the comradeship of the salon-style meetings, sponsored by the Arensbergs, through which Dreier and Duchamp first met, part of the initial conception of the Société Anonyme was that its artist members would work together to encourage the spirit of modernism in America, and to express that spirit through exhibitions and programs. The organization began with a gallery space at 19 East 47th Street, conceived as a modest forum in which to view modern art and discuss its relative merits. Through Dreier's constant nurture and Duchamp's tireless networking, it grew into an elaborate international web of correspondence and exchange among artists who were often introduced to one another through its auspices. These relationships continued to develop as the artists followed each other's activities and encouraged one another through the difficult emotional, political, spiritual, and financial crises of the interwar period.

The elaborate and diverse nature of this respectful "virtual" community is well recorded in the correspondence housed in the Katherine S. Dreier Papers/Société Anonyme Archive at the Beinecke Library at Yale University. Here one can read Kurt Schwitters's critique of a Max Ernst exhibition, or of a trip Heinrich Campendonk and his students took to see Duchamp's work in Paris, or of Wassily Kandinsky's plea to Dreier on behalf of a Bauhaus-school colleague, Hans Beckmann, for a visa to America. During and after World War II, many of these artists used Dreier's and Duchamp's well-established communication network to try to locate, encourage, and update one another on their work and livelihood, as well as to obtain news of illness, escape, internment, or worse. While Duchamp maintained the organization's activities through his social connections in Paris and New York, Dreier corresponded diligently from her office in West Redding, Connecticut, writing hundreds of letters to encourage artists in their studios, to solicit and dispense financial support, to call on artists such as Kandinsky and Schwitters for philosophical discourse, to keep up with the latest aesthetic trends, and to organize exhibitions. Artists in exile were sent food packages, challenging words of idealism, and advice on their marriages, friendships, and careers. It was through these personal exchanges, and the hope of exhibition opportunities, that artists such as Kandinsky, Schwitters, and Marsden Hartley found the motivation to continue working during years when their work was winning little public interest or financial remuneration. This artistic community, a living organism created by the Société Anonyme in a fractured cultural landscape, was its unparalleled contribution to modern art.

Like the work of many of its participants, the accomplishments of the Société Anonyme have been consistently marginalized in art-historical accounts of art in America in 1920–50, the period in which it operated. This omission may be due in

fig. 3
Katherine S. Dreier, president of the Société Anonyme, in 1920. Katherine S. Dreier Papers/Société Anonyme Archive. Yale Collection of American Literature, Beinecke Rare Book and Manuscript Library

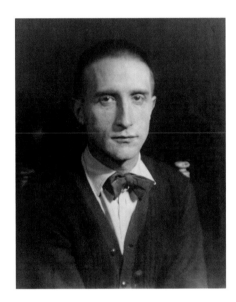

fig. 4
Man Ray. Photograph of Marcel Duchamp. 1920–21. Photograph mounted on cream paper, laid down on blue cardboard, 14⅝ x 11 in. (11.7 x 9.4 cm)

part to the fact that the Société ran its activities from Connecticut and Paris, in partnership with numerous commercial and nonprofit venues, rather than having a centralized point of operation in the New York art community. Probably more important is the fact that both Dreier and Duchamp, the mainstays of the group's activities, were idiosyncratic and private individuals who did not always make clear, even to each other, the full extent of their work, and who were rarely solicitous collaborators with chroniclers of the Société's legacy.

Dreier's generosity toward artists and her passion for art were unflagging. While maintaining her own successful career as a painter, she felt equally called to act as an advocate for artists and for art education. Eventually, through her work with the Société Anonyme, the latter roles surpassed the former as the focus of her energies. In her attention to her mission she was explosively opinionated, and this characteristic, coupled with a compulsion to try to correct or direct writers and others engaged with the Société Anonyme, may well have dissuaded them from a serious study of her endeavors.

Another factor that may have contributed to diminishing the renown of the Collection is that at a time when anti-German and anti-Russian sentiments were pervasive in the United States, the Société Anonyme, and Dreier herself, were seen as having a distinct investment in German and Russian art. Well into the second half of the twentieth century, too, the art generally considered to have been the primary progenitor of modernism was French. Furthermore, throughout the 1940s, 1950s, and 1960s — the period in which modernism found its legs in America — Yale University was unable to commit the financial resources to perpetuate the organization's broader educational mission, and the Collection's public profile remained subdued. This general response to the Collection, coupled with Dreier's naïve pro-German outlook and the misconception that she was a Duchamp-dreamy art maven, distanced scholars from the Collection's history.7

Duchamp, on the other hand, while known as a graceful social gadfly, was also reticent to an extreme (except in correspondence with intimate friends and family members later in his life). He lacked interest in, even loathed, the public life of art, and provided little insight into the activities of the Société Anonyme beyond his contributions to the Yale catalogue of 1950 and his private correspondence with Dreier.

Another reason for the relative anonymity of the Société Anonyme is acknowledged in letters to Dreier from artists such as Stella and John Storrs, who believed that the organization had been overshadowed by The Museum of Modern Art, New York, in receiving recognition for the establishment of modern art in America (see Wilson's essay in the present volume).8 Dreier and Duchamp shared a disregard for Barr's curatorial activities but acknowledged the Modern's growing importance.9 Barr and Dreier actively courted each other for the benefits they thought they could receive through mutual pleasantry; Barr hoped to secure works from Dreier's personal collection for the Modern, and even encouraged Nelson Rockefeller to make a small donation to the Société Anonyme to keep Dreier warm to their efforts, while Dreier knew that Barr's name lent credibility to the activities of her organization. It is clear, though, that Barr reciprocated Dreier's negative opinion, considering her a confounding and competitive presence in the art community, particularly because Duchamp remained so close to her and so supportive of her ideals.

Although museum curators, dealers, and artists in the United States and abroad recognized the Société Anonyme, well into the 1930s, as a source for loans of objects, and for information on modernism in America, Barr was reluctant to give it its due, at least in public. His own education in modern art had actually begun with Dreier's

knowledge of Russian and German modernists; he noted the inspiration of the Société Anonyme's Kandinsky exhibition at Vassar College in 1923, as well as the advice he solicited from her in curating his first exhibitions, at Wellesley College and at the Grace Horne gallery, Boston, in 1927.[10] Yet in a questionnaire on luminaries in the art world that he formulated for *Vanity Fair* in 1927, he omitted to cite Dreier.[11] It was only in his preface to his *Cubism and Abstract Art* exhibition catalogue of 1936, after the Modern was firmly established, that Barr acknowledged Dreier and the Société Anonyme as predecessors in bringing abstract art to America. Privately, however, he did recognize the prescience of the Société Anonyme in its vision of establishing an American museum of modern art in 1920. A letter of 1950 from Rockefeller to Dreier — but drafted by Barr — acknowledges,

> In 1929 when we opened our doors, the Museum of Modern Art quite unwittingly assumed the second half of the Société Anonyme's name. Since then we have followed your lead not only in name, but in several more important ways as our exhibitions and collections clearly show. Your foresight, imagination, courage, and integrity have been a frequent and important example to us.[12]

The truth of this praise is affirmed by Barr's continuous stream of requests to borrow artworks from Dreier and the Société Anonyme for MOMA exhibitions, as well as his aggressive tactics to secure works from Dreier's estate. The Société Anonyme was instrumental in defining the American vision of modernism in the first half of the twentieth century. It was not until the start of the twenty-first, however, that its moment of art-historical recognition arrived.

THE SOCIÉTÉ ANONYME, INC.: MUSEUM OF MODERN ART 1920
The artist founders of the Société Anonyme, while diverse in some of their goals, did commonly recognize a dearth in the presentation and appreciation of modern art in America, and saw a need to counter that lack. The closing of Alfred Stieglitz's 291 gallery in 1917 had left a hole in the exhibition life of New York City; as the first-year Société Anonyme member Marsden Hartley stated, the Société Anonyme is "to continue what was so well begun…at 291."[13] After the Armory Show of 1913 the New York art scene was flush with collectors and exhibition spaces (four years later, thirty-four galleries mounted some 250 exhibitions of works by artists labeled either "modern" or "progressive"), but these operations diverged from the idealism of the New York avant-garde, which was committed to noncommercial exhibitions that provided an experimental forum for the exchange of ideas.[14] The Société Anonyme was intended to be an intimate creative laboratory (fig. 5), an artists' museum where nonmembers paid for participation and where artists knew their work would not be sold.[15]

The goal of the organization in Duchamp's mind (as he conveyed it much later, in 1948, in a telegram to Dreier during the preparation of the Société Anonyme catalogue at Yale) was clearly to see and be inspired by the best available international modern artwork: "ALREADY 1920 NEED FOR SHOWING MODERN ART STILL IN CHAOTIC STATE OF DADA IN NON-COMMERICAL SETTING TO HELP PEOPLE GRASP INTRINSIC SIGNIFICANCE STOP AIM OF SA TO SHOW INTERNATIONAL ASPECT BY CHOOSING IMPORTANT MEN FROM EVERY COUNTRY UNKNOWN HERE SCHWITTERS MONDRIAN KANDINSKY VILLON MIRO. DUCHAMP 1920 DADA SA."[16] Dreier's goals were far more elaborate. A solicitation letter of 1921, which she drafted to be sent out by art writer Sheldon Cheney of the Société Anonyme's Library Committee, exemplifies the enthusiastic tone of much of her correspondence on behalf of the organization, which, she wrote,

came into existence last spring to meet an urgent need in the art world, where students of art, whether they be critics, writers, lecturers, artists, or art students, may come and acquaint themselves with the latest movements in modern painting and sculpture.

Those familiar with the art conditions in this country, realize the extreme need which exists for such a project to prevent us from continuing too limited in our aesthetic sympathies....

It was therefore decided to open a modest Gallery, without pretense or emphasis upon personal taste, where the works of serious men may be seriously studied, and bring new life and new inspiration to those artists, writers, and critics who cannot afford to go to Europe to study these same movements there....

Will you not help so important a movement for a better understanding of the nations of today through art, which is an international language, for this Gallery exhibits the *now*, not the past; the men who create, not the men who copy; the men who follow [John] Ruskin's advice when he says "Invent or perish," and the Stoics' interpretation of art, when they say "Art is to create and beget"! It is this creative element which we want to emphasize in the art we exhibit. We want this little Museum of Modern Art to belong to the people — and as one of the people *will you not contribute $5 or $10 by becoming a member for one year.*[17]

fig. 5
Exhibition rooms of the Société Anonyme, 19 East 47th Street, New York, 1920. Katherine S. Dreier Papers/Société Anonyme Archive. Yale Collection of American Literature, Beinecke Rare Book and Manuscript Library

Man Ray seems to have been the only true Dadaist in the triad, limiting his contributions as cofounder to the conception of the organization's name, basic gallery-maintenance tasks, and playful pranks at public events. Yet the success of the organization's first year clearly hinged on his and Duchamp's vitality, and on the curiosity of the social seekers who flocked to the East 47th Street gallery to observe the Dada craze they heard had arrived from Europe and would have its most complete New York representation through the Société Anonyme. Duchamp and Man Ray brought to the group their cohorts from the Arensberg and Stieglitz circles, while Dreier strategically cultivated critics, museum directors, and patrons to round out their ranks (fig. 6).

The glowing modernist orb that was the Société Anonyme in its inaugural year burned briefly but brightly, with ten in-house exhibitions and lectures and programs that included the likes of Louis Eilshemius, Hartley, Stella, Walter Pach, Man Ray, Henry McBride, and Mina Loy. At the end of that season the avant-garde abruptly abandoned New York: Duchamp and Man Ray went to Paris, the Arensbergs moved to California, and Dreier traveled in China for eighteen months. Yet despite this major shift, the momentum created by the original group left Dreier prepared to carry on her educational mission for the Société Anonyme alone after her return to New York, with a challenging, high-caliber roster of exhibitions and programs (see Greenberg's essay in the present volume).

The Société Anonyme artists felt compelled to unite behind the modernist cause in America for a variety of reasons. Even after the interest inspired by the Armory Show, the integration, acceptance, and assimilation of modern art in America remained an issue for both the art community and the general public. In the artists' minds the problem ranged from provincial nationalism through materialism and bad criticism to plain ignorance. According to Duchamp, "What was needed was to bring over paintings that permitted a confrontation of values…a comprehensive state of mind regarding contemporary art."[18] The Armory Show had left early American modernists such as Hartley, Charles Demuth, and Charles Sheeler inspired by the form and content of contemporary European art, but they struggled to integrate European technique and style with American culture and society. After the war, nationalism ran high in the United States, yet the country's identity was in some respects fragile and harbored a pervasive xenophobia toward the "invading" immigrants who poured through Ellis Island. Searching for a definition and representation of their own culture, many Americans were indifferent or worse toward art that revealed European influence. This attitude was paralyzing to American artists and confounding to Europeans, many of whom eventually felt forced to seek solace and support back in Europe.

This condition was exacerbated by the disposition of the art market. American art buyers were few, and those who did exist, oddly, continued to feel more confidence in European cultural traditions, even the young one of modernism, than in their own. Although European artists felt themselves intellectually unappreciated in America, then, their work still sold far more easily than that of their American counterparts. The extreme reaction to this tendency was exemplified by Stieglitz, whose profound resentment of the American embrace of French artists was the cause of his decision to close his 291 gallery and to focus his energies on assisting indigenous artists who were committed to expressing a purely American aesthetic. The American indifference and ignorance in relation to modern art clearly burned in the minds of the Société Anonyme's founders, who sought consolation in their newly established enclave. Duchamp was committed to holding up the banner of noncommercialism while Dreier sought to rectify America's provincialism through education.

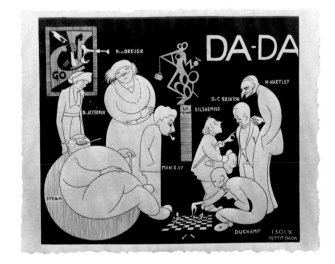

fig. 6
Richard Boix. *DA-DA* (*New York Dada Group*). 1921.
Ink on paper, 11¼ x 14½ in. (28.6 x 36.8 cm).
The Museum of Modern Art, New York. Katherine
S. Dreier Bequest

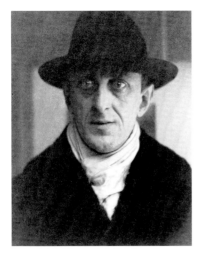

fig. 7
Marsden Hartley, photographed by Alfred Stieglitz. Alfred Stieglitz/Georgia O'Keeffe Archive. Yale Collection of American Literature, Beinecke Rare Book and Manuscript Library

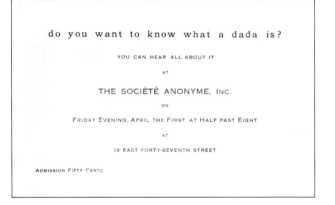

do you want to know what a dada is?

YOU CAN HEAR ALL ABOUT IT

AT

THE SOCIÉTÉ ANONYME, INC.

ON

FRIDAY EVENING, APRIL THE FIRST, AT HALF PAST EIGHT

AT

19 EAST FORTY-SEVENTH STREET

ADMISSION FIFTY CENTS

fig. 8
Invitation card for "do you want to know what a dada is?," lecture by Marsden Hartley and Katherine S. Dreier, April 1, 1921, Société Anonyme Galleries, New York. Katherine S. Dreier Papers/Société Anonyme Archive. Yale Collection of American Literature, Beinecke Rare Book and Manuscript Library

fig. 9 (opposite, top)
Kurt Schwitters, letter to Katherine S. Dreier, June 27, 1927. Katherine S. Dreier Papers/Société Anonyme Archive. Yale Collection of American Literature, Beinecke Rare Book and Manuscript Library

fig. 10 (opposite, bottom)
Katherine S. Dreier and Marcel Duchamp in the library at The Haven, her estate in West Redding, Connecticut, in the late summer of 1936, shortly after Duchamp had repaired his *Large Glass*. Above the bookshelf is *Tu m'*, installed there in 1931. Katherine S. Dreier Papers/Société Anonyme Archive. Yale Collection of American Literature, Beinecke Rare Book and Manuscript Library

Hartley (fig. 7) shared Duchamp's belief that America needed to be shocked into an awareness of modern art. This normally saturnine man, an active early member of the organization, was transformed through the Dada spirit pervading its early activities to the point of wearing an elaborate Dada costume for the Independents Ball of 1921. He became so passionate about the state of modernism in America that in 1920 he wrote a dissertation on modern painting and presented it as a Société Anonyme lecture (fig. 8). According to this essay, the struggle that preyed on the minds of the American artists at this time could be phrased as follows: "The question on the lips of the rest of the world is naturally why is there no art in America?…It is because we have not yet learned the practical importance of true artistic sensibility among us."[19] Hartley saw the battle for modernism in America as one shared by a varied group of Americans, whom he listed at length, and by a group of committed Europeans, many of whom had put their energies behind the Société Anonyme.[20] He poignantly expressed the spiritual, economic, social, and emotional poverty experienced by artists in America in a letter to Dreier, undated but written in the summer of 1921, after he had made the decision to retreat to Europe; thanking her for her support (she and Stieglitz had funded his passage), he plainly states his view of the situation, along with his reluctance to leave the enterprise of the Société Anonyme: "Every other country in the world but America I am free to say — appreciates the value of its artists and does more or less for their advancement and support.…Its too small a game here — and too — played. They have no understanding of art any more than they have for life."[21]

Notions of American provincialism clearly resounded among artists throughout Europe, and it was only the extremity of economic and political conditions there, beginning in the late 1920s, that drove artists to consider America as a recourse for exhibition and livelihood. In June 1927, after Dreier told Schwitters that an exhibition of his work to be sponsored by the Société Anonyme had to be postponed, the artist wrote in reply (fig. 9), "I am very sad that I still have to wait so long before having an opportunity.…I greatly admire the work you have done. You are not only important as an artist, but also as a major organizational talent. And something one rarely finds, you still have idealism. And in America, what is more."[22] By 1928 even Dreier had become worn out by her efforts to fill the black holes in America's cultural constellation, and she wrote Duchamp that she was thinking of ending her American campaign in order to return to her own artwork and perhaps carry out a modified version of the Société Anonyme's activities with him from Paris.[23] It was Dreier alone who sustained the Société Anonyme faith during these years; Duchamp remained committed merely because of his friendship with her. Her enduring idealism would eventually win him back to undertake much hard work on the organization's behalf, but in the 1920s and 1930s his distaste for the art world was profound:

Your 2 letters announcing the possible stop of activities of the S.A. did not surprise me — The more I live among artists, the more I am convinced that they are fakes from the minute they get to be successful in the smallest way.

This means also that all the dogs around the artists are crooks — If you see the combination *fakes and crooks* — how have you been able to keep some kind of a faith (and in what?). Don't name a few exceptions to justify a milder opinion about the whole "art game." In the end, a painting is declared good only if it is worth "so much" — It may even be accepted by the "holy" museums — so much for posterity — …

This will give you indication of the kind of mood I am in — stirring up the old ideas of disgust.

But it is only on account of you — I have lost so much interest (all) in the question that I don't suffer from it.

You still do — [24]

In the 1930s the roles that Dreier and Duchamp had played in the relationship they shared through the Société Anonyme began to change. As a means toward ending their stewardship of the organization's causes, both moved toward the idea of establishing a permanent Société Anonyme collection. Duchamp had been the elusive, reticent compatriot who rarely wrote more than cursory reports of his activities; now, after a trip to America in 1936 during which he made an extended stay with Dreier at The Haven, her home in West Redding, to repair his work *The Large Glass* (1915–23; fig. 10), he became a far more avid correspondent, often acting as Dreier's adviser and encourager and even taking the time to critique her painting.

Dreier turned sixty in 1938, and she began to be beset by health concerns, particularly a circulation problem in her legs that often kept her confined to West Redding. Throughout the next decade her correspondence — and that of many Société

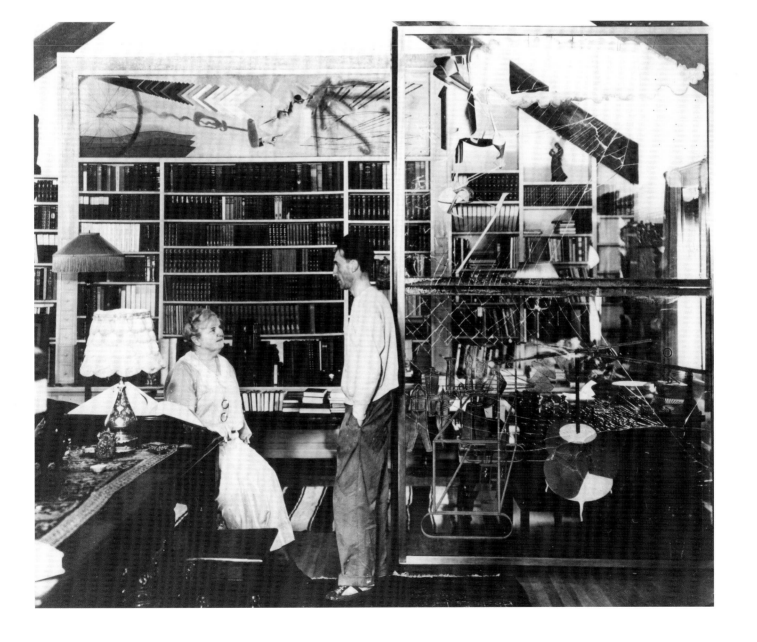

Anonyme artists, including Matta, Schwitters, and Stella — was haunted by discouraging statements about the state of affairs for modern artists and for art in America.[25] A letter to Stella dated February 9, 1942, illustrates her dark view, but also her sense of the importance of the organization's work:

> I am still very conscious of what pioneers we all are in spite of the thirty years of hard work, and that we were so in advance of our time that it has not alone taken all these years for the public to catch up but it will take even longer for them to realize that our group is for the 20th Century what Leonardo, Michael Angelo, Titian, etc., were for the 15th. There is no question in my mind but that with time your pictures will have places of honor — such as you deserve, of course, now — but I hope you will bear with the whole attitude toward Art in America a little longer and permit them to be the missionaries which will make possible this consciousness.[26]

Ultimately this dismal view of America's cultural landscape led Dreier to look to time to vindicate the work of the Société Anonyme, and she began to focus her efforts on the establishment of a permanent collection.

THE SOCIÉTÉ ANONYME COLLECTION

The one endeavor that gave Dreier hope for the future of modernism in America was the building of a collection that could continue to be a resource for exhibitions and lectures long after the organization's members were gone. The final work of the Société Anonyme was Dreier and Duchamp's ambitious undertaking to round out its collection by soliciting gifts from many of their old friends, and to write a catalogue that would stand as a record of the artists represented in that collection after it had been given to Yale University, in 1941 (fig. 11).

George Heard Hamilton, Yale's first curator of the Collection of the Société Anonyme, wrote eloquently of Dreier and Duchamp's efforts in his introduction to the catalogue that he helped them to publish in 1950:

> Although other collections of contemporary art have entered public museums it must be admitted that most of these were formed by persons who are primarily collectors or museum administrators rather than artists themselves. That fact should not be forgotten as one examines the works described in this volume or studies them in the galleries at Yale. They were selected by artists, which means that their choices were governed by their own immediate understanding of the issues which they knew to be important for the future of modern art. All other considerations which may from time to time affect one's choice, such issues as that thorny problem of what forever indeterminable value the future may set, or the temporary eminence of some particular artist or school, were absent as the Collection of the Société Anonyme was formed. For these reasons the Collection holds for all of us the excitement of discovery. Here is not merely a sequence of familiar figures carefully arranged to provide an historical survey of modern art; this *is* modern art in the sense that here are the issues and the personalities who made it, some well-known, others now or still obscure, who have established what we must consider the progressive liberalizing tendencies of the twentieth century.[27]

The idea of the Collection arose as early as 1923, when John Covert gave up the art world and donated several of his works to the Société Anonyme. When the organization was actively sponsoring exhibitions, Dreier would sometimes buy works that had been on loan to the exhibition program (as her means allowed; she suffered significant financial setbacks during the Depression). She recognized that many of the European

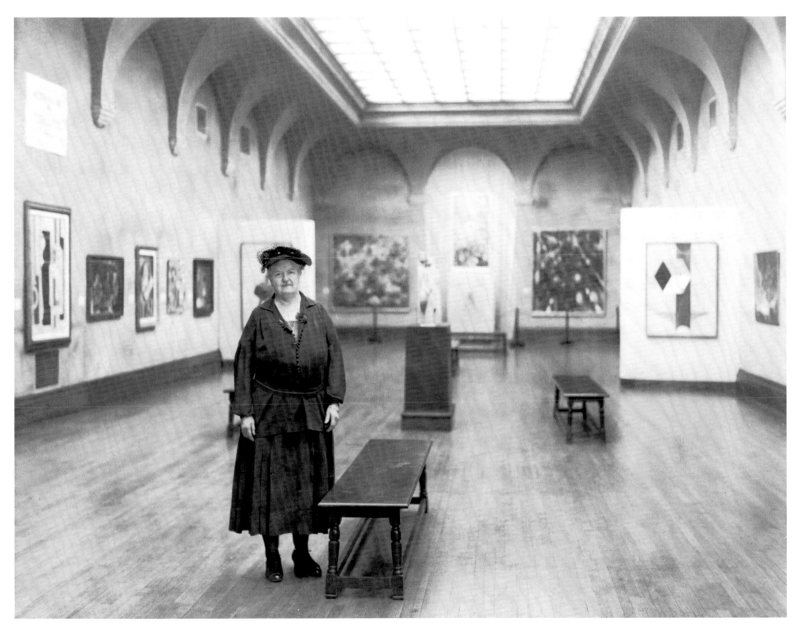

fig. 11
Katherine S. Dreier in the Société Anonyme
Collection exhibition at the Yale University
Art Gallery, 1942. Katherine S. Dreier Papers/
Société Anonyme Archive. Yale Collection
of American Literature, Beinecke Rare Book
and Manuscript Library

contributors could have sold works in Europe and had passed up that opportunity by sending them to be exhibited by the Société Anonyme. Accordingly she felt obliged to support them in turn to the best of her ability. Even in these transactions with the artists, however, her tactical instincts prevailed, and she often requested discounts and favorable exchange rates on behalf of the Société Anonyme in order to perpetuate the organization's educational mission.

Much as Dreier and Duchamp (fig. 12) had shared the decisions in the exhibition program, they shared the task of selecting works for the Collection. Dreier took the lead with suggestions, cajoling Duchamp to take an interest in Piet Mondrian, for example, who she was convinced was a significant artist. But Duchamp consistently edited the final selections. A letter from Dreier to Duchamp of April 4, 1936, when they began their work on the Collection in earnest, typifies their exchanges around the securing of artworks:

> This is indeed good news that you are coming over to prepare the Big Glass....I also wanted to ask you. Do you see Miro?
>
> I am beginning to show the collection of the Société Anonyme quite a little and thought it would be awfully nice if Miro would give the small blue canvas which we still have or let us buy it for the price he offered it to us ten years ago which was forty dollars.
>
> Do you suppose Picabia would let us have his which I thought was yours?
>
> John Graham has given me a very good painting of his for our collection and then this year he gave me a good example of [Serge] Charchoune. Do you know his work?[28]

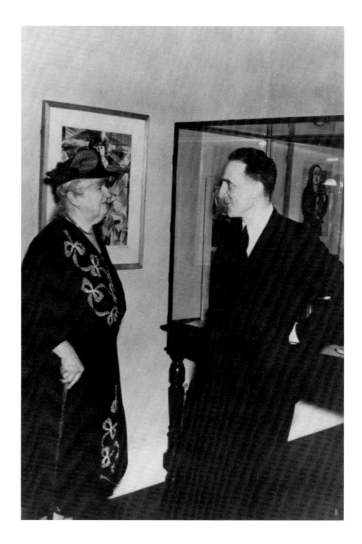

Duchamp's reply reveals his role as Dreier's ambassador: "You can use the Miro, Picabia, and Ernst as if they belonged to the S.A. I will fix it with them when I return."[29]

The artists' responses to Duchamp's and Dreier's inquiries were overwhelmingly positive. Even when they felt unable to give work outright to the Collection, they were often willing to participate in an exchange from Dreier's collection, or to contact their dealers to find another solution for securing a representative work. Many of their letters resound with delight, as artists who had become isolated during the war reconnected with old friends. Storrs wrote to Dreier from France in May of 1949,

> It would not be you if you were not working "*feverishly*" for our good old Société Anonyme — and it was so good to have news of you after all these years — and what years!
>
> No, we have not heard a word of your and Marcel's doings since before the war and it is very exciting to learn that you have made a gift of the collection of the Société Anonyme to Yale; and you can imagine how happy I am to be represented in such a collection — the collection *avant le* [*sic*] *lettre* of collections in America.
>
> I hope now, that the collection is taking a permanent and official place in American art life, and that it will at last (and in spite of certain of the last-minute authorities on "Modern Art") also be given its proper place in the sequence of constructive art appreciation of our day.
>
> It has always been a sore point with me the way you and the Société Anonyme were passed right over by the Museum of Modern Art crowd and their steam-roller, and very happy to see you bouncing back into your rightful place.[30]

Dreier and Duchamp's gift of the Collection to Yale in 1941 left their work still unfinished. In fact the next nine years included some of their most difficult and frustrating labor, as the war derailed their progress on completing the catalogue of the Collection — a project that Dreier considered essential to the educational stewardship of the Collection, and that she hoped would counterbalance the history of modern art being promoted by Barr at MoMA. In 1950, however, just in time for the retirement of Yale President Charles Seymour, their longtime advocate at the university, they completed the book. They officially dissolved the Société Anonyme at a dinner at the New Haven Lawn Club on April 30, 1950 (fig. 13), the thirtieth anniversary of the organization's founding.

The work was accomplished none too soon. Despite Dreier's long-standing belief that she would live into her eighties, her health rapidly declined and she died less than two years later, on March 29, 1952, at the age of seventy-four. Duchamp was one of her estate's three executors, who were empowered to distribute her private collection to nonprofit organizations. He worked hard to honor her wish to keep her collection together but was ultimately unsuccessful. It is clear from his correspondence that his and her intentions were absolutely allied in the final decisions over the future of the works they had spent a lifetime gathering together.[31]

As Duchamp attended to the details of Dreier's estate, he remained to all outward appearances the intellectual aesthetician the art community had come to consider him. In a letter to Louise and Walter Arensberg of May 6, 1952, however, he showed a rare moment of vulnerability, writing of the difficulty the death of his friend had caused him, and of the emotion he had wished to express to her but never could:

> Miss Dreier died already a month ago, as you know, after a slow and long illness....It is really a hard experience to be unable to show your feelings to some one in complete ignorance of the inevitable character of the situation. Fortunately we all have in us a curious animal belief in eternity, as though Time would stop in our personal case.[32]

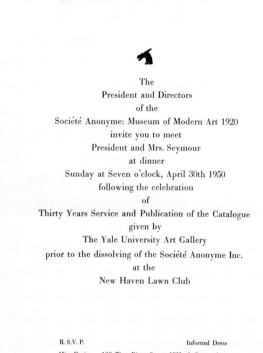

The
President and Directors
of the
Société Anonyme: Museum of Modern Art 1920
invite you to meet
President and Mrs. Seymour
at dinner
Sunday at Seven o'clock, April 30th 1950
following the celebration
of
Thirty Years Service and Publication of the Catalogue
given by
The Yale University Art Gallery
prior to the dissolving of the Société Anonyme Inc.
at the
New Haven Lawn Club

R.S.V.P. Informal Dress
Miss Dreier 130 West River Street, Milford, Connecticut

fig. 13
Invitation to the Société Anonyme's dissolution dinner, April 30, 1950, at the New Haven Lawn Club. Katherine S. Dreier Papers/Société Anonyme Archive. Yale Collection of American Literature, Beinecke Rare Book and Manuscript Library

Dreier died an unwavering spiritual optimist (fig. 14). While her attitudes often confounded Duchamp, he respected her idealism and vision, and her humanitarianism motivated him to invest in the art world beyond his personal inclinations. His correspondence from the period when he was working on closing Dreier's affairs suggests that she mitigated his profound pessimism, and that it was the polarity of their partnership that had made possible the Société Anonyme's breadth of vision. In a letter to Suzanne Duchamp and Jean Crotti, his sister and brother-in-law, sent with a gift from Dreier's estate, Duchamp reiterates his bitter long-standing vision of the artist's hopeless fate, given the deadening practices of the market, American museums, and art historians. What is unusual about this diatribe, though, is that Duchamp concludes his tirade with an exhortation, his dire and cerebral worldview shifting into an appeal for a deeper undercurrent of belief in creativity and the human spirit:

> You were asking my opinion on your work of art, my dear Jean. It's very hard to say in just a few words, especially for me as I have no faith — religious kind — in artistic activity as a social value. Artists throughout the ages are like Monte Carlo gamblers and the blind lottery pulls some of them through and ruins others. To my mind, neither the winners nor the losers are worth bothering about. It's a good business deal for the winner and a bad one for the loser.…It all takes place at the level of our old friend luck. Artists who, in their own lifetime, have managed to get people to value their junk are excellent traveling salesmen, but there is no guarantee as to the immortality of their work. And even posterity is just a slut that conjures some away and brings others back to life (El Greco), retaining the right to change her mind every 50 years or so.… The American museums want at all costs to teach modern art to young students who believe in the chemical formula. All this only breeds vulgarization and total disappearance of the original fragrance. This does not undermine what I said earlier, since I believe in the original fragrance, but, like any fragrance, it evaporates very quickly (a few weeks, a few years at most). What remains is a dried up nut, classified by the historians in the chapter "History of Art."…In a word, do less self-analysis and enjoy your work without worrying about opinions, your own as well as that of others.[33]

The concluding sentence of the letter reads as a tribute to Dreier's vision and voice in Duchamp's life, and an account of the hard work they had undertaken together on behalf of modernism under the auspices of the Société Anonyme. In the final analysis these two artists valued the artwork of their generation enough to keep their energies to the task at hand, through trial and loss of faith. Their legacy is both an extension of their personal artistic inquiries and a testimony to the transforming power of modernism.

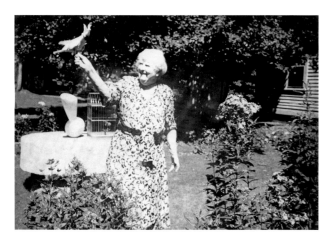

fig. 14
Katherine S. Dreier and Koko, her sulfur-crested cockatoo, at her home in Milford, Connecticut, after 1946. The Schlesinger Library, Radcliffe Institute, Harvard University

Notes

1 "I do not know whether you realize that for the past few years we have had to change our method of approach, for the little gallery we had caused such confusion of mind, that the average public thought we were a commercial gallery instead of a small experimental museum. We are working out a plan and are raising funds for our own permanent building, for we feel that there is a definite place for an experimental museum of art." Katherine S. Dreier, letter to William Henry Fox, July 19, 1926. Box 6, Folder 152, Katherine S. Dreier Papers/Société Anonyme Archive, Yale Collection of American Literature, Beinecke Rare Book and Manuscript Library, Yale University.

2 Outside advisers such as Duncan Phillips, of The Phillips Collection in Washington, D.C., and Alfred H. Barr, Jr., founding director of The Museum of Modern Art, New York, did continue to participate, but the Société Anonyme came to be principally an artist-run initiative.

3 In her introduction to the 1950 catalogue of the Société Anonyme Collection, Dreier wrote, "This Collection, having been formed and continued by two artists, represents the unusual selection in art

created by independent thinkers and doers. Being artists, they had a criterion in their own work, so were not side-tracked by work which was like a flash in the pan. Their selection represents real achievement of great and small talent — fearless and joyous artists who wanted to give expression to the birth of a new era we were entering. It is not, therefore, a collection of only high achievement based on the judgment of the period in which we live, which most collections are, but a living historical expression which, as the years pass, will be more and more sought after by historians." Dreier, Introduction to *Collection of the Société Anonyme* (New Haven: Yale University Art Gallery for the Associates in Fine Arts, 1950), p. xiii.

4 Dreier, letter to Katherine Kuh, November 28, 1951. Box 21, Folder 597, Katherine S. Dreier Papers.

5 Roberto Matta Echaurren, letter to Dreier, n.d. (c. 1940). Box 23, Folder 682, Katherine S. Dreier Papers.

6 Dreier, letter to Aline Louchheim, May 8, 1950. Box 31, Folder 895, Katherine S. Dreier Papers.

7 Like many of Dreier's economic, political, and religious beliefs, her position on German politics was inherently incongruous. Her family was devoted to Germany, an attachment she was raised to share, and she could not bear to hear anti-German sentiment, even from dissident members of her family. Her faith in Hitler as an able leader for Germany endured into the war. Her attitudes certainly did not improve her public image and contributed to a misconception of her as an insensitive tyrant. At the same time, she aided many German refugee artists and objected to Nazi censorship of many of her artist friends. Her correspondence reveals her as clearly anti-Semitic in business matters, an attitude she may have learned from her father, yet she respected and gladly kept company with many Jewish artists and other colleagues.

8 "I believe that your pioneer work, as an artist and as a patron of modern art, entitles you to the front rank. Too many charlatans try to usurp the high esteem that is due to you. I remain grateful to you and to your sister for what both of you have done in my behalf and in behalf of modern art in general." Joseph Stella, letter to Dreier, May 20, 1939. Box 33, Folder 967, Katherine S. Dreier Papers. See also John Storrs, letter to Dreier, May 15, 1949. Box 33, Folder 974, Katherine S. Dreier Papers.

9 "On the other hand I am sorry to have been lazy to write you, as I had asked [Julien] Levy and [Walter] Pach not to lend anything of mine to Mr. Barr....But do you remember my telling you about the arrogance of the gentleman and you know that my only attitude is silence — But please keep that for yourself and write what you know of the show." Marcel Duchamp, letter to Dreier, Paris, December 15, 1934. Box 12, Folder 320, Katherine S. Dreier Papers. "The Museum of Modern Art is going to build....It is too bad that our Group was not strong enough to carry it to completion. The more I work with the Modern Museum the more trying it is for there is neither love nor intelligence regarding art. ...I yet do not know what or where we lacked in judgment — but somewhere we did....It just makes me sick." Dreier, letter to Duchamp, March 1936. Box 12, Folder 321, Katherine S. Dreier Papers.

10 Barr, Preface to *Cubism and Abstract Art* (New York: The Museum of Modern Art, 1936), p. 9. See also Sybil Gordon Kantor, *Alfred H. Barr, Jr., and the Intellectual Origins of The Museum of Modern Art* (Cambridge: MIT Press, 2002), pp. 111–17.

11 Barr, "Modern Art Questionnaire," *Vanity Fair* 28 (August 1927): 85, 96, 98.

12 Nelson Rockefeller, letter to Dreier, April 30, 1950. Box 26, Folder 738, Katherine S. Dreier Papers. The Museum of Modern Art Archives, NY: [AAA: 2172; 973]. The full name of the Société Anonyme was "Société Anonyme, Inc.: Museum of Modern Art 1920."

13 Marsden Hartley, quoted in Dickran Tashjian, *Skyscraper Primitives: Dada and the American Avant-Garde, 1910–1925* (Middletown, Conn.: Wesleyan University Press, 1975), p. 61.

14 See Judith Zilczer, "'The World's New Art Center': Modern Art Exhibitions in New York City 1913–1918," *Journal of the Archives of American Art* 14, no. 3 (1974): 2–7.

15 "Dear old man, dear Suzanne, I have wanted nothing but to write to you for 6 months. But writing's a pain in the ass for me...etc. etc. Nothing much new here. The Société Anonyme is a gallery where you exhibit but don't sell. It costs 25 cents to go in. People find it hard to part with their 25 cents. My first idea was to charge critics 50 cents. But they don't come at all. Apart from that, it's the only thing of interest in N.Y. Nothing else." Duchamp, letter to Jean Crotti and Suzanne Duchamp, c. October 20, 1920, in *Affect/Marcel: The Selected Correspondence of Marcel Duchamp*, ed. Francis M. Naumann and Hector Obalk (London: Thames and Hudson, 2000), p. 93.

16 Duchamp, telegram to Dreier, January 16, 1948. Box 12, Folder 324, Katherine S. Dreier Papers.

17 Sheldon Cheney, letter to Kenneth Macgowan, March 18, 1921. Box 23, Folder 665, Katherine S. Dreier Papers. The tone of this solicitation strongly resembles many letters sent out by Dreier throughout the life of the organization.

18 Duchamp, quoted in an interview with James Johnson Sweeney, "11 Europeans in America," *Bulletin of The Museum of Modern Art* 13, nos. 4–5 (1946): 19.

19 Hartley, "Modern Painting," lecture at the Société Anonyme, November 30, 1920. Box 56, Folder 1543, Katherine S. Dreier Papers.

20 "Besides these indigenous names, shall we place the foreign artists whose work falls into line in the movement toward modern art in America, Joseph Stella, Marcel Duchamp, Gaston Lachaise, Eli Nadelman. There may at least be no questioning as to how much success all of these artists would have in their respective ways in the various groupings that prevail in Europe at this time. They would be recognized at once for the authenticity of their experience and for their integrity as artists gifted with international intelligence. There is no reason to feel that prevailing organizations like the Society of Independent Artists, Inc., and the Société Anonyme, Inc., will not bear a great increase of influence and power upon the public, as there is every reason to believe that at one time or another the public will realize what is being done for them by these societies, as well as what was done by the so famous '291' gallery." Hartley, "Modern Art in America," in *Adventures in the Arts (Informal Chapters on Painters, Vaudeville, and Poets)* (New York: Boni and Liveright, Inc., 1921; rpt. ed. New York: Hacker Art Books, 1972, pp. 62–63).

21. Hartley, letter to Dreier, n.d. (summer 1921). Box 84, Folder 2124, Katherine S. Dreier Papers.

22 Kurt Schwitters, letter to Dreier, June 27, 1927. Box 31, Folder 925, Katherine S. Dreier Papers.

23 Dreier, letter to Duchamp, October 7, 1928. Box 12, Folder 318, Katherine S. Dreier Papers.

24 Duchamp, letter to Dreier, November 5, 1928. Box 12, Folder 318, Katherine S. Dreier Papers.

25 For example: "My *dear* Miss Drier: To live in N.Y. is like on a blotting-paper — my life is sucked. ...My love, Matta." Matta, letter to Dreier, April 5, 1940. Box 23, Folder 682, Katherine S. Dreier Papers.

26 Dreier, letter to Stella, February 9, 1942. Box 33, Folder 967, Katherine S. Dreier Papers.

27 George Heard Hamilton, "The Société Anonyme at Yale," in Dreier and Duchamp, *Collection of the Société Anonyme*, pp. xix–xx.

28 Dreier, letter to Duchamp, April 4, 1936. Box 12, Folder 321, Katherine S. Dreier Papers.

29 Duchamp, letter to Dreier, April 21, 1936. Box 12, Folder 321, Katherine S. Dreier Papers.

30 Storrs, letter to Dreier from France, May 15, 1949. Box 33, Folder 974, Katherine S. Dreier Papers.

31 "Dear Totor, Dreier's large glass will most likely go to Philadelphia where the Arensberg collection is. As for the rest of her collection, I plan on giving it (in utmost secrecy) to Duncan Phillips (Phillips Memorial Washington) as I'm hoping I can get him to give it a room or 2 in the name of K.S. Dreier Collection. I would prefer this solution to everything being scattered all over the place. Keep me posted. Affectionately, Totor." Duchamp, letter to Henri-Pierre Roché, May 7, 1952, in *Affect/Marcel*, p. 315. Duchamp and Roché addressed each other using the pet name "Totor" in their letters.

32 Duchamp, letter to Louise and Walter Arensberg, May 6, 1952, ibid., p. 313.

33 Duchamp, letter to Crotti and Suzanne Duchamp, August 17, 1952, ibid., p. 321.

Joseph Stella and the "Conjunction of WORLDS"

Ruth L. Bohan

In 1921 Richard Boix, a cartoonist for *Vanity Fair* and *The Dial*, produced a cartoon showing Katherine Dreier and members of the Société Anonyme on the occasion of the organization's Symposium on the Psychology of Modern Art and Archipenko (see fig. 6 in Gross's introductory essay in the present volume). The organization's founders anchor the center of the composition along a diagonal that extends from Dreier through Man Ray to Marcel Duchamp, who sits cross-legged on the floor, engrossed in a game of chess. Facing Duchamp in a chair appropriate to his enormous girth is the rotund figure of Joseph Stella. While Man Ray turns his back on Dreier, a sign of the friction that often marred that relationship, Stella joyfully receives both Dreier, whose figure mirrors the contours of his own spherical form, and Duchamp, toward whom he directs an enormous grin. Boix's triangulation of the relationship of Stella, Dreier, and Duchamp hints at the complex and often elusive nature of the Société Anonyme's shifting internal alignments. The cartoon suggests the element of playfulness that infused the interactions between Stella and Duchamp, as well as Dreier's opposing seriousness, indicated by her erect bearing and commanding central position.

At its core, this unlikely threesome embodies the inclusive spirit and integrated conception of modernism that distinguished the Société Anonyme from other American sponsors of modern art during the 1920s. Duchamp, the conceptual artist and radical innovator, boldly challenged many of art's fundamental assumptions. While Stella and Dreier remained committed in their own art to the traditional medium of paint, Duchamp had produced his last oil painting two years before the Société Anonyme opened its doors. At the same time, Duchamp's wit and ironic detachment proved both an inspiration and a potent foil to Stella's mystically charged paeans to American technological might. In the diversity of their artistic attachments and the breadth of their familiarity with modernist developments internationally (Duchamp was French, Stella Italian, and Dreier American with strong ties to Germany), the trio reified Dreier's efforts to broaden the understanding of modernism in America.

Dreier, Duchamp, and Stella first joined forces while serving on the board of directors of the Society of Independent Artists, an important preamble to their collaboration in the Société Anonyme. Dreier's involvement in the society inaugurated a dynamic new dimension in her expanding commitment to modern art and provided her with an important public platform from which to proselytize on modern art's behalf. From the beginning she placed considerable value on Duchamp's contribution to the organization, terming his presence "essential" to its success and praising him for his "sincerity" and "originality," traits she found lacking in most American artists. But if she was quick to appreciate Duchamp's intellectual strengths, she was less sure, at least at this juncture, of his artistic contributions. She voted against the inclusion of his *Fountain* in the Independent Artists' show of 1917, she informed him, not because of any prudishness on her part but because she did not detect anything "pertaining to originality in it." Still, she was quick to recant this admission, confidently asserting that had her attention been drawn to "what was original by those who could see it," she "could…also have seen it."[1]

For Stella the significance of Duchamp's work was never in question. Shortly after the two met, in late 1915 or early 1916, Stella launched a series of reverse paintings on glass that marked a notable departure from his own artistic practice in their knowing appropriation of Duchamp's technical and conceptual unorthodoxies. One of the most significant of these, *Man in the Elevated (Train)* (1916; fig. 2), personalizes and recapitulates Duchamp's *Large Glass* (1915–23), then under construction in Duchamp's studio. The behatted man in profile, seen through the window of a commuter train, is a self-portrait. The fan-shaped red form suspended directly in front of his face, a simplified version of the *pendu femelle*, gives visual affirmation that this bachelor is daydreaming about the bride in Duchamp's glass. Most tellingly, Stella surrounded the principal shapes on the verso of the glass with lead wire.[2] Another of Stella's reverse paintings on glass hung between Duchamp's *Nude Descending a Staircase* (1912) and a 1914 study for *Chocolate Grinder* in Walter Arensberg's apartment. Perhaps it was here that Duchamp, in conversation with Arensberg and Stella, first hatched the idea for *Fountain*.[3]

Late in 1917, six months after Duchamp resigned from the Society of Independent Artists over the rejection of *Fountain*, Dreier too resigned and shortly thereafter commissioned him to paint a mural over a bookcase in her New York apartment (fig. 3). Duchamp considered *Tu m'*, begun in January 1918, "a kind of inventory of all my preceding works, rather than a painting in itself."[4] Repeated several times in this visual "inventory" are outlines of the 3 *Standard Stoppages*, Duchamp's invented system of measure. Later, when Duchamp gave the *Stoppages* to Dreier, *Tu m'* took on the suggestion of another sort of inventory: it hinted at the collection Dreier would amass of many more of Duchamp's works, including such major pieces as *The Large Glass*, which she acquired from Arensberg in 1923. It portends as well the developing bond that would join Dreier and Duchamp with Stella, for the *Stoppages* figures prominently in a work that Duchamp entrusted to Stella for safekeeping later that year.

Like others among Duchamp's friends, Dreier and Stella probed both their relationship with Duchamp and his significance within the modernist community through a series of portraits of the artist notable for their visual and conceptual diversity. Dreier considered her abstract portraits her special contribution to the modern movement, and her *Abstract Portrait of Marcel Duchamp* (1918) is one of the most striking of her works in this genre (fig. 4). One writer even declared that it "out-Duchamp[ed] Duchamp and his never-to-be-forgotten *Nude [sic] Descendant un Escalier*."[5] In a letter of April 1917 urging Duchamp not to resign from the Society of Independent Artists, Dreier had placed particular emphasis on his "spiritual sensitiveness," a quality she also admired in Stella.[6] Her convictions about the spiritual foundations of the modern movement grew out of her long-standing commitment to Theosophy, a belief system with which Duchamp himself had flirted earlier in his career.[7] Dreier accepted without question the notion that humans were equipped with a crucial "spiritual eye" that allowed them to see into the spiritual underpinnings of the universe. In *On the Spiritual in Art* (1912), a book Dreier valued most highly, Wassily Kandinsky, himself a student of Theosophy, likened the life of the spirit to "a large acute triangle" moving "slowly, barely perceptibly, forward and upward," advancing the spiritual life of the community. "At the apex of the topmost division," he noted, "there stands sometimes only a single man."[8] Triangles constitute a dominant motif in Dreier's portrait of Duchamp, where their richly patterned surfaces enframe and partially overlap a central golden disc.[9]

Dreier's *Portrait of Marcel Duchamp (Triangles)*, painted the same year as the *Abstract Portrait*, tantalizingly presents Duchamp as the one commanding the apex of

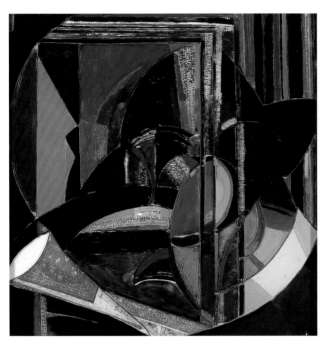

fig. 2
Joseph Stella. *Man in the Elevated (Train)*. 1916. Oil, wire, and collage on glass, 14 1/4 x 14 3/4 in. (36 x 37.5 cm). Mildred Lane Kemper Art Museum, Washington University in St. Louis. University Purchase, Kende Sale Fund, 1946

fig. 3
Marcel Duchamp. *Tu m'*. 1918. Oil on canvas, bottle brush, three safety pins, and one bolt, 27 1/2 in. x 9 ft. 11 5/16 in. (69.8 x 303 cm)

the spiritual triangle (fig. 5). In a stark studio setting Duchamp sits on a wooden stool very similar to the one used as the base for *Bicycle Wheel* (1913). Dressed in an overcoat belted at the waist, he holds a pipe in one hand and a fedora in the other. Triangular shapes abound, beginning with Duchamp's bent elbows and knee, including the negative space within the bend of his left elbow, and extending to the shadows on the wall. The painting, which has been lost, presents a striking contrast to a photograph taken at about the same time of Duchamp smoking a pipe in the feminized space of Dreier's New York apartment (fig. 6). In the photograph, Duchamp appears dwarfed by the patterned wallpaper and elaborate lampshade, which in placement and design suggests a woman's hat. In the painting, by comparison, Duchamp physically dominates the scene, while his angular posture and outdoor clothing assert a decisively masculine presence.

Projected against the back wall in the painting are two shadows, one broad and dark, the other vertical, lighter in color, and contained within a rectangular panel suspended behind the figure. Duchamp himself painted the vertical shadow for Dreier, then signed and dated it "Marcel Duchamp 1918," much as the sign painter A. Klang signed *Tu m'* just below the pointing hand that Duchamp asked him to add to that work. The darker shadow approximates the contours of the figure's body, but the shadow in the panel is more independent, even skeletal, in nature. In one of the notes in *A l'Infinitif* Duchamp writes, "Virtuality as 4th dimension. Not the Reality in its sensorial appearance, but the virtual representation of a volume (analogous to the reflection in a mirror)."[10] Almost certainly the rectangle on the back wall is a mirror and the shadow contained within it a reference to the fourth dimension. This extraordinary collaboration merges Dreier's Theosophical beliefs and Duchamp's involvement with the fourth dimension in a synergistic exchange indicative of the interpersonal and artistic dynamics of their relationship.

An early study for the painting reveals a more frontal pose — more like that in the photograph taken in Dreier's apartment — and a single, larger, and more amorphous shadow (fig. 7). An inscription in Dreier's hand in the upper-right-hand corner of the sheet reads "J Stella / c / o Dr. A. Stella / 214 E. 16th St." Dr. Antonio Stella was Joseph's brother and a modest but consistent supporter of the Société Anonyme in

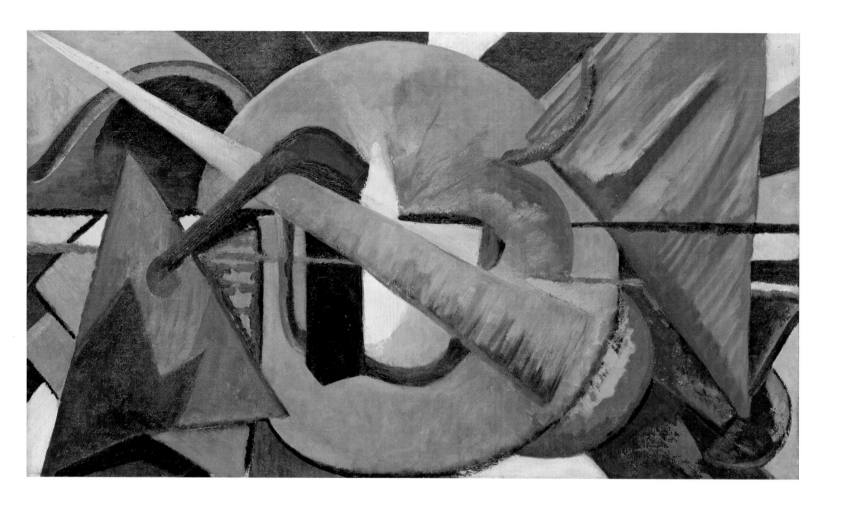

fig. 4
Katherine S. Dreier. *Abstract Portrait of Marcel
Duchamp.* 1918. Oil on canvas, 18 x 32 in.
(45.7 x 81.3 cm). The Museum of Modern Art,
New York. Abby Aldrich Rockefeller Fund

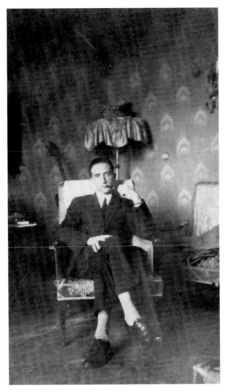

fig. 5
Katherine S. Dreier. *Portrait of Marcel Duchamp*
(*Triangles*). 1918. Original work lost. Photograph:
Katherine S. Dreier Papers/Société Anonyme
Archive. Yale Collection of American Literature,
Beinecke Rare Book and Manuscript Library

fig. 6
Marcel Duchamp in Katherine Dreier's New York
apartment, c. 1918. Katherine S. Dreier Papers/
Société Anonyme Archive. Yale Collection of
American Literature, Beinecke Rare Book and
Manuscript Library

fig. 7
Katherine S. Dreier. Study for *Portrait of Marcel
Duchamp* (*Triangles*). c. 1918. Katherine S. Dreier
Papers/Société Anonyme Archive. Yale Collection
of American Literature, Beinecke Rare Book and
Manuscript Library

its early years. Perhaps Stella, who would shortly complete his own figurative portrait of Duchamp, had asked to see Dreier's composition before starting his own. Certainly the inclusion of Stella's name on Dreier's sketch hints at the relationship that would soon reconnect this threesome during the Société Anonyme's first year.

From the moment of the organization's founding, in 1920, Stella distinguished himself as one of its most committed charter members. Man Ray would later contend that he was principally concerned with ingratiating himself with Dreier, but actually the Italian-born artist vigorously assisted Dreier and the organization well beyond the close of its first year, when Man Ray and Duchamp left for France.[11] Stella brought to the Société Anonyme firsthand knowledge of modernist practices in Europe and the United States and a growing reputation as an interpreter of urban American culture. As one who straddled two cultures, he appreciated the organization's determined internationalism and spirit of collaboration. In addition to his modernist credentials, Stella, like Dreier, was a supporter of humanitarian causes, particularly those involving immigrants. His dozens of drawings for the investigative journal *The Survey* recorded the dignity and vulnerability of immigrant laborers and recent Ellis Island detainees. As for Dreier, a child of immigrants, she was committed to improving the conditions of the urban poor. At her insistence the Société Anonyme held some of its exhibitions in such unlikely locales as the Manhattan Trade School for Girls, a social-service organization with which she had been actively involved since the turn of the century (see Greenberg's essay in the present volume). Dreier made a point of including works by Stella both times the Société Anonyme exhibited at the school, and Stella returned the favor by assisting her with one of the lectures she gave there.

During the Société Anonyme's first year Stella was active on several fronts. He was a member of the exhibition committee, which oversaw the selection and hanging of the exhibitions; he contributed a gallery talk to the group's educational program; and he answered questions following three of Dreier's lectures. The organization's first annual report classified him as an Italian and a Futurist, and it was probably he who donated publications on Futurist art to the Société Anonyme's library.[12] In 1912, during the first major showing of Futurist art in Paris, Stella had met a number of the Futurists. Like many of the artists drawn to Dreier and the Société Anonyme, he was encouraged to parlay his familiarity with the European vanguard to further the organization's ambition to establish strong working relationships with a broad spectrum of European artists and art movements. In the early 1920s Stella broached the possibility of a Société Anonyme exhibition in a letter to Carlo Carrà. Had the exhibition materialized, it would have been the first group show of Italian modernist art in New York and only the second such exhibition nationwide. In his letter Stella offered Carrà considerable latitude, specifying only that his Italian colleague organize a group of "all the artists you should deem appropriate" to exhibit together with the Société Anonyme the following year. He tempered this generosity, however, with a cautionary note: "It goes without saying," Stella advised, "that all pseudo-novelties and secessionist pranks are to be rejected *a priori*."[13]

In issuing this warning Stella was surely following directives from Dreier. He was not always so compliant, however; Duchamp and the freewheeling spirit of Dada proved alluring alternatives to Dreier's disciplined seriousness, as Stella's gallery talk and the events leading up to it suggest. Stella was originally scheduled to speak on January 8, 1921, but the talk was postponed due to an electrical fire in the gallery. The press carried conflicting accounts of the cancellation. One, which made no mention of the fire, described a crowd of "some 50 persons, for the most part devotees of 'modern' art," waiting on the sidewalk outside the galleries for an unnamed speaker

who failed to appear. The reviewer reported that the assembled crowd dispersed without incident but that the size of the group had prompted some passersby to suspect an automobile accident.[14] Several weeks later Stella's friend Joseph F. Gould disputed that account, charging the reporter with having let "his 'cubist' or 'vorticist' imagination run riot." Gould estimated the crowd at "about a hundred people" and criticized Dreier for refusing to let the talk proceed despite the group's eagerness to hear Stella, even if that meant sitting "on burned chairs, without lights."[15]

When Stella finally presented his lecture, nearly three weeks later, the audience was not disappointed. Witty and irreverent, the talk included a number of disparaging remarks about such sacred cows as the academy and the pope. Stella began with a parable about the birth of painting as viewed through the fractured lens of his Italian heritage: he described Jupiter angrily instructing Apollo to "go back to the Greenwich Village" while "that little son of gun of Cupid…splashe[s] some red, blue and green on the glossy plasticity of Venus." In a frequent refrain of Stella's, he went on to admonish his fellow artists to rid themselves of oppressive rules: "Rules don't exist," he insisted. "If they did exist everybody would be artist."[16] Two days later, in a question-and-answer session following one of Dreier's lectures, Stella joined Duchamp in answering the question "What is Dada?": "Dada," he told a reporter, "means having a good time.…It is a movement that does away with everything that has always been taken seriously. To poke fun at, to break down, to laugh at, that is Dadaism."[17]

A few months later, in April 1921, the single-issue journal *New York Dada* announced the "Coming Out Party" of Stella and Marsden Hartley, also active in the Société Anonyme, to be held at Madison Square Garden. In keeping with the Garden's popularity as a boxing venue, this "beautiful pair of rough-eared debutantes," billed as two "Pug Debs," were to be dressed in the latest pugilist attire. Hartley was to wear "a neat but not gaudy set of tight-fitting gloves" and the rotund Stella a pair of "full-dress tights" and six-ounce suede gloves with "a little concrete in 'em if possible." Poet Mina Loy was to release "flocks of butterflies…from their cages" with the turn of a "gold spigot." Afterward the butterflies would "flitter through the magnificent Garden, which has been especially decorated with extra dust for the occasion. Each butterfly will flit around and then light on some particular head."[18] The butterflies seem calculated to evoke Stella's exquisite drawings of butterflies, two of which he gave Dreier. In one, a butterfly appears about to alight on a single delicate flower whose circular shape reminds one of a human head (fig. 8).

Stella probably presented the drawing to Dreier just before her departure for China at the close of the Société Anonyme's first year. The inscription reads: "Buon viaggio e buona fortuna per la 'Société Anoime'" — perhaps a punning rendering of the society's name as Anomie, lawlessness. It is one of five drawings that Stella gave Dreier over the course of their long friendship. Both the sincerity of the inscription and the delicacy of the drawing stand in sharp contrast to the satiric content of Stella's lecture. They are equally at odds with a gift Dreier had received several months earlier from another Dada conspirator, Man Ray, whose *Three Heads (Joseph Stella and Marcel Duchamp)* (1920) shows Stella and Duchamp staring blankly out at the viewer while seated under a photographic head overlaid with the collaged silhouette of a young girl holding a bouquet of flowers (fig. 9). Susan Fillin-Yeh has argued that this image "knowingly and intriguingly recapitulates Duchamp's *Large Glass*," with Stella and Duchamp, both bachelors, occupying "an area corresponding to the Bachelor's zone of the *Large Glass*" and the partially obscured, wavy-haired figure in the photograph above them invoking "the wavy evanescence of Duchamp's Bride and her Veil." Fillin-Yeh further proposes that the girl's silhouette can be seen "as an emblem for Dreier herself, with her large hats, girlish round face, and flowered dresses," a scenario

fig. 8
Joseph Stella. *Flower and Butterfly*. c. 1920–30. Crayon and graphite on paper, 14 1/8 x 11 1/4 in. (35.9 x 28.6 cm)

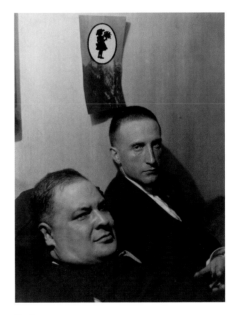

fig. 9
Man Ray. *Three Heads (Joseph Stella and Marcel Duchamp)*. 1920. Gelatin silver photograph with paper collage mounted on red poster board, 11 1/8 x 8 in. (28.3 x 20.3 cm)

fig. 10

Joseph Stella. *Portrait of Marcel Duchamp,* 1920. c. 1921. Silverpoint on paper, 27¼ x 21 in. (69.2 x 53.5 cm). The Museum of Modern Art, New York. Katherine S. Dreier Bequest

fig. 11

Jean Crotti. *Portrait of Marcel Duchamp (Sculpture Made to Measure).* 1915. Original work lost. Seen here as reproduced in *The Soil,* December 1916

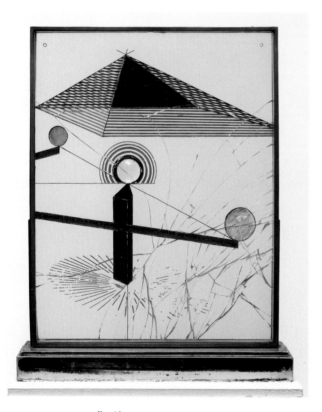

fig. 12a

Marcel Duchamp. *To Be Looked At (From the Other Side of the Glass) with One Eye, Close To, for Almost an Hour.* 1918. Oil paint, silver leaf, lead wire, and magnifying lens on glass (cracked), 19½ x 15⅝ in. (49.5 x 39.7 cm), mounted between two panes of glass in a standing metal frame, 20⅛ x 16¼ x 1½ in. (51 x 41.2 x 3.7 cm), on painted wood base, 1⅞ x 17⅞ x 4½ in. (4.8 x 45.3 x 11.4 cm), overall height 22 in. (55.8 cm). The Museum of Modern Art, New York, Katherine S. Dreier Bequest

that has Dreier "playing bridesmaid to the Bachelor's Bride."[19] Stella's drawing and its uplifting inscription seem quaint, even old-fashioned, by comparison.

Part sentimentalist, part Dada conspirator, part independent modernist, Stella was a person of contrasts. The composer Edgard Varèse, a close friend, described him as "sometimes friendly, and sometimes hostile — you never knew, with Stella....He was in some ways so refined, so delicate — a purist — and then he could be so vulgar, obscene. And physically, too, he was a paradox — big, fat, heavy-bodied, and yet so graceful."[20] Stella's paradoxical nature is evident in his silverpoint *Portrait of Marcel Duchamp,* 1920 (c. 1921; fig. 10), begun during the Société Anonyme's inaugural season. Like the drawings he gave Dreier, the work defies the antiart gestures of Dada: in style, medium, and pose, his portrait of this most challenging and unconventional of contemporary artists is, incongruously, deeply rooted in the Renaissance heritage of Stella's Italian youth. Historically, profile portraits have been used to immortalize a figure, and, just as often, to effect a distance between subject and audience. Accordingly, like Dreier's abstract portrait of Duchamp, Stella's silverpoint portrait complicates rather than clarifies access to the sitter. Duchamp is defined solely by his head, as he also is in a wire portrait of him by Jean Crotti, which, when viewed from the side, presents a profile view (fig. 11). Yet in contrast to Crotti's representation, with its applied hair and glass eyes, the disembodied figure in Stella's work appears removed and remote. Reinforcing Duchamp's inscrutability, the profile pose, with its necessarily averted gaze, thwarts the viewer's interaction with the subject. Stella believed that "the language of the painter must be precise and elusive in the same time"; the portrait illustrates that contention.[21]

Stella often employed the silverpoint medium for portraits, but its relationship to Duchamp merits special consideration. In silverpoint drawing a delicate silver wire is applied to a carefully prepared sheet. It is a demanding medium, producing a fine, even line that allows for no errors of execution. Both the medium and its painstaking means of application recall Duchamp's labor-intensive use of lead wire in the bachelor panel of *The Large Glass.* They may also relate to the silvering of the oculist witness in *To Be Looked At (From the Other Side of the Glass) with One Eye, Close To, for Almost an Hour* (1918; fig. 12), which Stella no doubt saw at Dreier's apartment. Duchamp's silvering was a subtractive process rather than an additive one, involving scratching away from an already silvered surface rather than adding a silver line to a blank sheet; but both techniques share the metallic quality of the line. The inflexibility of the silverpoint medium particularly appealed to Stella, who embraced it "in order to avoid careless facility. I dig my roots obstinately, stubbornly in the crude untaught line buried in the living flesh of the [Italian] primitives," he advised, "a line whose purity pours out and flows so surely in the transparency of its sunny clarity."[22] Yet for all the "sunny clarity" of the medium, Stella's drawing assiduously avoids any attempt to clarify Duchamp's vibrant inner self. The obstinate passivity of the pose focuses exclusively on the oft-remarked blandness of Duchamp's exterior self. In this it perpetuates the masklike inscrutability that Duchamp cultivated, as Nancy Ring has demonstrated, during his years in New York.[23]

Dreier acquired Stella's silverpoint drawing shortly after its completion and retained it, as she did his flower drawings, as part of her private collection until her death. Like her preparatory sketch for *Portrait of Marcel Duchamp (Triangles),* inscribed with Stella's name, the drawing connects these three associates in a matrix that extends from Stella (the producer) through Duchamp (the subject) to Dreier (the patron). In 1923 Dreier paired Stella's drawing with her *Abstract Portrait of Marcel Duchamp* on opposite pages in her book *Western Art and the New Era.* "Those who have studied closely the two pictures together," she wrote, "have been amazed at the

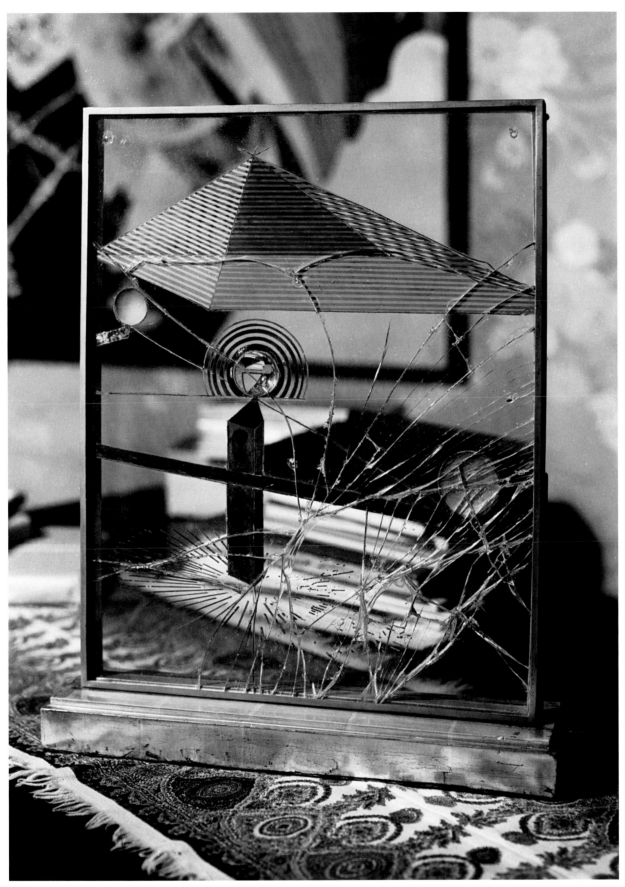

fig. 12b
Photograph of Marcel Duchamp's
To Be Looked At (From the Other Side of the Glass)
with One Eye, Close To, for Almost an Hour. n.d.
From Katherine S. Dreier's private collection

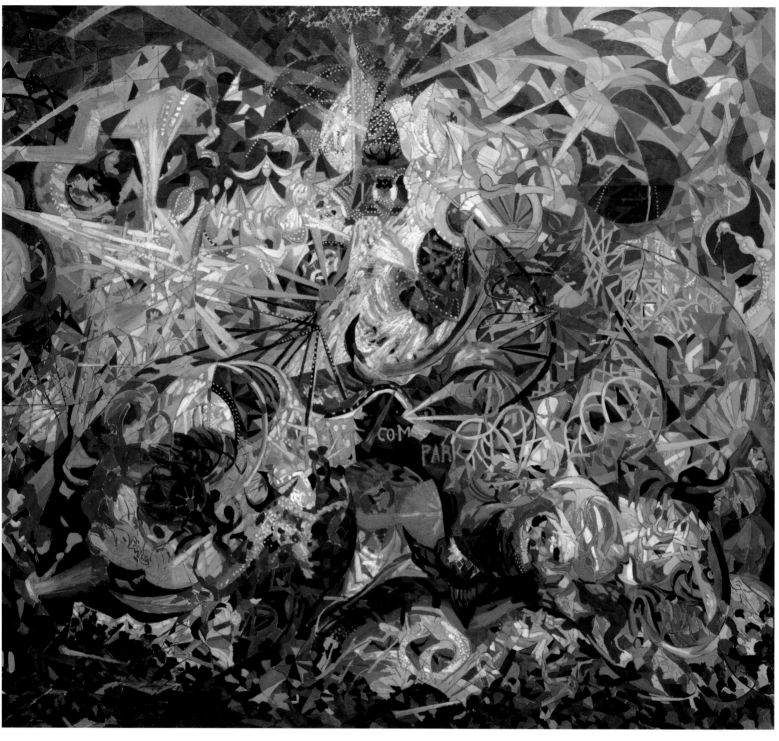

same reaction which they have received from two such totally different forms of interpretation."[24] Like Duchamp, Stella was what Dreier believed a modern artist should be: receptive to new themes in a new manner, sensitive, innovative, and responsive to the changing tenor of the times. She told Antonio Stella that she considered his brother "one of the great artists of his generation,…[who] as all great artists…is ahead of his times.…He is a true poet, with a true vision."[25] She later characterized him as a "strong vital figure in art."[26]

Over the next several years Dreier acquired many more works by this "strong vital figure." By the late 1920s she and the Société Anonyme together owned some fifteen of Stella's paintings, drawings, and pastels — only slightly fewer than the twenty works she owned by Duchamp.[27] Among these were two of Stella's most important paintings: *Brooklyn Bridge* (1918–20; see fig. 1) and *Battle of Lights, Coney Island, Mardi Gras* (1913–14; fig. 13).[28] In January 1923 the Société Anonyme showcased another major Stella, the massive five-panel *New York Interpreted (The Voice of the City)* (1920–22; fig. 14), in a one-person exhibition. In the accompanying brochure (fig. 15) Dreier praised Stella's abilities as an "interpreter" of New York: "Few painters have ever lived who had the amount of vitality to give that New York demands — and Stella is vital." She also contrasted his representation of the "inhumanness of New York, its cold, hard, metallic brilliancy" with "the softness [and]…warmth" of his native Italy, adding that these sensations "could never have been expressed along the old lines. New energies demand new expressions."[29] Stella's epic portrayal of New York synthesized the city's contradictory moods in a contrapuntal celebration of the transcendent power of the machine. Here as in *Brooklyn Bridge* Stella seized on the technological forms of the modern urban environment to construct an image of mystical and spiritual grandeur. "Painting is high poetry," Stella explained, in the picturesque prose characteristic of his writing. "Things must be transfigured by the magic hand of the *artist*. The greatest effort of an artist is to catch and render permanent (materialize) that blissful moment (inspiration) of his when he sees things out of normal proportion, elevated and spiritualized, appearing new, *as seen for the first time*."[30]

Duchamp, in his installation of the Société Anonyme's 1926 Brooklyn Museum exhibition, capitalized on the revelatory potential of Stella's art to illuminate aspects of his own work and to dramatize both the commonalities and the contradictions of

fig. 14
Joseph Stella. *New York Interpreted (The Voice of the City)*. 1920–22. Five panels: *The Port (The Harbor, The Battery)*, oil and tempera on canvas, 88 1/2 x 54 in. (224.8 x 137.2 cm); *The White Way I*, oil on canvas, 88 1/2 x 54 in. (224.8 x 137.2 cm); *The Skyscrapers (The Prow)*, oil on canvas, 99 3/4 x 54 in. (253.4 x 137.2); *The White Way II (Broadway)*, oil and tempera on canvas, 88 1/2 x 54 in. (224.8 x 137.2 cm); *The Bridge (Brooklyn Bridge)*, oil on canvas, 88 1/2 x 54 in. (224.8 x 137.2 cm). The Newark Museum, New Jersey. Purchase, Felix Fuld Bequest Fund, 1937

fig. 15
Katherine S. Dreier. *Stella*. 1923. Exhibition brochure. Katherine S. Dreier Papers / Société Anonyme Archive. Yale Collection of American Literature, Beinecke Rare Book and Manuscript Library

the relationship between these two very different artistic personalities. In the imposing galleries of the Brooklyn Museum Duchamp placed Stella's *Brooklyn Bridge* within feet of the first public showing of his own monumental work *The Large Glass*. An installation photograph shows *The Large Glass* positioned several feet out from a partition wall in one of the main galleries (fig. 16); *Brooklyn Bridge* is hung just to the left of the partition, close enough that it and *The Large Glass* can easily be seen together. From the angle of the photograph they almost seem to touch. Earlier, in the wake of the *Fountain* incident, Duchamp had advised the American public that "the only works of art America has given are her plumbing and her bridges."[31] *Fountain* had wittily celebrated the former; now, in Stella's representation of the Brooklyn Bridge, Duchamp was directing the public's attention toward the latter, albeit with a twist.

Stella and others had been monitoring progress on *The Large Glass* in the privacy of Duchamp's studio for much of the previous decade. In 1918, when Duchamp sailed for Argentina, he had entrusted to Stella several studies and related works for *The Large Glass*, including two studies for *Chocolate Grinder* and *Network of Stoppages* (1914; fig. 17).[32] *Network of Stoppages*, Duchamp's last oil painting before *Tu m'*, deploys a plurality of visual strategies. At its core is a sketch for the proto-Cubist *Young Man and Girl in Spring* of 1911, turned ninety degrees and bounded at top and bottom by a black border. Superimposed over this is a half-scale layout for *The Large Glass* and the nine capillary tubes from the bachelors' region of the glass. The work's combination of figuration and abstraction mirrors the duality of Stella's own

fig. 16
International Exhibition of Modern Art, organized by Katherine S. Dreier and the Société Anonyme, Brooklyn Museum, November 1926–January 1927. Installation view. Katherine S. Dreier Papers/Société Anonyme Archive. Yale Collection of American Literature, Beinecke Rare Book and Manuscript Library

artistic practice, while its references to *The Large Glass* connect it to Stella's earlier use of glass and wire in works like *Man in the Elevated (Train)*.

In one of the notes for *The Large Glass* Duchamp had proposed, "As a background, perhaps: An electric fête recalling the decorative lighting of Magic City or Luna Park or the Pier Pavilion at Herne Bay."[33] This kind of lighting dominates Stella's kaleidoscopic *Battle of Lights, Coney Island, Mardi Gras*, which celebrates the carnival atmosphere and dizzying sense of movement characteristic of Brooklyn's Luna Park. An explosion of tiny colored lights sparkles across the painting's throbbing surface and radiates outward from the bejeweled electric tower that rises from the center of the composition. Perhaps Duchamp intended a similar "battle of lights" for what he envisioned as his work's "magical (distant) backdrop."[34] He eventually abandoned the idea of using lights, turning instead to glass.

The construction of *The Large Glass*, its two panels superimposed one above the other, evokes a double-hung window. The mechanistic features of the bachelors in the lower panel are contrasted against the powerful but evanescent blossoming of the bride above. The transparency of the glass significantly enhances the irony of a work whose meaning is far from transparent. Stella's *Brooklyn Bridge*, too, is concerned with the contrast between fundamentally unlike elements: on the one hand the industrial reality of the bridge's stone-and-steel construction, on the other the mystical transcendence of the spirit. Also like *The Large Glass*, *Brooklyn Bridge* resembles a window, in this case a richly patterned stained-glass window. The painting's fractured surface evokes the myriad colored elements of stained glass, while the crisscrossing web of delicate black lines suggests its leaded infrastructure.

Stella transforms the mundane aspects of the bridge into soaring symbols of transcendence through a manipulation of the traditional symbols of Catholicism. By stacking the bridge's Gothic piers one above the other, and placing a third, invented pier atop the other two, he creates the illusion of a steeple, its tripartite form suggesting the Trinity. The iconic quality of the steeple evokes the iconic imagery of the stained-glass window in a medieval church. While the bridge's steel cables vibrate with "divine messages from above," the shifting patterns of light and dark evoke the transformative quality of natural light as it passes through the many colored panes of such a window. Stella's pedestrian encounters with the bridge left him feeling "deeply moved, as if on the threshold of a new religion or in the presence of a new DIVINITY." The whole impressed him "as the shrine containing all the efforts of the new civilization of AMERICA — the eloquent meting of all forces arising in a superb assertion of their powers, in APOTHEOSIS."[35]

Duchamp shared Stella's Catholic heritage, and like Stella he drew extensively on Catholic symbology in his art. Indeed, in an illuminating study, David Hopkins has argued convincingly that Catholicism ironically functioned "as Duchamp's chief aesthetic resource."[36] Duchamp extracted irony from such religious paradoxes as the virgin birth and from traditional representations of the Assumption and Coronation of the Virgin. In *The Large Glass* the relationship between the bride in the upper panel and the bachelors below recalls traditional representations in which the Virgin Mary hovers in a cloud above the earthbound apostles (bachelors).

Duchamp's juxtaposition of the highly irreverent religious inferences in *The Large Glass* with the uplifting and emotional Catholic symbolism in *Brooklyn Bridge* intensifies the religious irony central to his work. In this setting Stella's painting becomes a foil for Duchamp's glass. It contributes an element of revelation that disrupts the secular thematics of the glass, and it confirms Duchamp's conviction that "the creative act is not performed by the artist alone; the spectator brings the work in contact with the external world by deciphering and interpreting its inner qualifications

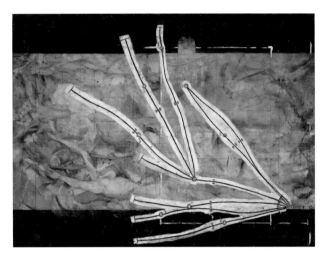

fig. 17
Marcel Duchamp. *Network of Stoppages* (*Réseaux des stoppages*). 1914. Oil and pencil on canvas, 58⅝ x 66⅝ in. (148.9 x 169.2 cm). The Museum of Modern Art, New York. Abby Aldrich Rockefeller Fund and gift of Mrs. William Sisler

and thus adds his contribution to the creative act."[37] While neither Stella nor Duchamp shared Dreier's commitment to Theosophy, she perceived both artists as possessing the all-important "inner" or "spiritual" eye.[38]

Her spiritual beliefs notwithstanding, Dreier often expressed her belief in the power of the modern movement through conventional religious analogies. In her foreword to the Brooklyn Exhibition catalogue, for example, she described modern art as "the outgrowth of a cosmic expression," and noted that "like the saints of old, it is… infinitely bigger than any one man or than some personal conception of beauty."[39] The Société Anonyme and the Brooklyn Exhibition, too, were larger than any one man or woman, or than any single philosophical or aesthetic position. The triangulation linking Dreier, Duchamp, and Stella as revealed by the juxtaposition of *The Large Glass* and *Brooklyn Bridge* forcefully recapitulates this point: in the apposition of these two visually and philosophically divergent works one is confronted with the competing and often contradictory strategies that united these artists in the dynamic and continually shifting interface that was the Société Anonyme.

David Joselit has observed that *Tu m'* "assiduously avoids any form of synthesis."[40] The same could be said of the relationship between Dreier, Duchamp, and Stella: in contrast to the solid footing of the Brooklyn Bridge, with each pier anchored firmly in bedrock, the relationship between these three resembles the bridge's swaying cables, vibrating with messages from above. For Stella this "metallic weird Apparition under a metallic sky" tracked "the conjunction of WORLDS."[41] So, too, the intersecting worlds of Dreier, Duchamp, and Stella converged in the bridging structure of the Société Anonyme.

As Stella negotiated the interpersonal and ideological differences between Dreier and Duchamp, by his very presence he embodied the organization's diversity, its most enduring hallmark. He and Duchamp, meanwhile, were something other than cheerful Dada co-conspirators; their relationship was more challenging and complex, as evidenced by the apposition of their works at the Brooklyn Museum. The relationship between Stella and Dreier likewise resists easy categorization. Stella certainly respected Dreier's commitment to the cause of modern art in America, and she and the Société Anonyme in turn favored him with frequent exhibitions and the purchase of several of his most important works; but the two were temperamentally ill matched, and Stella was a loner at heart. Yet for all their differences, during the period of their most intense interaction these three artists focused their individual and collective energy on the incredible combination of opportunities and responsibilities associated with organizing and running the Société Anonyme. Their efforts testify vividly to the complexity and camaraderie that defined that organization's contribution to modernism in America.

Notes

1 Katherine Dreier, letter to Marcel Duchamp, April 13, 1917. Folder 317, Box 12, Katherine S. Dreier Papers/Société Anonyme Archive, Yale Collection of American Literature, Beinecke Rare Book and Manuscript Library, Yale University.
2 See Ruth L. Bohan, "Joseph Stella's *Man in Elevated (Train)*," in *Dada/Dimensions*, ed. Stephen C. Foster (Ann Arbor: UMI Research Press, 1985), pp. 187–219. For a discussion of Jean Crotti's appropriations from Duchamp's *Large Glass*, produced about the same time as Joseph Stella's, see Linda Dalrymple Henderson, "Reflections of and/or on Marcel Duchamp's *Large Glass*," in *Making Mischief: Dada Invades New York*, ed. Francis M. Naumann and Beth Venn (New York: Whitney Museum of American Art, 1996), pp. 228–37.
3 See Arturo Schwarz, *The Complete Works of Marcel Duchamp* (New York: Harry N. Abrams, 1970), p. 466.
4 Duchamp, quoted ibid., p. 471.
5 *New York Evening World*, June 9, 1921. Scrapbook, Box 128, Folder 2872, Katherine S. Dreier Papers.
6 Dreier, letter to Duchamp, April 13, 1917. Box 12, Folder 317, Katherine S. Dreier Papers.

7 See John F. Moffitt, "Marcel Duchamp: Alchemist of the Avant-Garde," in Maurice Tuchman et al., *The Spiritual in Art: Abstract Painting 1890–1985* (Los Angeles: Los Angeles County Museum of Art, and New York: Abbeville, 1986), pp. 258–59. See also Moffitt, *Alchemist of the Avant-Garde: The Case of Marcel Duchamp* (Albany: State University of New York Press, 2003), pp. 98–117.

8 Kandinsky, *On the Spiritual in Art*, 1912, in *Kandinsky: Complete Writings on Art*, ed. Kenneth C. Lindsay and Peter Vergo (Boston: G. K. Hall, 1982), 1: 133.

9 For more on Dreier's interest in and knowledge of Theosophy see Ruth L. Bohan, *The Société Anonyme's Brooklyn Exhibition: Katherine Dreier and Modernism in America* (Ann Arbor: UMI Research Press, 1982), pp. 15–25. See also Francis M. Naumann, *New York Dada, 1915–23* (New York: Harry N. Abrams, 1994), p. 159.

10 Duchamp, "A l'Infinitif," in *Salt Seller: The Writings of Marcel Duchamp (Marchand du Sel)*, ed. Michel Sanouillet and Elmer Peterson (New York: Oxford University Press, 1973), p. 99.

11 For Man Ray's criticism of Stella see his *Self Portrait* (Boston: Little, Brown, 1963), p. 93.

12 *Report 1920–1921* (New York: Société Anonyme, Inc., [1921]), pp. 13–29. Stella is listed as an Acquaintance for his contribution of $5; his brother Antonio is classed as a Friend for his contribution of $10.

13 Stella, letter to Carlo Carrà, n.d. [1920], trans. in Irma Jaffe, *Joseph Stella* (Cambridge: Harvard University Press, 1970), pp. 141–42.

14 "Modernists Disappointed," *American Art News*, January 15, 1921. Scrapbook, Box 128, Folder 2872, Katherine S. Dreier Papers.

15 "Correspondence: Stella Lecture Incident," *American Art News*, February 5, 1921. Scrapbook, Box 128, Folder 2872, Katherine S. Dreier Papers.

16 Stella, "On Painting," *Broom* 1 (December 1921): 119–23, rpt. in Barbara Haskell, *Joseph Stella* (New York: Whitney Museum of American Art, 1994), pp. 202–3.

17 Stella, quoted in Margery Rex, "'Dada' Will Get You if You Don't Watch Out: It Is on the Way Here," *New York Journal*, January 29, 1921. Scrapbook, Box 128, Folder 2872, Katherine S. Dreier Papers.

18 "Pug Debs Make Society Bow," *New York Dada*, April 1921.

19 Fillin-Yeh, "Three Heads and Other Mysteries: Man Ray's Photographs of Marcel Duchamp and Joseph Stella," *Arts Magazine* 62, no. 8 (April 1988): 101–2.

20 Edgard Varèse, quoted in Jaffe, *Joseph Stella*, pp. 2–3.

21 Stella, "Notes (c. 1921–25)," in Haskell, *Joseph Stella*, p. 205.

22 Stella, "Confession," ibid., p. 220.

23 For an excellent discussion of Duchamp's calculated inscrutability see Ring, "New York Dada and the Crisis of Masculinity: Man Ray, Francis Picabia, and Marcel Duchamp in the United States, 1913–1921," Ph.D. diss., Northwestern University, 1991.

24 Dreier, *Western Art and the New Era* (New York: Brentano's, 1923), p. 112.

25 Dreier, letter to Antonio Stella, June 14, 1921. Box 85, Folder 2202, Katherine S. Dreier Papers.

26 Dreier, *Modern Art* (New York: Société Anonyme — Museum of Modern Art, 1926), p. 100.

27 See Robert L. Herbert, Eleanor S. Apter, and Elise K. Kenney, eds., *The Société Anonyme and the Dreier Bequest at Yale University: A Catalogue Raisonné* (New Haven: Yale University Press, 1984), pp. 225–45, 626–38, 771–72.

28 The Société Anonyme also regularly exhibited Stella's work. During its first year, only one other artist, Duchamp's brother Jacques Villon, received more exhibitions.

29 Dreier, *Stella*, exh. brochure (New York: Société Anonyme, 1923), pp. 3, 7.

30 Stella, "Notes (c. 1921–25)," p. 205.

31 Duchamp, "The Richard Mutt Case," *Blind Man* 2 (May 1917).

32 Duchamp also gave Stella a perspective sketch, now lost, for the bachelor machine. See Schwarz, *Complete Works of Duchamp*, pp. 125, 441.

33 Duchamp, quoted in Dawn Ades, Neil Cox, and David Hopkins, *Marcel Duchamp* (New York: Thames and Hudson, 1999), p. 90.

34 Ibid.

35 Stella, "The Brooklyn Bridge (A Page of My Life)," in Haskell, *Joseph Stella*, pp. 206–7.

36 Hopkins, *Marcel Duchamp and Max Ernst: The Bride Shared* (Oxford: Clarendon Press, 1998), p. 90.

37 Duchamp, "The Creative Act," in *Salt Seller*, p. 140.

38 See, for example, Dreier, *Western Art and the New Era*, pp. 97–101.

39 Dreier, *Modern Art*, [p. v].

40 Joselit, *Infinite Regress: Marcel Duchamp 1910–1941* (Cambridge: MIT Press, 1998), p. 69.

41 Stella, "The Brooklyn Bridge," p. 206.

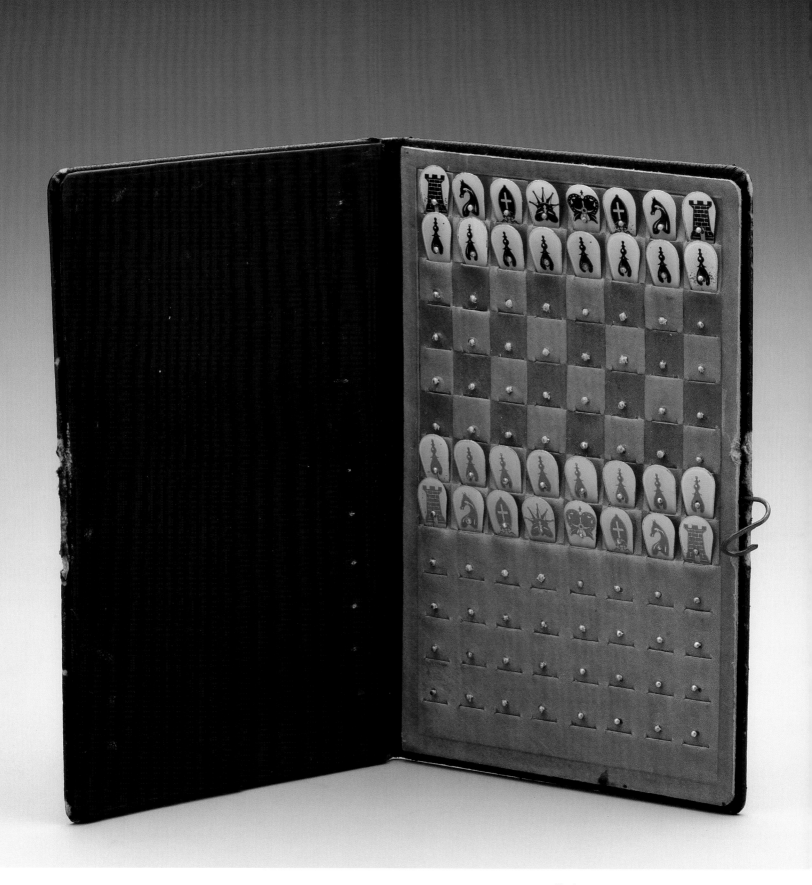

fig. 1
Marcel Duchamp. *Pocket Chess Set*. 1943. Leather pocket chessboard, celluloid pieces, and pins in black leather wallet, closed: $6\frac{1}{2}$ x $4\frac{1}{2}$ x $\frac{1}{2}$ in. (16.5 x 11.4 x 1.3 cm), open: $6\frac{1}{2}$ x $8\frac{3}{4}$ x $\frac{1}{4}$ in. (16.5 x 22.2 x 0.6 cm)

The Artist Readymade Marcel Duchamp and the Société Anonyme

David Joselit

INCORPORATION

The more I live among artists, the more I am convinced that they are fakes from the minute they get to be successful in the smallest way.

This means also that all the dogs around the artists are crooks—If you see the combination *fakes and crooks*—how have you been able to keep some kind of a faith (and in what?). Don't name a few exceptions to justify a milder opinion about the whole "art game." In the end, a painting is declared good only if it is worth "so much."

—*Marcel Duchamp, letter to Katherine Dreier, 1928*

In 1920 Marcel Duchamp, the president of the Société Anonyme, designed stationery for the new organization.[1] The logo he produced is sometimes called a "laughing ass," but is, in fact, a chess knight (figs. 1, 2). Given Duchamp's later declaration "chess is my drug; don't you know it!" his association of that game with America's first Museum of Modern Art may seem little more than a personal whim, but his choice of a logo should not be dismissed so lightly.[2] In part because Duchamp's legacy since World War II has positioned him as an antiartist engaged in "institutional critique," it is little acknowledged — but well known — that from 1920 onward he devoted a great deal of energy to art world speculation.[3] His apocryphal exit from artmaking in favor of playing chess corresponds to an equally complex if not always equally enthusiastic engagement with the game of art. The presence of a chess knight as avatar of the Société Anonyme is consequently far from accidental — a fact marked by his gift of a drawing of the same subject to Dreier on her seventy-fifth birthday, inscribed "To Katherine Dreier, Knight of the Société Anonyme" (fig. 3).[4] As is typical of Duchamp's oblique mode of signification, an ostensibly ironic detail opens onto a major insight: after 1920 Duchamp saw the artist as a readymade, to be moved through the market like a chess piece on its grid.

The substantiation of this claim requires several layers of circumstantial evidence. The first appears in "The Modern Ark — A Private Museum," a document articulating the philosophy of the Société Anonyme (before it received its permanent name). Here Dreier identifies a strongly speculative dimension to her mission:

> Most of us want to own pictures other people know about. Half the pleasure in ownership is the envy it arouses in others. To own pictures few understand contains little pleasure for the average person. It is not a good business proposition therefore, for dealers to bring over the works of new men unknown in this country, for which no one cares and no market exists. This causes it still to be a luxury to the dealer....
>
> As men in the Patent Office will tell you that new patents will appear from all over, the credit often going simply to the one who physically lived nearest Washington and the Patent Office, just so in the art world these ideas [modern art] had their origin everywhere. We may give credit to this man or that one, simply because he came within our range of vision first, rather than someone else living in the wilds of Russia or Rumania.[5]

fig. 2
Marcel Duchamp. Société Anonyme stationery. n.d. Katherine S. Dreier Papers/Société Anonyme Archive. Yale Collection of American Literature, Beinecke Rare Book and Manuscript Library

fig. 3
Marcel Duchamp. *To Katherine Dreier, Knight of the Société Anonyme.* 1951. Graphite on paper, 6 x 4⁵⁄₁₆ in. (15.6 x 12 cm)

fig. 4
Marcel Duchamp. *Fresh Widow*. 1920. Miniature
French window, painted wood frame, and eight panels
of glass covered with black leather, 30 1/2 x 17 5/8 in.
(77.5 x 44.8 cm), on wood sill, 3/4 x 21 x 4 in.
(1.9 x 53.3 x 10.2 cm). The Museum of Modern Art,
New York. Katherine S. Dreier Bequest

fig. 5
Marcel Duchamp. *Wanted: $2000 Reward*. 1923.
Replica from the *Box in a Valise (Boîte-en-valise)*,
1941. Philadelphia Museum of Art. The Louise and
Walter Arensberg Collection, 1950

Dreier makes two shrewd observations about the early reception of modern art in New
York. First, it was dependent upon commerce. Art dealers were not motivated to import
artworks that had no market; and in 1920, the year of the Société Anonyme's founding,
American museums were not yet taking up the slack. In Dreier's view (and probably in
Duchamp's as well), making a space for the exhibition of modernism was inseparable
from the need to market modernism. Commercial evangelism was a fundamental goal
of the Société Anonyme, which, even though it did not sell works directly, helped to
broker business relationships between galleries and its exhibiting artists.

Dreier's second point is one usually associated with *post*modernism: an
acknowledgment that aesthetic invention has required *author*-ization. In a particular
historical moment, she persuasively argues, a variety of artists may practice new modes
of image making, but only those closest to art world centers can "patent" their inven-
tions by receiving official critical and institutional imprimaturs. It is hard to avoid link-
ing Dreier's compelling, if eccentric, use of patent law as a metaphor to Duchamp's
(or his alter ego's) claim of copyright in *Fresh Widow* (1920), a little model of a French
window inscribed "FRESH WIDOW COPYRIGHT ROSE Sélavy 1920" (fig. 4).[6]

Duchamp's attitudes toward the market were certainly more nuanced than
Dreier's, but the two shared perspectives on many levels — how else could they have
collaborated over such a long period? Indeed, while the letter cited in the epigraph to
this essay includes Duchamp's ostensible condemnation of the "art game," it also
contains a passage that is seldom quoted in the literature, let alone discussed. In 1928
Duchamp, with the encouragement of Dreier and other friends, was considering
taking a job running the Brummer Gallery in New York for half the year, partly on the
strength of his success in facilitating and designing a Constantin Brancusi exhibition
for the gallery in 1926. The letter ends with an update on negotiations:

> — It is "verbally" understood that Brummer would pay my expenses (ocean trip and
> stay in N.Y. for 2 months about) —
> But please don't see him about this because I want him to realise by himself
> whether he wants me or not —
> I don't care personally one way or the other.[7]

Despite the rather unconvincing disavowal of the last line, it is stunning that in the
same letter that carries a condemnation of artists and art dealers as *"fakes and crooks,"*
Duchamp recounts his own negotiations with an art dealer to *become* one of those
crooks (and perhaps a fake into the bargain).

Duchamp asks Dreier not to see Brummer "about this because I want him
to realise by himself whether he *wants* me or not" (my emphasis). This slightly odd,
personalized phrasing (he does not say "whether he wants to *hire* me or not") has an
uncanny echo in *Wanted: $2000 Reward*, an assisted readymade of 1923 in which
Duchamp attached his own "mug shots" to a joke police bulletin (fig. 5). Here crim-
inality and capital come together in the crucible of desire, pivoting on the word
wanted as though Duchamp were already one of the crooks who peddle art. Five years
later Dreier uncannily reenacted this gesture, without tongue in cheek. Eager to
lure Duchamp back to New York (he had returned to live in Paris in 1921), she gave
him extensive advice in his negotiations with Brummer, writing in a letter of May
10, 1928, "Last Saturday I sent you the following cable: Get written agreement if possi-
ble and ask adequate salary for New York position Brummer offers." The salary she
and other friends (including Duchamp himself) agreed upon was $1,000 per month,
and later in the letter she emphatically admonishes, "NOW BE SURE YOU ASK THAT
FOR THAT IS YOUR COMMERCIAL VALUE IN NEW YORK."[8]

Duchamp's business flirtation with Brummer — which according to his correspondence was quite serious[9] — repeats in the game of art the double incorporation of the self imagined in many of his art objects of the 1920s, including not only *Wanted: $2000 Reward* but also *Belle Haleine: Eau de Voilette* (1921), in which Rrose Sélavy is featured on the label of a perfume bottle, and *Monte Carlo Bond* (1924), where Duchamp's shaving cream–laden head is represented on the face of a simulated financial note (figs. 6, 7). In each case the artist manipulates his own representation as a readymade captured in the market's web, appearing respectively as a criminal, a product spokeswoman, and a financial guarantor. In these works *incorporation* connotes both the literal inclusion or representation of a body within a work (which is itself a microcosm of a market) and the constitution of a new legal subject — the corporation — that may function autonomously in the world of business.[10] Duchamp's contemporaneous split into Rose Sélavy in 1920 suggests a further dimension of incorporation as a pointedly gendered experience of corporeality — a literal "putting into a body" describing the hyperembodiment of transvestism.[11]

By offering a multivalent reading of *incorporation* I hope to cast a different light on the famous story of Man Ray's devising of the name Société Anonyme — the French term for "incorporated," misunderstood by him as "anonymous society" and then doubled by the State of New York as Société Anonyme, Incorporated.[12] This serendipitous stutter between French and English must have seemed uncannily prescient to Duchamp, in whose art of the 1920s incorporation signified a double action in which an institution is constituted as a subject (a corporation) and subjects are drawn into (incorporated in) institutions. Indeed, this bilateralism of artist and institution precisely describes on the one hand the work of the Société Anonyme and on the other Duchamp's assisted readymades of the 1920s.

This convergence finds material manifestation in an arch advertisement for the Société Anonyme's Alexander Archipenko exhibition that Duchamp contributed anonymously to the issue of *The Arts* for February–March 1921 (fig. 8). Dreier's correspondence indicates that she declined the magazine's solicitation for a paid advertisement at least twice, but she somehow obtained a donated page that February. In writing to arrange for the ad, she confided to Hamilton Easter Field, the magazine's editor, that "Marcel Duchamp has consented to write a few words on condition that it is not known except to you and one or two other people. The article [*sic*] will be signed by the Societe Anonyme."[13] Duchamp's "article," illustrated by Archipenko's relief sculpture *Woman* (which resembles the enlarged nib of a fountain pen), is an advertisement for the "ARCHIE PEN CO." and reads in part:

> Today an ARCHIE PEN draws automatically a line of accurate length such as, for instance, the hypotenuse of a possible triangle in which the length of the two other sides is given arithmetically.
>
> It thinks for you.
>
> To use it reveals new experiences, even to the most blasé....
>
> Write us if you are unable to secure genuine ARCHIE PENS at your favorite stationer.

A certain C. F. Boswell of Pasadena actually did write inquiring about the pen, "its operation and price," leading the indefatigable Dreier to try to sell him a Société Anonyme brochure.[14] Mr. Boswell's gullibility notwithstanding, Duchamp's invention of the ARCHIE PEN CO. accomplishes an incorporation of the artist Archipenko, but one with a decidedly double edge, for at the same time that the artist's work is associated with a commodity, it is endowed with agency or subjectivity: "It thinks for you,"

fig. 6
Marcel Duchamp. *Belle Haleine, Eau de Voilette.* 1921. Assisted Readymade: Rigaud perfume bottle with label created by Duchamp and Man Ray. Philadelphia Museum of Art. Purchased with the Alice Newton Osborn Fund with funds contributed by Alice Saligman, Ann and Donald W. McPhail, and ARCO, 1987

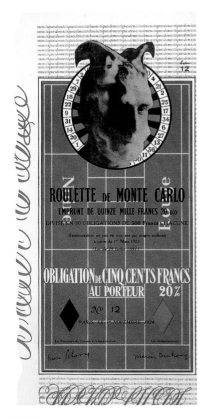

fig. 7
Marcel Duchamp. *Monte Carlo Bond.* 1924. Replica from the *Box in a Valise* (*Boîte-en-valise*), 1941. Philadelphia Museum of Art. The Louise and Walter Arensberg Collection, 1950

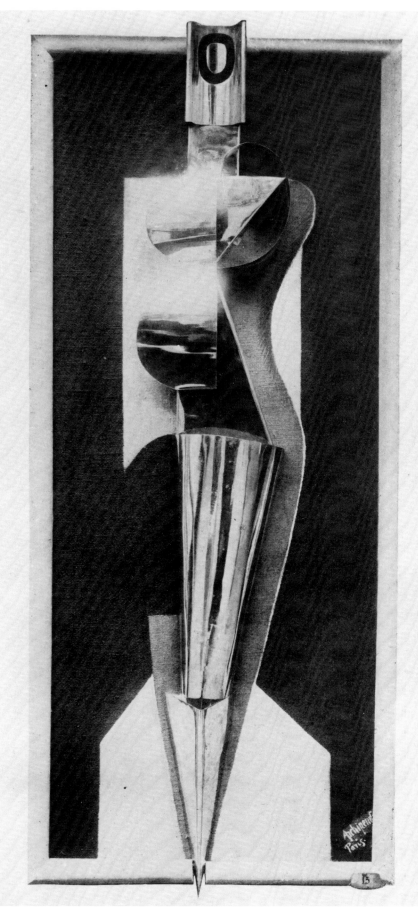

ARCHIE PEN CO.

SOCIETÉ ANONYME, INC.
19 EAST 47TH STREET
New York, N. Y.

For having invented the circle, Columbus, as everyone knows, was tried and sentenced to death. Today an ARCHIE PEN draws automatically a line of accurate length such as, for instance, the hypothenuse of a possible triangle in which the length of the two other sides is given arithmetically.

It thinks for you.

To use it reveals new experiences, even to the most blasé.

A distinct achievement of the ARCHIE PEN is its ability to bring delicacy of line and graceful poise to a hard dry mechanical drawing.

It has already found great favor among architects, draughtsmen, because it covers a third more space than the old-fashioned Fountain Pen and complies with the exigencies of what the French Scientists call: les inhibitions imbibées.

It does away with blotter.

For artistic design, quality and value, ARCHIE PENS are without equal.

Presented for your approval at the Société Anonyme, 19 East 47th Street, New York City.

Write us if you are unable to secure genuine ARCHIE PENS at your favorite stationer.

The name will be found at the bottom as an assurance.

[This brilliant caricature of a modern magazine advertisement is the work of an artist well-known in many fields who, unfortunately, objects to having his identity revealed.—EDITOR.]

fig. 8
Marcel Duchamp. "Archie Pen Co." Advertisement from *The Arts* 1, no. 3 (February–March 1921)

and "to use it reveals new experiences."[15] In other words, subjectivity is captured by the market — but never completely.

It is this "never completely" that explains the extreme ambivalence Duchamp exhibits regarding the "art game" — an ambivalence that leads him to label art dealers crooks in one passage of a letter while aspiring to join their ranks a few paragraphs later. Duchamp was a practical artist and a practical man. He never imagined that the market could be eradicated; instead, he invented tactics to skew its operations. One of these was the neutralization of profit: he had a perverse romance with "breaking even" that would have shocked any proper capitalist. Of his *Monte Carlo Bond*, a simulated bond issue whose profits were to be derived from a martingale he invented for winning at roulette, he wrote to Jacques Doucet,

> I'm beginning to play and the slowness of progress is more or less a test of patience. I'm staying about even or else am marking time in a disturbing way for the aforementioned patience. But still, doing that or something else....
> I'm neither ruined nor a millionaire and will never be either one or the other.[16]

"Neither ruined nor a millionaire" describes Duchamp's various speculations in the art of Brancusi and Francis Picabia as well. In 1928 he wrote Dreier, "I arranged with Stieglitz to have that show of Picabia because he used to like Picabia, and I thought it was the only way to show these things in N.Y. — I don't really expect any financial returns from it."[17] And in his clearest statement regarding capital to Dreier, he responded to her suggestion that he increase the cost of his "Rotoreliefs" (which she was trying to sell for him in New York) with the following blunt and almost child-like declaration: "So you have all liberty to sell them from $1.25 to $3.00 — If people find it too cheap, too bad, but the cost of making it does not allow me to more profit."[18] What kind of capitalist limits his returns in this way? Perhaps one who, as a member of a family of artists, imagines calling an exhibition of their work "Duchamp frères et sœur — like the sign on a commercial firm in France."[19] For if, on the one hand, the artist is incorporated, on the other the corporation (including that double incorporation, the Société Anonyme, Incorporated) may find its value not as an engine of profit but as a medium of art.

In the 1920s Duchamp practiced speculation as a kind of "markmaking" — a "sketching on chance," as he called *Monte Carlo Bond*.[20] But if these "sketches" tended, as we have seen, toward a stasis reminiscent of the erotic standoff in *The Large Glass* (1915–23), Duchamp adopted a more dynamic position when it came to speculating on an artist's reputation — and particularly his own, which he controlled first by carefully molding the two major private collections of his work, then by helping to bequeath them to museums.[21] In the game of art, in other words, Duchamp suppressed profits of one sort in order to increase returns of another. This bifurcation of value is articulated in a poignant letter he sent to Dreier in 1938, in response to her anxieties about money:

> Don't you think that a great distinction should be made between spending and giving. Often (not always) spending is giving to yourself.
> Giving is generally meant for others: one gives to others.[22]

One might say that Duchamp's engagement in the market — in both his artistic and his curatorial activities — is a form of giving rather than spending. Whereas spending presumes an expectation of return on one's investment, giving is meant to produce no financial dividend.

Here is where chess returns as a model for Duchamp's game plan in art. As a topographical readymade (one with a set of rules, positions, and pieces), chess resembles the market, yet its two players are more often than not comrades rather than antagonists, each giving the gift of time and mental stimulation to the other.[23] I think Duchamp chose the chess knight as a logo for the Société Anonyme because he saw his "sketches on chance" as a way of superimposing the ethics of chess onto the ruthlessness of commerce. In 1925, referring to *Monte Carlo Bond*, Duchamp wrote to Doucet, "I would like to force the roulette to become a game of chess."[24] And to Ettie Stettheimer he wrote of his roulette playing, "I spent a month last year in Monte Carlo and was able to establish that I am not a gambler = So I am going to play over there in this frame of mind [*esprit*]: a mechanical mind against a machine [*un esprit mécanisé contre une machine*]."[25] Perhaps this "esprit mécanisé" was Duchamp's gift, as well as his weapon, against the machine — and the capital that fuels it. But certainly an "esprit mécanisé" also describes the root of Duchamp's paradoxical relation to the market; for its oxymoronic ring perfectly captures the rich dilemma of the artist as readymade.

EXCORPORATION

The logic of incorporation that Duchamp explored through his participation in the Société Anonyme and his contemporaneous artworks marks a shift in his initial model of the readymade, as defined in a note published in the *Green Box* of 1934:

> **Specifications for "Readymades."**
> By planning for a moment to come (on such a day, such a date such a minute), "*to inscribe*" a readymade — The readymade can later be looked for. — (with all kinds of delays)
> > *The important thing then is just* this matter of timing, this snapshot effect, like a speech delivered on no matter what occasion but *at such and such an hour*. It is a kind of rendezvous.[26]

In his assisted readymades of the 1920s, and in the closely related advertisement for ARCHIE PEN CO., Duchamp's readymade procedure shifted from the inscription of a commodity as articulated in this note to the incorporation of a self (through its photographic representation) in a commercial matrix. In works like *Belle Haleine*, *Wanted: $2000 Reward*, and *Monte Carlo Bond*, all of which closely correspond to his involvement with the Société Anonyme, the readymade migrates from objects to subjects.

There could be few more appropriate realms to explore the subjectification and spatialization of the readymade than exhibition design, where a kind of readymade saturated with subjective affect — the artwork — is arrayed in meaningful formations. In 1917 Duchamp served as head of the hanging committee for the Society of Independent Artists (which would ultimately censor his anonymously submitted *Fountain*). His concept for this vast installation, though brilliant, was rooted in a textual model: Duchamp proposed hanging the works of all the artists, regardless of generation or style, in alphabetical order by the artist's last name. Through this organizing principle the logic of the letter scrambled normative groupings according to aesthetics or chronology, defamiliarizing the relations among artists — just as, in the early readymades, an inscription projected a new idea onto a given object. As Walter Pach, treasurer of the Independents during this period, wrote in an official letter to Dreier (herself a director and guarantor), "Many artists who were at first doubtful about the alphabetical system of hanging have been fully convinced of its wisdom. The idea that instructive comparisons would result from hanging together the work of all schools,

and of men of different ages, from the most distinguished to those beginning their careers, has been successfully demonstrated."[27]

Perhaps Duchamp's conceptually elegant mode of installational estrangement was too easily recuperated — at least according to Pach's account. For whatever reason, though, his design for the Société Anonyme's inaugural exhibition, in 1920, produced a more ineffable and embodied experience of defamiliarization. In this regard it modestly prefigured Duchamp's more dramatic installations of Surrealist exhibitions in 1938 and 1942, and ultimately the *Etant donnés* of 1946–66.[28] To understand the move he made we must visualize the Société Anonyme installation, which is difficult since there is virtually no known documentation. The most vivid account, which I will quote at length, is by the art critic Henry McBride:

> For the Societe Anonyme, Inc., is a shrine of cubism. It aims to be the clearing house in America of all the new artistic impulses that spring up anywhere in the world.... These works are coolly presented to citizens of New York in a gallery that is so neat and simple that one has to be in it some time before one realizes that once again one's intelligence has been insulted by these cubists.
>
> It is curious, is it not, what attractive exteriors vice knows how to assume? Moralists before this have often hoped that Virtue might borrow the robes of Vice, but have hesitated to counsel the act lest Virtue in knowing anything at all of Vice should become less virtuous. True virtue knows nothing else than virtue. True virtue is rare of course. ...But however that may be, the Societe Anonyme, Inc., has covered its walls with a pale bluish white oilcloth than which nothing could be purer, and tinted the fireplace and woodwork to match. The floor covering is of grey ribbed rubber. It seems to have been chosen for its quality of texture and color, and not at all with the idea of insuring firmer foothold for tottering Academicians who drift into these precincts in search of ideas. Consequently it has an expensive look. Before applying the shiny bluish white paint the woodwork of the rooms, which previously had been in the best civil war style of interior decoration, had been simplified so cleverly that even those who know nothing about cubism, and judge everything that comes along in the way they judge candy, by the sensations they get from it, would admit that the structure was worthy of the holy and somewhat Arabian bluish white. Then there are some nice wicker chairs, and some electroliers that are so astonishingly neat that they must be included in the works of art. I have used the word "neat" more than once in this description of the new rooms, but let not Academicians be seduced by this neatness! The pictures are not the kind that Academicians permit their wives and daughters to see. Danger lurks in this neatness....
>
> Of examples of old fashioned cubism there are Mr. [Georges Ribemont-] Dessaignes's "Silence," in which noise enters a scarlet funnel at the top of the picture and comes out congealed, certainly silent, in a blue mass at the bottom; Jacques Villon's clever still life; admirable Brooklyn Bridges by James Daugherty and Joseph Stella; and a strong still life by [Patrick Henry] Bruce; and all these paintings are framed in strips of lace paper.[29]

McBride was an insider in the Société Anonyme circle; he would become a member in 1921, and he participated that year in a Société-sponsored reading of unpublished works by Gertrude Stein.[30] In 1922 his journalism provided content for a Société Anonyme publication, *Some French Moderns Says McBride*, designed by Duchamp.[31] His response is therefore valuable not only for the detailed information it offers but also because its camp tone may well be informed by discussions with the artist.[32] The central metaphor organizing McBride's review is a profoundly gendered opposition between vice, which he associates with the modern paintings on exhibit, and virtue,

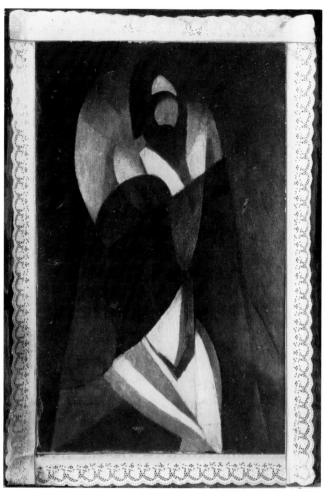

fig. 9
Marcel Duchamp. Postcard showing Jacques Villon,
In Memoriam, 1919, with lace frame. Photograph by
Man Ray, 1920. Katherine S. Dreier Papers/Société
Anonyme Archive. Yale Collection of American Lit-
erature, Beinecke Rare Book and Manuscript Library

linked, according to tradition, to feminine rectitude. To dispel any doubt as to his impli-
cation, he declares with a rhetorical flourish, "Let not Academicians be seduced by
this neatness! The pictures are not the kind that Academicians permit their wives and
daughters to see. Danger lurks in this neatness." Just at the moment when Duchamp
divided into Rose Sélavy, he created an equally hermaphroditic exhibition in which
masculinized artworks occupied a feminized salon. And he ensured that his audience
would get the point by framing those "dangerous paintings" in strips of lace (fig. 9).

The link between lace and femininity is obvious enough, but for Duchamp it
probably had specific associations with his close friends the three Stettheimer sisters,
and particularly with Florine Stettheimer, the painter of the family. For her one-person
exhibition at New York's Knoedler Gallery in 1916 (which Duchamp is known to
have attended), Stettheimer had the gallery redecorated as a pseudodomestic space.[33]
As with Duchamp's installation for the Société Anonyme, there is a dearth of doc-
umentary evidence, but Stettheimer's biographer, Parker Tyler, offers a particularly
rich account which fleshes out the artist's own telegraphic diary entries:

> Florine planned a setting that would provide as little dislocative violence as possible
> for objects (her pictures) which might have been construed to have human feelings.…
> Her home was already known as a consciously devised setting of luminously transpar-
> ent white and gold for paintings of flowers, figures, and flowers with figures; its exquis-
> iteness of effect was to suffer as little loss as might be through transference to a com-
> mercial gallery. The walls would be disguised to suggest the perspective *chez elle*, and
> in the midst of white draped muslin the pictures, like actors, would take their places as
> though they had not stirred from home. But Florine…had decided not to rely on the
> transformed walls alone. She would also effect a magical transference of Florinesque
> atmosphere by reproducing in the gallery the canopy over her bed, thus presenting
> her works in the atmosphere to which they were accustomed, and in which they had
> been created: that of the boudoir![34]

I know of no photographs of the Knoedler exhibition, but a photograph does exist of
Stettheimer's bedroom, which was a riot of lace (fig. 10). According to Tyler, she,
like Duchamp after her, was prone to unusual frames: "As to fringe, she was a miracle-
worker with it, gilt or beaded, using it even as a picture frame for her painting,
Music [c. 1920], which for a while hung over her boudoir table."[35] Compounding this
association between Stettheimer's bohemian femininity and Duchamp's rooms for
the Société Anonyme is a suggestive but ultimately mystifying line from a letter
Duchamp sent to Ettie Stettheimer in 1923: "Somebody's birthday. Mine is day after
tomorrow. Dear Ettie, thank you for the telegramic handkerchief and shame on me
for not having wired a piece of lace from Brussels."[36]

The thematic of incorporation that Duchamp located in the Société Anonyme
was thus complemented in his exhibition design by a corresponding "excorporation,"
or projection of bodily qualities into space. In a proto-Derridean move, this installation
emphasized the "leakage" between object and environment by insisting on the
centrality of framing.[37] By encircling the "vice" of Cubism with the "virtue" of lace,
Duchamp offered a theory of gender and modernism that was articulated entirely
through formal means. In lace he found a material signifying not only the feminine
"frames" of clothing or curtains but an abstract texture that is "all frame" — a tracery
of lines delineating a pattern of gaps.[38] If Jacques Derrida understood the frame as
standing against two grounds — the work on the one hand and its surroundings on the
other — Duchamp's deployment of lace suggests a further destabilization by establish-
ing between figure and ground a permanent oscillation that is internal to the frame.[39]

The inaugural exhibition at the Société Anonyme was thus characterized by a wholly visual logic of formal proliferation in which the juxtaposition of two or more image languages (lace and Cubism's fractured surfaces) may produce a sum greater than its parts — a conceptual as well as perceptual form of depth. The design thus represents a different paradigm from the inscriptional model of the readymade, belonging more squarely alongside Duchamp's contemporaneous fascination with stereoptic vision, in which a double representation produces the optical illusion of depth.[40] In 1949, in a panel discussion titled "The Western Round Table on Modern Art," Duchamp would advance a theory of spectatorship metaphorically akin to the inherent duality of the stereoptic. This meditation on the "esthetic echo" must certainly have arisen alongside his secret work on *Étant donnés* after 1946, but it also casts light retrospectively on his 1920 exhibition design for the Société Anonyme, as well as on his Surrealist installations of 1938 and 1942. Here is how he defined the concept:

> Everybody is welcome to look freely at all works of art and try to hear what I call an esthetic echo. We also imply that art cannot be understood through the intellect, but is felt through an emotion presenting some analogy with a religious faith or a sexual attraction — an esthetic echo….The important point here is to differentiate taste from the esthetic echo….
>
> Quite differently, the "victim" of an esthetic echo is in a position comparable to that of a man in love, or of a believer, who dismisses automatically his demanding ego and, helpless, submits to a pleasurable and mysterious constraint. While exercising his taste, he adopts a commanding attitude. When touched by the esthetic revelation, the same man, in an almost ecstatic mood, becomes receptive and humble.[41]

fig. 10
Florine Stettheimer's lace boudoir. Florine Stettheimer Papers. Rare Book and Manuscript Library, Columbia University

I consider Duchamp's exhibition design for the Société Anonyme one of the earliest indications of a shift in his career away from a textual, or cerebral, mode of inscription (exemplified, for example, by his alphabetical scheme for the Independents) and toward an art of the esthetic echo, its target not the mind but the body — an art that renders the spectator ecstatic, "receptive and humble," or that, as McBride suggested, might cause Academicians to totter.[42] In 1920 Duchamp evoked the boudoir as the proper environment for art; by 1966, with the completion of the *Etant donnés*, he had prescribed much stronger medicine. In this, his last major work, the feminization of space is no longer signaled with a wink but sniggered like an obscenity.[43] Duchamp must have recognized that to escape the predations of incorporation one must invent an art of excorporation — a literal form of ecstasy. Through the esthetic echo the body of the viewer (and viewed), no longer contained, exceeds the envelope of flesh in a circuit of desire that is both extrapersonal and embodied. Already in 1920 Duchamp was aiming much lower than the brain, and even lower than the eyes: he was looking to grab us in our guts.

Notes

I would like to thank Jennifer Gross, Susan Greenberg, and Kristin Henry for their generous and good-humored assistance in the preparation of this essay. In relation to the title I would also like to acknowledge Moira Roth, "Marcel Duchamp in America: A Self Ready-Made," Arts 51, no. 9 (May 9, 1977): 92–96.

Epigraph: Marcel Duchamp, letter to Katherine Dreier, November 5, 1928. Box 12, Folder 318, Katherine S. Dreier Papers/Société Anonyme Archive, Yale Collection of American Literature, Beinecke Rare Book and Manuscript Library, Yale University.

1 Duchamp was president only briefly, to be replaced by Dreier in November 1920, when he became head of exhibitions. See the excellent chronology in Robert L. Herbert, Eleanor S. Apter, and Elise K. Kenney, eds., *The Société Anonyme and the Dreier Bequest at Yale University: A Catalogue Raisonné* (New Haven: Yale University Press, 1984), p. 751.

2 Duchamp, letter to Dreier, March 12, 1928. Box 12, Folder 318, Katherine S. Dreier Papers.

3 A good overview of these activities in a single source appears in Calvin Tomkins, *Duchamp: A Biography* (London: Pimlico, 1996). A partial list includes Duchamp's offer to help Walter Arensberg sell art through Léonce Rosenberg in Paris (p. 239); a 1926 auction at the Hôtel Drouot, Paris, of works by Francis Picabia that he owned (p. 270); his purchase, with his friend Henri-Pierre Roché in 1924, of John Quinn's collection of Constantin Brancusi sculptures, of which he organized exhibitions at the Brummer Gallery, New York, and the Arts Club of Chicago (pp. 270–75); and the offer of a regular job from the Brummer Gallery (pp. 285–86), which I discuss at greater length in this essay. Tomkins details throughout his book the close relationship between Duchamp, his primary collectors Walter and Louise Arensberg, and Dreier. The artist was careful to find or save important works for these collectors and ultimately helped to broker their transfer intact to museum collections. Tomkins also details the many tasks Duchamp undertook as Dreier's agent in Paris. For another treatment of Duchamp and money see Francis M. Naumann, "Money Is No Object," *Art in America* 91, no. 3 (2003): 67–73.

4 Although the Société Anonyme logo is directly based on the design for a chess knight included in a 1920 drawing by Duchamp titled *Designs for Chessmen*, Jennifer Gross has pointed out to me that it does indeed resemble a laughing ass when compared to the more staid drawing presented to Dreier on her birthday. This difference may indicate that early on in the Société Anonyme the strategic thinking I have associated with chess was generously leavened with Dada irreverence.

5 Dreier, "The Modern Ark — A Private Museum," typescript, n.d. Box 42, Folder 1246, Katherine S. Dreier Papers/Société Anonyme Archive, p. 2.

6 For a brilliant discussion of the slippage between patent and copyright in *Fresh Widow* see Molly Nesbit, "Ready-Made Originals," *October* 37 (Summer 1986): 53–64.

7 Duchamp, letter to Dreier, November 5, 1928. Box 12, Folder 318, Katherine S. Dreier Papers.

8 Dreier, letter to Duchamp, May 10, 1928. Box 12, Folder 318, Katherine S. Dreier Papers. Dreier also makes a suggestive slip in the letter, in recounting to Duchamp her machinations with John Storrs regarding the salary: "Storrs will also speak to Brummer about it and will tell him what we think should be the price. Or salary." Here Duchamp is literally treated as a commodity, like an artwork with a *price*.

9 In a letter to Dreier of July 2, 1928, Duchamp writes, "I have been waiting and waiting to write you, expecting every day to see Brummer — and yesterday I heard that his brother had died — This is a great loss for Brummer, as you know, and it might have the most unexpected consequences on the future of the gallery —

"As for me, I am almost ready to take the position for six months a year but am afraid it would not be such a good business proposition for Brummer, as you may think — However, I will have to ask $1000 a month, if I have to do it 'socially' — He may not even come over to Europe this year." Box 12, Folder 318, Katherine S. Dreier Papers.

10 Thierry de Duve brilliantly articulates Duchamp's artistic persona in relation to the corporation, in part by demonstrating how, in *Fountain* (1917) and other works, Duchamp simultaneously adopts the position of capitalist and of worker. De Duve,

"Marcel Duchamp, or *The Phynancier* of Modern Life," *October* 52 (Spring 1990): 61–75.

11 For the best discussion of the significance of Rrose Sélavy, see Amelia Jones, "The Ambivalence of Rrose Sélavy and the (Male) Artist as 'Only the Mother of the Work,'" in *Postmodernism and the En-Gendering of Marcel Duchamp* (Cambridge: Cambridge University Press, 1994), pp. 146–90.

12 The standard account of the Société Anonyme's name is given by Man Ray himself, in *Self Portrait* (Boston: New York Graphic Society, 1963), p. 77.

13 Dreier, letter to Hamilton Easter Field, January 28, 1921. Box 3, Folder 73, Katherine S. Dreier Papers. Dreier wrote to Field on December 7, 1920, and January 1, 1921, declining a paid advertisement on account of cost; Box 3, Folder 73, Katherine S. Dreier Papers.

14 C.F. Boswell, letter to Société Anonyme, April 20, 1921. Box 2, Folder 53, Katherine S. Dreier Papers. The same file contains a letter of March 16, 1921, from Alma Warr of Kamas, Utah, inquiring about the pens, and Dreier's response to Boswell of May 7, 1921, which clears up the misunderstanding and attempts to sell him the Archipenko pamphlet for the price of thirty-five cents plus five cents postage.

15 For a fuller discussion of these issues see my *Infinite Regress: Marcel Duchamp, 1910–1941* (Cambridge: MIT Press, 1998), pp. 179–93.

16 Duchamp, letter to Jacques Doucet, n.d. [1924], in *The Writings of Marcel Duchamp*, ed. Michel Sanouillet and Elmer Peterson (New York: DaCapo, 1973), p. 187.

17 Duchamp, letter to Dreier, April 18, 1928. Box 12, Folder 318, Katherine S. Dreier Papers.

18 Duchamp, letter to Dreier, December 7, 1935. Box 12, Folder 321, Katherine S. Dreier Papers.

19 Duchamp, letter to Dreier, October 4, 1951. Box 12, Folder 324, Katherine S. Dreier Papers.

20 Duchamp, letter to Picabia, n.d. [1924], in *The Writings of Marcel Duchamp*, p. 187.

21 De Duve perceptively articulates the double nature of Duchamp's speculative art, particularly in his discussion of Duchamp's association of painting with the writing of checks. In de Duve's argument a museum collection functions as a kind of bank, authorizing the currency of individual works of art. See his "Marcel Duchamp, or *The Phynancier* of Modern Life."

22 Duchamp, letter to Dreier, July 27, 1938. Box 12, Folder 323, Katherine S. Dreier Papers.

23 I make this argument in *Infinite Regress*, pp. 157–64.

24 Duchamp, letter to Doucet, January 16, 1925, in *The Writings of Marcel Duchamp*, p. 188.

25 Duchamp, letter to Ettie Stettheimer, March [or May] 27 [1925], in *Affectionately, Marcel: The Selected Correspondence of Marcel Duchamp*, ed. Francis M. Naumann and Hector Obalk, trans. Jill Taylor (Ghent: Ludion, 2000), p. 151.

26 Duchamp, note from the *Green Box* (1934), in *The Writings of Marcel Duchamp*, p. 32.

27 Walter Pach, letter to Dreier, May 2, 1917. Box 28, Folder 806, Katherine S. Dreier Papers.

28 For the most comprehensive account of Duchamp's Surrealist exhibition designs see Lewis Kachur, *Displaying the Marvelous: Marcel Duchamp, Salvador Dalí, and Surrealist Exhibition Installations* (Cambridge: MIT Press, 2001).

29 Henry McBride, "News and Views of Art, Including the Clearing House for Works of the Cubists," *New York Sun and Herald*, May 16, 1920, p. 8.

30 See Herbert, Apter, and Kenney, *Société Anonyme*, pp. 751–52. McBride seems to have been on the organization's advisory board, though the date of his appointment is unclear. A letter from Dreier to him dated March 4, 1921, refers to an offer he made to help solicit funds; Box 23, Folder 661, Katherine S. Dreier Papers. In a letter of December 8, 1925 (same box and folder), McBride resigns in rather curt fashion: "I am not contributing to your society nor to any other this winter for the simple reason that I cannot afford it. I don't know what my status with you is but at the last account I was upon your advisory board. As it is an equivocal position I therefore resign it."

31 McBride, *Some French Moderns Says McBride* (New York: Société Anonyme, c. 1922). I discuss this publication at some length in my essay "Dada's Diagrams," in *The Dada Seminars*, ed. Leah Dickerman and Matthew S. Witkovsky (Washington, D.C.: Center for Advanced Study in the Visual Arts, 2005).

32 In a long passage of the article, directly following the description of the gallery rooms, McBride satirically takes Duchamp to task for, among other things, his affront to labor. The bantering tone suggests some kind of private joke: "For an instance there's Marcel Duchamp's chef d'oeuvre in glass, metal and legend [*To Be Looked At (From the Other Side of the Glass) with One Eye, Close To, for Almost an Hour*]. It is part of M. Duchamp's willfulness that he endeavors to fetch back into art the literary quality that Academicians are just beginning to drop. M. Duchamp leans heavily upon the legend. Academicians will loathe M. Duchamp's work, and rightly, for M. Duchamp's art disturbs good persons who are almost upon the point of buying. But the legend! The legend refers to a glass disc that is embedded ingeniously in the glass panels — Academicians must not allow themselves to admire the workmanship — Academicians must not admire anything — and it says the glass disc must be looked through from the back for about an hour, but it doesn't say why you must look through it. The glass panels framed in metal have been splintered in several places as though the artist in the fury of composition had hauled off and struck the reluctant material a smashing blow with his hammer. M. Duchamp is really too daring. Up to this point I have been with him. But this splintering of a splendidly built-up mechanism is nothing more or less than an insult to labor. This is no time to fool with labor. M. Duchamp, beware!"

33 Florine Stettheimer's diary entry from October 24, 1916, reads, "This aft it was amusing at my show. I got there by appointment (date) at 4:20 to meet Duchamp — he looks thin poor boy." Box 6, Folder 114, Florine and Ettie Stettheimer Papers, Yale Collection of American Literature, Beinecke Rare Book and Manuscript Library, Yale University.

34 Tyler, *Florine Stettheimer: A Life in Art* (New York: Farrar, Straus, 1963), pp. 26–27.

35 Ibid., p. 27.

36 Duchamp, letter to Ettie and Carrie Stettheimer, July 26, 1923, in *Affectionately, Marcel*, p. 135.

37 See Jacques Derrida's discussion of the parergon in *The Truth in Painting*, trans. Geoff Bennington and Ian McLeod (Chicago: University of Chicago Press, 1987), especially pp. 37–82.

38 In 1914 Duchamp photographed a window through a gauzy, lacelike curtain whose contours yielded the forms of the Draft Pistons in the upper, "Milky Way" part of the region of the Bride in *The Large Glass*. These photographs differently articulate a relationship between femininity, space, and a texture resembling lace. According to Arturo Schwarz, "He had originally planned to glue the three square of gauze (frozen in the shapes the photographs had revealed) directly onto the glass." Schwarz, *The Complete Works of Marcel Duchamp*, 3rd rev. and exp. ed. (New York: Delano Greenidge, 1997), 2: 617.

39 "But the parergonal frame stands out against two grounds [*fonds*], but with respect to each of those two grounds, it merges [*se fond*] into the other." Derrida, *The Truth in Painting*, p. 61. Derrida also develops in depth a trope of interlacing that on another occasion would be appropriate to explore further in the context of Duchamp's use of lace frames.

40 This interest is most directly developed in a work of 1918–19, *Handmade Stereopticon Slide*. Both pictures in the slide include a drawing of a pyramid and its reflection against a photograph of the sea. In a bawdier (and for my purposes more pertinent) instance of the stereoptic, Tomkins reports, "Dreier bought [Duchamp] one of the first handheld movie cameras, and he and Man Ray tried using it to make a three-dimensional film. Their subject was the Baroness von Freytag-Loringhhoven shaving her pubic hair." Tomkins, *Duchamp*, p. 230.

41 "The Western Round Table on Modern Art, San Francisco, 1949," in *West Coast Duchamp*, ed. Bonnie Clearwater (Miami Beach: Grassfield, 1991), p. 107.

42 It must be admitted that the spectator Duchamp presumes is a heterosexual man — though in the same roundtable discussion he engages in a spirited defense of homosexuality against Frank Lloyd Wright. Ibid., p. 110.

43 Jean-François Lyotard writes of the optical situation established by *Etant donnés*, "A cunt is he who sees." In *Duchamp's TRANS/formers*, 1977, English trans. Ian McLeod (Venice: Lapis, 1990), p. 175. See also Rosalind E. Krauss's discussion in *The Optical Unconscious* (Cambridge: MIT Press, 1993), especially pp. 111–25.

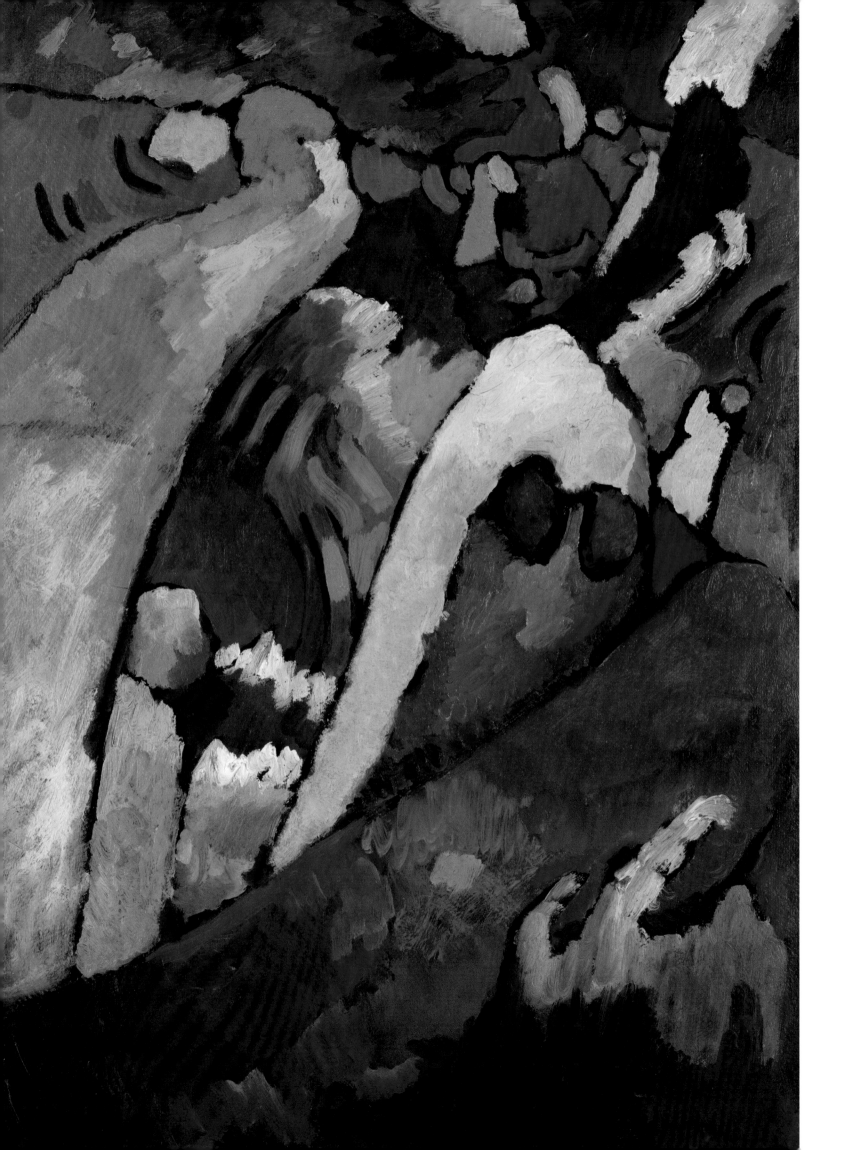

"A Big Cosmic Force" Katherine S. Dreier and the Russian/Soviet Avant-Garde

Dickran Tashjian

International forces and circumstances seemingly worked against her, yet Katherine S. Dreier became a leading player in the presentation of Russian artists in the United States between the two world wars. Her improbable achievement is a story that has been obscured by the anomalous character of the Société Anonyme, Inc., the "Museum of Modern Art" she cofounded in 1920. This first-generation German-American woman (fig. 2), of Teutonic proportions and inclinations, assisted by a French expatriate, acted upon Theosophical beliefs at odds with the material values of an American society increasingly driven by the machine. From these incongruities Dreier emerged as an energetic missionary of modern art enmeshed in the machine age of the 1920s and 1930s. The unlikeliness of this outcome was surpassed only by that of her initiative to feature the then-little-known artists of a Russian/Soviet avant-garde in the making.

Dreier's project could easily have been overwhelmed by turbulent events dating from 1917, when a world caught up in the European war, with the United States about to plunge into the struggle against Dreier's native country, witnessed the upheavals of the Russian Revolution. The formation of the Soviet state, seeking a new economic and social order in the ruins of that of the tsars, fragmented the art world of the old regime, resulting in both a diaspora of Russian artists and an effort by many others to enlist their art in the revolutionary cause. Meanwhile, the United States refused to recognize the Soviet Union, seeing itself in a fundamental conflict over economic and political systems with this new nation.

The anxieties attendant on this policy inevitably infected the American art world. Confused and bewildered by the pathbreaking New York Armory Show of 1913, critics had cast modern art in political terms as the machination of anarchists. The Russian Revolution simply added the possibility that the new art was a Communist plot. In 1924, as Dreier was involved in mounting a series of exhibitions of Russian/Soviet art, the reactionary critic Frederick Ruckstuhl, writing as "Veritas," published *Bolshevism in Art and Its Propagandists*. Despite Ruckstuhl's pseudonym, however, truth was lost amid a farrago of conspiracy theories drawn from a long tradition of paranoid thinking in American history. While the phrase "Bolshevism in art" may have alluded explicitly to the Russian Revolution, it simply became a metaphor in a campaign to smear abstract art as an un-American plot fostered by radical political movements throughout Europe. Abstraction was ultimately deemed pathological, "a disease of the mind...rank insanity!"[1] This vitriol spewed a destructive misconception that persisted long after World War II.

Dreier's initiative first to champion abstraction and then to give prominence to Russian/Soviet art thus ran counter to a virulent strain of American sentiment and ideology. To combat such deep-seated opposition she used the auspices of the Société Anonyme to mediate between Russian/Soviet art and American viewers. Her Theosophical beliefs profoundly shaped her educational efforts, which took the form of exhibitions, catalogues, lectures, and attendant events.[2] The range of Russian artists under her purview included exiles in the United States and western Europe as well as the Soviet avant-garde espousing Suprematism and Constructivism.

fig. 2
Katherine S. Dreier. The Schlesinger Library, Radcliffe Institute, Harvard University

fig. 1
Wassily Kandinsky. *Improvisation No. 7 (Storm)*. 1910. Oil on pasteboard, 27 9/16 x 19 3/16 in. (70 x 48.7 cm)

The scope of Dreier's efforts required collaborations with such artists as Louis Lozowick and Constantin Alajálov, as well as with Christian Brinton, a curious mix of idealist and entrepreneur, art lover and hustler, who had promoted Russian art since the turn of the century. Dreier's alliance with Brinton introduced her to the New York community of Russian émigrés, while Lozowick had key contacts abroad as well as important projects and commissions with an American avant-garde led by Jane Heap of *The Little Review* and Harold Loeb and Matthew Josephson of *Broom* magazine.[3] By reconstructing the network of Dreier's efforts, we can gain a sense of how her Russian project both was embedded in and shaped an important episode of American culture between the wars.

In 1944, after Yale University had accepted the Collection of the Société Anonyme, Dreier published a monograph on David Burliuk, a Russian artist who had immigrated to the United States in the summer of 1922 (fig. 3). The book, titled *Burliuk*, was a handsome production, with soft deep-red covers in simulated leather and Burliuk's bold signature in black as the title. Although Dreier was already engaged in writing a catalogue of the Collection, she labored over *Burliuk* for ten months and held her own painting in abeyance.[4] With no apparent loss of energy she also pub-

fig. 3
David Burliuk. Katherine S. Dreier Papers/Société Anonyme Archive. Yale Collection of American Literature, Beinecke Rare Book and Manuscript Library

lished a small study of Marcel Duchamp's *Large Glass* (1915–23), written in collaboration with the young Chilean Surrealist Roberto Matta Echaurren.[5] Dreier's homage to Duchamp arose out of their partnership over the previous two decades, but her effort on Burliuk's behalf is harder to fathom, since he has been dismissed in some quarters as one of the minor artists in the Collection.[6] If Dreier's interest in him was limited to showing how abstraction prevailed even among minor figures, why would she honor him with one of the last publications of the Société Anonyme?

The odd couple of Burliuk and Duchamp testifies to Dreier's sweeping vision: like Walt Whitman, she was able to "contain multitudes." Beyond shared largesse, her spiritual affinities with Whitman and Emerson came from her Theosophical beliefs, which set the terms of her monograph on Burliuk. Thus her tribute to Burliuk brings into relief the dynamics of her patronage and promotion of Russian/Soviet artists dating back virtually to the origins of the Société Anonyme itself.

The first part of Dreier's narrative offers an account of Burliuk's life and artistic growth in Russia and then in the nascent Soviet Union through the turbulence of World War I, the Revolution, and the ensuing civil war. The second part tells the story of Burliuk's American life. The narrative throughout has the strange albeit charming effect of modulating two voices. At the outset Dreier recalls in her own voice her first meeting with Burliuk, in 1923, at a large exhibition of émigré Russian art at the Brooklyn Museum. Here Brinton introduced Burliuk to her as "the father of Modern Russian Art."[7] As Dreier turns to Burliuk's Russian past, a second voice comes to the surface, rather awkward in syntax, hinting at English as a second language. This undercurrent derives from collaboration with the artist's son Nicholas, and from rich detail available only from the artist himself, who, perforce speaking in the third person, takes on a folk quality, a larger-than-life persona "by turns eclectic and primitive," ultimately "a simple, dynamic, extravagantly personal Russian," according to the collector Duncan Phillips's foreword.[8] Here is a mythic figure in the making: Burliuk becomes the archetypal Russian, representing his heroic countrymen, America's new allies, who at terrible cost were withstanding the Nazi onslaught on the eastern front and turning the tide of World War II.

Dreier regains her own voice in the second half of the narrative, when Burliuk and family, having traveled across Siberia to Japan, land in Manhattan: "There they stood, the Burliuk family, in Grand Central Station, looking about, on that hot September night, getting their bearings in this new country amidst all the noise and confusion which all railroad stations hold at any hour of the day or night."[9] The change in tone and voice is palpable, although it is sustained only intermittently. Dreier takes over the narrative on her home territory, partly by presenting Burliuk's American life in terms of activities organized by the Société Anonyme. This strategy allows her to promote the Société Anonyme while she enters the narrative during the course of Burliuk's efforts to establish himself in the New World.

Omissions are as significant as what is said. In the main, politics are muted, at whose behest is unclear. Silence on the reasons why Burliuk and his family left the Soviet Union is especially deafening, despite the drama of flight across the steppes. Perhaps it was assumed that the reader would recognize the social and economic status of Burliuk's family: his father's lifetime employ as an overseer of large agricultural estates had brought financial security as a member of the managerial class. And perhaps the reader was assumed to understand that with the fall of the provisional government after the October Revolution, the Bolsheviks' coming to power forecast disaster for the Burliuk family.

In any case, the cataclysm of 1917 in Russian history — "the short-circuit which split the world in two," as El Lissitzky later described it — clearly bifurcated Burliuk's

life. The years leading up to Russia's plunge into World War I were already in artistic ferment, led by Burliuk, among others, as an energetic poet, painter, and promoter of the radical Russian Cubo-Futurists. Burliuk was a mentor of Vladimir Mayakovsky, the young poet who was to become an acclaimed literary representative of the Revolution, a favorite of Lenin's and, after his suicide in 1930, of Stalin's as well. Conjuring a wonderful moment, Burliuk would later recall their reunion in Manhattan in the summer of 1925, when he arranged for the visiting poet a luncheon that included Duchamp. Although Mayakovsky was apparently disappointed by his American journey, he was impressed by the Brooklyn Bridge, which he addressed in a poem, thereby joining Joseph Stella and the young American poet Hart Crane in their celebration of this great symbol of American technology.[10]

With her eye on the spiritual advancement of art, Dreier regarded Burliuk less as the archetypal Russian — a characterization that Brinton always had at the ready — than as the epitome of the creative spirit. She claimed to have recognized being "in the presence of a great personality" at that first meeting, one with "the power of the dynamic creation…which bursts all prisons, created in the mind or circumstances."[11] Dreier considered Burliuk the classic protean-talented avant-gardist, representing progress in the arts and nurturing the human spirit. In 1928 Burliuk had given her *The Eye of God* (1923–25; fig. 4), a large painting whose spiritual import, connecting

fig. 4
David Burliuk. *The Eye of God*. 1923–25. Oil and sand on canvas, 39⅞ x 30¹/₁₆ in. (101.3 x 76.4 cm)

cosmic forces with vision, was central to his patron's thinking. Earlier, in a radio address of 1926, Dreier had quoted Emerson's assertion that "beauty is for the seeing eye and that God brings together beauty and the eye." She would have connected the painting with Emerson's claim to have become a "transparent eyeball" as life forces coursed through him in communion with nature.[12]

Dreier's claim for the spiritual in art had developed well before the founding of the Société Anonyme. As a young woman she had seized upon the beliefs of Madame Helena Petrovna Blavatsky, founder of the Theosophical Society in 1875, and had gradually adapted them to the visual arts. Dreier's synthesis of the spiritual and the aesthetic would be confirmed by Wassily Kandinsky, who exhibited at the 1913 Armory Show, in which Dreier too had an entry. His disquisition *Concerning the Spiritual in Art*, published in German in 1912, insisted upon the "inner" life of a painting, setting its spiritual value against the vulgar material forces of the time — on the authority of none other than Madame Blavatsky. Kandinsky approvingly repeated her prophecy: "The earth will be a heaven in the twenty-first century in comparison with what it is now."[13]

Dreier purchased her first Kandinsky oil in 1920, from Der Sturm Gallery in Berlin. Ten years later, in Cologne, she bought *Improvisation No. 7 (Storm)* (1910; see fig. 1). Although her later purchase is not completely abstract, its veiled drama of figures adrift in a roiled sea nonetheless allegorizes Kandinsky's sense of human striving toward spirituality through the threatening forces of materialism.[14] Dreier eventually acquired paintings from Kandinsky's geometric phase, begun after he worked with Kasimir Malevich and Lissitzky upon returning to Russia in 1918. Subsequent pedagogical differences with his colleagues drove him to Germany to teach at the Bauhaus in late 1921.[15] After making a pilgrimage to meet him in Weimar in October 1922, Dreier gave Kandinsky his first solo exhibition in America the following spring.

While Kandinsky was the first Russian artist included in a group show of the Société Anonyme, in November 1920, he was not the first to be given a one-artist exhibition. That distinction is held by Alexander Archipenko, a Russian expatriate whose friendship with Duchamp resulted in his meeting Dreier on her visit to Paris in 1919. Scheduled for February 1921, with New York Dada still in play and Duchamp's single-issue journal *New York Dada* forthcoming in April, Archipenko's exhibition at first glance resembled another Dada hoax: in the February–March issue of *The Arts*, Duchamp published an announcement of it in the form of an advertisement for the "ARCHIE PEN CO." (see fig. 8 in Joselit's essay in the present volume). Poor Archipenko's show had proven the perfect setup for Duchamp's inveterate love of puns — from the Russian artist's name to a picture of an "Archie pen," in actuality one of his sculptures, *Woman* (1920), made out of sheet metal set against a framed panel of wood and burlap. Duchamp's play with appearance mocked a question commonly asked by puzzled viewers of modern art: "What is it?" This pen, he assured the reader, "thinks for you."

Duchamp's games, however, were not played at the artist's expense. In April 1920 he had written to Archipenko, "New York needs to see what you have done these last years."[16] Archipenko may have derived his sculpture from Cubism, and he often worked with the traditional female nude, but he was nonetheless original in his use of unconventional materials, resulting in sculptures that often become an assemblage of sheet metal, wood, cloth, and plaster. A symposium on him that Dreier organized to accompany the exhibition featured Marsden Hartley, who reportedly said that "Archipenko's conception of a woman, as exemplified in the works of art upon the walls of the Société Anonyme, had all the incomparable beauty of modern

plumbing....Although not a plumber, Mr. Hartley said he loved plumbing."[17] Hartley's allusion to plumbing harked back to Duchamp's infamous readymade *Fountain*, the urinal rejected from the 1917 Independents Exhibition (an event that precipitated the friendship between Dreier and Duchamp). Hartley slyly understood that Archipenko took Duchamp's enigmatic "Buddha of the Bathroom" in a positive direction.[18]

Dreier's antipathy toward a materialistic, machine-driven world, certainly exemplified by urinals and the like, was mollified by Ivan Goll's appreciation of Archipenko, reprinted in English by the Société Anonyme. Goll, an Alsatian poet on the Paris avant-garde scene, took the artist on a cosmic ride: "The cerebral artist succeeds the religious artist and replaces his God by his attributes. Power! Movement! New Divinities!" (The word *cerebral* here recalls Duchamp's advertisement, which implicitly proclaimed the impersonality of Archipenko's art, its rational, machinelike perfection.) Archipenko, Goll added, had developed "a style at once spiritualized and enlarged to the dimensions of its new experiments."[19]

In her enthusiasm for Archipenko, Dreier found an ally in Brinton, who had already arranged commercial exhibitions for artists as they washed ashore in the wake of the Russian Revolution. Recruited to the board of the Société Anonyme, Brinton was soon assisting Dreier in organizing exhibitions. In turn she introduced him to Archipenko, whom he was anxious to meet: "*Get him absolutely with us*," he emphasized. "I know no one in the field of plastic expression who approaches him. He is the Kandinsky of sculpture and more."[20] The meeting resulted in Archipenko's second American solo exhibition, at the Kingore Gallery, New York, in January and February 1924. Brinton gave Goll's mythmaking a Russian spin in his introduction to the catalogue, its cover featuring Archipenko's name in bold block letters repeated in Cyrillic below. In near-purple prose Brinton evoked the sculptor's "memories of the luxuriant Slavo-orientalism of his beloved Ukraine" and "the mystic appeal of the great cathedral of Saint Sophia, with its shimmering frescoes in the ancient ikonic manner." Through his Russian heritage, Brinton continued, Archipenko had tapped into a "mystic stylistic vision," resulting in "a perfect embodiment of plastic absolutism."[21]

Brinton noted that Archipenko's father was a wealthy engineer and inventor who had motivated the artist to explore new materials and to "invent" new forms. The most literal instance of Archipenko's engineering was the invention of the Archipentura, an "apparatus for displaying changeable pictures" that the artist patented in 1927 (figs. 5, 6). In 1931 he demonstrated the Archipentura before a packed audience at the New School for Social Research, New York, as part of Dreier's final lecture in a series on modern art.[22] This motorized device offered a screen/facade of horizontal strips, akin to a venetian blind, that scrolled to present a changing image. The audience viewed a fashionable model changing clothes, from dresses to chemise, a striptease that eventually left her nude: "A Miracle," as the opening caption trumpeted, ambiguously referring to either Archipenko's contraption or the exposed mechanical bride.

In January 1921, on the eve of the Archipenko exhibition, Dreier took the initiative in seeking out Russian/Soviet art by writing to Ludwig Martens, a Russian-German engineer and the Soviet trade representative in New York. "Might I ask you," she wrote, "when you return to Russia, to put me in touch with Mr. Kandinsky, or if that is not possible, with Commissaire [Anatoly] Lunarcharsky [*sic*] at Moscow. You will see by the enclosed card how interested we are in modern Russian art, and it would be of great interest to us to know what Russia is doing at present." She added, "Any book or magazine on this extreme movement, which you can have sent to us, we would appreciate enormously." In a postscript: "It might interest you to know that I am a sister-in-law of Raymond Robins," who was lobbying Congress for recognition of the

fig. 5
Alexander Archipenko. *Archipentura* (Chemise). 1927.
Archipenko Archives, The Archipenko Foundation

fig. 6
Alexander Archipenko. *Archipentura* (Nude). 1927.
Archipenko Archives, The Archipenko Foundation

fig. 7
El Lissitzky. Cover of *Erst Russische Kunst Austellung* (First Russian art show). Exh. cat., 1922. Katherine S. Dreier Papers/Société Anonyme Archive. Yale Collection of American Literature, Beinecke Rare Book and Manuscript Library

Soviet Union (eventually secured in 1933, under the administration of Franklin D. Roosevelt).[23] Whatever strings Dreier hoped to pull for information about "this extreme movement" in Russian art were not forthcoming: Martens was persona non grata in the United States, forcing him to leave the country just before Dreier's letter, and one step ahead of congressional orders for his deportation.

Dreier, never one to remain passive, decided in the meantime to learn more at first hand about the new art stirring in Germany, where she returned in the fall of 1922, after a lengthy sojourn in China. At the time, New York art circles were ever more attracted to France, a tendency accentuated by Duchamp, increasingly Dreier's partner and adviser in directing the Société Anonyme; but her decision to scout modern art in Germany was understandable given her enthusiasm for the country of her origin. Indeed, her attachment was sufficiently strong to counterbalance the French drift in the New York art world.

Dreier could not have arranged better timing to arrive in Berlin. Although the capital had become a grotesque carnival, suffering severe economic depredations in the aftermath of defeat in World War I, the falling German mark was extremely favorable for an affluent woman seeking to augment her collection. (Josephson, the young editor of *Broom*, would later recall, "In the Germany of 1922–1923 my earnings of thirty dollars a week definitely placed me in the millionaire class." *Broom* had actually moved its offices to Berlin from New York for a favorable dollar exchange.)[24] Most fortuitous, however, was the October opening of the *Erst Russische Kunst Austellung* (First Russian art show), a large exhibition of contemporary Russian/Soviet art at the van Diemen Gallery, cosponsored by the Soviet government and an international Committee to Help the Starving (fig. 7). (Proceeds from the sale of paintings were supposed to aid Russians suffering in the famine of those years.)[25]

At that moment, with Soviet artists and national and international politics inextricably engaged in a slow dance, the cultural clime was in flux, generating conflicting agendas and motives — mixed if not impure.[26] In Germany, war torn and battered by ideological violence, the van Diemen Gallery offered something of a political haven for the art on the walls — not a blank slate, perhaps, but a slate, if with visible erasures. Crossing the threshold of the *Erst Russische Kunst Austellung*, Dreier moved into a neutral zone (more apparently neutral than really so) and saw what she wanted to see. Whereas the primary interests of the Soviet government were to convert art into cash and in the process gain some much-needed favorable publicity, Dreier sought abstract art. Their interests met, largely unimpeded by explicit propaganda (as the German and Soviet governments had agreed).

Among the six hundred to seven hundred works displayed by the Soviet state, which had purchased this art for resale, Dreier turned to her catalogue and checked off those artists now in the modern pantheon, most of them either Suprematist or Constructivist in orientation: Marc Chagall, Naum Gabo, Kandinsky, Lissitzky, Malevich, Alexander Rodchenko, and Vladimir Tatlin, as well as lesser-known figures such as Alexander Drewin, Konstantin Medunetsky, Liubov Popova, and Nadezhda Udaltsova.[27] Dreier purchased on the spot Lissitzky's *Proun 19D* (1922?), Drewin's *Suprematism* (1921), Gabo's *Construction in Relief* (1920), Malevich's *The Knife Grinder* (1912–13), Medunetsky's *Spatial Construction* (1919), two versions of Popova's *Painterly Architectonic* (1918), and Udaltsova's *At the Piano* (1915) (figs. 8–15). Dreier's sharp eye would surely have turned rapidly to the contemporary abstractions of Suprematist and Constructivist art, but on visual grounds alone, Malevich's *Knife Grinder*, from a decade earlier, must have been one of the highlights of the exhibition and quite difficult for her to pass by or pass up.

Malevich brilliantly exploited Cubist techniques to achieve a Futurist sense of movement, his figure simultaneously flashing from profile to head-on confrontation of the viewer. Despite her preference for what she considered cutting-edge contemporary art beyond Cubism, Dreier would later remain proud that *The Knife Grinder* stood out in a trade show sponsored by the Macy's department store in May 1928.[28] Malevich, of course, had indeed moved beyond Cubism with his radical paintings of simplified geometric shapes, exemplified by two Suprematist paintings at the van Diemen Gallery, including the now celebrated but then notorious *White on White* (1918). Why Dreier left these paintings behind is inexplicable, especially if she knew that Malevich claimed spiritual values for his abstractions. But his major theoretical statement *The Non-Objective World* did not become available to her until 1927, when it was translated into German and published by the Bauhaus as *Die Gegenstandslose Welt.*[29]

What, then, did Dreier know in 1922? The unsigned catalogue essay for the *Erst Russische Kunst Austellung* provided scant information beyond some brief comments about revolution and revolutionary art. She checked the margin beside a statement that conveyed some inaccuracies about Suprematism: although the reference to "abstract planes" and "precise laws" as the basis of Suprematism as a "non-objective" art would have appealed to her, the inclusion of Rodchenko among the Suprematists was either an error — for in 1922 he was leader of a Constructivist group — or an indication that the relationship between the two avant-garde factions was still fluid.[30] In the Soviet Union of the period, *Constructivism* had become a contested term, as some avant-garde artists, notably Rodchenko and Tatlin, sought to steer their comrades away from art toward utilitarian projects involving architecture, engineering, and the factory life of the proletariat. Malevich, with his spiritual orientation, was meanwhile becoming increasingly isolated, suffering the same kind of treatment that had precipitated Kandinsky's departure for the Bauhaus. As a follower of Malevich, Lissitzky stood on the cusp between factions. Thus his flat geometric "Prouns," a Russian acronym for "Project for the Affirmation of the New," were indeterminate, betwixt and between, "station[s] on the road towards constructing a new form."[31]

Further blurring distinctions at the exhibition was the presence of Gabo's work, which was described in the catalogue as offering "a parallel to the Constructivists."[32] Gabo, one of the organizers of the *Erst Russische Kunst Austellung*, was an expatriate who, like the Constructivists, worked with new materials and forms that echoed machine technology but who refused to follow Rodchenko by renouncing the making of art and aesthetic concerns for "production," as his Realistic Manifesto of 1920 made clear.[33] Within the threshold of the van Diemen Gallery lay a dearth of the information that would have enabled Dreier to gain a window on avant-garde positions in the Soviet Union. Instead she was allowed to imprint her Theosophical beliefs on avant-garde work that she found attractive.

Dreier's Russian education was hardly advanced by two exhibitions held upon her return to New York. The year 1923 opened with Brinton's *Exhibition of Russian Painting and Sculpture* at the Brooklyn Museum, showing the readily available work of expatriates in the United States and Europe. In his introduction Brinton assured museum-goers that the art "upon these walls is strictly contemporary," even though "the more acute products of Russian radicalism have not yet reached our shores."[34] There was no need to travel beyond Brooklyn for an exotic thrill: "The magic carpet that bears the plastic and colouristic message of Russia around the world, has for the moment descended into our midst." A year later the Soviet government delegated Igor Grabar, director of the National Tretiakov Gallery in Moscow, to hang *The Russian*

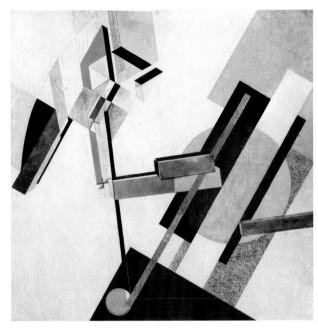

fig. 8
El Lissitzky. *Proun 19D.* 1922(?). Gesso, oil, collage, etc., on plywood, 38⅝ x 38¼ in. (97.5 x 97.2 cm). The Museum of Modern Art, New York. Katherine S. Dreier Bequest

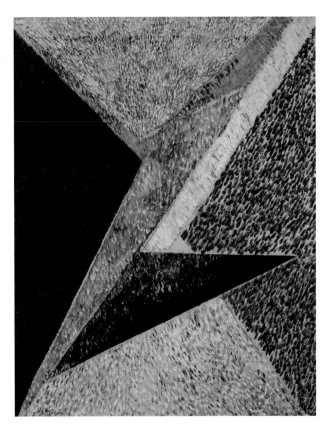

fig. 9
Alexander Drewin. *Suprematism* (formerly *Abstraction*). 1921. Oil on canvas, 42³/₁₆ x 34³/₁₆ in. (107.2 x 86.8 cm)

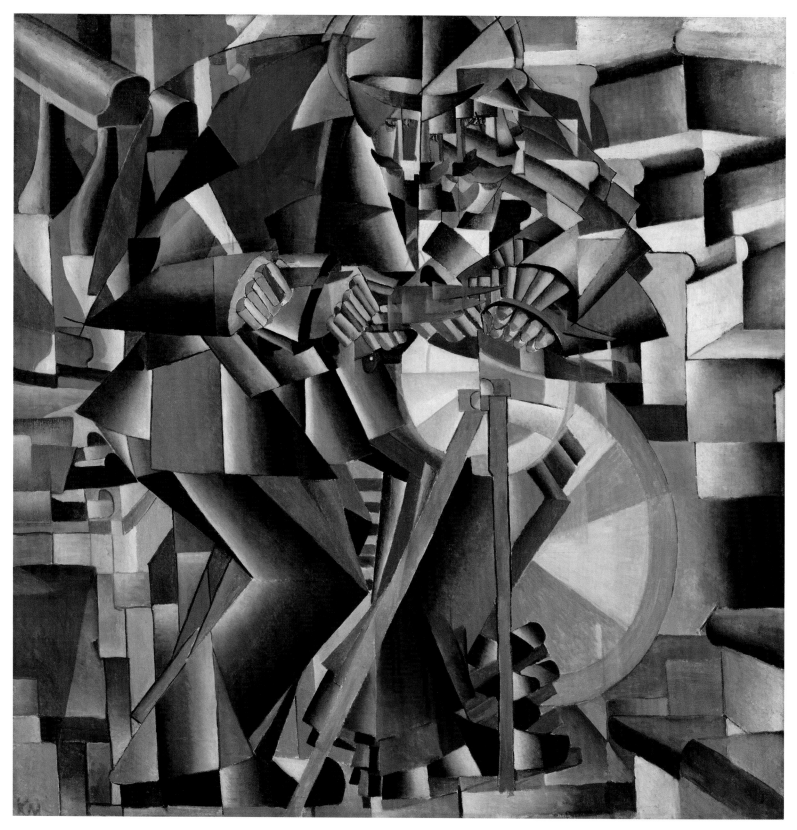

fig. 11
Kasimir Malevich. *The Knife Grinder* or *Principle of Glittering* (*Tochil'shchik Printsip Mel'kaniia*). 1912–13. Oil on canvas, 31⁵/₁₆ x 31⁵/₁₆ in. (79.5 x 79.5 cm)

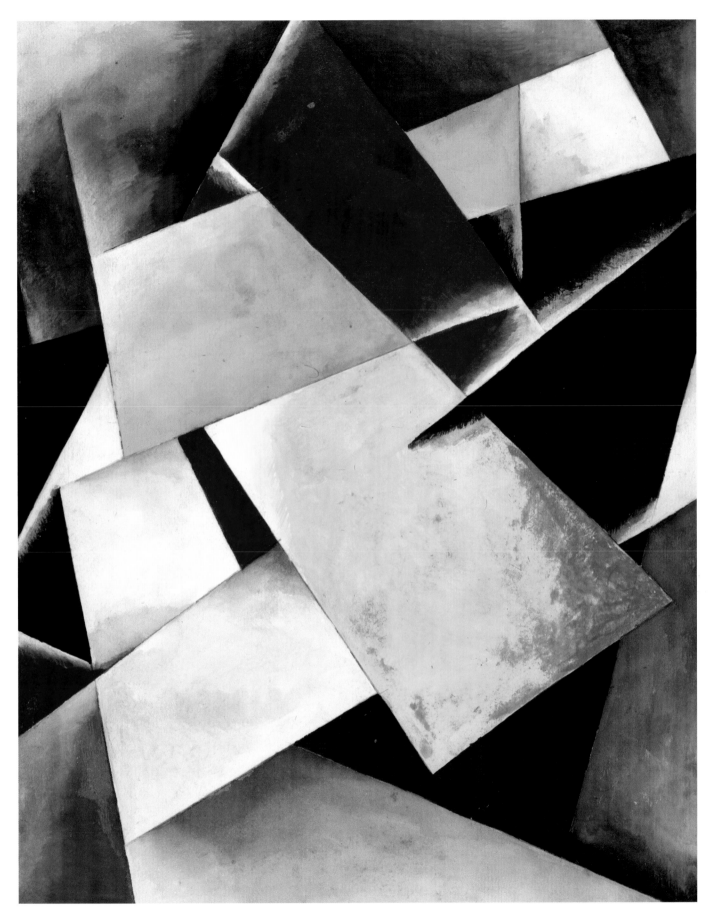

fig. 14
Liubov Popova. *Painterly Architectonic*. 1918. Gouache
and watercolor with touches of varnish on paper,
11⁹⁄₁₆ x 9¹⁄₄ in. (29.3 x 23.5 cm)

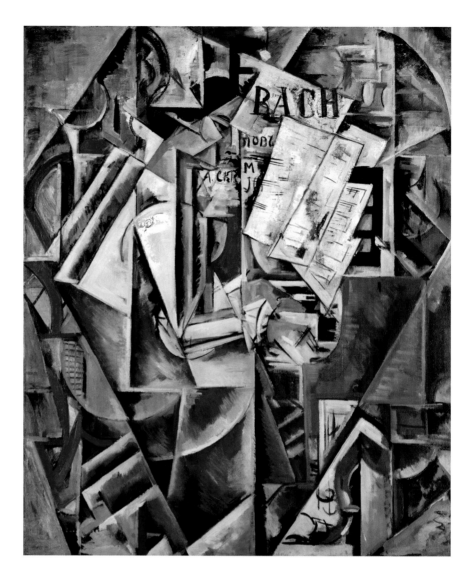

Art Exhibition at the Grand Central Palace in Manhattan. A shipment of 914 academic paintings licensed Brinton to rhapsodize in his foreword over the "Slavic soul" while waxing sanguine about the absence of "Cubo-futurist, Suprematist, Tatlinist, and kindred exuberant searchers after new and startling phases of self-expression."[35]

Both exhibition catalogues made but oblique references to either the Russian Revolution or the Soviet Union. Brinton's strategy for addressing the Revolution, which after all was the main reason why so many Russian artists were expatriates in the first place, was to softpedal it by claiming that its effects on Burliuk and others were "transitory."[36] Dreier took a different tack, made evident in her book *Western Art and the New Era,* which she had settled down to write after seeing the van Diemen show. Not surprisingly, she was reticent about her viewing experiences in Berlin and mentioned no Russian artists besides Archipenko and Kandinsky. She referred to Russia (not the Soviet Union) as only one among many western European nations that were sites for the new art: "We find that this new desire in art sprang into existence everywhere at once." Citing specific nations served to demonstrate that modern art was a global phenomenon, virtually spontaneous in its widespread appearance (hence Dreier's classification of artists by nationality in her catalogue for the Société's 1926 *International Exhibition of Modern Art* at the Brooklyn Museum). Seeing art as a "uni-

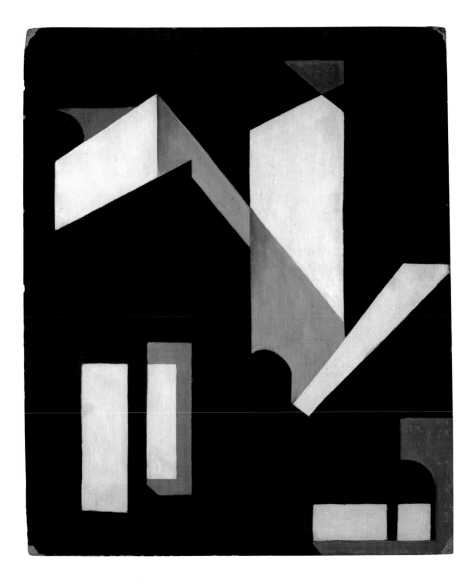

fig. 16
Louis Lozowick. *City Shapes*. 1922–23. Oil on
composition board with canvas-textured surface,
18 1/8 x 14 15/16 in. (46 x 38 cm)

versal" human force, she could pluck abstract art out of historical and cultural con-
tingency. This decontextualization further allowed her to blur distinctions between
capitalism, socialism, and communism, as well as between national boundaries. When
"thought" was privileged as the decisive factor underlying ideologies and nation-
alities, the political became extraneous. Since art took merely different outer forms or
"dress," its essential universal force would eventually lead to a transcultural and
transnational "new era" for humanity.[37] Dreier's utopian vision was filtered through a
Theosophical lens of millennialism.

In February and March 1924, in an attempt to present contemporary Soviet art
as a corrective to the two large exhibitions engineered by Brinton, Dreier organized
Modern Russian Artists at the Heckscher Building, the Société Anonyme's new quarters.
She had discovered a new and extremely knowledgeable ally in Lozowick, a young
American artist of Russian heritage who was keenly interested in artistic developments
in the Soviet Union (figs. 16, 17).[38] Since he had recently returned from Europe,
where he had attended the *Erst Russische Kunst Austellung* in Berlin, Dreier invited
him to give an informal lecture on avant-garde Russian art to accompany the exhi-
bition. This lecture was to become the basis for his informative monograph *Modern
Russian Art*, which the Société Anonyme would publish in 1925 (fig. 18).

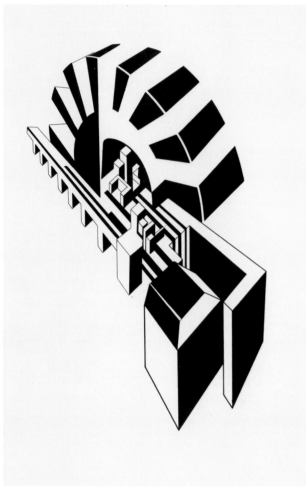

fig. 17
Louis Lozowick. *Machine Ornament. Abstraction.*
c. 1925–26. Ink on paper, 18⁹⁄₁₆ x 12 in. (47.2 x 30.5 cm)

fig. 18
Louis Lozowick. Cover of *Modern Russian Art.*
Exh. cat., 1925

The flier for *Modern Russian Artists* attempted to cover the exhibition's short-comings. Lozowick's comments, interspersed throughout, gave a clear sense of the differences between the Constructivists and the Suprematists, whose leader was identified as Malevich. But since the Société Anonyme owned only Malevich's *Knife Grinder*, not Suprematist but Cubo-Futurist in style, Dreier added works by Drewin and Lissitzky (who was sliding over to Constructivism) — presumably *Suprematism* and *Proun 19D*, respectively — that she had acquired in Berlin. The flier offered a laundry list of Constructivists, who "adored" the machine, but Dreier's collection could offer only Medunetsky's *Spatial Construction* and Gabo's *Construction in Relief* for display. Gabo, of course, was an expatriate at odds with the Soviet Constructivists. The exhibition was rounded out by the inclusion of "Lozowick, the American, [Laszlo] Peri, the Pole [actually Hungarian], and [Sandor] Bortwick, the Czecko-Slovakian [actually also Hungarian], along with such French artists as Georges Braque, Jean Metzinger, Albert Gleizes, Jacques Lipchitz, and Pablo Picasso."[39] Through Dreier's universalizing the Soviets lost proprietary rights to Constructivism, which the exhibition cast as a generic international movement. The Constructivists' attempts to historicize ideas through concrete, collaboratively produced social actions and artifacts ran up against Dreier's "cosmic force."

Modern Russian Artists was the first New York exhibition to introduce the Soviet avant-garde to the American public. The inclusion of French artists, probably to fill the gallery, anticipated the challenges Dreier faced in sponsoring and organizing two large-scale exhibitions in 1926. Constrained to husband her collection, she sent only five works for inclusion in a Russian section of an exhibition of modern art organized by Brinton as part of the Sesqui-Centennial Exposition in Philadelphia (fig. 19). The rest she saved for her major effort the *International Exhibition of Modern Art*, opening that November at the Brooklyn Museum, for which she secured supplementary loans from the United States and Europe. By virtue of her universalizing beliefs she managed to display a large selection of both utilitarian and nonutilitarian Constructivist work, made both in and outside the Soviet Union.[40] Lissitzky's eight Prouns were exceeded by nine works by the Hungarian László Moholy-Nagy, who was matched in number by Lozowick (insisting on his American nationality); Gabo's three constructions were matched by those of his brother Antoine Pevsner, including his abstract *Portrait of Marcel Duchamp* (1926), which Dreier had commissioned (fig. 20). Her inner eye rendered distinctions among the Constructivists moot.

Whether exercising her outer or inner eye, Dreier was unerring in her selection of Prouns for the Brooklyn exhibition. Because Lissitzky had become reticent in his support of the Revolution after moving to Germany, in 1921 Dreier was free to give his abstractions her own spiritual spin.[41] As "station[s] on the road towards constructing a new form," Lissitzky's Prouns had a prophetic aura that was most evident in his *Victory over the Sun*, a brilliant portfolio of ten lithographs published in 1923 (figs. 21–30). The prints were based on a landmark experimental opera by Alexei Kruchenykh and Mikhail Matyushin that had been performed in 1913 with costumes and scenery by Malevich. The title alone suggests the cosmic power of revolutionary art, and Lissitzky's mechanized figures strut, gesticulate, and fly through space in their colorful streamlined outfits. Given her claim that all the arts partook of a new universal force, Dreier would above all have appreciated the integration of art forms implicit in the portfolio, which united theater and musical performance in its visual presentation. She purchased the portfolio sometime after seeing a preliminary drawing for it at the *Erst Russische Kunst Austellung*.

fig. 20
Antoine Pevsner. *Portrait of Marcel Duchamp.* 1926.
Celluloid in several tones (or other forms of plastic),
iron strip, mounted on copper in 1957 (originally
zinc), 25 ³/₄ x 37 in. (65.4 x 94 cm)

fig. 19 (opposite)
Constantin Alajálov. Cover of *Modern Art at the
Sesqui-Centennial.* Exh. cat., 1926. Katherine S.
Dreier Papers/Société Anonyme Archive. Yale
Collection of American Literature, Beinecke Rare
Book and Manuscript Library

figs. 21–30
El Lissitzky. *Victory over the Sun (Sieg über die Sonne).*
1923. Ten color lithographs, composition: 21 ¹/₈ x 17 ¹⁵/₁₆ in.
(53.5 x 45.5 cm), sheet: 21 ¹/₂ x 18 ¹/₂ in. (54.5 x 47 cm)

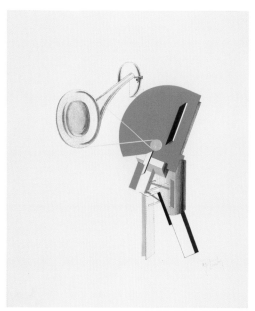

The Machinery (Teil der Schaumaschinerie)

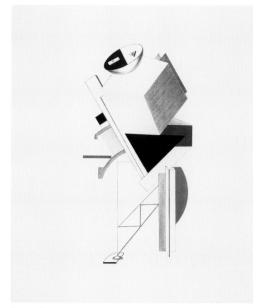

Sentinel (Posten)

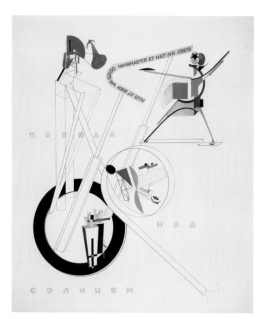

Announcer (Ansager)

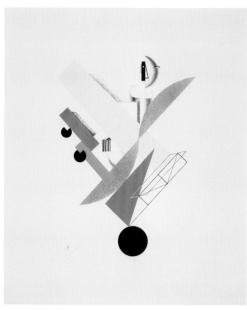

Globetrotter (in Time) (Globetrotter [in der Zeit])

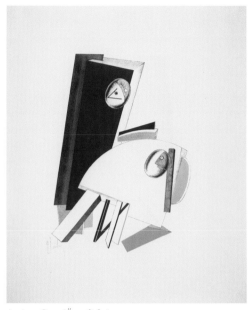

Anxious Ones (Ängstliche)

Troublemaker (Zankstifter)

Old Man (Head Two Paces Behind)
(Alter [Kopf 2 Schritt hinten])

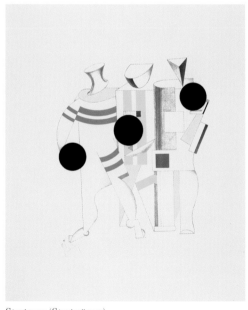

Sportsmen (Sportmänner)

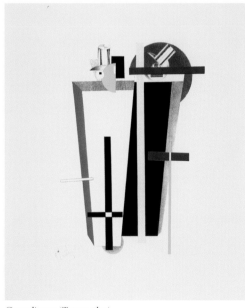

Gravediggers (Totengräber)

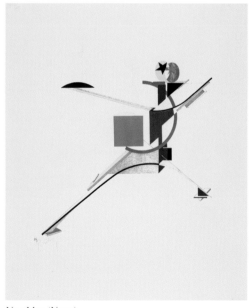

New Man (Neuer)

The Prouns were flexible and transformational, taking Lissitzky into interior design, architecture, and urban planning. What most attracted Dreier to him, however, was his influential book design and typographical daring: she certainly saw his intricate typographical design for the cover of the *Erst Russische Kunst Austellung* catalogue, and then his February 1923 cover for *Broom* (fig. 31). Josephson would recall this "man with a wonderfully symmetrical bald head, delicate features and hands and keen brown eyes" inviting him to the print shop to prepare the lithographic stone: "With those pure mechanical forms he would carry off remarkable feats of equilibrium, a magician and engineer in one."[42] No wonder, then, that Lozowick would keep an eye on Lissitzky in designing the interlocking typography for the cover of *Modern Russian Art*, and in turning out his elegant ink "machine ornaments."

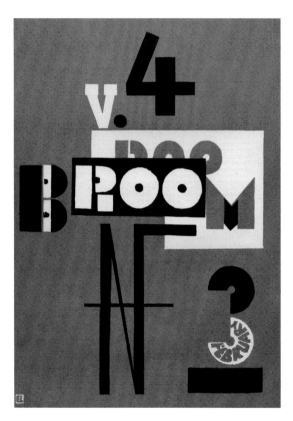

fig. 31
El Lissitzky. Cover of *Broom*. February 1923

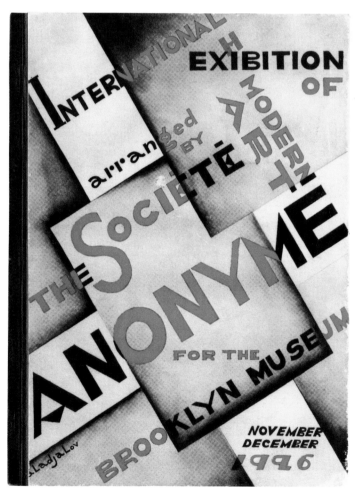

fig. 32
Constantin Alajálov and Katherine S. Dreier. Cover of *Modern Art*, 1926. Katherine S. Dreier Papers/ Société Anonyme Archive. Yale Collection of American Literature, Beinecke Rare Book and Manuscript Library

Although the Brooklyn exhibition was international in scope, with German art rivaling Soviet in numbers, Dreier gave the catalogue an aura of the Soviet avant-garde.[43] She emphasized the spiritual by dedicating the book to Kandinsky and making its frontispiece an illustration of his *Blauer Kreis* (Blue cross, 1922). The cover was crucial; Dreier especially wanted a cutting-edge design for the Brooklyn catalogue (fig. 32). She was no doubt motivated in this desire by the presence in New York of the offices of Heap's *Little Review*, and of the Little Review Gallery; she was certainly aware of the eye-catching typography on the covers of the *Little Review* (figs. 33, 34), which illustrated the work of Kandinsky, Moholy-Nagy, Gabo, and Tatlin throughout the 1920s. On the surface the two impresarios were on good terms. In April 1926, when the Little Review Gallery exhibited *Gabo and Pevsner: Russian Constructivists*, Heap had sold Gabo's *Monument for an Observatory* (1922) to Dreier. In 1925, too,

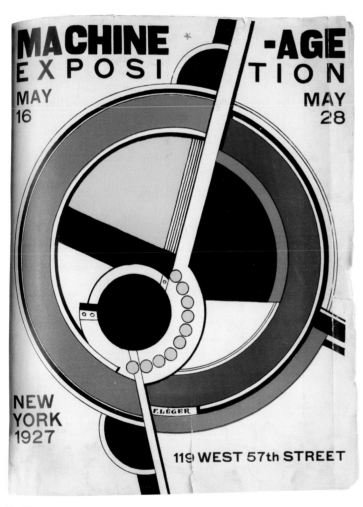

fig. 33
Cover of the *Little Review*. 1927

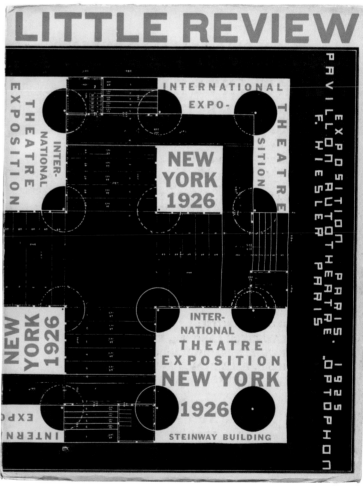

fig. 34
Cover of the *Little Review*. 1926

she had sought Dreier's assistance on the Machine Age Exposition (which would open in the Steinway Building in May 1927). Dreier had declined, pleading a backlog of work, but the two women's stationery had taken on bright hues in a display of rival plumage belying their alliance.[44]

As a visual model for the cover Dreier turned her eye to Lissitzy's innovative typography. She "composed" the cover and title page herself, in close collaboration with Alajálov (fig. 35), a Russian expatriate painter and magazine illustrator whom she had earlier enlisted to design the cover for Brinton's *Modern Art at the Sesqui-Centennial* catalogue. There, setting the title horizontally, Alajálov had deployed block sans serif letters that he had varied in size and color and had integrated with a geometrical background of interlocking rectangles, creating a field of indeterminate surface and depth. The design bears a striking resemblance to Rodchenko's cover for *Decorative and Industrial Art of the USSR*, the catalogue for the landmark decorative-arts exhibition in Paris in 1925.[45]

That this cover also owed something to Bauhaus design underscores the degree to which typographic innovation was transnational, stretching across Germany and eastern Europe to the Soviet Union. For the Brooklyn catalogue, however, Alajálov turned to the dynamism of Lissitzky's Prouns. Dreier proposed a cover that kept the letters on the horizontal but elongated their shapes. Alajálov instead took to the diagonal. Overlapping and interlocking rectangles swept across the cover, off-white and air-brushed gray and black — an ambiguous planar surface for the block sans serif lettering of the title. While most of the words were on a diagonal, Alajálov heeded Dreier by reserving some phrases for the horizontal as well as the opposing diagonal, locking the design on the rectangular cover. For the title page he returned to horizontal phrasing while giving over the central space to two overlapping squares, one red, the other black, on the edges of which ran Dreier's name. The squares, of course, alluded to Malevich's Suprematist paintings.[46]

Dreier also took full command of the content and layout of the pages. A bold horizontal bar stretching across the top margin of both left and right pages unified the opened book flat. Having separated the artists by nationality, Dreier asked Alajálov to draw a map of each nation represented. She became particularly concerned about his map of Germany: "The map part is beautiful," she granted, "but the way you have crossed her [Alajálov had drawn a grid over his map] makes it appear as if she were looking through prison bars."[47] (Intentionally or not, Alajálov's initial depiction was ironic and prescient, given Germany's tragic course over the next decades.) Dreier also included photographs of the artists themselves. (The ever-vain Burliuk was unhappy with her choice because his earring was not prominently displayed.)[48]

The most dazzling feature, saved for the book's last page, was a remarkable advertisement for the Polygraphic Company of America (fig. 36), headed by David Werblow, who not only was Dreier's printer but had also served as business manager of the Société Anonyme. A combined collage and photomontage, all aslant with jazzy diagonals and superimpositions, the advertisement visually reminded readers of the photo-offset innovations that had made the catalogue possible. Not until the advertisements in *Fortune* magazine during the next decade would readers come across such advanced layouts. Here was modernity led by American technology. Index tabs down the catalogue's right margin, with letters corresponding to the nations represented, were the finishing touch, rendering Dreier's book an American landmark of integrated typographical design and layout.[49]

In subsequent years Alajálov continued to design the public face of the Société Anonyme, most notably the covers for the two issues of Dreier's short-lived journal *Brochure Quarterly* in 1928 and 1929 (fig. 37). His innovative designs were powerfully

fig. 35
Constantin Alajálov. Katherine S. Dreier Papers/ Société Anonyme Archive. Yale Collection of American Literature, Beinecke Rare Book and Manuscript Library

symbolic for Dreier. At their generic level they announced the modernity of her enterprise. More crucially, however, Alajálov's covers paid homage to the Soviet avant-garde, even though the gesture was fraught with the uncertainty of political events and Dreier's ambivalence. During a brief period of the 1920s the Soviet Revolution stirred her utopian hopes for a new world order, engineered in no small measure by the Soviet avant-garde. Aware that the materialist ideology of the Soviets was at odds with her Theosophical beliefs, she nonetheless held her reservations in abeyance, for the Constructivists held out the possibility that abstract art could have a national, indeed global impact. That vision was fundamental to her educational mission for the Société Anonyme. Further, innovative graphic design was an effective way to take art into everyday life. Whereas Dreier's exhibitions would inevitably be dismantled, her catalogues would remain as an enduring record, circulating throughout society. Such were her millennial dreams.

Dreier was proud of her work as a painter and would never have conceded her role as an artist. By declaring art a spiritual force realized through the individual, she turned the Marxist ideology of material forces on its head — yet she thrived on collaboration no less than her Soviet counterparts, who submerged their individuality to engage in collective "production." Collaboration is self-evident in Dreier's role as a patron of the arts. It is generally more difficult to discern in her artwork, but it is strikingly demonstrated in her album of lithographs *40 Variations* (1934–37; figs. 38, 39).

40 Variations was long in gestation. Like Lissitzky's *Victory over the Sun*, it encapsulated the arts and made a bow to the Russians. Dreier began it in 1934 with a single lithograph, the ground for linear configurations echoing Kandinsky's *Kleine Welten* (1922), a portfolio of six lithographs that she had purchased in 1922. Dreier then

made her "variations" with overlays of watercolor on the lithograph, which lend a bright lyricism to the linear armature. The idea of variation may have had its source in Kandinsky but also in the music of Beethoven. At this point collaboration began. Ted Shawn choreographed a dance based on one Variation, accompanied by a score composed by Jess Meeker and performed by Shawn's company in 1936. Duchamp supervised the pochoir printing of the lithographs in Paris in 1937. By the time they were distributed, in 1942, Alajálov had entered the process by designing the cover of the album; Moholy-Nagy wrote an introduction, praising this "motion picture in color"; while Alfred H. Barr, Jr., Frederick Kiesler, and Duchamp, among others, also provided brief commentaries.[50]

At the center of *40 Variations* stood Dreier, who was not overshadowed by her stellar supporting cast. She wrote her own poetic commentary for the album without straining for poetry, remaining light-hearted and hardly ponderous, as many readers have characterized her writing. Expanding on the trope of sailing, she claimed, "My Variations should be taken lightly, joyously, as one sails along./Let the wind sweep out all the cobwebs which have gathered — and relax in the glorious sunshine."[51] The same joyous quality and inner spirit prevailed in a photograph of her taken in 1948, more than a decade later: she stands against her white clapboard house, extending her cockatoo toward the camera, and smiling, leaning slightly forward to greet the world (fig. 40).

The touchstone of Dreier's political sympathies was the promotion of abstract art. She thus became ambivalent toward the Soviet government when it officially rejected avant-garde art in favor of Socialist Realism, in 1930. Her ambivalence extended even to the Soviet Constructivists, whose art she had patronized: in a lecture at the New

fig. 39
Katherine S. Dreier, *40 Variations* (#8). 1937.
Colored ink (au pochoir) over lithograph, composition: 8⁷/₁₆ x 12³/₁₆ in. (21.4 x 31 cm), sheet: 11⁷/₈ x 8¹/₂ in. (30.2 x 21.6 cm)

Katherine S. Dreier 1934

Vol. I. 8.

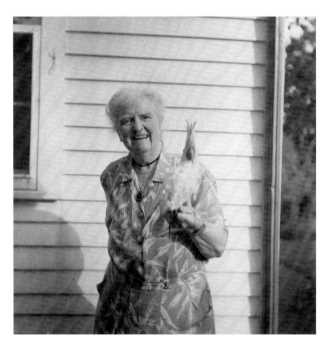

fig. 40
Katherine S. Dreier and Koko at her home in
Milford, Connecticut, 1928. Katherine S. Dreier
Papers/Société Anonyme Archive. Yale Collection of
American Literature, Beinecke Rare Book and Man-
uscript Library

York's New School for Social Research in February 1931 she was skeptical of a Construc-
tivist program that sacrificed art for social production, an agenda that met "imme-
diate need" but turned "the artists away from the art which would enrich the spirit."[52]
In a subsequent lecture at the New School she praised *The Realistic Manifesto* of
Gabo and Pevsner, who set the vitality of life invested in "the forms of space and time"
against the transience of "states, political and economic systems."[53] For her this
manifesto showed the way for others, "just as the big ocean liners know their path on
the high sea."[54]

As a big ocean liner, however, the Soviet Union seemed to be losing its way.
For Dreier the Soviet emphasis on "materialism" created an imbalance; she felt that
art should nurture "the spirit as well as the body," or else it became mediocre, as it
had under a conservative Soviet regime. The best she could say was both generous and
devastating: "In my judgment the greatest service which Soviet Russia rendered the
rest of the world was not in her experiment in government…but that she acted as an
eruption with such force that she scattered away many of her creative and living
spirits over the entire world."[55] (In 1933, grateful for her patronage, the Russian émigrés
of New York invited her to mount a retrospective of her painting at the Allied Arts
Gallery, sponsored by the Allied Arts Academy.)[56] Recognizing the dark side of the
Revolution for the light it shed light elsewhere, Dreier had evolved an ironic vision of
the Soviet Union: its destructive forces had released spirits to the world, even while
its rage for order had caused imprisonment and the disintegration of the creative spirit
at home. Meanwhile her own spiritual "manifesto" had led her to collect the art of
the Russian/Soviet avant-garde, scattered or eventually imprisoned, for the American
public, thereby opening new possibilities. As she declared in 1926, "Only to that
which we love do we give sufficient time to permit to speak to us."[57]

Notes

*I am indebted to Robert L. Herbert, Eleanor S.
Apter, and Elise K. Kenney, eds.,* The Société
Anonyme and the Dreier Bequest at Yale Uni-
versity: A Catalogue Raisonné *(New Haven:
Yale University Press, 1984), and to Ruth L.
Bohan,* The Société Anonyme's Brooklyn Exhi-
bition: Katherine Dreier and Modernism in
America *(Ann Arbor: UMI Research Press, 1982).
The research and rigorous scholarship in these
books made this essay possible.*

1 "Veritas," *Bolshevism in Art and Its Propagandists*
(New York: Veritas, 1924), p. 15. Marcel Duchamp's
work was illustrated as an example of this "insanity,"
and a product of "charlatanism" to boot. For a full
discussion of the 1913 Armory Show and the critical
response to it see Milton W. Brown, *The Story of
the Armory Show* (Washington, D.C.: Hirshhorn
Foundation, 1963).
2 For a sense of the sweep of the spiritual in abstract
art, see Maurice Tuchman et al., *The Spiritual in
Art: Abstract Painting, 1890–1985* (Los Angeles: Los
Angeles County Museum of Art, and New York:
Abbeville, 1986).
3 On Jane Heap see Dickran Tashjian, "From
Anarchy to Group Force: The Social Text of *The Lit-
tle Review*," in *Women in Dada: Essays on Sex,
Gender, and Identity*, ed. Naomi Sawelson-Gorse
(Cambridge: MIT Press, 1998), pp. 262–93; on
Matthew Josephson, Harold Loeb, and *Broom* see
Dickran Tashjian, *Skyscraper Primitives: Dada and
the American Avant-Garde, 1910–1925* (Middle-
town, Conn.: Wesleyan University Press, 1975), pp.
116–42.
4 Addressing "Dear Brother Burliuk," Katherine
Dreier wrote in February 1944, "I wonder whether
you realize that I have devoted ten months of my
life to this book — and I can assure you that it is
something that I would never repeat for anyone else.
Ten months without having been able to paint at
all!!! I don't regret having done it — for I think that

you have created and given my country something
very precious — you and Marussia." Dreier, letter to
David Burliuk, February 10, 1944. Box 7, Folder
174, Katherine S. Dreier Papers/Société Anonyme
Archive, Yale Collection of American Literature,
Beinecke Manuscript and Rare Book Library,
Yale University.
5 On Matta in New York in the 1940s, and his rela-
tionship with Duchamp, see Martica Sawin, *Surreal-
ism in Exile* (Cambridge: MIT Press, 1995), 316–23.
6 See Herbert, Apter, and Kenney, *Société
Anonyme*, p. 118.
7 Dreier, *Burliuk* (New York: Société Anonyme
and Color and Rhyme, 1944), p. 1.
8 Ibid., pp. viii, xiv.
9 Ibid., p. 93.
10 See Victor Margolin, *The Struggle for Utopia:
Rodchenko, Lissitzky, Moholy-Nagy* (Chicago: Uni-
versity of Chicago Press, 1997), p. 23, and Dreier,
Burliuk, pp. 124–26. On Vladimir Mayakovsky's
poetry and the visual arts, along with Burliuk's
involvement, see Vahan D. Barooshian, *Russian
Cubo-Futurism, 1910–1930: A Study in Avant-
Gardism* (The Hague: Mouton, 1974), and Juliette
Stapanian, *Mayakovsky's Cubo-Futurist Vision*
(Houston: Rice University Press, 1986). For a lively
translation of Mayakovsky's poem on the Brooklyn
Bridge see Vladimir Mayakovsky, *Poems*, trans.
Dorian Rottenberg (Moscow: Progress, 1972), pp.
60–63.

11 Dreier, *Burliuk*, p. 2.

12 Dreier, "Speech to be Spoken over the Radio," December 1926, unpublished ms., p. 4. Box 47, Folder 1379, Katherine S. Dreier Papers. Ralph Waldo Emerson, "Nature," in *Selections from Ralph Waldo Emerson*, ed. Stephen E. Whicher (Boston: Houghton Mifflin, 1957), p. 24.

13 Wassily Kandinsky, *Concerning the Spiritual in Art*, trans. M. T. H. Sadler (New York: Dover, 1977), pp. 13–14. Dreier believed Madame Blavatsky to have been "one of the great women of the last century"; see Dreier, "'Intrinsic Significance' in Modern Art," in *Three Lectures on Modern Art* (New York: Philosophical Library, 1949), p. 7. For an extended discussion of Dreier, Blavatsky, and Theosophy see Bohan, *The Société Anonyme's Brooklyn Exhibition*, pp. 15–19.

14 See Herbert, Apter, and Kenney, *Société Anonyme*, p. 359.

15 For the cultural politics of Kandinsky's return to Russia as well as a context for *Concerning the Spiritual in Art*, see John E. Bowlt, "Vasilii Kandinsky: The Russian Connection," in *The Life of Vasilii Kandinsky in Russian Art: A Study of "On the Spiritual in Art,"* ed. John E. Bowlt and Rose-Carol Washton Long (Newtonville, Mass.: Oriental Research Partners, 1980), pp. 1–41.

16 Duchamp, quoted in Katherine Janszky Michaelson and Nehama Guralnik, *Alexander Archipenko: A Centennial Tribute* (Washington, D.C.: National Gallery of Art, 1986), p. 48.

17 Marsden Hartley, quoted ibid., p. 49, from *New York Herald*, February 20, 1921. The symposium was titled "The Psychology of Modern Art and Archipenko."

18 See Louise Norton, "Buddha of the Bathroom," *The Blind Man* 2 (May 1917):6.

19 Ivan Goll, "An Appreciation," in *Archipenko* (New York: Société Anonyme, 1921), pp. 5, 6.

20 Christian Brinton, letter to Dreier, October 26, 1923. Box 5, Folder 143, Katherine S. Dreier Papers.

21 Brinton, Introduction to *The Archipenko Exhibition* (New York: Kingore Gallery, 1924), n.p. For an extensive discussion of Brinton's role in bringing Russian/Soviet art to the United States, see Robert C. Williams, *Russian Art and American Money, 1900–1940* (Cambridge: Harvard University Press, 1980), pp. 83–110.

22 For her final lecture, titled "Art of the Future," Dreier presented, in addition to the Archipentura, Duchamp's *Anémic Cinéma* and a demonstration of Thomas Wilfred's electric color-organ, the Clavilux. See Herbert, Apter, and Kenney, *Société Anonyme*, p. 761. For a detailed discussion of Archipenko's invention see Michaelson and Guralnik, *Alexander Archipenko*, pp. 64–67. I am indebted to Susan Greenberg for sending me material on the Archipentura patent from the Archipenko Foundation.

23 Dreier, letter to Ludwig Martens, January 19, 1921. Box 23, Folder 655, Katherine S. Dreier Papers. On Martens and Raymond Robins see Williams, *Russian Art and American Money*, pp. 98–99, 197–209.

24 Matthew Josephson, *Life Among the Surrealists: A Memoir by Matthew Josephson* (New York: Holt, Rinehart and Winston, 1962), p. 200.

25 For a detailed account of this landmark exhibition see Andrei Nakov, ed., *The 1st Russian Show: A Commemoration of the van Diemen Exhibition, Berlin 1922* (London: Annely Judah Fine Art, 1983).

26 As Peter Nisbet notes, "The details [of mounting this exhibition] reveal the confused mixture of motives which guided its development, with the interplay between propaganda, commerce, diplomacy and art often difficult to disentangle from the available documents." Nisbet, "Some Facts on the Organizational History of the van Diemen Exhibition," ibid., p. 69.

27 See the checklist in Dreier's copy of *Erst Russische Kunst Austellung* (Berlin: Galerie van Diemen, 1922). Box 65, Folder 1705, Katherine S. Dreier Papers.

28 In *The Catalogue of the Exposition of Art in Trade at Macy's (May 2–7, 1927)*, Dreier noted, "Malevitch's Scissor Grinder was shown in a small study against a cork wall background: beautifully lighted, it caused much comment though it was not listed" (p. 10). Box 88, Folder 2284, Katherine S. Dreier Papers. In 1926 Dreier eagerly asked Burliuk if it would be possible to find some more work by Kasimir Malevich for the Brooklyn Exhibition. Dreier, letter to Burliuk, September 2, 1926. Box 7, Folder 173, Katherine S. Dreier Papers.

29 Published in English as Malevich, *The Non-Objective World*, trans. Howard Dearstyne (Chicago: Paul Theobald, 1959).

30 *Erst Russische Kunst Austellung*. Box 65, Folder 1705, Katherine S. Dreier Papers. For a translation of the catalogue essay see Stephen Bann, ed., *The Tradition of Constructivism* (New York: Viking, 1974), pp. 72–76.

31 El Lissitzky, quoted in Margolin, *Struggle for Utopia*, pp. 22, 33.

32 *Erst Russische Kunst Austellung*, in Bann, *Tradition of Constructivism*, p. 76.

33 See Naum Gabo, *The Realistic Manifesto*, in *Gabo on Gabo: Texts and Interviews*, ed. and trans. Martin Hammer and Christina Lodder (East Essex: Artists Bookworks, 2000), pp. 26–27.

34 Brinton, Introduction to *Exhibition of Russian Painting and Sculpture* (New York: Brooklyn Museum, 1923), n.p. The Société Anonyme lent work by Archipenko and Kandinsky to the exhibition.

35 Brinton, Foreword to Igor Grabar, *The Russian Art Exhibition* (New York, 1923), n.p.

36 Brinton, Introduction to *Exhibition of Russian Painting and Sculpture*, n.p.

37 Dreier, *Western Art and the New Era* (New York: Brentano's, 1923), pp. 4, 13, 71–72.

38 On Louis Lozowick and Soviet art see Virginia Hagelstein Marquardt, "Louis Lozowick: An American's Assimilation of Russian Avant-Garde Art of the 1920s," in *The Avant-Garde Frontier: Russia Meets the West, 1910–1930*, ed. Gail Harrison Roman and Marquardt (Gainesville: University Press of Florida, 1992), pp. 241–74.

39 Flier for *Modern Russian Artists* exhibition. Box 87, Folder 2249, Katherine S. Dreier Papers.

40 For a detailed account of the Brooklyn exhibition, as well as an account of Dreier's trip to Europe to secure loans, see Bohan, *The Société Anonyme's Brooklyn Exhibition*, chapters 4 and 5. For the useful distinction between utilitarian and nonutilitarian Constructivism see Christina Lodder, *Russian Constructivism* (New Haven: Yale University Press, 1983), pp. 2–5.

41 On Lissitzky's reticence if not evasiveness about his stand on the Revolution, see Margolin, *Struggle for Utopia*, pp. 28–37, 66–72.

42 Josephson, *Life Among the Surrealists*, p. 209.

43 Dreier, *Modern Art* (New York: Société Anonyme, Museum of Modern Art, 1927).

44 See Heap, letter to Dreier, January 8, 1925, and Dreier, letter to Heap, dated January 9, 1924, but actually 1925. Box 22, Folder 641, Little Review, 1923–27, Katherine S. Dreier Papers.

45 For an illustration of Rodchenko's catalogue cover see Margit Rowell and Deborah Wye, *The Russian Avant-Garde Book* (New York: The Museum of Modern Art, 2002), p. 181.

46 For a detailed account of Dreier's collaboration with Constantin Alajálov on the two catalogues, see Bohan, *The Société Anonyme's Brooklyn Exhibition*, chapter 6. Bohan sees their graphic design as stemming from the Bauhaus, which I think is more true of the Sesqui-Centennial catalogue than of the Brooklyn one.

47 Dreier, letter to Alajálov, September 29, 1926. Box 1, Folder 17, Katherine S. Dreier Papers.

48 Dreier, letter to Burliuk, March 21, 1927. Box 7, Folder 171, Katherine S. Dreier Papers.

49 On Julien Levy's gallery and its publications see Ingrid Schaffner and Lisa Jacobs, eds., *Julien Levy: Portrait of an Art Gallery* (Cambridge: MIT Press, 2000), and Dickran Tashjian, *A Boatload of Madmen: Surrealism and the American Avant-Garde, 1920–1950* (New York: Thames and Hudson, 1995), pp. 176–201. On Werblow see Bohan, *The Société Anonyme's Brooklyn Exhibition*, pp. 75–76.

50 For a brief account of *40 Variations* see Herbert, Apter, and Kenney, *Société Anonyme*, pp. 215–16. Dreier wrote a monograph on Ted Shawn: *Shawn the Dancer* (New York: A. S. Barnes, 1933).

51 "For the Paramount Newsreel — One Minute — February 8th 1935. '40 Variations' by Katherine S. Dreier. Held at the Annot Art School — R.K.O. Building — Rockefeller Center." Box 43, Folder 1265, Katherine S. Dreier Papers.

52 Dreier, "Present Day Russian Tendencies," a lecture at the New School, New York, February 23, 1931, p. 11. Box 47, Folder 1410, Katherine S. Dreier Papers.

53 Gabo, *Realistic Manifesto*, pp. 26–27.

54 Dreier, "The Place of the Abstract in Art," a lecture at the New School, March 16, 1931, p. 14. Box 47, Folder 1405, Katherine S. Dreier Papers.

55 Dreier, "Present Day Russian Tendencies," p. 2.

56 Burliuk, who had become director of the Allied Arts Gallery, offered to mount a retrospective of Dreier's early work. The handsome catalogue, which included a short essay by Burliuk, sported a cover with a striking typographical layout. Box 67, Folder 1747, Katherine S. Dreier Papers.

57 Dreier, "Informal Talk on Modern Art," a lecture at the Painters and Sculptors Gallery, New York, January 28, 1926. Box 46, Folder 1356, Katherine S. Dreier Papers.

INTERNATIONAL EXIBITION OF MODERN ART

arranged by

THE SOCIÉTÉ ANONYME

FOR THE BROOKLYN MUSEUM

NOVEMBER DECEMBER 1926

Ladjalov

"One Big Painting" A New View of Modern Art at the Brooklyn Museum

Kristina Wilson

I always treat my exhibitions, as you may know, as one big painting, for in that way alone do the rooms look complete. People wonder why my exhibitions give such satisfaction and why even if they do not like the individual pictures, they always like the sensation of the room.

— *Katherine Dreier, letter to Stuart Davis, September 29, 1926*

Among the many public programs that Katherine Dreier organized under the auspices of the Société Anonyme, none rivaled the scope and ambition of the *International Exhibition of Modern Art* held at the Brooklyn Museum from November 19, 1926, to January 1, 1927 (fig. 2). Dreier, determined to demonstrate the vitality of modern art and to rebuff those who claimed the movement was "dying out," gathered together more than 300 contemporary works by 106 artists representing (as Dreier classified them) twenty-three countries.[1] Not only was the exhibition broad in its selection of artists, it also brought together works of extraordinary aesthetic diversity, ranging from the rigorous geometric abstractions of Constructivists such as El Lissitzky through the prismatic, spiritually infused figurative works of German Expressionists Franz Marc and Heinrich Campendonk to the Cubism of Georges Braque and Pablo Picasso. Dreier did not find the group assembled in Brooklyn discordant; rather, she believed the works shared a common philosophical agenda: to reveal, through color and form, larger questions about the metaphysical state of humankind in the modern world. As she explained in a lecture at the Brooklyn Museum, delivered shortly after the exhibition closed, "To the Société Anonyme the term Modern Art represents a distinct point of view and holds within itself a definite meaning, which is — that it is an expression of the new cosmic forces coming to the fore, which in time will change our vision of life, as well as that of art, as radically as when Giotto broke with the Byzantine. Therefore, the Exhibition gathered together was not a haphazard affair — as many people seem to think."[2]

The diversity of the Brooklyn exhibition may seem cacophonous to twenty-first-century viewers, who think of early-twentieth-century modernism as a series of discrete "isms." Indeed, as Dreier's somewhat defensive comments suggest, the show was unusual even in its day for its open embrace of varying modes of modernism. The *International Exhibition* was far more expansive than the focused shows of modern art put up in New York by Alfred Stieglitz in the 1910s at his 291 gallery, or by A. E. Gallatin at his Gallery of Living Art, which opened in 1927. Although it was conceived on the scale of the notorious Armory Show of 1913, it did not share that earlier event's interest in categorizing and writing a history of modern art. Whereas Arthur B. Davies had organized the Armory Show around individual artists and common aesthetic approaches, Dreier's installation of contemporary art (few items were more than ten years old) divided the work of individual artists and followed no discernible national or aesthetic groupings.[3] When The Museum of Modern Art opened a few years after, in late 1929, it shared with the Société Anonyme an interest in representing the broad swath of practices that constituted modern art, but in its exhibition programs it tended to follow the historical, categorical approach of the Armory Show.

fig. 1
Constantin Alajálov and Katherine S. Dreier. Cover of *Modern Art* (detail), 1926. Katherine S. Dreier Papers/Société Anonyme Archive. Yale Collection of American Literature, Beinecke Rare Book and Manuscript Library

Although the Brooklyn show received a flurry of reviews during the weeks it was open, by July 1927 the critic Henry McBride was already remarking that in the end it had "attracted much less public attention than it deserved."[4] One can only speculate on the many reasons why it did not garner the enduring publicity that the Armory Show had received, or that The Museum of Modern Art was to attain in a few years. Undoubtedly as a consequence, it has been misunderstood by subsequent generations of scholars. I shall attempt here to reassess the contributions of the *International Exhibition* to the understanding of modern art in the United States by putting the show in dialogue with better-known displays of this radical art during the years before World War II. The Brooklyn show embodied both the collective nature of the Société Anonyme — a group of artists who, with fluctuating degrees of engagement, evaluated and promoted one another's work — and the views of Dreier herself. As such, it offered a vibrant, occasionally quirky view of modern art. The voice of the Brooklyn show, when folded into the discourse generated by the Armory Show, Stieglitz, Gallatin, and MOMA, significantly enhances our understanding of the reception and interpretation of modernism in this country.

fig. 2
International Exhibition of Modern Art, organized by Katherine S. Dreier and the Société Anonyme, Brooklyn Museum, November 1926–January 1927. Installation view. Katherine S. Dreier Papers/Société Anonyme Archive. Yale Collection of American Literature, Beinecke Rare Book and Manuscript Library

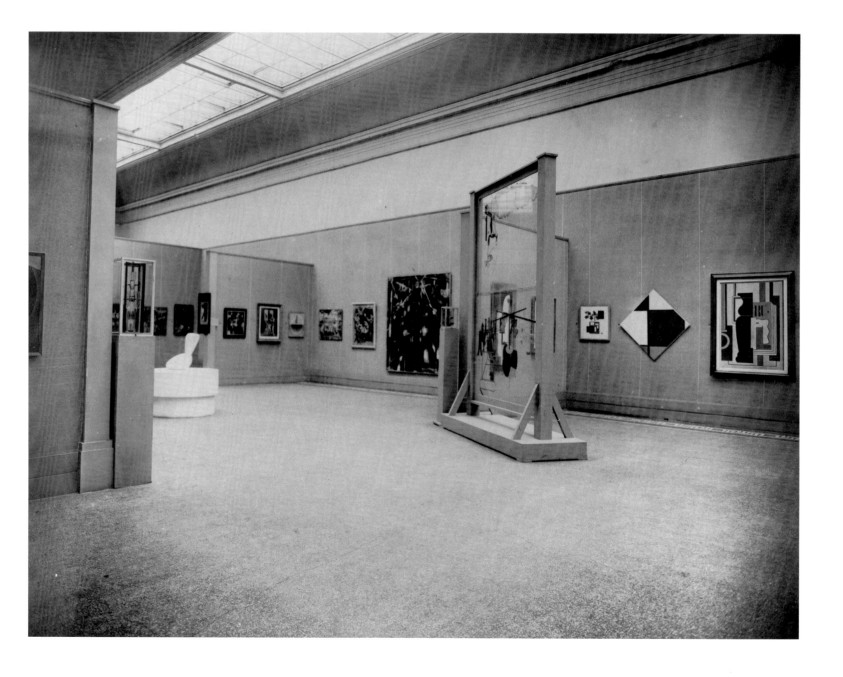

ANTECEDENTS TO THE BROOKLYN SHOW

In the years preceding the Société Anonyme exhibition at the Brooklyn Museum, displays of modern art tended to gravitate toward one of two poles. On the one hand, exhibitions were sometimes held in small galleries, where, despite limited space, the works tended to be hung in a single row with room between them.[5] The best-known American example of this type of institution was Stieglitz's commercial gallery 291, in operation from 1905 to 1917: in the small rooms he rented on the top floor of 291 Fifth Avenue, he covered the walls in a light gray burlap-type material and usually hung works in an evenly spaced single row (fig. 3).[6] The minimal decoration was intended to help focus visitors' attention on the art but also created a particular, intimate atmosphere, larger than the works themselves, to which visitors submitted when they entered.

Larger exhibitions of modern art, on the other hand — including the Armory Show and the Society of Independent Artists' exhibition in 1917 — were sometimes installed in spaces recalling the grand galleries of such Beaux Arts institutions as New York's Metropolitan Museum of Art.[7] In many Beaux Arts museums before World War I, galleries of paintings were hung following a centuries-old salon-style formula: canvases were stacked on the wall, rather than hung in a single row, and were arranged by size and shape to create large, roughly symmetrical patterns. Exhibitions of modern art such as the Armory Show, held in a large, vaulted space, followed this practice, clustering the new canvases in ways that resonated with the display of older, more established works (fig. 4).

In the years before the *International Exhibition* in Brooklyn, the Société Anonyme made use of both of these exhibition practices. The installations at its first exhibition space, at 19 East 47th Street, fell squarely within the first display trope (see fig. 5 in Gross's introductory essay in the present volume). Dreier often described this gallery as an "experimental" museum, implying that within its walls, established precedents for the display and reception of art would be set aside in pursuit of new paradigms.[8] The two rented rooms were decidedly domestic in scale: a floor plan labels the larger room 21'7" by 15'2" and the smaller room 14'7" by 15'6". Each had an 8'10" ceiling, a fireplace, and windows.[9] Despite the small space, the works on display seem not to have been clustered tightly. Judging from exhibition checklists that include only sixteen to twenty works, it is likely that Dreier and Marcel Duchamp, head of the exhibitions committee, preferred to show fewer works with more wall space for each.[10] The space, like that at 291, encouraged viewers to examine the art closely.

In addition to its air of unhurried contemplation, the gallery on East 47th Street embodied the first, Stieglitz-type display of modern art in its decoration: Duchamp covered the walls with a bluish-white oilcloth, its light tint reminiscent of the muted tones at 291, which he believed created a "neutral" background for the art.[11] For the Société's inaugural exhibition, in 1920, he outfitted the picture frames with lace paper. These quirky elements turned the gallery itself into an artwork: the art no longer was located simply in the canvases hung on the walls but rather comprised the entire atmosphere of the room. These decorating choices also instigated a quintessential Dada challenge to art-viewing precedent: the oilcloth walls created an almost industrial backdrop for the art, and the lace transformed the picture frames from props conferring (masculine) importance and establishment into ephemeral (feminine) accessories.

By the spring of 1921 the finances of the Société Anonyme were precarious, and Dreier was temporarily forced to close the East 47th Street gallery. In search of alternative venues, she contacted several museums, hoping to find institutions that would broaden the audience of the Société Anonyme and also confer on it an impri-

fig. 3
Alfred Stieglitz's 291, c. 1906. Installation view. Alfred Stieglitz/Georgia O'Keeffe Archive. Yale Collection of American Literature, Beinecke Rare Book and Manuscript Library

fig. 4
Armory Show, 1913. Installation view. Image courtesy of the Walt Kuhn, Kuhn family papers and Armory Show records, 1882–1966, Archives of American Art, Smithsonian Institution

The Installation

Dreier's arrangement of artworks in the Brooklyn exhibition represented a surprising convergence of the Société Anonyme's first installation — the small, intensive modern-art space at East 47th Street — and the salon-style arrangement exemplified at the Worcester Art Museum. The physical space that the show occupied at the Brooklyn Museum (see fig. 2) shared many features with the Beaux Arts architecture of the Worcester museum: the hall was monumental in scale, with tall ceilings and vast overhead lights that cast a bright, even glow across the entire show.[14] A neoclassical cornice crowned the space, and a second narrow molding ran along the wall at approximately two-thirds of the wall height. This second molding formed an edge for a muted wall covering that was installed as a backdrop for the works of art; it created a kind of intermediate ceiling height, keyed to human scale, that kept the grand space from overwhelming visitors.[15] The large room was subdivided by a series of partitions that, while not extending the full height to the ceiling, configured the room in a conventional enfilade (fig. 7). The enfilade — a progression of rooms opening one onto another, the doorways following a single axis — was a typical motif of the Beaux Arts museum, copied from earlier European museums, such as the Louvre, that had previously been palaces.[16]

While the architectural frame of the *International Exhibition* had an unmistakably grand, public scale, elements of the installation recalled more intimate displays of modern art. The paintings were hung in a single row, with more space between them than at Worcester. While some bays were anchored by a large, central canvas (such as Johannes Molzahn's *Family Portrait II* in fig. 8), others seem to have had no clear focal work, appearing as a simple array (as in the sequence of Béla Kádár and Campendonk canvases in fig. 9). Most important, perhaps, was the absence of a dado rail, which allowed Dreier to hang the paintings at any height she wished. Whereas Joseph Stella's large *Battle Lights, Coney Island, Mardi Gras* (1913–14), anchored along the dado rail, had towered over visitors to the Worcester show (see fig. 5), in the *International Exhibition* his equally large *Brooklyn Bridge* (1918–20) was hung low to the ground (see fig. 2). It still loomed large, but it was placed so that viewers could examine many parts of the canvas closely, its cluster of vanishing points, at about eye level, palpably pulling one into its vortex of light and color. By hanging large works closer to the ground and allowing more space between them, Dreier created a series of intimate viewing zones. Her exhibition, then, had the scale and legitimizing architectural frame of an established public salon — it was, as she called it, "monumental" — while simultaneously importing the contemplative, immersing mode of aesthetic experience fostered at her smaller gallery.[17]

It is worth noting that Dreier's successful negotiation of these two distinct modes of displaying art — intimate versus public, detailed scrutiny versus grand effects, modernist rebellion versus establishment masters — was perhaps the first of its kind in the United States. Although her innovation has been overlooked, it must have been an inspiration for the young Alfred H. Barr, Jr., who attended the *International Exhibition* as a professor at Wellesley College and would become, in 1929, the founding director of The Museum of Modern Art.[18] Barr's museum lacked the funds to build its flagship modernist home until 1939, and during its first decade it occupied a series of fairly conservative spaces; rather than minimize the antimodern elements of these early architectural frames, Barr carefully balanced them against a spaced-out, single-row hang (fig. 10) recalling Dreier's arrangements for the Société Anonyme.[19] This hybrid exhibition style was promptly forgotten when MOMA opened its new building, but it contributed significantly to the museum's success by presenting often unfamiliar art within a familiar structure of visual cues.

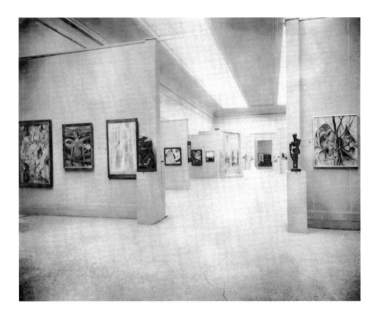

fig. 7
International Exhibition of Modern Art, organized by Katherine S. Dreier and the Société Anonyme, Brooklyn Museum, November 1926–January 1927. Installation view. Katherine S. Dreier Papers/Société Anonyme Archive. Yale Collection of American Literature, Beinecke Rare Book and Manuscript Library

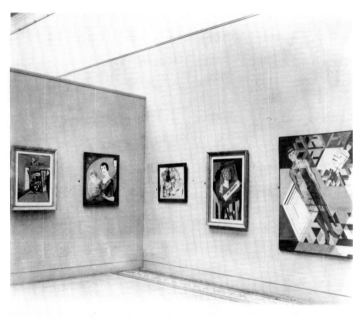

fig. 8
International Exhibition of Modern Art, organized by Katherine S. Dreier and the Société Anonyme, Brooklyn Museum, November 1926–January 1927. Installation view. Katherine S. Dreier Papers/Société Anonyme Archive. Yale Collection of American Literature, Beinecke Rare Book and Manuscript Library

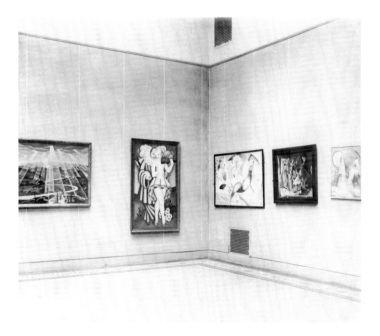

fig. 9
International Exhibition of Modern Art, organized by Katherine S. Dreier and the Société Anonyme, Brooklyn Museum, November 1926–January 1927. Installation view. Katherine S. Dreier Papers/Société Anonyme Archive. Yale Collection of American Literature, Beinecke Rare Book and Manuscript Library

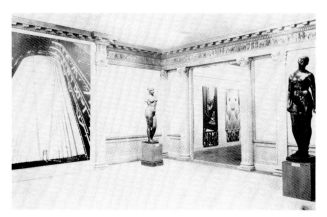

fig. 10
The Museum of Modern Art, 11 West 53rd Street,
1932. Installation view. The Museum of Modern
Art Archives

The Diverse Voices of the Société Anonyme

In addition to its innovative hanging strategy, the *International Exhibition* offered a selection of modernist art of unprecedented diversity. Although Dreier installed the exhibition, and was thus responsible for the way the public experienced the art, she was eager to explain that the selection of works was the consequence of conversations she had shared with a wide range of European artists over the course of a lengthy scouting trip during the spring and summer of 1926. In the foreword to the exhibition catalogue, she thanked, among others, Duchamp, who had accompanied her in Paris and Italy; Fernand Léger, who had shown her the work of his best students in Paris; and Kurt Schwitters, who had introduced her to the community of abstract artists in Hannover. She emphasized that all of these figures were artists and asserted that the resulting selection of works was infused with the high standards of creativity and expressiveness that only artists could fully judge in one another. The exhibition, she explained, was "not the work of one person, but really represents the modern group of Europe, for my long experience and personal friendship with many of these artists made it possible for me to turn to them in all friendliness and ask their aid, which they gave with a generosity which only artists extend to each other, when the aim is art and not personal advancement."[20]

An exhibition of modern art curated by a modern artist — or a group of modern artists — was not without precedent in the United States: not only had the progressive painters Arthur B. Davies and Walt Kuhn jointly decided which works to include in the Armory Show thirteen years earlier, but Stieglitz himself had first developed his reputation as a practitioner of an avant-garde art form, photography. Dreier consulted far more artists, however, than had been involved in either of these two venues. The result of her far-reaching contacts and open mind was an exhibition that gathered, as described by one critic, a daunting, if energizing, array of modern art:

> Despite our earnest efforts, the constructivists, the suprematists, the exponents of the Intérieurs Méchaniques and Intérieurs Metaphysiques — even the clarificationists of Holland, — began after a time to blend into a huge kaleidoscope, shifting from one colorful and entrancing pattern to another, until finally sensations of form and color became blurred. There is perhaps no way to remedy this condition save repeated visits to the Museum.[21]

Among the works exemplifying the exhibition's diversity were paintings by Ragnhild Keyser, Suzanne Phocas, Carl Buchheister, and Finnur Jónsson. Keyser, a Norwegian artist studying with Léger, had shown several works in Paris during the spring and summer of 1926, when Dreier was in the city scouting new art. Through Léger, Dreier had invited Keyser to participate in the upcoming show. Her paintings in the *International Exhibition*, such as *Composition I* (1926; fig. 11), reflect the tutelage of the Purists and testify to Dreier's esteem for Léger. Working with a group of objects that included a ladder-back chair, a vase, and a plaster torso, Keyser simplifies the forms into a flattened geometric pattern; all that remains of the chair are a few abbreviated slats, hovering at right angles to the back stile, and the red seat cushion. The torso has been transformed into a pair of interlocking semicircles. Although the predominant palette of grays, black, and white is more muted than Léger's, Keyser manages to convey some of the monumentality of her teacher's work through boldly overlapping shapes, and through such subtle passages as the shaded right edge of the vase in the painting's lower right.

Dreier also discovered in Paris the work of Phocas, who had made a reputation by painting apparently primitivist works such as *Child with Dog* (1925–26; fig. 12).

Phocas's style was in fact a product of careful cultivation (the rows of curls on the girl's head, and her semicircular eyebrows, in particular owe a debt to Léger).[22] But Dreier celebrated such elements as the girl's awkward pose and the dog's weirdly triangular fur, believing that Phocas had achieved an honest vision that, while different from Léger's and Keyser's, was equally important. In the exhibition catalogue she asserted that Phocas "was so absolutely unspoiled in her sincerity [that] the naive purity of her work is part of her own personality."[23]

Dreier also used her contacts to learn of new artists in Germany. Schwitters introduced her to the radically nonobjective work of a group of abstract artists based in Hannover, including Buchheister. When Dreier met him and decided to include his work in the Brooklyn show, Buchheister was actively involved with an international coterie of Constructivist artists, including fellow Brooklyn exhibitors Lissitzky and László Moholy-Nagy. Such works as *White with Black Wedge* (1931; fig. 13) resemble those Buchheister contributed in 1926. The abstract arrangement of shapes has no pictorial depth, yet the sharp point of the black wedge assumes an animated, dramatic quality, as if it were propelled into the world of the canvas by an unseen force to the right. As it enters the painting, the black meets the resistance of a field of white sand, which both adds texture to the work and acts as an imported, three-dimensional reference to the real world of construction and labor. Buchheister's radical principles come through in his artist's statement for the Brooklyn catalogue: "Do you know a method how to shake abstract pictures out of one's sleeve? It cannot be done — therefore, one has to work like a Philistine — consecutively — constantly work."[24]

Dreier's well-established affinity for the expressionistic, spiritualist vein in modern art found a new outlet in the work of the Icelandic artist Jónsson. She discovered him at Der Sturm, her favorite gallery in Berlin and a highly respected institution of modern art. Jónsson was represented in the *International Exhibition* by *Woman at the Card Table* (c. 1918–25; fig. 14), a Cubist-influenced work of highly saturated colors. The mechanomorphic female figure, seated at a table that seems to fall out of her pictorial world into a separate three-dimensional space, is surrounded by a fractured array of infused colors (sweeping in pinks and blues through the lower left of the canvas, fanning out in blues and browns before her Brancusi-like face) and luminescent, biomorphic clouds of blue, gray, and, behind her head, pink fading to deep red.

The polyphony of the Société Anonyme's approach to modern art can also be seen in the extravagant "special catalog," *Modern Art*, that accompanied the *International Exhibition*. In Dreier's mind the catalogue was an essential complement to the exhibition; while the show was necessarily temporary, *Modern Art* would provide a permanent record of the event.[25] This 124-page book was designed by Constantin Alajálov, a Russian émigré artist living in New York, in close consultation with Dreier, who believed the book should embrace modernism in an unusual, aggressive graphic design. Alajálov's design accomplished precisely that: throughout, the text is framed with bold black rectangles; a simplified yet legible map introduces each country, key cities and boundaries marked by dramatic lines of longitude and latitude; and the text itself shifts shape over the course of the book, expanding and retracting like construction blocks in an elaborate edifice (figs. 15, 16). In its bold design, *Modern Art* contributed yet another modernist voice to the art in the *International Exhibition* and can be compared with such contemporary ventures in book production as the two influential catalogues produced by the *Little Review* magazine, *International Theatre Exposition* (1926) and *Machine-Age Exposition* (1927).[26]

Modern Art also exemplified the multiple voices of the Société Anonyme in its content. Dreier organized the catalogue geographically, grouping artists by their coun-

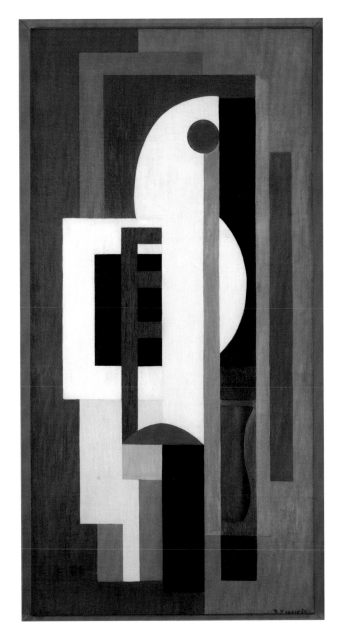

fig. 11
Ragnhild Keyser. *Composition 1.* 1926. Oil on canvas, 51 x 25⅝ in. (129.5 x 65.1 cm)

fig. 12
Suzanne Phocas. *Child with Dog.* 1925–26. Oil on
unprepared canvas, 29⅞ x 39⅜ in. (75.9 x 100 cm)

fig. 13
Carl Buchheister. *White with Black Wedge*. 1931. Oil,
enamel, sand, and wood on panel, 25 x 30⅛ x 1⅜ in.
(63.5 x 76.5 x 3.5 cm)

fig. 14
Finnur Jónsson. *Woman at the Card Table.* c. 1918–25.
Oil and gold paint on burlap, 25 1/4 x 20 5/16 in.
(64.1 x 51.6 cm)

try of residence. This system differed from the exhibition installation — in which works were arranged without regard to nationality — and resulted in a narrative comprising protagonists with distinct national identities. These protagonists were further individualized in the actual pages of the catalogue, where each was represented visually by both a portrait photograph and a reproduction of his or her art (see fig. 15). Dreier wrote brief summaries of the biography and philosophy of many of the artists but left several to speak for themselves. In addition to Buchheister's statement, for example, she included the words of the U.S. artist Paul Gaulois, who exemplified a certain America-first, boosterish rebellion common among his compatriots: "I am self-taught. I was born in the Middle West, much to my delight. I may mention I have very little desire to go to Europe, as America seems to possess much more than I can really know."[27] An excerpt from a 1920 manifesto by Antoine Pevsner and Naum Gabo demonstrated a concern with the abstract, and perhaps fourth-dimensional, potential of sculpture: "We deny the static as the only measure of rhythm. We insist there is a new element in the pictorial arts. We insist that kinetics is a new element in art. It is the foundation of the outward reality of our time."[28] The effect of multiple, overlapping personalities and artistic agendas was enhanced by the selected reprinting of artists' signatures (see fig. 16). The barely legible scrawls of Fritz Stuckenberg, John Covert, and Paul Klee, among others, ensured that readers appreciated the broad scope of the modern art movement.

Katherine Dreier's Vision

While the aesthetic and philosophical points of view represented in the Brooklyn show were unprecedented in their variety, Dreier repeatedly argued that the collection possessed a unifying theme. For her, the defining feature of modern art — present in all of the works in the show — was its ability to offer a profound interpretation of the relationship between the individual and the larger contemporary world. In an era of modern machinery, modern communication, and modern transportation, people were at once more readily in contact with one another and more readily alienated from the patterns of life that had defined society for centuries. This crisis of the individual was tinged with larger questions about the existence of spiritual forces that might offer an enlivening presence in daily life.[29] Dreier could be maddeningly oblique as she tried to "explain" the meaning of modern art to the public, but in her writings relating to the Brooklyn show she continually connected the unifying power of art to the unifying power of spiritual belief. In an article for the *Brooklyn Museum Quarterly* published before the exhibition opened, she explained that modern art might look different from other artworks in the museum because it concerned itself with issues that had no preexisting visual vocabulary:

Art is never unconscious, for it is the highest expression of the most developed and conscious soul — the seer. *It must*, therefore, be prophetic. The form art chooses to express itself in, depends upon the century in which it makes its appearance....

Therefore, the form which Modern Art has chosen in which to express itself had to be a new form. For to use a parable that Christ used, one cannot put new wine into old skins, for the wine in expanding will burst the skins. Art had reached its completion in the forms of the past, therefore, the artist with a prophetic vision had to seek new forms in which to express the psychic emotions of his day.[30]

Dreier pursued these allusions in her impassioned introduction to *Modern Art*. Celebrating the dedication of so many artists to the exhibition, she declared that "only cosmic forces can bring forth such a response." She then made her goal explicit: "Our work is to preserve the energy of art and direct it to future fruition. To encourage artists

fig. 15
Katherine S. Dreier. *Modern Art*, 1926. Designed by Constantin Alajálov. Page 68

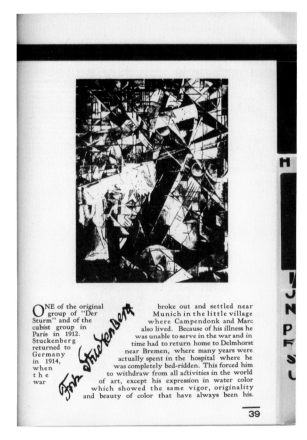

fig. 16
Katherine S. Dreier. *Modern Art*, 1926. Designed by Constantin Alajálov. Page 39

to be true to themselves and the vision that is God given." Finally, although the voices in the show were many and varied, Dreier proposed that her vision of modern art "is bigger than any one nationality and carries the follower into a large cosmic movement which unites him in thought and feeling with groups throughout the world."[31]

Dreier's single-row hanging at the Brooklyn Museum reflected her ideas about the universal nature of modern art in two ways. First, in her effort to demonstrate the "large cosmic movement which unites" artists from all countries, she hung the paintings uniformly throughout the galleries, with no regard to nationality or even to groupings of an artist's own works. This arrangement contrasted markedly with the emphatic internationalism of the *Modern Art* catalogue (and with Dreier's own tendency to underscore, in her publicity statements, the large number of nations represented).[32] The hang promoted the sense that these diverse works were equal in importance, and brought to the foreground surprisingly resonant similarities in composition and palette. Speaking to a Brooklyn civic club in the museum galleries, Dreier reminded her audience that the countries represented in the exhibition "were shut off from each other's influence during the period of the terrible world war. Bearing this in mind, it is all the more amazing to see how united the underlying thought is and how united we fundamentally are." Explaining her installation design, she continued, "I have purposely, therefore, interchanged the nations in hanging to bring out this idea of the close unity that binds us."[33]

Second, Dreier's hang encouraged viewers to engage each individual work as a complex, philosophically resonant statement in its own right. By leaving space between the artworks — allowing each to be contemplated separately — and by ignoring some of the rules of symmetrical hanging, she prevented the art from being subsumed into a larger decorative scheme. Dreier was aware that the flatness of abstract art made it seem merely ornamental to some viewers, and her installation seems to have been calculated to avoid any of the superficial undertones lurking in a salon-style hang. She explained the distinction between decoration and abstraction in several lectures and articles written around the time of the Brooklyn show, for example in describing the Constructivist murals of Willi Baumeister:

> To many Abstract Modern Art is simply decorative art. But this is not the case. A decoration must always be flat to be good. A painting must always have depth to be good. This new Division of Color Space breaks up the wall and introduces a vibration which has hitherto not been taken into consideration.[34]

In avoiding the decorative patterns of salon-style arrangements, Dreier refused to let abstract canvases become swaths of decorative wall covering and insisted on the separateness of each work — insisted on its ability to convey both "depth" and "vibration."

In addition to the formal galleries, Dreier also had at her disposal four smaller spaces partitioned off at the corners of one of the large galleries (fig. 17). Writing to Duchamp in July 1926, she described these as "four quaint small rooms…[which] will make a charming intime background for certain pictures and water colors."[35] By September, Dreier's installation plans for the rooms had become more complex: no longer content to use spaces suggesting domestic intimacy merely in their scale, she had decided to outfit them with furniture in order to demonstrate "how Modern Art looks in the home." Explicitly attempting to make the displays realistic for the audience she hoped to attract, she chose conservative, period-styled objects: "The more I think of making a selection of furniture which Abram & Straus will have for sale, the more pleased I am with the thought, especially as Abram & Straus is the big store where the big middle class Brooklynites buy."[36]

fig. 17
International Exhibition of Modern Art, organized
by Katherine S. Dreier and the Société Anonyme,
Brooklyn Museum, November 1926–January 1927.
Installation view. Katherine S. Dreier Papers/Société
Anonyme Archive. Yale Collection of American Lit-
erature, Beinecke Rare Book and Manuscript Library

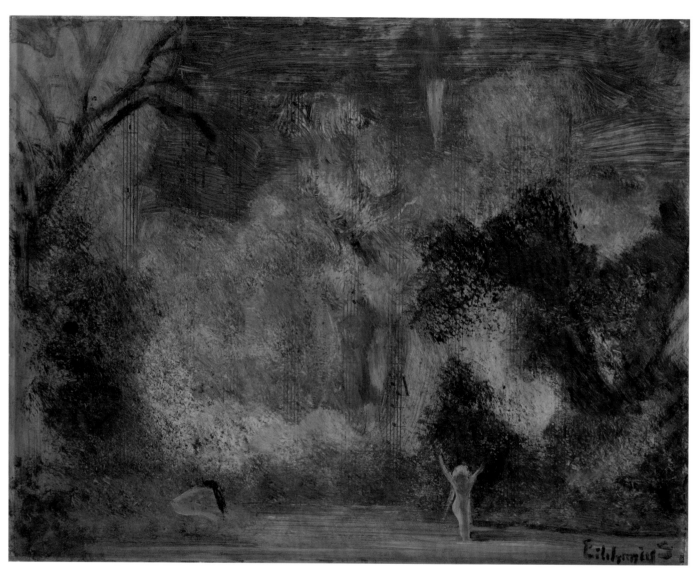

fig. 18
Louis Michel Eilshemius. *The Pool*. c. 1920. Oil on printed sheet of music paper, laid down on laminated chipboard, 10 11/16 x 13 5/8 in. (27.1 x 34.6 cm)

Dreier's motivation for displaying modern art in models of the home was in part a consequence of her belief in art's "psychic" value. To her mind the public could best learn from this work — created by artists who had perceived a "cosmic force …[which] clarifies his vision and sweeps him upwards to greater heights" — through sustained, intimate daily encounters.[37] As she explained in a lecture of 1930, the home was the ideal site for such interactions because "the HOME is a woven part of ourselves." Quoting Oswald Spengler, a favorite writer, she stated, "Of all the expressions of race — the purest is the house.…The prime form of the house is everywhere a product of feeling and of growth."[38] It was thus in the home, where cultural identity was so firmly rooted, that the philosophical investigations of modern art would have the greatest impact.

And what art did Dreier deem appropriate for the homes of "middle class Brooklynites"? Among the works hung in these model rooms were an assortment of impressionistic landscapes by American artist (and Société Anonyme favorite) Louis Eilshemius, possibly including *The Pool* (c. 1920; fig. 18).[39] While the small size, loose brushwork, and subject matter of this work make it an unsurprising choice to hang in a dining room, other selections for these domestic spaces indicate that Dreier believed in the public's capacity to embrace more extreme art. In the parlor she hung Jacques Villon's etched version of Édouard Manet's famous *Olympia* — a work with an unsettling confrontational glare, despite its figurative realism (fig. 19). In the library she collected at least five of Schwitters's Merz collages, perhaps including *Merz 1003 (Peacock's Tail)* (1924; fig. 20), in which a thin strip of black wood seems to be anchored by a yellow rectangle, forming the vortex of a spiraling array of muted red, gray, black, and white shapes. Additionally outfitted with abstractions by Jean Arp, Baumeister, and David Kakabadzé, the model rooms themselves became works of art within the larger exhibition, spaces meant to open the eyes and, Dreier hoped, the "souls" of Brooklynites.[40]

The year after Dreier's *International Exhibition* opened in Brooklyn, her fellow collector of modern art A. E. Gallatin opened his own permanent space, the Gallery of Living Art, on the campus of New York University. While Gallatin and Dreier shared an interest in exhibiting international avant-garde art and educating the public

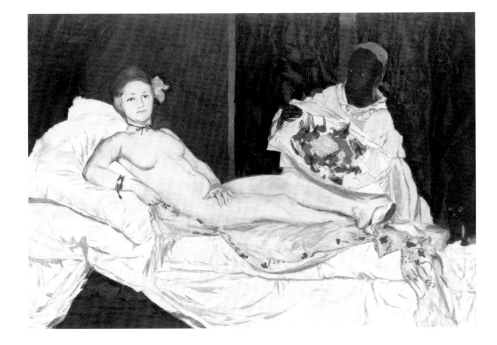

fig. 19
Jacques Villon. *After "Olympia" by Manet.* 1926.
Color etching, 20 5/16 x 26 1/4 in. (51.5 x 66.5 cm)

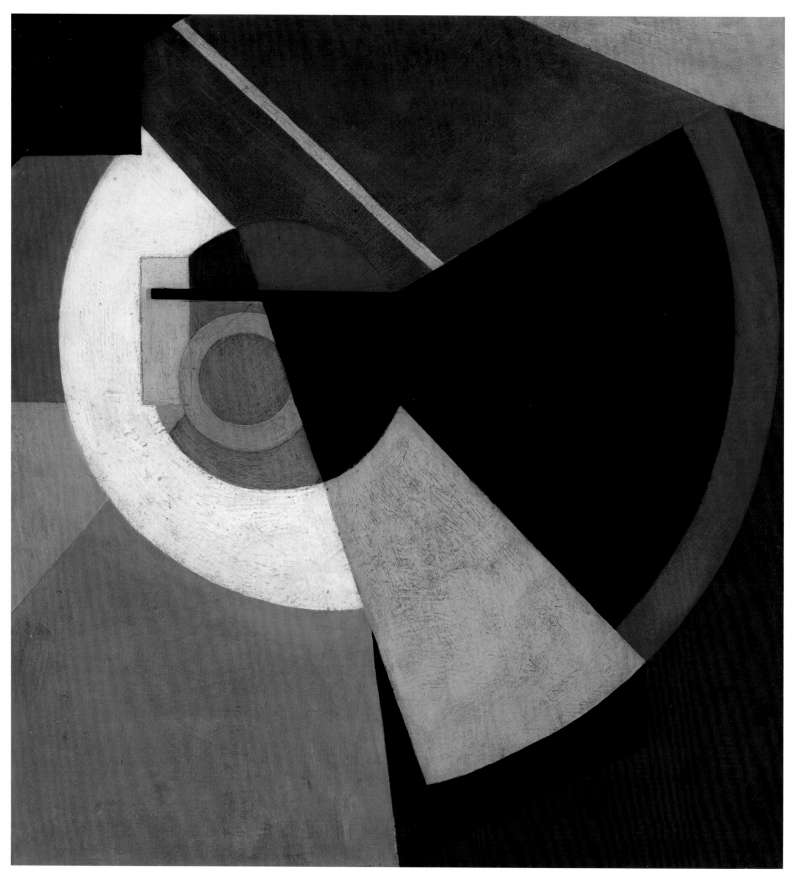

fig. 20
Kurt Schwitters. *Merz 1003* (*Peacock's Tail*). 1924.
Oil and wood on composition board, 28⅝ x 27¹³/₁₆ in.
(72.7 x 70.6 cm)

about it — and preceded The Museum of Modern Art in doing so — their opinions about the significance of modern art were at times diametrically opposed. Both showed the works of Picasso, Braque, Piet Mondrian, Juan Gris, and Arp (among many others), but where Dreier emphasized the philosophical essence that she saw residing in this work, Gallatin consistently highlighted its pictorial innovations. He had been introduced to modern art through the formalist criticism of Clive Bell, and as he built his collection in the late 1920s and early 1930s, he increasingly sought works that embodied formalist sophistication through abstraction.[41] In stark contrast to the ardent passion of Dreier's writings associated with the *International Exhibition*, Gallatin's first elaborate exhibition catalogue, published in 1933, featured a cerebral essay by the young James Johnson Sweeney. Entitled simply "Painting," Sweeney's essay discussed modern art solely in terms of the progressive elimination of pictorial illusionism and the pursuit of flatness and abstraction.[42]

Just as Gallatin and Dreier approached modern art from different intellectual viewpoints, they also approached the business of hanging differently. For Dreier, the kaleidoscopic mix of works in the Brooklyn show was a conscious strategy to celebrate the diversity of modern art; she would maintain this diversity throughout the remaining years of the Société Anonyme's existence. As Gallatin's collection grew, by contrast, he narrowed his focus to abstract artists, and his hanging style reflected his categorizing impulse: rather than mixing works up, he arranged them according to their mode of abstraction (referring in the 1933 catalogue, for example, to Cubist "groups" organized around Picasso and Braque, and to the Surrealist "group" of Arp and Joan Miró).[43] And whereas Dreier used the single-row hang to draw out a fundamental unity in her collection, Gallatin hung his collection in a salon-influenced mode, stacking works and clustering them symmetrically to create groups of related formal elements, distinct from other groups. Ultimately, Dreier's and Gallatin's work as collectors and exhibitors of modern art reveal a dynamic, multifaceted discourse about the meaning of modern art in the years between the world wars.

THE LEGACY OF THE BROOKLYN SHOW

With its vibrant, wide-ranging collection of art, its passionate advocate in the person of Katherine Dreier, and its practical lifestyle displays, the Société Anonyme's *International Exhibition* might be expected to be better known in the American annals of modern art. Although historians must be wary of inferring simple causal relationships, hindsight does offer us a few possible avenues to explore in quest of the Brooklyn show's quick relative disappearance. The most prominent reason can be located in the birth, in 1929, of The Museum of Modern Art. With its hardy financial base and ever-growing team of opinionated scholars, MOMA quickly came to dominate the American modern art scene in the interwar years. Barr and his assistants made use of the discourse that had concerned collectors and artists in the years before MOMA opened: from Dreier, arguably, Barr adopted the pairing of the single-row hang with more conservative, architectural frames, while he shared with Gallatin the impulse to categorize modern art and establish its historical sequence. Stieglitz's intensive artist's space, Dreier's universalizing embrace, and Gallatin's studiousness were all lost in the wake of the new modern museum.

MOMA also offered the public a few things that Dreier in particular could not. First, the museum's major supporters — the Rockefeller family — possessed celebrity as well as wealth, and lent to the institution an incomparable aura of establishment and glamour. Second, with its elite board of trustees and Ivy League–trained director, MOMA promised in its founding documents to provide trustworthy guidance through the confusing waters of modern art. Critics eagerly embraced this proposal, celebrating

the "disinterested committee" and "qualified judges" who would ensure that the museum did not "flood its galleries with the banal and meretricious."[44] Their comments indicate a lurking desire to find order in the apparent chaos of new styles and isms — a desire that Dreier did not share. Although she was specific about the qualities she embraced in modern art, she believed that many different kinds of modernism achieved it. In the end she had an inspiringly optimistic view of the public, believing that if individuals were exposed to a sufficiently wide variety of art, they would find works that resonated for them on the "cosmic" level. Perhaps, ultimately, the American public was not entirely ready to take on the challenge of Katherine Dreier and her fellow artists, and to hear the polyphonous voices gathered in the Société Anonyme.

Notes

Epigraph: Box 10, Folder 281, Katherine S. Dreier Papers/Société Anonyme Archive, Yale Collection of American Literature, Beinecke Rare Book and Manuscript Library, Yale University.

1 Katherine S. Dreier, Foreword to *Modern Art* (New York: Société Anonyme, 1926), p. 1.

2 Dreier, "Lecture on Modern Art with Lantern Slides," January 28, 1927. Box 46, Folder 1369, Katherine S. Dreier Papers.

3 See Bruce Altshuler, *The Avant-Garde in Exhibition: New Art in the 20th Century* (Berkeley: University of California Press, 1994), p. 63.

4 Henry McBride, "Modern Art," *Dial* 83 (July 1927): 86.

5 For trends in France see Martha Ward, "Impressionist Installations and Private Exhibitions," *Art Bulletin* 73 (December 1991): 599–622.

6 See Sarah Greenough, ed., *Modern Art and America: Alfred Stieglitz and His New York Galleries* (Washington, D.C.: National Gallery of Art, and Boston: Bulfinch, 2000), and Kristina Wilson, "The Intimate Gallery and the *Equivalents*: Spirituality in the 1920s Work of Stieglitz," *Art Bulletin* 85 (December 2003): 752–55.

7 See Francis M. Naumann, "The Big Show: The First Exhibition of the Society of Independent Artists, Part I," *Artforum* 17, no. 2 (February 1979): 34–53.

8 Dreier, letter to William Henry Fox, director of the Brooklyn Museum, July 19, 1926. Box 6, Folder 152, Katherine S. Dreier Papers.

9 Gallery blueprint. Box 90, Folder 2322, Katherine S. Dreier Papers.

10 See exhibition paraphernalia in Box 87, Katherine S. Dreier Papers, as well as Robert L. Herbert, Introduction to *The Société Anonyme and the Dreier Bequest at Yale University: A Catalogue Raisonné*, ed. Robert L. Herbert, Eleanor S. Apter, and Elise K. Kenney (New Haven: Yale University Press, 1984), p. 5.

11 Duchamp described the wall covering in a letter of 1922: "The overall thing looks very good especially since these walls made of pale blue green almost white oilcloth — neutral." Duchamp, letter to Jacques and Gaby Villon, December 25, c. 1922, in *Affect/Marcel: The Selected Correspondence of Marcel Duchamp*, ed. Francis M. Naumann and Hector Obalk, trans. Jill Taylor (London: Thames and Hudson, 2000), p. 127. In his Introduction to *Société Anonyme*, Herbert mentions that Man Ray "arranged the blue lighting" for this first exhibition (p. 4). Man Ray, in his autobiography, says that he installed "blue daylight bulbs" in the gallery, which would have created the effect of clear daylight, not blue light. Man Ray, *Self Portrait* (Boston: Little, Brown, 1963), p. 79. McBride described a "pale bluish white oilcloth," supporting Duchamp's description of the wall covering. Henry McBride, "News and Views on Art, Including the Clearing House for Works of the Cubists," *New York Sun and Herald*, May 16, 1920. It is unlikely, then, that the light bulbs created a blue light; more probably the oilcloth had a slight blue tint. My thanks to Jennifer Gross and Kristin Henry for directing me to these references.

12 Quotation from unidentified clipping, c. 1921. Box 89, Folder 2311, Katherine S. Dreier Papers.

13 Installation photographs of the first exhibitions held at the Worcester Art Museum depict a single-row hang. See photographs in the Worcester Art Museum Archives.

14 Fox wrote to Dreier that the exhibition "will be arranged in one of the top-lighted galleries, with the over-flow, if any, in a side-lighted gallery." February 25, 1926. Box 6, Folder 152, Katherine S. Dreier Papers.

15 Although the extent to which the galleries were custom-fitted for the Société Anonyme show remains unknown, Dreier did brag to Walter Arensberg that "the Brooklyn Museum is doing its part in a most royal manner and is giving me all the space I need, besides doing over the rooms for this Exhibition." Dreier, letter to Arensberg, July 28, 1926. Box 2, Folder 56, Katherine S. Dreier Papers.

16 See Carol Duncan and Alan Wallach, "The Universal Survey Museum," *Art History* 3 (December 1980): 448–69.

17 Dreier, letter to Fox, January 31, 1927. Box 6, Folder 154, Katherine S. Dreier Papers.

18 See Sybil Gordon Kantor, *Alfred H. Barr, Jr., and the Intellectual Origins of the Museum of Modern Art* (Cambridge: MIT Press, 2002), p. 112.

19 On the Fifth Avenue space see Terence Riley, *The International Style: Exhibition 15 and The Museum of Modern Art* (New York: Columbia Books on Architecture, 1992). The Museum of Modern Art rented its first gallery space in the Heckscher Building, a Fifth Avenue skyscraper. The Société Anonyme had rented space in the same building in 1924 (see Tashjian's essay in the present volume), which Alfred Barr, then a graduate student at Harvard, may have known. On the Rockefeller brownstone, see Russell Lynes, *Good Old Modern: An Intimate Portrait of The Museum of Modern Art* (New York: Atheneum, 1973), p. 96; William Rice Pearsall, "Changing a Residence into an Art Museum," *Archi-*

tectural Record 71 (May 1932): 349; and Kristina Wilson, "Exhibiting Modern Times: American Modernism, Popular Culture, and the Art Exhibit, 1925–1935," Ph.D. dissertation, Yale University, 2001, chapter 3.

20 Dreier, *Modern Art*, p. 4; Ruth L. Bohan, *The Société Anonyme's Brooklyn Exhibition: Katherine Dreier and Modernism in America* (Ann Arbor: UMI Research Press, 1982), pp. 45–49.

21 "Société Anonyme's Exciting Show," *American Art News*, November 27, 1926, rpt. in *Brooklyn Museum Quarterly*, January 1927, p. 20. Box 88, Folder 2272, Katherine S. Dreier Papers.

22 Suzanne Phocas was married to the Cubist Jean Metzinger. See Herbert, Apter, and Kenney, *Société Anonyme*, p. 526.

23 Dreier, *Modern Art*, p. 25.

24 Carl Buchheister, ibid., p. 41.

25 Bohan discusses the development and content of *Modern Art* in detail in chapter 6 of *The Société Anonyme's Brooklyn Exhibition*.

26 Frederick Kiesler and Jane Heap, *International Theatre Exposition* (New York: Little Review, 1926), and Heap et al., *Machine-Age Exposition* (New York: Little Review, 1927).

27 Paul Gaulois, in Dreier, *Modern Art*, p. 112.

28 Antoine Pevsner and Naum Gabo, ibid., p. 74.

29 Many of Dreier's avant-garde compatriots, notably Wassily Kandinsky, were interested in spiritualism and mysticism in the decades before World War II. See, e.g., Louise Welch, *Orage with Gurdjieff in America* (Boston: Routledge and Kegan Paul, 1982), and Wilson, "The Intimate Gallery and the *Equivalents*."

30 Dreier, "Regarding Modern Art," *Brooklyn Museum Quarterly* 13 (October 1926): 117–18.

31 Dreier, *Modern Art*, pp. 5, 1.

32 Bohan, *The Société Anonyme's Brooklyn Exhibition*, p. 51. *Modern Art* identified twenty-three nations that had nurtured and produced modern artists. Some of the attributions are puzzling, however: the Japanese-American artist Yasuo Kuniyoshi, for example, is listed as being from Japan, when all his artistic training, and his career, were undertaken in the United States.

33 Dreier, "Lecture to the Brooklyn Civitas Club," 1926. Box 46, Folder 1368, Katherine S. Dreier Papers.

34 Variations on this statement appear in the exhibition catalogue for the traveling version of the *International Exhibition* at the Albright Art Gallery, Buffalo (*International Exhibition of Modern Art Assembled by the Société Anonyme* [Buffalo: Buffalo Academy of Fine Arts and the Albright Art Gallery, 1927], p. 9), and in the article "Explaining Modern Art," *American Art Student,* March 1927. See Box 87, Folder 2255, and Box 42, Folder 1234, Katherine S. Dreier Papers.

35 Dreier, letter to Duchamp, July 20, 1926. Box 12, Folder 317, Katherine S. Dreier Papers.

36 Dreier, letter to Paul Woodward, September 14, 1926. Box 6, Folder 153, Katherine S. Dreier Papers.

37 Dreier, *Modern Art*, p. 1.

38 Dreier, "The Home and Its Changes," lecture delivered on October 28, 1930. Box 46, Folder 1364, Katherine S. Dreier Papers.

39 Louis Eilshemius's *Spirit of the Pool* is included in a section of the catalogue entitled "List of Pictures Hung but Not Catalogued." The specific works on view, then, are sometimes difficult to confirm.

40 Dreier, "Lecture to Members of the School Art League," delivered at the Brooklyn Museum, November 20, 1926. Box 46, Folder 1367, Katherine S. Dreier Papers.

41 See Gail Stavitsky, "A.E. Gallatin's Gallery and Museum of Living Art (1927–1943)," *American Art* 7 (Spring 1993): 48, 50.

42 See ibid., p. 54, and James Johnson Sweeney, "Painting," in *Gallery of Living Art: A.E. Gallatin Collection* (New York: Gallery of Living Art, 1933), n.p.

43 A.E. Gallatin, "The Plan of the Gallery of Living Art," in *Gallery of Living Art*, n.p.

44 Forbes Watson, "To Our New Museum," *The Arts* 16 (September 1929): 46; A. Philip McMahon, "A New Museum of Modern Art," *Parnassus* 1 (October 1929): 31; James W. Lane, "The Moderns in America," *Commonweal*, January 1, 1930, p. 254.

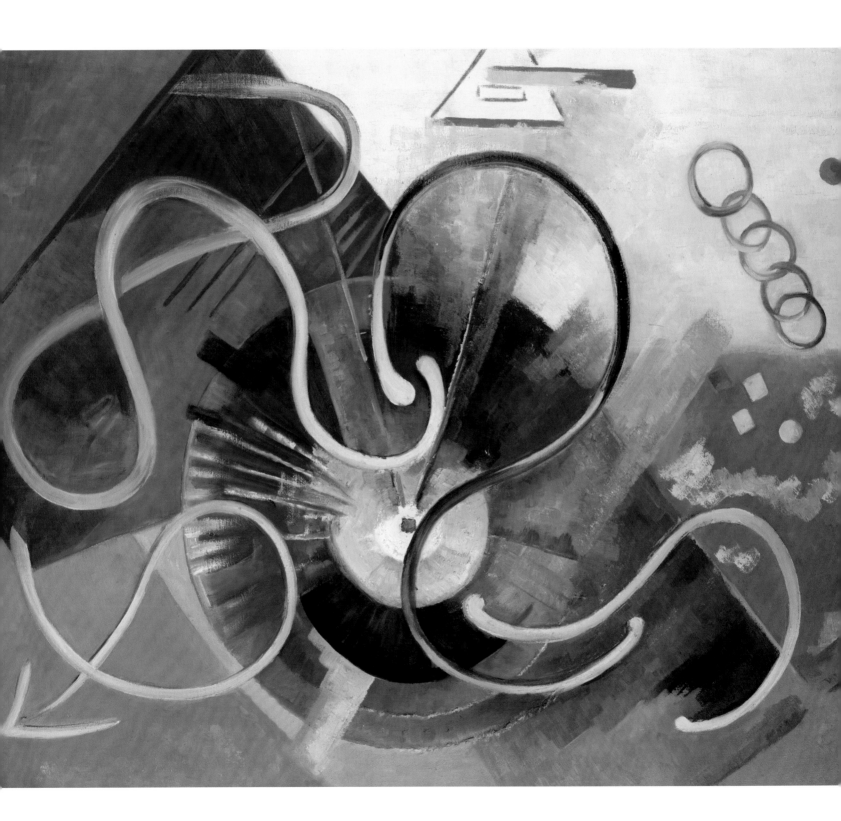

Art as Experience Katherine S. Dreier and the Educational Mission of the Société Anonyme

Susan Greenberg

If American museums today have become known for their collections and building projects, with education overshadowed, the balance of operations of the Société Anonyme was quite the reverse. For the organization's founders — the artists Katherine Dreier, Marcel Duchamp, and Man Ray, but especially Dreier — education and critical thinking came first. To them, art was not a silent entity to be enshrined in a museum but an experience mediated by the multiple voices of artists, critics, poets, and musicians, not only in their gallery space on East 47th Street but also in workers' clubs, community centers, and art schools. Between the wars the organization hosted talks and symposia based on the experimental exhibitions at their New York gallery, while Dreier also took art objects on the road for lectures and exhibitions, sometimes for weeklong installations, other times just for one day. Dreier's emphasis on the social significance of art intersected with the aims of other art organizations of her day, such as The Museum of Modern Art (founded in 1929), yet in the relationship between art and audience she emphasized a deeper level of intimacy. As she wrote to a colleague in 1925, "It is very important that art should be brought to all classes and that we should develop in our country a genuine love which does not end in attending lectures, but ends in the desire to own pictures. If they could develop in our people the need to own paintings, with which they could live constantly, it would be a great step forward."[1]

Today it is difficult to imagine a museum that would circulate works by artists like Paul Klee and Wassily Kandinsky to high schools, student dorm rooms, and university lounges. But at the core of the Société Anonyme's mission was a desire to teach as broad a public as possible about the new currents in modern art. *Its Why & Its Wherefore*, a six-page pamphlet of 1920, explains the founders' wish to educate Americans about the "new approach towards Art," evident in Europe since around 1908, through a "small museum of Modern Art" with exhibitions and a reference library. The ultimate goal of the organization was to form a "chain of Galleries and Reference Libraries where these expressions of this present desire of the modern artist, can be studied throughout this country." The brochure continued,

> For there is a closer relationship between all progressive people, all people who are living in the "now," rather than those who belong to the past, even if they are not of the same profession. Spiritual ties are always the strongest. So we turn to all those related to us and ask them to take up their personal share of responsibility towards art in this country by helping to establish first, this small museum at 19 East Forty-seventh Street, and eventually its branches: a chain of Galleries which liberate the thoughts in the art world.[2]

These words were most likely written by Dreier, who would manage the educational aspects of the organization. The language of the brochure, which seems to function as a mission statement, is strongly reminiscent of the Progressive thinkers of the early twentieth century, who encouraged educational reforms and the role of the arts in experimental learning. These debates were inspired by the American philosopher John

fig. 1
Katherine S. Dreier. *Explosion*. 1940–47. Oil on canvas, 24$^{1}/_{16}$ x 29$^{15}/_{16}$ in. (61.1 x 76 cm)

Dewey (1859–1952), whose advocacy of the social importance of education, and, more specifically, of the primacy of learning through doing, later informed his promotion of the use of actual art objects for instruction.[3] Dewey's thinking influenced Albert Barnes (1872–1951), who taught his factory workers about art in seminars featuring paintings from his famous collection.[4] The language of *Its Why & Its Wherefore* recalls in particular the visionary ideas of John Cotton Dana (1856–1929), a progressive thinker who directed public libraries until, in 1909, he became the director of the Newark Museum, a position he held until his death. Dana lamented "the gloom of the museum" and encouraged smaller viewing spaces at branch museums that would afford a more intimate viewing experience. Branches would be enabled by the free lending of objects to "schools, libraries, art schools, civic centers and what not in the town to which they belong," rather than keeping objects in "splendid isolation" in "an elaborate and forbidding structure." Instead of the "aimless stroll" through the museum, and the resulting deadening "gaze," Dana encouraged active art education based on objects. If art museums were concerned about how to reach the young, he suggested, "Why not take the museum to the young people?"[5] The remarkable array of educational activities organized by the Société Anonyme sought to accomplish this task. Past scholarship has focused on Dreier's strong will and dominating personality as the catalyst for these activities, but her quest can also be understood more broadly in relation to the promotion of social change and experimental learning during the Progressive era out of which she came.[6] Dreier particularly imbibed a faith in progressive education from her family.

KATHERINE DREIER'S PROGRESS

Dreier and Duchamp met in New York in 1916, and their ensuing friendship led to the founding, with Man Ray, of "The Société Anonyme, Inc.," in January 1920. Dreier was then in her early forties, and the founding of the group was the culmination of twenty years of commitment to art and social change. The art historian Ruth L. Bohan has charted Dreier's formative years in the 1890s and her work in art and reform in the early 1900s.[7] The unusual nature of her background merits reemphasizing, however, because her family directly exposed her to the reform activities of the Progressive movement on a local, national, and international level.

Katherine Sophie Dreier was born in 1877, a year that marked a number of shifts in American society. The Reconstruction period that had begun with the defeat of the South in the Civil War ended in 1877, along with the presidency of Ulysses S. Grant. That year also brought the first nationwide strike (of railroad workers), which kicked off a movement for reform and a search for ways to face what would become key twentieth-century problems: urbanization, industrialization, and immigration.[8] It also inaugurated what the historian Robert H. Wiebe calls the "search for order" and the transformation of American society and values from "those of the small town in the 1880s to those of a new, bureaucratic-minded middle-class by 1920."[9] Large-scale reform movements like Progressivism became possible through the organizing capabilities of this middle class.

Dreier's well-off family was deeply involved in these movements. She was the youngest of five children born to Theodor and Dorothea Adelheid Dreier, immigrants from Bremen, Germany, who lived comfortably in Brooklyn Heights, New York, through Theodor's success as a representative of a London-based firm of iron and steel merchants. Their four other children were Margaret Dreier Robins (1868–1945), Dorothea Adelheid Dreier (1870–1923), H. Edward Dreier (1872–1955), and Mary Elisabeth Dreier (1875–1963; figs. 2, 3). The eldest daughter, Margaret, gained national recognition as the president, from 1907 to 1922, of the Women's Trade Union League,

fig. 2
Katherine S. Dreier as a child, c. 1880. The Schlesinger Library, Radcliffe Institute, Harvard University

an advocacy group dedicated to unionization for working women. In 1919 she also called the International Congress of Working Women, a group of representatives from nineteen countries that promoted fair labor standards for women. Her reform efforts began early on: in 1905 she had married Raymond Robins, a lawyer and social worker actively involved in many progressive causes, and the couple lived in Hull-House, Chicago, the "settlement house" founded in 1889 by the American social worker Jane Addams to serve the neighborhood immigrants.[10] Hull-House was to become a center for social reform, and the first of a movement of such houses across the United States. It is worth noting that the settlement houses, influenced by John Ruskin's ideas on beauty and good design as a way to bring meaning into the lives of workers, were pioneers in bringing art to the poor.[11]

Margaret Dreier was not the only unionist in the family: Mary Dreier, who was to write Margaret's biography in 1950, was president of the New York Women's Trade Union League.[12] The Dreiers' reform work also was enabled and encouraged by their parents. Katherine Dreier would recall Dorothea and Theodor's emphasis on action, and their belief that all of their children "were to be interested in the happenings of the day — politically or socially, in the nation or the community, among neighbors or friends." Mary Dreier's recollections echoed her sister's: "One thing was certain. Mother believed in keeping us busy."[13] They also encouraged their children to have a proud sense of their German heritage.[14] Translating her own words into action, in 1898 Dreier's mother founded the German Home for Women and Children in Gravesend Bay, on the edge of Brooklyn, with funds left by her husband after his death the year before.[15] According to Katherine, her mother's encouragement of action was combined with a suspicion of book learning and an opposition to a college education. Instead she wanted her children to think critically for themselves. Yet this encouragement of original thinking does not appear to have included painting, and Katherine's early decision to study not music but art was a "deep disappointment" to her mother.[16]

Like her mother and sisters, Katherine Dreier too participated in social assistance and reform. In 1903 she cofounded the Little Italy Neighborhood Association, a settlement house in Brooklyn, and was also named director of the Manhattan Trade School for Girls, which trained younger women in skills that would help them to find better jobs. After her mother's death she also helped with the German Home for Women and Children. But her primary interest was always art. For much of her life, in fact, Dreier would be challenged to justify her interests against the work of her sisters Margaret and Mary, as she explained to a representative of the Women's University Club who solicited her help soon after she cofounded the Société Anonyme:

It makes it very complicated when four members of one's family are so active as we are, each with their own interests, which are quite different. My sisters, Miss Mary Dreier and Mrs. Robins, have always worked for civic and working women's rights, whereas my work belongs to the art world.

I am trying to build up a tremendous thing in New York, and that is to break down the prejudice which exists against the new approach to art. This is as great a burden and means as much money as the work which my sister Mrs. Robins has undertaken through her international work, as we are also international, and meet the expenses of all paintings and sculptures to and from Europe. It took me a long time to become fully convinced that what I was attempting to do was as constructive a piece of work as what my sister is trying to do.... I have given so much of my time and money in assisting my sisters in the past, that I feel that I must now concentrate on my own expression in life, and see that that also is given its share.[17]

fig. 3
Dorothea, Mary, and Katherine S. Dreier, 1891. The Schlesinger Library, Radcliffe Institute, Harvard University

fig. 4
Katherine and Dorothea Dreier (?) in a gondola in Venice, 1902. Katherine S. Dreier Papers/Société Anonyme Archive. Yale Collection of American Literature, Beinecke Rare Book and Manuscript Library

Dreier's recollections and letters suggest that the time and energy required of her by her family's social activism necessitated an ongoing negotiation with her own commitment to modern art. Yet rather than exhausting her, this tension seems to have fueled her powers, and may even be said to have been at least partly responsible for her many accomplishments at the head of the Société Anonyme. For it informed her democratic vision of modern art and led her to bypass established educational networks — the elite universities, which she did not attend. Instead, her world was ordered around public schools, clubs, and other organizations known to her through her family.

Dreier did share her interest in painting with one family member, her sister Dorothea, the second-eldest Dreier daughter.[18] In 1902, following training at the Brooklyn Art School in 1895–97 and the Pratt Institute, Brooklyn, in 1900, Dreier went with Dorothea to Italy to study art (fig. 4). Dreier went on to travel extensively — to

fig. 5
Edward Steichen. *Portrait of Katherine S. Dreier.* 1907.
Platinum print, 9³/₄ x 9⁵/₈ in. (24.8 x 24.5 cm)

Paris in 1907 and possibly 1908, to London in 1909–11, and to Munich in 1912 — only to return to the United States just after the outbreak of World War I. The ease with which she moved through these different cultures would serve her well as the organizer of the Société Anonyme. It was during these years that she met important figures of the European art world, like Gertrude and Leo Stein and Edward Steichen (fig. 5), who had traveled between Paris and New York since 1900. She also pursued her career as an artist and in 1911, in London, had her first one-woman show, exhibiting Whistler-like landscapes that received positive reviews from the press (fig. 6). She continued to paint for much of her life (fig. 7). She also attended exhibitions, like the 1912 Sonderbund show in Cologne, and familiarized herself with artists, their studios, and their families.[19] Dreier was to return to Europe often during the Société Anonyme years, acquiring works for exhibitions and, later, for the Collection.

fig. 7
Katherine S. Dreier. *The Eternal Hills.* c. 1937. Oil on canvas, 23¹⁵/₁₆ x 48¹/₁₆ in. (60.8 x 122 cm)

fig. 6
Katherine S. Dreier. *Moonlight on the Thames, London.* 1910. Oil on canvas, 20 x 14 in. (50.8 x 35.6 cm)

A MOVABLE ART

Dreier's commitment to art and reform, and her remarkable skill at organizing exhibitions, contributed substantially to the fullness of the Société Anonyme's early schedule of events. In the organization's first two years, when its membership was at a peak, it staged most of its exhibitions at its own gallery, two rented rooms on the third floor at 19 East 47th Street; in 1924, it briefly ran a second space in the Heckscher Building, at 44 West 57th Street.[20] Some of these exhibitions featured eclectic groupings of works by modern American and European artists, installed in experimental styles designed by Duchamp and Man Ray. Others were one-person exhibitions, many of them introducing European artists to the American public. The lineup of now-major figures of European and American modernism shown by the Société Anonyme in its early years is worth listing in full: Louis Eilshemius (1920, 1924), Alexander Archipenko (1921, 1924), Jacques Villon (1922–23), Joseph Stella (1923), John Storrs (1923), Kandinsky (1923), Klee (1924), David Burliuk (1924), Heinrich Campendonk (1925), and Fernand Léger (1925). All but the Stella and Storrs shows were these artists' first one-person exhibitions in the United States.

To explain this new art to the public, Dreier, Duchamp, and Man Ray brought in the artists themselves to speak about their work, or about modern art in general.[21] On the occasion of Eilshemius's one-man exhibition in 1920, for example, viewers were treated to the artist's ideas on topics as wide-ranging as William Blake, Frederic Remington, academic art, photography, Ernst Meissonier, and Édouard Manet.[22] Patrons of the Société Anonyme could have heard Marsden Hartley's ideas on modern art in relation to vision and psychology before he published them in essay form.[23] The sculptor Elie Nadelman also spoke at a Société Anonyme group exhibition, trying to clarify, as he put it, "today's already very much confused ideas on art."[24] There were panel discussions with seductive titles like "Do You Want to Know What a Dada Is?" featuring Dreier and Hartley, or "Symposium on the Psychology of Modern Art and Archipenko," with a panel comprising the writer Phyllis Ackerman, the critic Christian Brinton, Hartley, Man Ray, and Dreier as chair. The Société was also presciently interdisciplinary, staging literary events (an evening of Gertrude Stein's poetry in 1921, for example, with readings by Hartley, the writer Henry McBride, and the poet Mina Loy) and, after 1924, a number of modern-music concerts and dance performances. All of these events, which sometimes took place in Dreier's home on Central Park West, were informed by her belief that all of the arts were interrelated and, further, were all entering a new, modern era.

The New York art press commented on the experimental activities on 47th Street, often in a language that reflected their incomprehension: "The canvases in the present exhibition all belong to the shot-to-pieces school," as one newspaper writer wrote in 1920.[25] Less notorious, but an integral part of the group's educational mission, were off-site lectures and exhibitions organized by Dreier. As if in response to Dana's opinions on the museum, these programs brought modern art to audiences who were less likely to visit it, whether at the Worker's Center, the Women's City Club of New York, or a New York City public high school. Dreier had many audiences, never favoring one in particular. Her message to all of them, delivered in passionate (and, it must be admitted, long) lectures, was clear: America was entering a new era in the arts and in life, and this upheaval, though chaotic and difficult to accept, needed to be understood. As she announced in one lecture, "The new spring we are facing means not the entry of a short new era as the Victorian which we have just left behind — but a change such as has not happened to us for centuries." The time of the past, both in painting and in life, was over, and it was time to look forward: "Therefore one can see that the tranquil landscapes of the past, so beautifully expressed

by a Corot, belong to a period that is no longer in existence, for the delicacy of his conceptions belongs to a time that was sensitive to the details and minuteness of a limited and serene horizon." "I hope I have made clear to you," she continued in the same lecture, "why Modern Art annoys and disturbs. I also hope that I have helped you to overcome some of your prejudices and have made you realize that there is a distinct contribution — awakening thereby your curiosity to study the subject more deeply."[26]

Not only did Dreier want people to understand art, she wanted them to live with art and to make it a fundamental part of their lives. To sensitize her audiences to the uniqueness of actual art objects, she brought paintings, works on paper, and even sculptures from the Société Anonyme's holdings to her lectures. She was adamant on speaking in front of works of art, and if not with the actual works, then always with lantern slides. This practice of movable art exhibitions seems all the more remarkable today, given that the works Dreier carted around New York City and elsewhere are now canonical objects, entrenched in the history of modernism.

Dreier's first off-site lecture under the auspices of the Société Anonyme was "Rebels in Art," held in conjunction with the People's School of Philosophy in the auditorium of the Manhattan Trade School for Girls on 22nd Street and Lexington Avenue and delivered on January 15, 1921, in the company of Duchamp and Stella. The lecture featured Man Ray's original paper version of *Lampshade* (1921; fig. 8) and Stella's *Brooklyn Bridge* (1918–20; see fig. 1 in Bohan's essay in the present volume).[27]

fig. 8
Man Ray. *Lampshade*. 1921. Painted tin, metal rod, wing bolt, square bolt, and round metal flange screwed to round wood base, 45 3/8 x 3 1/16 in. (115.3 x 7.7 cm)

A month later she spoke to students at the School of Design and Liberal Arts, founded by the artist Irene Weir to train students in many different fields, including painting, design, craftsmanship, and camp counseling. Her lecture stemmed from a one-week installation, chosen to appeal to "a student's point of view."[28] The installation included Stella's *Brooklyn Bridge*, Hartley's *Rubber Plant* (1920; fig. 9), two abstract compositions by Patrick Henry Bruce (1916; fig. 10), and Villon's *In Memoriam* (1919; fig. 11), as well as lesser-known works like Heinrich Vogeler's *The Island of Peace* (c. 1918–19; fig. 12) and Carlo Mense's *River Wuppe* (1913; fig. 13). Only the week before, Dreier had featured Villon and Vogeler's paintings, along with works by Rudolph Bauer, Georges Braque, Kandinsky, Johannes Molzahn, Georges Ribemont-Dessaignes, Kurt Schwitters, and others, in her lecture "The Revolution in Art," given to a group affiliated with the League for Industrial Democracy, which had been founded in 1905 by Upton Sinclair, Jack London, and others to educate Americans about the labor movement and socialism.[29] Many of the paintings and sculptures featured in Dreier's early lectures had been installed in the Société Anonyme's inaugural exhibition in April–June 1920, which was similarly eclectic and demonstrated the organization's mission to display, but not to edit, the new approaches to art. Dreier's off-site lectures in the form of a wonderfully hybrid, hand-carried, traveling lecture/exhibition reiterated this endorsement of a heterogeneous modern art.

fig. 9
Marsden Hartley. *Rubber Plant*. 1920. Oil on canvas, 32 x 26 in. (81.3 x 66 cm)

fig. 10 (opposite)
Patrick Henry Bruce. *Composition I*. 1916. Oil on canvas, 45⅝ x 34⅞ in. (115.9 x 88.6 cm)

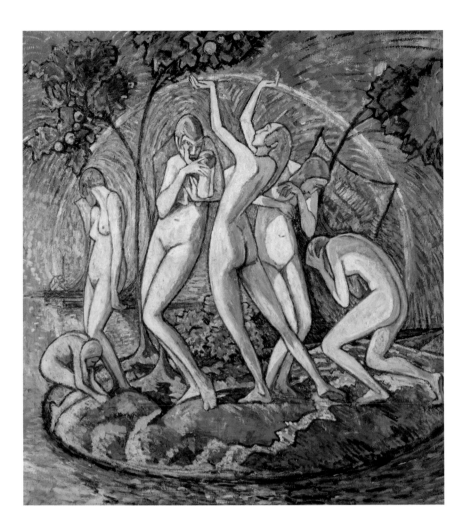

fig. 12
Heinrich Vogeler. *The Island of Peace.* c. 1918–19.
Oil on canvas, 41¹/₈ x 38 in. (104.5 x 96.5 cm)

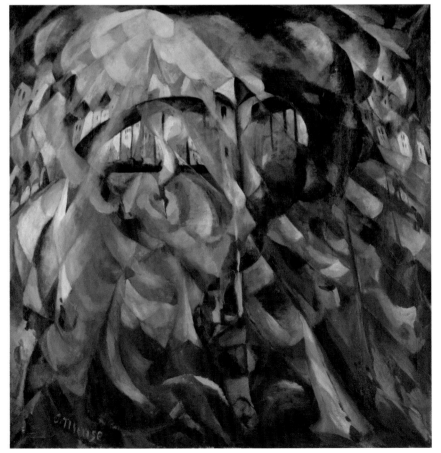

fig. 13
Carlo Mense. *The River Wuppe.* 1913. Oil on canvas,
44 x 42 in. (111.8 x 106.7 cm)

fig. 11 (opposite)
Jacques Villon. *In Memoriam.* 1919. Oil on burlap,
51¹/₁₆ x 32¹/₁₆ in. (129.7 x 81.5 cm)

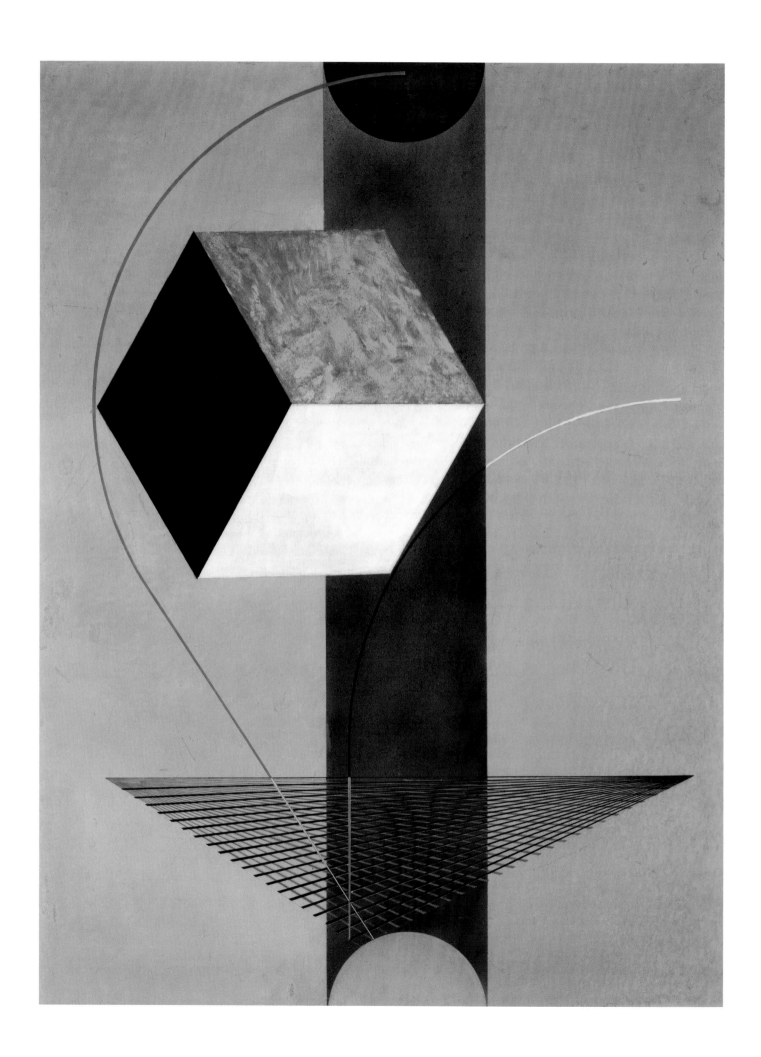

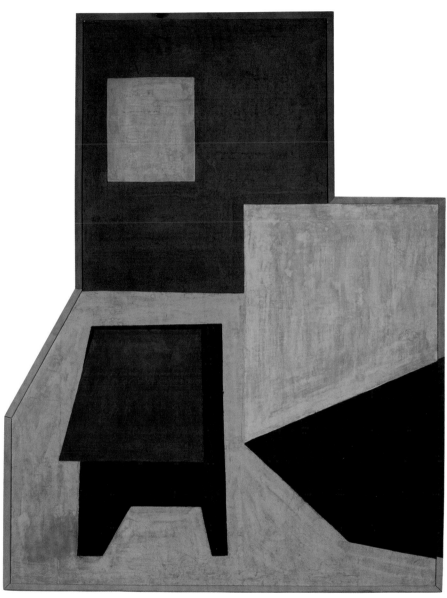

fig. 19
Program for "Art of the Future," evening program at
The New School for Social Research, March 23,
1931. Katherine S. Dreier Papers/Société Anonyme
Archive. Yale Collection of American Literature,
Beinecke Rare Book and Manuscript Library

Thomas Hart Benton on art and craftsmanship, and Mark Van Doren on contemporary drama.[43] Dreier wrote for The New School an entirely new set of lectures, entitled "The Fundamentals of Present Day Art," which returned her focus to the tendencies in recent painting.[44] The culmination of these lectures was a special evening program in March 1931 called "Art of the Future," which featured avant-garde films by Duchamp and Lotte Reiniger; Archipenko's rotating painting the *Archipentura*, first demonstrated in 1928 at the Anderson Galleries in New York; and Thomas Wilfred's color organ, the *Clavilux* (fig. 19).[45]

Dominating Dreier's collaboration with The New School, however, was the exhibition to be installed in the fifth floor of the new building for the school's much anticipated reopening. Dreier began planning the exhibition seven months before, and sought the help of Duchamp in Paris, even offering him an honorarium of $600 if he would come to New York to help her. He chose to remain abroad, however, where he secured new paintings for her through visits to artists' studios and galleries. In July 1930 Dreier sent him a list of fourteen artists, wanting two works by each: Francis Picabia ("of new period," she wrote), Max Ernst, Amédée Ozenfant, Jean Viollier, and — "of course," she inserted — Piet Mondrian, Villon, Jean Crotti, and Suzanne Duchamp, four artists who had been included in the Société Anonyme's 1926 exhibition at the Brooklyn Museum. She also requested, more generally, "some Germans and Belgians."[46]

Duchamp began his selection in early September and sent a full list in October, describing what he had chosen. His exquisitely diverse choices included Mondrian's *Fox Trot A* (1930; fig. 20) and *Fox Trot B* (1929; fig. 21) and Ernst's *Anthropomorphic Figure (Plaster Man)* (1930; fig. 22). Adding his own personal touches to her list, he included a flower and butterfly drawing by Stella (fig. 23) and Georges Papazoff's Surrealist *Head* (*Tête*, c. 1927–29; fig. 24), among other works.[47] To these Dreier added a number of paintings that she had recently brought over from Europe, including Willi Baumeister's *Soccer Players* (*Fussballspieler*, 1927–28; fig. 25), purchased the year before at a gallery in Paris; Campendonk's recent mural studies (1928–30; fig. 26); and Schwitters's striking *Relief with Red Segment* (*Relief mit rotem Segment*, 1927; fig. 27), as well as works by artists featured in her past exhibitions, such as Kandinsky, Klee, Léger, and Joan Miró.[48]

Dreier installed the works in the lounge and west dining room of the building's fifth floor (fig. 28). These spaces, according to the brochure for the new building, were designed as the "center of the social and artistic life of the institution…where groups of pictures may be exhibited from time to time and supply the visual material for the critical lectures on art that form an essential element in every program of adult education."[49] The floor plan also shows the proximity of Dreier's paintings to the kitchen and pantry as well as the dining room, reestablishing the relation between art and domestic space that Dreier had created at the Brooklyn Museum. Furthermore, the floors above and below Dreier's installation featured design exhibitions, which demonstrated new approaches to floor coverings, furniture, and interior decoration. On the fourth floor were rugs designed and manufactured by a group of modern painters and sculptors, including Benton and Storrs. In the penthouse an exhibition of modern furniture and interior decoration showed both recherché products of handicraft and designs for industrially made furniture, rugs, textiles, ceramics, glass, chinaware, wallpaper, lighting fixtures, linoleum, and mirrors.[50]

Dreier's considerable efforts to spotlight the Société Anonyme at The New School opening were overshadowed, however, by two installations that became the focal point of debate in the press: mural paintings on the third and fifth floors by Benton and the Mexican painter José Clemente Orozco (1883–1949). Both artists pre-

fig. 21
Piet Mondrian. *Fox Trot B*. 1929. Oil on canvas,
17⁷/₈ x 17⁷/₈ in. (45.4 x 45.4 cm). © 2005 Mondrian/
Holtzman Trust

fig. 20
Piet Mondrian. *Fox Trot A*. 1930. Oil on canvas,
30¹³/₁₆ x 30¹³/₁₆ in. (78.2 x 78.3 cm). © 2005 Mondrian/
Holtzman Trust

Fig. 22
Max Ernst. *Anthropomorphic Figure (Plaster Man)*.
1930. Gouache on plaster over plywood,
27 ¹⁵/₁₆ x 21 ⁹/₁₆ x 1 in. (71 x 54.8 x 2.5 cm)

Fig. 23
Joseph Stella. *Flower and Butterfly*. c. 1920–25.
Crayon and graphite, 14 ¹/₈ x 9 ¹/₈ in. (35.9 x 23.2 cm)

fig. 24
Georges Papazoff. *Head (Tête)*. c. 1927–29. Oil on
canvas, 38 ³/₈ x 32 in. (97.5 x 81.3 cm)

fig. 25
Willi Baumeister. *Soccer Players (Fussballspieler)*. 1927–28. Pencil and gouache on paper, 17⁵/₁₆ x 13³/₈ in. (43.9 x 34 cm)

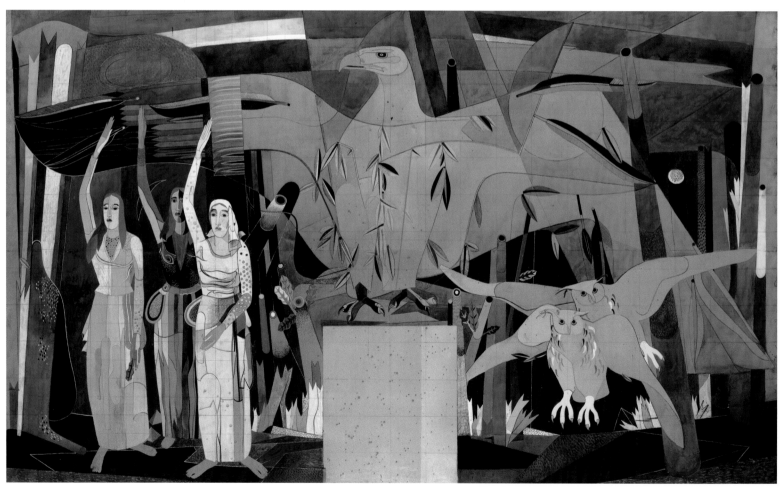

fig. 26
Heinrich Campendonk. *Cartoon for a Mural Commemorating the Return of Schneidemühl to the German Nation*. 1928–30. Ink, watercolor, and gouache on paper squared up in pencil, 41¹/₈ x 68⁷/₈ in. (104.4 x 175 cm)

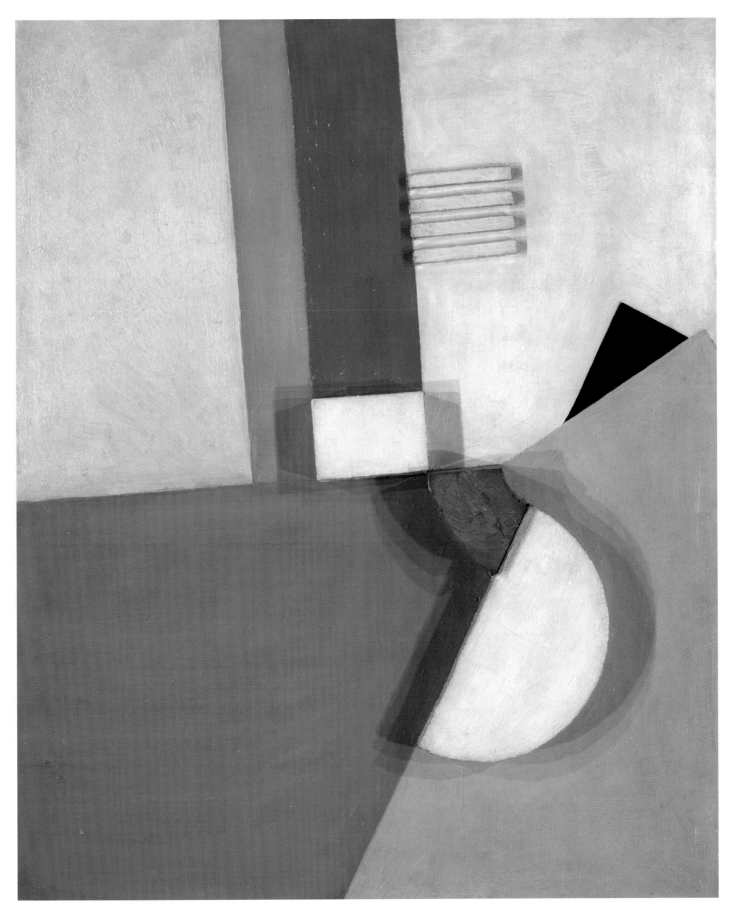

fig. 27
Kurt Schwitters. *Relief with Red Segment* (*Relief mit
rotem Segment*). 1927. Oil and wood on plywood,
29¹/₂ x 24⁵/₈ x 1¹⁵/₁₆ in. (75 x 62.5 x 5 cm)

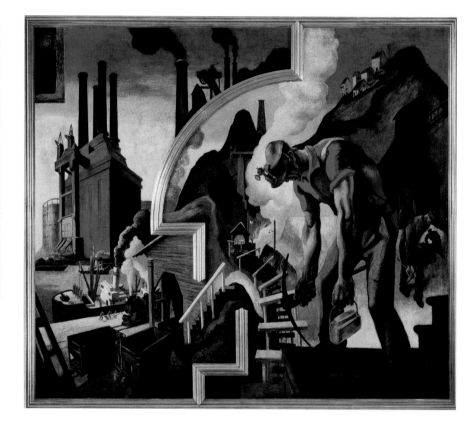

sented ambitious portrayals of contemporary life, but in markedly different ways:
Benton's *America Today* murals celebrated modern industry through powerful, rippling
forms and vibrant color (fig. 29), while Orozco somberly chronicled contemporary
political unrest in India, Mexico, and Russia (fig. 30). The two sets of murals, with their
drastically different conceptions of modern life, set up a dialogue with each other, a
"complementary" relationship reiterated by Johnson in later publications, and appear
to have disallowed any broader discussion at the time about the remarkable cross-
section of the arts on view in the entire building.[51]

Two weeks after the New School opening Dreier described the reception of
the exhibition in a letter to Duchamp:

> The exhibition at the New School is getting somewhat sidetracked. The whole build-
> ing [meaning Urban's International Style design] has created so much stir and then
> the murals by Orozco and Benton that my end has been side-tracked.... But the pub-
> lic has been keenly interested for the 300 Who's Who which I had made were gone by
> the third day and the next five hundred the next afternoon. That I think speaks vol-
> umes from the public.[52]

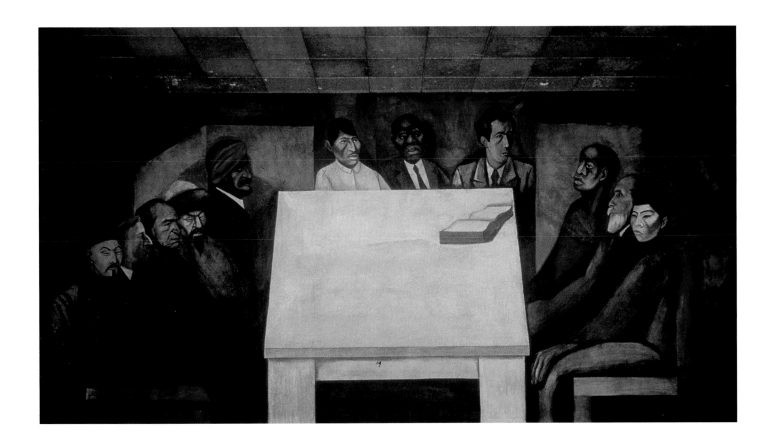

Dreier was expressing her frustration with the writers' and critics' habit of quickly
seizing upon new buildings or individual artists in their evaluation of contemporary art.
Their homogenizing view was at odds with Dreier's more holistic consideration of
modern art and life.

Dreier's dedication to a broad-based interest in modern art continued well into
the 1930s. She delivered lectures, participated in roundtable discussions, and organized
small exhibitions of Société Anonyme works at institutions as disparate as the
Bauhaus in Berlin, Black Mountain College in North Carolina, the Academy of Allied
Arts in New York, the Wadsworth Atheneum in Hartford, and the American Women's
Association, to name only a few. By 1939 Dreier was deeply involved in plans for a
permanent home for the Société Anonyme Collection (see Kenney's essay in the pres-
ent volume). When she and Duchamp donated a portion of the Collection to Yale
University in 1941, Dreier assured Campendonk that the educational mission of the
Société Anonyme would continue: "one of the conditions of giving the collection to
Yale University is that it should travel and continue to inspire the students of other
colleges and universities."[53] Their gift to Yale was a fitting end to the Société Anonyme's
twenty-year history of educational collaboration, and also a new beginning.

Notes

1 Katherine S. Dreier, letter to Miss Mabel Leslie, secretary of the Women's Trade Union League, December 28, 1925. Box 37, Folder 1114, Katherine S. Dreier Papers/Société Anonyme Archive, Yale Collection of American Literature, Beinecke Rare Book and Manuscript Library, Yale University.

2 [Dreier?], *Its Why & Its Wherefore*, 1920, rpt. in *Société Anonyme (The First Museum of Modern Art: 1920–1944): Selected Publications*, vol. 1 (New York: Arno, 1972), n.p.

3 See John Dewey, *Art as Experience* (New York: Minton, Balch, and Company, 1934), a series of lectures that Dewey gave at Harvard University in 1930–31.

4 See Mary Mullen, "The Barnes Foundation: An Experiment in Education," *Journal of the Barnes Foundation* 1, no. 1 (April 1925): 2–5.

5 John Cotton Dana, *The Gloom of the Museum* (Woodstock, Vt.: Elm Tree, 1917), pp. 25–31. In this publication Dana developed ideas he had first expressed in 1913 in the *Newarker* and in letters to the *New York Times*.

6 Dreier's personality colors Robert L. Herbert's Introduction to *The Société Anonyme and the Dreier Bequest at Yale University: A Catalogue Raisonné*, ed. Robert L. Herbert, Eleanor S. Apter, and Elise K. Kenney (New Haven: Yale University Press, 1984), pp. 1–32.

7 Ruth L. Bohan, *The Société Anonyme's Brooklyn Exhibition: Katherine Dreier and Modernism in America* (Ann Arbor: UMI Research Press, 1982), pp. 1–25. See also Herbert, Apter, and Kenney, *Société Anonyme*, pp. 210–12, 747–50, and Apter, "Regimes of Coincidence: Katherine S. Dreier, Marcel Duchamp, and Dada," in *Women in Dada: Essays on Sex, Gender, and Identity*, ed. Naomi Sawelson-Gorse (Cambridge: MIT Press, 1998), pp. 362–413.

8 See Robert H. Wiebe, *The Search for Order, 1877–1920* (New York: Hill and Wang, 1967), pp. 1–10.

9 Ibid., p. vii.

10 Jane Addams described the home in her 1910 book *Twenty Years at Hull-House* (rpt. ed. New York: New American Library, 1960). In 1931 she would win the Nobel Peace Prize.

11 See Allen F. Davis, *Spearheads for Reform: The Social Settlements and the Progressive Movement, 1890–1914* (New York: Oxford University Press, 1967), p. 41.

12 Mary E. Dreier, *Margaret Dreier Robins: Her Life, Letters, and Work* (New York: Island Press Cooperative, 1950).

13 Margaret Dreier Robins et al., *In Memory of the One Hundredth Anniversary of the Birth of Dorothea Adelheid Dreier* (New York: Katherine S. Dreier, 1941), pp. 75, 67.

14 Katherine Dreier recalled, "Both Mother and Father had the true democratic spirit and they respected the inner qualities of their fellow man. It did not bother them what the outer circumstances represented. It was the heritage of the Free City of Bremen, from which the family came and which had been a free and independent city since the days of Charlemagne. Father and Mother loved America deeply. Early in their lives, it had become their land of adoption and they taught us a profound responsibility towards the accurate interpretation of this country to Europe and vice-versa. They would not tolerate the wild tales which passed for truth, as told in Europe, especially about our country, nor did these stories meet their sense of humor." Ibid., pp. 74–75.

15 See Katherine Dreier, "Excerpts from the Report of the Twenty-Fifth Anniversary of the German Home for Recreation of Women and Children, 1898–1923," ibid., p. 83. The home comprised a country house and fair-sized grounds right on the water. In 1934 the house and land were given to the City of New York. After renovations under Park Commissioner Robert Moses, they became Dreier-Offermann Park.

16 Ibid., p. 76. Katherine Dreier wrote, "Neither did she value book-learning or college education as it was valued by her circle of friends, unless there was a decided bent in that direction. But she laid great stress on keeping quiet and on thinking, and I can recall the hours of sitting beside her on the veranda, summer nights, watching the sunset fade and the moon rise and later the stars appearing." Ibid., pp. 74–75.

17 Dreier, letter to Miriam Shepherd, April 26, 1921. Box 37, Folder 1115, Katherine S. Dreier Papers.

18 After Dorothea's early death, in 1923, from tuberculosis, Dreier honored her sister through many exhibitions. See Herbert, Apter, and Kenney, *Société Anonyme*, pp. 206–9.

19 In 1912, for example, Dreier initiated a friendship with Vincent van Gogh's sister, Elisabeth du Quesne van Gogh, a relationship that led to her translation of Elisabeth's recollections of her brother, *Personal Recollections of Vincent Van Gogh* (Boston: Houghton Mifflin, 1913). Their many letters suggest a warm friendship, and du Quesne van Gogh was a great admirer of Dreier's commitment to hard work: "How busy you are, and how your spirit will work and worry within you; your beautiful spirit, always laboring for Beauty's and art's sake! Don't perform to [sic] much. The best of people have suffered by over-working themselves." Elisabeth du Quesne van Gogh, letter to Dreier, July 21, 1913. Box 15, Folder 412, Katherine S. Dreier Papers.

20 The 47th Street space was open from 1920 to 1923. In 1924, the Société Anonyme reopened its gallery operations in a space in the Heckscher Building, at 44 West 57th Street; that gallery closed in May 1924 owing to a lack of funds. The Société Anonyme continued to organize exhibitions, however, which took place in other gallery and museum spaces.

21 For a complete listing of the lectures and programs sponsored by the Société Anonyme, see Herbert, Apter, and Kenney, *Société Anonyme*, pp. 773–75. For a guide to the objects featured in the Société Anonyme exhibitions, see ibid., pp. 776–79.

22 "An Informal Talk by Mr. Louis Eilshemius." Box 49, Folder 1444, Katherine S. Dreier Papers.

23 Marsden Hartley, lecture notes. Box 56, Folder 1543, Katherine S. Dreier Papers. This talk became the article "Dissertation on Modern Painting," *Nation*, February 9, 1921, pp. 235–36.

24 Elie Nadelman, letter to Dreier, February 9, 1923. Box 84, Folder 2162, Katherine S. Dreier Papers.

25 W.G. Bourdoin, "Second Exhibit of Modern Art

at Société Anonyme," *Evening World*, June 28, 1920.

26 Dreier, "What Has Modern Art Contributed?" lecture at Baltimore Museum of Art, January 26, 1925. Box 48, Folder 1430, Katherine S. Dreier Papers.

27 Dreier delivered two additional lectures at the Trade School: "Evolution of Painting," with lantern slides, and "How to Look at Pictures," with a new set of artworks. There is a typescript "Rebels in Art" in Box 48, Folder 1413, Katherine S. Dreier Papers.

28 Dreier, letter to Irene Weir, February 8, 1921. Box 37, Folder 1089, Katherine S. Dreier Papers.

29 For Dreier's typescript of the lecture see Box 48, Folder 1415, Katherine S. Dreier Papers. On the League for Industrial Democracy see Bernard K. Johnpoll and Mark R. Yerburgh, *The League for Industrial Democracy: A Documentary History*, 3 vols. (Westport, Conn.: Greenwood, 1980).

30 The Rand School enabled working men and women to continue their education. In 1917 it moved from its original offices to 7 East 15th Street, named the People's House, which served as its headquarters until the school's closing in 1956. See *The Case of the Rand School* (New York: Rand School of Science, 1919), a pamphlet the school published in response to a special investigation by the New York State Assembly, which was suspicious of the school's socialist base.

On the first fifty years of The New School, see Peter M. Rutkoff and William B. Scott, *New School: A History of the New School for Social Research* (New York: Free Press, 1986). I am grateful to Katherine Fields and Dr. Camen Hendershott at The New School for their assistance during my research.

31 The lecture series also featured talks by the poets Pierre Loving and Henri-Martin Barzun and by the artists Peter Mueller-Munk and Nathaniel Poussette-Dart. On the Rand lecture series see Box 89, Folders 2295–99, Katherine S. Dreier Papers.

32 Dreier's exhibition is usually mentioned in the literature on The New School but is not discussed at any length; see, for example, Rutkoff and Scott, *New School*, p. 55.

33 From the early 1920s until the mid-1940s the school expanded its course offerings from socialist instruction to a wider range of subjects, including music, art, psychology, public speaking, and education. See "Descriptive Summary," in "Guide to the Rand School of Social Science Records 1905–1962," Tamiment Library/Robert F. Wagner Labor Archives.

34 At the end of the 1930 fall semester, Dreier wrote to Anna Bercowitz, executive director of the Rand School, "Dr. Bohn thought that maybe the art was too advanced but we found that they did not look more at the other pictures than at the modern ones. It might prove an interesting experience for you to try another group of paintings another year to see what your experience would be along those lines." Dreier, letter to Bercowitz, December 14, 1930. Box 30, Folder 866, Katherine S. Dreier Papers.

35 The first exhibition, *Early Italian Primitives Lent by The Metropolitan Museum and the Twentieth Century Lent by the Société Anonyme, Inc.*, opened for one month on October 7, 1930; the second, *Pictures Lent by The Metropolitan Museum and the Société Anonyme, Inc.*, opened on November 10,

1930, and was also installed for one month. See Box 89, folder 2295, Katherine S. Dreier Papers.

36 For the first exhibition at the Rand School Dreier borrowed eight works from The Metropolitan Museum of Art: a late-fourteenth-century *Crowning of the Virgin*; a seventeenth-century *Angel and Cherub*, attributed to Volterrano (since deaccessioned); a late-fifteenth-century *Monk Reading*, by Vittore Crivelli (since deaccessioned); and four heads from a series of twelve from the first quarter of the sixteenth century, by an Italian (Lombard) painter named by Dreier as Bartolomeo Bramantino. I am grateful to Andrew Caputo, Department of European Paintings, The Metropolitan Museum of Art, for information on the loans.

37 On the installation at the Worker's Center see Box 37, Folder 1119, Katherine S. Dreier Papers.

38 "Statement of The Société Anonyme for the Press." Box 89, Folder 2299, Katherine S. Dreier Papers.

39 In a summary of her many activities, Dreier noted: "Was the first person to arrange an exhibition between the Metropolitan Museum of Art and the Rand School — Out of that was grown their desire to work more closely with the social workers." Box 60, Folder 1634, Katherine S. Dreier Papers.

40 Box 89, Folder 2298, Katherine S. Dreier Papers.

41 See Rutkoff and Scott, *New School*, pp. 84–106.

42 Alvin Johnson, letter to Dreier, May 16, 1930. Box 26, Folder 763, Katherine S. Dreier Papers. Johnson also asked Dreier to recommend art books for the New School's reading library. Among those she listed were Oswald Spengler's *Decline of the West*, Wassily Kandinsky's *Art of Spiritual Harmony* and *Punkt und Linie zur Flache*, Goethe's *Farben Lehre*, and her own publication of 1923, *Western Art and the New Era*. See Dreier, letter to Johnson, November 10, 1930. Box 26, Folder 764, Katherine S. Dreier Papers. She writes in the same letter, "Also I would like you to preface the recommendation of these books with the following: 'Miss Dreier believes that all reading in relation to art should only be done with the distinct mental conviction that it cannot train the eye to see art — but only stimulate the imagination with regards to seeing. The true appreciation of art and beauty can only come through direct contact with art and beauty and by taking the time to train the eye to observe.' This may seem quite unnecessary to you but I find that it is very essential in teaching art to our people here in America. Through our colleges they have received the impression that one can learn to see through reading."

43 Course listings for 1931, New School for Social Research. Box 26, Folder 764, Katherine S. Dreier Papers.

44 Manuscripts of these lectures can be found in Boxes 45–48, Katherine S. Dreier Papers.

45 See Box 45, Folders 1348–49, Katherine S. Dreier Papers.

46 Dreier, letter to Marcel Duchamp, July 10, 1930. Box 12, Folder 319, Katherine S. Dreier Papers.

47 Duchamp, letter to Dreier, October 22, 1930. Box 12, Folder 319, Katherine S. Dreier Papers.

48 See "Who's Who." Box 120, Folder 2843, Katherine S. Dreier Papers.

49 *The New School for Social Research* (New York: Murbull, 1930), n.p. Box 26, Folder 763, Katherine S. Dreier Papers.

50 A full description of the installations at the opening can be found in the brochure *Informal Opening of the New Building* (New York: New School for Social Research, 1931). Box 89, Folder 2293, Katherine S. Dreier Papers.

51 Johnson, *Notes on the New School Murals* (New York: New School for Social Research, 1940). See the reviews in Box 89, Folder 2293, Katherine S. Dreier Papers.

52 Dreier, letter to Duchamp, January 10, 1931. Box 12, Folder 320. The "Who's Who" was a listing of brief artists' biographies compiled by Dreier.

53 Dreier, letter to Heinrich Campendonk, December 19, 1945. Box 8, Folder 192, Katherine S. Dreier Papers.

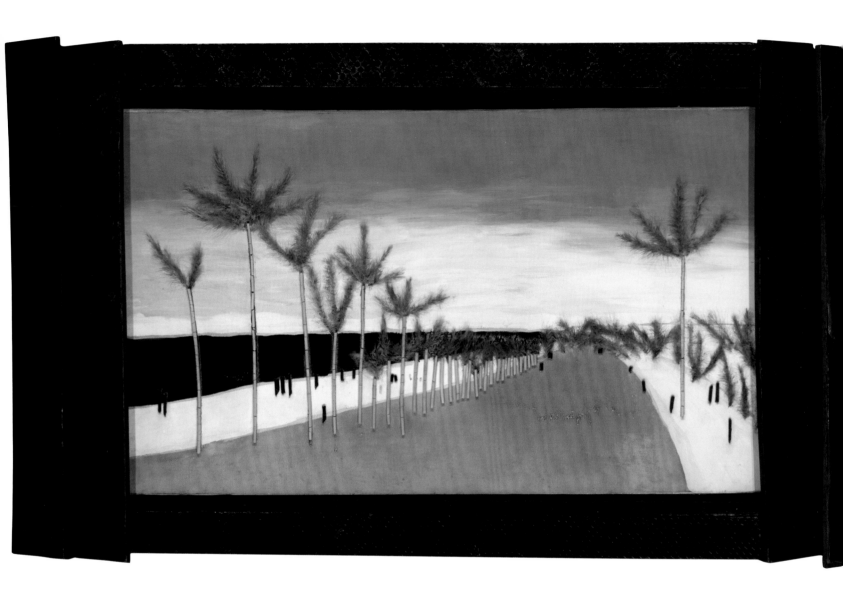

fig. 1
Francis Picabia, *Midi (Promenade des anglais)*.
c. 1923–26. Oil, feathers, macaroni, and leather on
canvas in snakeskin frame by Pierre Legrain, 21³/₄ x
39¹/₄ in. (55.3 x 99.7 cm)

Believe Me, Faithfully Yours

Jennifer R. Gross

The rich tapestry of the life of the Société Anonyme is woven into the correspondence of Katherine S. Dreier (fig. 2) with the numerous artists, dealers, museum directors, writers, and collectors who formed its ranks. Its woof comprised the lives of the people she and Marcel Duchamp knew, each with a distinct set of values and aesthetics that together defined a broad field for modernism; its warp was the shifting political, social, and economic backdrop of Europe and America from 1920 to 1950. The stories recorded in these pages form the elaborate history of modernism experienced by this incorporation of artists.

The letters reveal the harsher realities of life during and after the world wars and the Depression. They also convey the mutual trust, respect, and care that John Graham, Marsden Hartley, Wassily Kandinsky, László Moholy-Nagy, Man Ray, Kurt Schwitters, Joseph Stella, and many lesser-known artists had for Dreier, emotions that further yielded their investment in one another's work and in the goals of the Société Anonyme. With each other these artists traded heavily in everything from gossip to — when needed — such necessities as clothing, sugar, and sardines. But above all they found and gave encouragement, as they deeply and honestly wrote of their love for and hope in art. In Dreier they had found a compassionate and intensely loyal ear and advocate, and in the Collection that she and Duchamp formed, a hope for the future appreciation of their work.[1] Historians will continue to unravel the history of the Société Anonyme as the archives are studied and interwoven with the scholarship that already exists on many of these artists and their work. Meanwhile, the picture that emerges from their voices changes modernism as it has come to be known: it is more intimate, more personal, more generous and inclusive, a complex and colorful tapestry defined by an art history lived out by artists rather than encapsulated by art-historical definitions.

Equally compelling is the thirty-year record, in hundreds of letters, notes, and telegrams, of Dreier's relationship and work with her Société Anonyme cofounder, collaborator, and friend Marcel Duchamp (fig. 3). Their letters capture the heart of the Société Anonyme — the depth of their friendship and the information network they established. Their rapport defined the essence of the Société Anonyme as a "virtual community," one that began as an effective, formal vehicle for their international art aspirations and developed into a deeply personal web of collaborations and dependencies.

The relationship between Dreier and Duchamp took root slowly. They met in 1916, when both served on the board of directors of the Society of Independent Artists, a collective interested in hosting nonjuried exhibitions (fig. 4). Beyond posing the philosophical dilemma of the readymade object, the landmark controversy that surrounded the withdrawal of Duchamp's *Fountain* (R. Mutt's urinal) from the organization's exhibition the following year sparked another big bang for modernism: it catalyzed the friendship that became the foundation for the Société Anonyme.

It was Duchamp who set the ball of their acquaintance in motion, writing politely to Dreier, in the spring of 1917, that he was unable to help decorate the Society

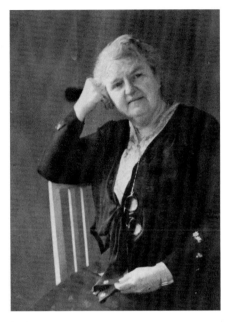

fig. 2
Katherine S. Dreier, c. 1930–35. Katherine S. Dreier Papers/Société Anonyme Archive. Yale Collection of American Literature, Beinecke Rare Book and Manuscript Library

fig. 3
Marcel Duchamp on the balcony of Hotel Brighton, Paris, 1924. Photo: Katherine S. Dreier. Philadelphia Museum of Art, Marcel Duchamp Archive, gift of Jacqueline, Peter, and Paul Matisse in memory of their mother, Alexina Duchamp

fig. 4
The Society of Independent Artists Exhibition at
Grand Central Palace, New York, 1917. Installation
view. Katherine S. Dreier Papers/Société Anonyme
Archive. Yale Collection of American Literature,
Beinecke Rare Book and Manuscript Library

fig. 5
Marcel Duchamp, photographed by Alfred Stieglitz,
1923. Alfred Stieglitz/Georgia O'Keeffe Archive. Yale
Collection of American Literature, Beinecke Rare
Book and Manuscript Library

of Independent Artists' tearoom since he was stepping down from the board due to the society's handling of the R. Mutt case.[2] Dreier's response was swift and eloquent:

> My dear Monsieur DuChamp [*sic*]:
>
> Rumors of your resignation had reached me prior to your letter of April eleventh.
>
> As a Director of the Society of Independent Artists I must use my influence to see whether you cannot reconsider your resignation. I feel there is nobody on the Board who can contribute exactly what you can. Those of us who are devoted to our country are very conscious of the commercial side and the lack of real appreciation of the beautiful in art or that art ought to be introduced into the simplest objects.
>
> I know you will forgive my being rather personal, but how can one emphasize our great need of you in the Society unless I am? Though I have only known you since our work threw us together I had naturally known of you long before; and when I found the personal sincerity to equal the sincerity of your painting, I was even more impressed by your originality. It is a rare combination to have originality of so high a grade as yours combined with such strength of character and spiritual sensitiveness....
>
> With the deepest of appreciation of the work you rendered as director of the Society of Independent Artists, and the sincere hope that you will continue to be one of us,
>
> Believe me, Faithfully yours[3]

Dreier's voice in Duchamp's life was consistent from the beginning: she was respectful, even lavish, in her praise of his creativity and in her expression of regard for his character. This initial letter rings with the conventions of courtesy, a tone her correspondence with him would keep well into the late 1920s. Although Dreier clearly did not grasp the aesthetic issues involved in the R. Mutt case, she was alert to the moral issues at stake, and moral issues were often primary in the grandstanding that surrounded modern art during this early period.

Duchamp ignored Dreier's plea not to resign, but the correspondence generated an acquaintance that over the next three years grew into an avid friendship. The difference in their ages surely played a part in defining their roles. At thirty-nine, Dreier had assumed a matronly persona, and her formal posture, seniority, and economic independence cast her in a position of authority in relation to Duchamp and his peers.[4] In 1918, by commissioning *Tu m'* (see fig. 3 in Bohan's essay in the present volume), she literally established herself as Duchamp's patron. The thirty-year-old Duchamp, on the other hand, was basking in the heat of a rollicking New York social life, often carousing late into the evening with the art patron Walter Arensberg, the artist sisters Florine, Carrie, and Ettie Stettheimer, Beatrice Wood, and Man Ray.

In 1918, when Duchamp left New York to spend a year in Buenos Aires, his travel companion was Yvonne Chastel, the recently divorced wife of the Swiss artist Jean Crotti (who would become Duchamp's brother-in-law by marrying Duchamp's sister Suzanne the following year). Dreier soon followed them. In Buenos Aires she largely kept to her own affairs, researching a book on the social status of women in Argentina, *Five Months in the Argentine from a Woman's Point of View*, and attempting to write articles for the magazine *International Studio*.[5] Duchamp meanwhile worked on drawings for *The Large Glass* (1915–23) and nurtured his growing obsession with chess (fig. 7). But the two did meet socially, and by the time Dreier returned to New York and Duchamp to Paris, their acquaintance had developed enough that in the fall of 1919, when Dreier was traveling in Europe, she met up with Duchamp and went with him to meet his family in Rouen. The family immediately adopted her, gratefully appreciating her watchful care over their wayward son and brother. Dreier in turn was greatly taken with them — she remained in touch with Duchamp's parents until

fig. 6
Marcel Duchamp, letter to Katherine S. Dreier, April 11, 1917. Katherine S. Dreier Papers/Société Anonyme Archive. Yale Collection of American Literature, Beinecke Rare Book and Manuscript Library

their death, and corresponded consistently and affectionately with Suzanne Duchamp and Crotti, as well as with Duchamp's other siblings.[6] Dreier's role as a patron/matron in Duchamp's life is clear from a letter written to her by the artist's mother, Lucie Duchamp, in March 1923:

> Dear Miss Dreier:
> I received your lovely letter a few days before Marcel arrived here. Thank you. Very sensible of your so devoted kindness to Marcel, my husband and I express our gratitude to you. We hope that Marcel will set himself to work. He is well aware that he cannot remain without an occupation. Happily he is in better health — we found him much better and stronger. We will do all we possibly can to help him to find something stable to do, suitable for his state of health. I agree with you that he ought not to go to Paris where he gets dragged down by his friends who prefer pleasure to work....
> Most affectionately, L. Duchamp[7]

On Duchamp's return to New York, in January 1920, he and Dreier began to refine an idea they had had of forming a society of artists for the purpose of exhibiting modern art. During her visit to Europe the previous year, Dreier had traveled extensively,

fig. 7
Marcel Duchamp. *Cemetery of Uniforms and Liveries, No. 2 (Cimitière des uniformes et livrées No. 2)*, also known as *The Bachelors and Nine Malic Moulds*. 1914. Pencil and watercolor on paper, 26 x 39 5/16 in. (66 x 99.8 cm)

fig. 8
Marcel Duchamp. *Pocket Chess Set*. 1943. Leather pocket chessboard, celluloid pieces, and pins in black leather wallet, closed: 6 1/2 x 4 1/2 x 1/2 in. (16.5 x 11.4 x 1.3 cm), open: 6 1/2 x 8 3/4 x 1/4 in. (16.5 x 22.2 x 0.6 cm)

making her most important connection with Herwarth Walden of Der Sturm Gallery in Berlin. Walden exhibited the work of artists from Russia, eastern Europe, and Germany, and he was also the publisher of *Der Sturm* magazine. He held symposia, sponsored educational programs, and published prints and books by the gallery's artists. His work became the prototype for the activities of the Société Anonyme. Dreier had also visited one of the first Dada exhibitions in Cologne, where the controversial works of Johannes Baargeld and Max Ernst had been relegated to a separate room. These experiences convinced her of the dearth of information on European modernism in America, and upon Duchamp's return to New York, their discussions began with Man Ray regarding the formation of a small experimental museum.

On May 25, soon after the founding of the Société Anonyme, Dreier wrote on its behalf inviting Ernst to exhibit in New York, using the name of her famous friend Marcel as a mark of validation for the fledgling organization and as a link to the more established French Dadaists. Ernst was keen on the opportunity to exhibit with either German or French Dadaists in New York, but the British occupation authorities, deeming his work scandalous, denied Dreier an export license.[8] This roadblock did not dissuade her, and on a subsequent trip to Germany in search of work to exhibit at the Société Anonyme, she was soon attempting to arrange a shipment of art from Berlin's controversial *Erste internationale Dada-Messe* (First international Dada fair), which included work by George Grosz, Raoul Hausmann, John Heartfield, and Johannes Baader.[9] Permission to take this work out of the country was again denied, but these records demonstrate Dreier's decisive and prescient commitment to the German avant-garde. It was decades before their work became publicly visible in quantity in the United States; Dreier was unable to show Ernst's work until the 1926 *International Exhibition of Modern Art* at the Brooklyn Museum.

Duchamp brought the flavor of Dada and Paris to the profile of the Société Anonyme, most literally by pulling in his playmate and collaborator Man Ray to assist in setting up the gallery. Dreier brought business strategy and structure to their ideas. The organization's exhibition program rolled out in the spring of 1920 (see Greenberg's essay in the present volume) with a group exhibition reflecting a broad definition of modernism: Constantin Brancusi, Patrick Henry Bruce, James Henry Daugherty, Duchamp, Juan Gris, Vincent van Gogh, Francis Picabia, Man Ray, Georges Ribemont-Dessaignes, Morton Livingston Schamberg, Stella, Jacques Villon, and Heinrich Vogeler were all represented. The eclectic checklist, which included works as diverse as Brancusi's *Little French Girl (The First Step III)*, Man Ray's *L'Impossibilité Danger/Dancer* (fig. 9), and van Gogh's *Adeline Ravoux*, reflected the balance Dreier and Duchamp would strike over the next thirty years, not so much through compromise as through the polarity of their values.

The team they constituted was an effective one. Dreier conceived their strategies, secured Duchamp's input, and then labored with pen and paper to attain whatever it was the Société needed: art, press coverage, transportation, information. If art world savoir-faire was required to achieve a particularly difficult connection, Duchamp's social skills and elaborate international network neatly met their needs. Their relationship with Picabia and his wife, Gabrielle, who oversaw his business affairs, exemplifies their strategies. When the Picabias were in New York in 1920, Duchamp introduced them to Dreier, who later courted Mrs. Picabia, taking her to lunch and apprising her of the aspirations of the Société Anonyme. A letter to her from that May reveals the multilayered support that Dreier and Duchamp, then acting as the Société Anonyme's president, hoped the Picabias' involvement with the organization would supply:

fig. 9
Man Ray. *L'Impossibilité Danger/Dancer.* 1920. 27⅞ x 13¹¹/₁₆ in. (70.8 x 45 cm). Musée National d'Art Moderne, Centre Georges Pompidou, Paris, France

At the request of our President, Mr. Marcel Duchamp, I am writing to you to ask you to attend to a few matters with regard to next winter's exhibitions.

Will you kindly get in touch with Mr. [Alexander] Archipenko, 77 rue de Denfert Rochereau, Paris, to whom we have written to ask for a group of his pictures, which we would like to exhibit next winter at our Gallery....

We should also like to arrange for an exhibit of your husband, Mr. Picabia's work. We would like you to ask him, whether he would wish to exhibit with the French Dadas or separately. We leave it to his judgment and, if he prefers a separate exhibition, we would like him to make a selection, and the French Dadas work could cover another six weeks. You might also get in touch with Brancusi and ask him if he would like us to handle his works, or whether he prefers [Marius] Dezayas [*sic*] to do it?...

It may interest the Dadas to know that when I am in Germany, I shall get in touch with Max Ernst and I hope to arrange for an exhibition of his work and that of his confreres as well.

Would you be so kind as to get in touch with [Tristan] Tz[a]ra and ask him how much he would charge to send us a monthly public letter with short telegraphic sentences, telling us about the general happenings and the exhibitions pertaining to the modern art movement in Europe. We are going to have a bulletin board in our little reference library on which we would like to place announcements of all galleries handling modern work in Europe. If you, or Tz[a]ra, could send our name to such galleries we would appreciate it very much, and we feel that it would be of great value eventually to them....

Deeply appreciating your assistance in establishing the true value of our little gallery in New York,

Believe me, Cordially[10]

In July 1921, after an extremely robust first year of activity for the Société Anonyme, Duchamp and Man Ray left New York for Paris, and Dreier embarked on an eighteen-month trip to China and Europe. She and Duchamp restarted the organization's activities as soon as she returned to New York, in December 1922, with an exhibition of work by Villon, Duchamp's brother. Duchamp was already back in New York, working on his *Large Glass* and on the Société Anonyme publication *Some French Moderns Says McBride*. On her way back to New York Dreier swept through Europe, visiting Kandinsky and Paul Klee at the Bauhaus and arranging one-person exhibitions for both of them with the Société Anonyme.

YOUR, KANDINSKY

Of all the artists Dreier worked with and supported over the course of her lifetime, none was more influential on the development of her aesthetic than Kandinsky.[11] Profoundly affected by his art and writings, she gave him his first one-person exhibition in the United States, in 1923, and would become his lifelong friend. She visited him and his wife, Nina, in Germany and France on many occasions, including her last trip to Europe, in 1937. She made herself Kandinsky's apostle in America, and indeed it was Kandinsky who turned Dreier into an abstract painter; her painterly vocabulary shows a striking resemblance to his (fig. 10). Kandinsky's voice — his Theosophical belief in the cosmic forces of art, his stance against the evils of American materialism, his zeal for abstraction — also echoes in her lectures and writings. Kandinsky's devotion to painting, and his spiritualizing of artistic practice, certainly counterbalanced Duchamp's more cerebral approach. In 1925 Dreier made him an honorary vice president of the Société Anonyme, a position he kept until his death, in 1944. Dreier

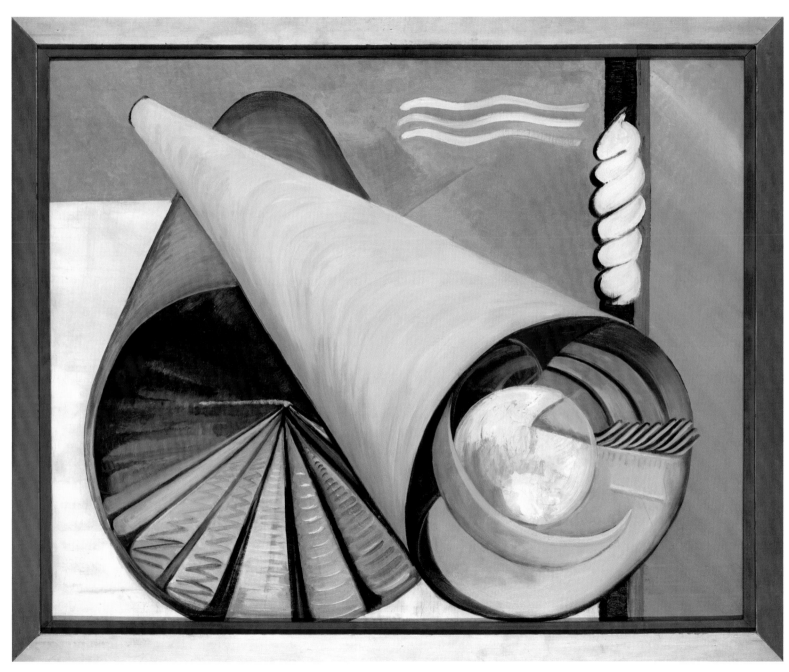

fig. 10
Katherine S. Dreier. *Two Worlds (Zwei Welten)*. 1930.
Oil on canvas, 28¼ x 36⅛ in. (71.8 x 91.7 cm)

often sought him out as an adviser to the Société Anonyme exhibition program and as a source for information on the European art scene.

Dreier's correspondence with Kandinsky provides a unique window into his life, revealing him as an ambitious businessman and an astute tracker and sharp critic of the art world. He, Nina, and Dreier savored their relationship and the opportunities it provided for frank discussions of art. When they were exhausted by their individual efforts to enlighten the world about modernism, they found comfort and encouragement in each other's work. In 1927 Kandinsky wrote to Dreier from the Bauhaus in Dessau,

> I was delighted to receive your letter of October 16....It is truly extraordinarily sad that the Americans have so little interest in new (and especially, apparently, abstract) art. They will buy our pictures later, once we are all dead and our pictures command tens of thousands. And it is very nice to see how despite all the difficulties you never lose your courage and your incredible energy, but keep working and never shy from any kind of work (I think of the tedious business correspondence that you have to attend to in connection with exhibitions). Hopefully your countryman will one day learn to appreciate your merits.[12]

UNTIL THEN...

Simultaneously with her efforts to build a rapport with European artists, Dreier was extending the Société Anonyme network in the United States. The rate of her correspondence would only accelerate over the years, building a web of information and activity among her Société cohort, including Duchamp, Man Ray, and Alfred Stieglitz. One of Duchamp's and her own early favorites was Stella, whom they knew from their days at the salon of Louise and Walter Arensberg and at the Society of Independent Artists. For the rest of his life, Stella actively pursued Dreier as a writer on and collector of his art; she eventually acquired more than a dozen of his works. He was also the first American artist she sought (unsuccessfully in this case) to bring to Europe under the auspices of the Société Anonyme, by introducing him to Walden of Der Sturm. The international flow of exhibitions and information that Dreier endeavored to effect through the Société Anonyme was never fully realized (she and Duchamp also tried to exhibit the work of both Louis Eilshemius and Dorothea Dreier, Katherine's sister, in Europe, to no avail), but the full range of Dreier's ambition for the globalization of modernism is evident in a letter she wrote to Stella in 1923:

> My dear Stella,
> ...You will be happy to hear that I had a letter from Der Sturm, Berlin, in which they say they would be very much interested in considering an exhibition of your work next winter. This, you see, is the beginning of the international exchange, towards which end I have been working, for if your pictures are once in Germany I think I can arrange to have them travel to various other cities....When are you planning to sail?[13]

While Dreier was pounding the pavement for the Société Anonyme on the streets of New York, Duchamp acted as her alter ego in Europe. Dreier continued to travel there frequently, but Duchamp began to leave longer and longer gaps between his trips to the United States, thus establishing himself as the Société Anonyme's European agent.

In the spring of 1926 the Brooklyn Museum offered Dreier the opportunity to curate an international exhibition of modernist art (see Wilson's essay in the present volume). Her letters to Duchamp during this project, the Société's most ambitious, fused familiarity — by now she addressed him as "Dee" — with serious business:

Dear Dee:

Well I am coming over!!!!! Won't it be jolly to see you and tell you all the gossip.... And I need you especially now as The Brooklyn Museum has asked me to arrange for them a complete Modern Exhibition, giving me absolute freedom of selection....I shall stop at the Hotel Brighton and they told me that I could have the same room. 318. Until then,...[14]

Duchamp's replies reveal the pair's continued negotiation of the curatorial conception of the exhibition, as well as the finer, often political details of the exhibition's organization.

The *International Exhibition of Modern Art* opened at the Brooklyn Museum on November 19, 1926, and ran until the following January 1. In the spring of 1927 Dreier remained preoccupied with the Brooklyn exhibition, as she was arranging for selections from it to travel to three additional venues. She was no doubt stunned that May, then, to receive a letter from Duchamp notifying her of his pending marriage. Considering that her closest friend and confidant had sprung on her this most unexpected news, her response, promptly sent by telegram (the draft is undated), was diplomatic, even brave: "VERY HAPPY OVER YOUR MARRIAGE. SEND MUCH LOVE TO BOTH. BOXES SENT TO POIRET STEAMSHIP PARIS MAY 24TH. LETTER FOLLOWS. DREIER."[15] A follow-up letter sent on June 16 addressed a number of business items pertaining to the Société Anonyme, then ended with an additional affirmative inquiry:

Well, I have no time to gossip even though I would like to. How is the wife? It seems so funny to write that to you!!!!! When will you write and send me her picture. I hope soon. My love to her and with the same to you. Affectionately[16]

On the same day that Dreier penned this letter to Duchamp, she resorted to the Société Anonyme network for support and to vent her feelings, writing to Man Ray on the excuse of obtaining photographs he had recently taken of her home:

My dear Man Ray:

You must think me awfully ungrateful to only thank you now for the pictures you took of my place...but I could not help regretting that you did not just send me shiny prints for reproduction as I hoped that I could sell them for you here in connection with an article on "Modern Art in the Home."

I feel the greatest contribution to Modern Art in the Home is Duchamp's marriage. Were you bowled over by it....[17]

She could not have been disappointed by Man Ray's response:

It is nearly a month since I received your kind letter, but I have been waiting to get that portrait of Mme. [Duchamp]. To tell you the truth, when Marcel told me of his getting married, it had the same effect on me as if he had told me he was going to paint impressionist landscapes from now on. But when I met Lydie [Duchamp's new wife], I realized he was rather inclined to Rubens.[18]

The portrait, a photograph of the new Mme. Duchamp taken by Man Ray (fig. 11), arrived soon after. Man Ray's tacit sympathy must have helped Dreier through this seemingly dramatic change in the life of the Société Anonyme comrades.

Duchamp's marriage ended, however, as abruptly as it had begun. His final letter on the subject, written the following March, swept aside any confusion that the

fig. 11
Mme. Marcel Duchamp, photographed by Man Ray, 1927. Katherine S. Dreier Papers/Société Anonyme Archive. Yale Collection of American Literature, Beinecke Rare Book and Manuscript Library

Nr.　Liebe Miss Dreier!

Hannover, den 27.2.30

Das war eine grosse Freude, als Ihr Telegramm aus New-York anka[m]
Nur bedauerten wir, dass wir Ihnen nicht wiederschreiben konnten. Ich bin
in Hannover und freue mich riesig, Sie zu begrüssen. Wollen Sie uns im Hau-
se besuchen? Vielleicht zum Abendessen? Bitte geben Sie mir doch noch
Nachricht, vielleicht telefonisch, Fernruf 8 27 46. Ich habe grosse Bilder
geklebt und besonders Plastiken geschlemmt, und an meinen 3 Säulen gearbei-
tet.
Als Sie uns aus New-York telegrafierten, habe ich sofort auf den 2.3. einer
abstrakten Abend festgesetzt, und wir haben auch auf die Einladung gedruckt
dass Sie voraussichtlich diesen Abend besuchen würden. Nun kommen Sie ja
erst am 3.3. nach Hannover, schade. Vor allen Dingen dürfen Sie sich nicht
durch unseren Abend an Ihnen sonstigen Reiseabsichten stören lassen. Wenn
es allerdings möglich wäre, würden Sie uns alle sehr erfreuen, wenn Sie an
unserem Abend da wären und uns etwas aus Amerika erzählten. Wie Sie es sich
einrichten wollen. Es sind mehrere Leute in Hannover, die Sie gern bei die-
ser Gelegenheit kennen lernen würden. Der Abend findet statt bei Dr. Büder
in der Theaterstrasse 15 um 20 Uhr 30, das ist von Kasten gleich um die Ek-
ke, das dritte Haus.
Also ich freue mich riesig, Sie zu sehen, bestimmt am Montag. Mit den
herzlichsten Grüssen Ihr

Kurt Schwitters

Wie schön, dass Sie wieder nach Hannover kommen! Alle möchten Sie sehen, auch
meine Mutter würde Sie gerne, wenn es möglich wäre, kennen lernen. Ernst
sagte, Miss Dreier kommt doch auch zu uns, damit ich sie sehe. Also, liebe
Miss Dreier, auf baldiges frohes Wiedersehen Ihre dankbare

Anna Schwitters.

fig. 12
Kurt Schwitters, letter to Katherine S. Dreier, February
27, 1930. Katherine S. Dreier Papers/Société Anonyme
Archive. Yale Collection of American Literature,
Beinecke Rare Book and Manuscript Library

fig. 13
Kurt Schwitters. Katherine S. Dreier Papers/Société
Anonyme Archive. Yale Collection of American Lit-
erature, Beinecke Rare Book and Manuscript Library

marriage might have caused in his relationship with Dreier: "I have been going to
the Post Office almost every day expecting to get a letter from you — Now I am afraid
that the letter has been lost — …Divorce is over — since Jan. 25th — …Affectionately,
Dee. (Vorced)."[19]

Although Duchamp's marriage barely interrupted the activities of the Société
Anonyme, it dramatically changed his personal relationship with Dreier: her respect-
ful support and advice through this episode in his life cemented their friendship.
The pair carried on with their Société Anonyme work, and in the spring of 1929 they
made an extended tour of Spain together, then returned to Paris before traveling on
to visit Schwitters in Hannover.

SINCERE BEST WISHES FROM, KURT MERZ

Dreier had first seen Schwitters's work in 1920, at Der Sturm in Berlin. Her correspon-
dence with him had begun in 1925, at his behest, and she had first visited him in
Hannover in 1926. The two had often been in touch in the years since, and had devel-
oped a significant bond. Schwitters's letters indicate his hunger for word of the art
scene in America, and he engaged Dreier to present public programs in Hannover
whenever she visited him there.[20] In his and his Hannover colleagues' eyes, Dreier and
Duchamp were international stars, and the Société Anonyme had almost mythic
status (fig. 12). Through Dreier, too, Schwitters connected with a broader community
of artists in Europe. He engaged himself fully in the Société Anonyme network:

> I am going to visit Duchamp my next time in Paris, for in the foreseeable future I
> have to go again because of an exhibition. I saw [Jean] Arp frequently in Strasbourg
> and Paris. Together with his wife and with [Theo van] Doesburg he is painting a large
> café in Strasbourg consisting of some fifteen rooms. He's a truly amazing person. By
> contrast, the Max Ernst show I saw in Paris I found weak, so weak that I had no desire
> to see him. He is now painting like [Arnold] Böcklin. Ernst is always painting in a dif-
> ferent style, I don't actually know where the true Ernst in Ernst might be. Why do you
> like him so much? I will let Doesburg know why you didn't see him.…
>
> So take good care of yourself and get better. I am still sad that you won't be in
> Germany this year.[21]

Schwitters (fig. 13) kept Dreier abreast of his work as well as his peripatetic lifestyle
allowed. Much as in her relationship with Kandinsky, her efforts brought encourage-
ment to his province of modernist activity. A letter he wrote from Amsterdam in 1936
reveals how dire the circumstances of the German avant-garde had become:

> How are you? It has been so long since we heard from you. We are all well, and in
> Germany we have enough to live on.…But I am deathly sorry that I have no contact.
> In Germany my art is shown only in the exhibition "Degenerate Art." I do not show
> my atelier to a soul, of course, but even though the windows are whitewashed it sad-
> dens me so that I cannot show it to anyone. My work survives in voluntary banish-
> ment, from which it cannot free itself. It has been so long since we had the pleasure
> of seeing you here that you know nothing of the new turn in my art. I have become
> mainly a sculptor, build columns and rooms, white, smooth, imaginative but simple!
> …If you write, please write *only* to Amsterdam, otherwise one cannot know what
> difficulties might arise for me. In general, I would like to be known by the pseudonym
> Robert Lee. If you write me in Hannover, please only New Year's greetings or some
> such. You can only mention that the Lee business is going well or that Lee is going to
> design a room and that you have told his friend Fint. It is such a ridiculous time, a

person has to worry that his own words are taken in the wrong way.

All the best to you. Sincere best wishes from, Kurt MERZ[22]

The days of easy travel and communication that had made these Société Anonyme friendships possible were disappearing rapidly.

IN THESE TIMES

Dreier made her last trip to Europe in 1937. Problems with the circulation in her legs, combined with the travel restrictions resulting from World War II, would keep her from returning before her death, in 1952. This final trip, though, was a thoroughly satisfying one, packed with the routine round of visits to artists that had become the mainstay of her travel abroad. The only excitement that marked the excursion was one of blessed happenstance: Dreier missed her planned passage home, which was to have been on the *Hindenburg*, arriving in New Jersey on May 6, 1937. The crash of the zeppelin that day prompted a flurry of concerned correspondence as such Société Anonyme friends as Frederick and Stefi Kiesler, Schwitters, and Duchamp, who had been tracking her travels and knew her original plan, sent notes to express their relief at not finding her name on the passenger list. Schwitters wrote emotionally to her, "You missed the ship, and thus a lucky chance has preserved you for us and for art."[23] Even the self-possessed Duchamp was unnerved by Dreier's near miss and, clearly compelled to express the anxiety it had caused him, wrote asking her for a note of assurance:

> It is a relief to write to you to an earthly boat.…For, if we all miss catastrophic trains, very few control the taking or the non taking of a dirigible. Too new to accept it cold-bloodedly — …Good sea and safe landing
> Write from Cherbourg a little note. Affectionately, Dee[24]

The Société Anonyme correspondence for the years after Dreier's return from Europe is weighty, first with the issues of the war, and then with the effects of her own aging and with her preoccupation with securing a long-term solution for the future of her organization's Collection. She and Duchamp tried to keep track of the artists they knew through the network of their correspondence, but they both began to slow down significantly. Happy memories were overshadowed by the war, financial duress, and the constant press of anxiety caused by the silence of their friends, as Duchamp wrote in 1939:

> Well, it has to come. How long will it last? Is my first question — How will we come out of it, if we come out of it?…I am in Paris waiting for the first bomb to leave [for] somewhere in the country.…Paris is half deserted and black at night.…I can't say I will see you soon but who knows? In these times, Affectionately, Dee[25]

Meanwhile Dreier struggled to comprehend the political situation that pitted her beloved Germany against the rest of Europe and her artistic homeland, France:

> Dee…You know how I love France — and my heart just ached. If only we could get together — all nations — and create a Peace.…Do you really believe that the Democracies are so effete? Sometimes I do — when I see the indifference to principle — but I can't bear the thought — though I know what a backbone Hitler has put into the German Youth. But they all seem so sad — that I can't help wonder whether it is not possible to come to terms — or is the whole ghastly situation based on such different conceptions of a new economic order. One can only ask oneself questions.[26]

In the autumn of 1937 the art dealer Karl Nierendorf and the architect Mies van der Rohe, both German exiles, visited Dreier at her home in Connecticut.[27] In May 1938 Dreier wrote to Nierendorf seeking news of Mies, who had settled in Chicago, and of the painter Rudolph Bauer, who was still in Germany.[28] Nierendorf replied promptly, but with less than encouraging news, and Dreier soon obtained more information, either from Nierendorf or from another source, for in June she wrote to Duchamp, "Bauer did not report some foreign holdings and now sits in a Concentration Camp! Do they give the real reason — no — they say he was imprisoned because he mocked Goebels [sic] book."[29] Bauer's release would not be secured until 1939, through the efforts of Solomon Guggenheim. He lived in the United States for the rest of his life.

Before and during the war, many Société Anonyme artists wrote to Dreier hoping that she could help to secure work for them or their friends in the United States. Miriam and Naum Gabo's inquiry of October 1938 on behalf of their friends the English artists Barbara Hepworth and Ben Nicholson (the German couple were living in London at the time) is typical of the stream of requests for assistance that came to Dreier and Duchamp during these years.[30] By the time the United States was actively engaged in the war, however, Dreier had become discouraged about the prospects of the European émigrés; she had seen the transatlantic move prove unsatisfactory to many artists, whether because they could not find work or because they had difficulty adjusting to the culturally limited American lifestyle.

In June 1942 Duchamp finally secured his passage to the United States, via Casablanca in French Morocco. Immediately upon arrival he went to The Haven, Dreier's home in West Redding, Connecticut, to spend the weekend with her (fig. 14).[31] He would visit her regularly there, since Dreier was anxious for news and felt isolated owing to her immobility and the unreliability of mail to and from Europe. She

fig. 14
Library of The Haven, Katherine S. Dreier's home in West Redding, Connecticut. Katherine S. Dreier Papers/Société Anonyme Archive. Yale Collection of American Literature, Beinecke Rare Book and Manuscript Library

had many visitors at The Haven, and at her second home in Milford, Connecticut, during and after the war. The time came when she could no longer maintain her correspondence, but Duchamp continued to arrange visits on her behalf, and her collection, including Duchamp's *Large Glass*, turned her nest into a pilgrimage site for art world luminaries (fig. 15). A partial list of her visitors in Connecticut is impressive: Alfred H. Barr, Jr., André Breton, Simone de Beauvoir, Miriam and Naum Gabo, the German critic Julius Meier-Graefe, Moholy-Nagy, Henri-Pierre Roché, Julien Levy, Matta, and the Kieslers.

After the war, Dreier and Duchamp attempted to reconnect with many of the artists of the Société Anonyme, and to round out its Collection by securing gifts from and trades with artists whose works were not included.[32] The letters they received in response to their inquiries are remarkable for the immediacy of the artists' accounts of their experience of the war, and for their thrilled response at reconnecting with the Société Anonyme.[33] In November 1947 the Italian Futurist Ivo Pannaggi, whose work (fig. 16) had been exhibited in the Société Anonyme's Brooklyn exhibition in 1926, wrote to Dreier from Norway of the entirely new life he had established during the war, and of the sharp political perspective his experiences had given him:

> I survived the war very well as I was successful the entire time in remaining very far away from Fascist Italy. The news I am continuing to get from Italy is still very poor. It is in fact so bad that it is enough to keep me for the foreseeable future from returning to my fatherland. Fascism is still not completely extinguished; instead, it is just the opposite as it continues to flourish due to support from the Catholic Church via the Occupational Authority that, without fail, is pushing for a return to the old ideals of Fascism. They are not even attempting to show a little bit of originality along with the fact that they are not even trying to generate new propaganda methods. Gobbels [*sic*] finished his teachings! The "new world" can not do anything better than to believe Gobbels Christian tactics, which consists of intimidating and scaring the entire world with ideas of the alleged dangers of Communism in order to attain their own personal intention of expanding power while using the association of war-preparations as a disguise.
>
> This is the result after five years of an anti-fascist war! How is it going with the modern art? I am afraid that you also are fighting against the fact that your art is being disapprovingly viewed as unrecognized, Communistic, and un-American; similar to when your art was disapprovingly viewed as unrecognized, Communistic, and un-German during Hitler's reign....
>
> I would be overjoyed to hear something from you very soon. I do so hope that you have good news to pass on from your side....
>
> Most heartfelt, Ivo Pannaggi[34]

Dreier was particularly at pains to find friends with whom she had lost touch during the war, and who had not been faring well when she had last communicated with them. When Duchamp returned to Europe in 1946, she urged him to obtain information on Schwitters, Heinrich Campendonk, and the Gabos:

> Roché has arrived and I hope that he can come and spend the week-end of the 13th — for I am most anxious to see him and hear all he will have to tell....Is there any chance of going to Amsterdam to see Campendonk[.] And can you find out what has happened to Schwitters? He has been so much on my mind lately and when are the Gabos coming and who is the[ir] friend in Woodbury [Connecticut]? Maybe Pevsner can tell you.[35]

fig. 15
Parlor at The Haven. Katherine S. Dreier Papers/ Société Anonyme Archive. Yale Collection of American Literature, Beinecke Rare Book and Manuscript Library

fig. 16
Ivo Pannaggi. *Architectonic Function 3U.* c. 1925–26. Oil on canvas, 59 1/16 x 35 7/16 in. (150 x 90 cm)

Dreier reconnected with Schwitters that year — he was now in Ambleside, in the Lake District in the North of England. She had been out of touch with him since 1939; they maintained an avid correspondence until his death, a year later. Schwitters had obviously been broken by the hardships the war had brought upon him and his family, and he looked to Dreier as a reliable old friend (fig. 17). After their years of isolation and battles with health issues, they found in each other's words a comfort and understanding that are profoundly heartwarming. Dreier updated Schwitters on news of the Société Anonyme and its artists, and arranged for him to receive financial support, food, and vitamins (fig. 18):[36]

fig. 17
Katherine S. Dreier in her garden in Milford, Connecticut. Schlesinger Library, Radcliffe Institute, Harvard University

fig. 18
Kurt Schwitters, letter to Katherine S. Dreier, October 6, 1947. Katherine S. Dreier Papers/Société Anonyme Archive. Yale Collection of American Literature, Beinecke Rare Book and Manuscript Library

My dear dear Friend Kurt Schwitters:

Your letter of October 24th has just reached me and I cannot tell you how glad I was to hear from you. I had not heard any word since you were in Camp interned in London or near by —I can't get over that [Schwitters's wife] Helma died. There are few people I loved and honored as much as I did Helma....

How tragic all the illness you had to pass through and especially that you had a stroke. I can't tell you how sad it made me feel. But how wonderful that a book is coming out of your Merz Drawings. You know how I love them....

But I hear so little and meet so few people these last years — for I grew so lame that I had to lead a very secluded life. I am working very hard to conquer my lameness for I do want to go over to Europe once more before I die....

In 1941 Duchamp and I gave The Collection of the Societe Anonyme — Museum of Modern Art 1920 to Yale University. There are over 500 items and you are fairly well represented....My paintings — both my own and those of my many friends which I own I love and when I get quite depressed with the world I go to my painting-room and enjoy them for I have far more than I can hang in my home....Do write again soon. I presume you heard that Mondrian died — which was a great loss — and now recently one of our own great modern artist died Joseph Stella.

Do get well soon. Can I send you anything? Would you like a package of food — I will send you something — and to England it will not take so long. And do write me soon again — for I am so eager for news.

My love to you and my true friendship[37]

Schwitters replied in his best English on April 18, 1947, informing Dreier of his financial difficulties, the destruction of his first Merzbau installation in Hannover, and the pending birth of his grandchild.[38] He and Dreier began to discuss the possibility of an exhibition of his work in the United States, but by December of 1947 his health had declined markedly, and on January 15, 1948, his son, Ernst, wrote to tell Dreier of his death.[39] The Société Anonyme had lost one of its greatest artists and Dreier one of her dearest friends. The extraordinary representation of Schwitters's works in the Société Anonyme Collection — twenty-two in all — stands as testimony to his significance in the organization's history.

In 1948 and 1949 Dreier and Duchamp remained extremely busy with their work on the catalogue of the Société Anonyme Collection at Yale. The book was completed in 1950, and Dreier and Duchamp officially dissolved the Société Anonyme at a dinner at the New Haven Lawn Club on April 30 of that year.

The publication of the catalogue left Dreier and Duchamp with one last task to undertake on behalf of the community in which their lives had become so inextricably interwoven: the bequest of Dreier's own significant art collection. The placement of these works inspired her and Duchamp to new heights of political negotiation; even so, a final home was not found for all of them until after her death. Duchamp, as the principal executor of her will, kept much of the Collection together at Yale and dispersed major works to key institutions across the country, including The Phillips Collection, Washington, D.C.; the Art Institute of Chicago; The Museum of Modern Art, New York; and the Philadelphia Museum of Art.

YOU, ME

Dreier's letters from the last years of her life are to her and Duchamp's immediate families.[40] As her health declined, Duchamp visited her regularly in Milford (fig. 19), and when she felt well enough she enjoyed his bringing old friends along with him, as she wrote in the winter of 1951:

Dee: I was so sorry that I was so tired again when you came up on Sunday so that I do not think I gave you any idea how grateful I am that you have established the connection for my Collection to become a part of The Philadelphia Museum.

I am so grateful and you too must be very happy to know where the various things which you have created and which have been in my care all these years will go. It really is quite wonderful the way it is all turning out. And I think that we both should not only be happy about it but grateful....

Has Man Ray arrived? I thought it might be nice to have you bring Man Ray and his wife to New Haven for lunch and have him meet Mr. Gallup and then come over to me after seeing the Gertrude Stein Collection at the Yale Art Gallery. It was through David Gallup that G.S. gave her papers all to the Yale Library and Mr. Gallup quoted from a letter G.S. had written Man Ray in his lecture. I thought it would be nice if they met. And I can easily have you for lunch there.[41]

Dreier's condition had worsened by the summer of 1951, and Duchamp's letters reflect his concern for her care and his need to see and hear from her, even if only with a few words (fig. 20).[42] Dreier rallied briefly in the autumn but in October Duchamp received her last letter. He continued to write her newsy notes, which emulated the tenor of their earlier dialogues, but his chatty tone indicates he is carrying both sides of the conversation in an attempt to cheer and involve Dreier, whose health was beginning to fail conclusively.

Your long letter came yesterday. — I am glad that Dr. Lee does not object to your seeing some people — He does not realize that there is as much medication in a friend's visit as in any good drug....Here in N.Y. very little is happening. Most of the people are not back yet....Saturday I am going to the Tanguys [the artist Yves Tanguy and his wife, Kay Sage] for a whiff of fresh air. A chess tournament is in the offing — but only one day a week at my club....Let me know when you want me to go up to Milford —

Affectionately, Dee[43]

Duchamp sent his last letter to Dreier on January 15, 1952. His underlined assertion of Dreier and himself as the letter's primary subjects is a sweetly playful tribute to their connection, and an acknowledgment of it as his grounding in the art world whirl he now found himself in without her:

The circus continues: Tomorrow an interview appears in the Art Digest as a forerunner of the show — I will send it to you —

— Rose Fried told me today that "Life" is interested and will probably interview me a little later —

Also the "Talk of the Town" in the New Yorker might ask me a few questions at the time of the show.

All this to show *you* how my peaceful life has been changed into a publicity machine.

I received from George Hamilton a "delighted" letter telling *me* how happy he was to lend his drawing for the show....

Hoping to receive a little note from you telling me the last news of your village I am sending you my best wishes from my village —

Affectionately, Dee[44]

No note came back from Dreier — the pen that had articulated the primary voice of the Société Anonyme remained silent (fig. 21). Katherine Dreier died on March 29,

fig. 20
Marcel Duchamp and Katherine S. Dreier in her garden in Milford, Connecticut. The Schlesinger Library, Radcliffe Institute, Harvard University

fig. 21
Katherine S. Dreier at her home in Milford,
Connecticut. Katherine S. Dreier Papers/Société
Anonyme Archive. Yale Collection of American Lit-
erature, Beinecke Rare Book and Manuscript Library

1952. Duchamp was by her side throughout her final illness. She remained what she called the optimistic "otherself" to his dour persona until the end, confounding his desire to find closure for their friendship as her death approached.[45] No art world team has ever been less likely yet has accomplished so much.

Notes

1 In 1933 Katherine S. Dreier asked the author and art critic Henri-Pierre Roché, her good friend and Marcel Duchamp's, to write the introduction for a brochure that was to be published for her retrospective exhibition at the Academy of Allied Arts, New York. Dreier loved the witty and exacting image Roché painted of her as a forceful presence who charged the atmosphere wherever she went:
"I am searching — Katherine Dreier — among my half conscious memories, and I chose the following:
"Five years ago, I saw her subconsciously — it was a sun-burnt shore — my friends, some French painters, were lying on the yellow sand.
"Miss Dreier appeared on the blue sea, in the shape of a small iceberg, which came floating gently near the shore, and the air became cooler, though the iceberg did not melt.
"This vision took place several days after a luncheon at Prunier's which she gave to her Paris friends.
"Around the table the air was filled with the silence of spirit, with flowers, gentleness and hidden bombs — and no one knew where to begin. It was the candor — in its highest meaning — the patient, curious, rigorous, stimulating, restful, creative candor of Miss Dreier which gave to all the pure basis of rich conversation, with nine voices taking part, which made a veritable 'Banquet,' at which she did the questioning....
— Paris, September 1933 Henri Pierre Roché"
Roché, draft of text sent with letter to Dreier, September 20, 1933. Box 30, Folder 881, Katherine S. Dreier Papers/Société Anonyme Archive, Yale Collection of American Literature, Beinecke Rare Book and Manuscript Library, Yale University. Roché's "dream" of Katherine Dreier humorously counterbalances her formidable presence against her ability to generate an energetic artistic atmosphere.
2 Duchamp, letter to Dreier, April 11, 1917. Box 12, Folder 317, Katherine S. Dreier Papers. The Society of Independent Artists had been founded on the principle of being willing to exhibit the work of any artist member. But when Duchamp pseudonymously submitted a urinal as the work of the artist "R. Mutt," the Society promptly rejected it, and he accordingly resigned.
3 Dreier, letter to Duchamp, April 13, 1917. Box 12, Folder 317, Katherine S. Dreier Papers.
4 Duchamp was apparently perplexed as to how to address Dreier in his letters. He initially called her "Miss Dreier," but as the two became more intimate and such formality became inappropriate, he dropped all salutation completely, an assumption of familiarity he did not take with any of his other friends. Meanwhile, Dreier often signed her letters to Duchamp "Adopted-Mother" or "Friend," a strange amalgam that hints at her roles in his

life and indicates both correspondents' inability to identify the bond that they had come to share. It was only after Dreier's death that Duchamp used her first name in his letters, calling her Kate or Katherine in correspondence with friends and with Dreier's family.
5 Dreier, *Five Months in the Argentine from a Woman's Point of View, 1918 to 1919* (New York: F.F. Sherman, 1920).
6 See, e.g., Suzanne Duchamp, letter to Dreier, October 26, 1934: "Dear Katherine,...I wish dear Miss Dreier that we should see you again in Paris, soon, and that time would be as joyful as formerly. With love and kiss from your affectionately, Suzanne Duchamp." Box 12, Folder 327, Katherine S. Dreier Papers.
7 Lucie Duchamp, letter to Dreier, March 15, 1923. Box 12, Folder 316, Katherine S. Dreier Papers.
8 Max Ernst, letter to Dreier, June 16, 1920. Box 13, Folder 349, Katherine S. Dreier Papers.
9 Dreier, letter to Ernst, May 25, 1920. Box 13, Folder 349, Katherine S. Dreier Papers.
10 Dreier, letter to Gabrielle Buffet-Picabia, May 10, 1920. Box 29, Folder 834, Katherine S. Dreier Papers.
11 Subheading: Wassily Kandinsky, letter to Dreier, October 6, 1925. Box 20, Folder 567, Katherine S. Dreier Papers.
12 Wassily Kandinsky, letter to Dreier, February 29, 1927. Box 20, Folder 567, Katherine S. Dreier Papers. Trans. Russell Stockman.
13 Dreier, letter to Joseph Stella, May 2, 1923. Box 33, Folder 967, Katherine S. Dreier Papers.
14 Dreier, letter to Duchamp, March 7, 1926. Box 12, Folder 317, Katherine S. Dreier Papers.
15 Dreier, telegram to Duchamp, n.d. Box 12, Folder 317, Katherine S. Dreier Papers.
16 Dreier, letter to Duchamp, June 16, 1927. Box 30, Folder 868, Katherine S. Dreier Papers.
17 Dreier, letter to Man Ray, June 16, 1927. Box 30, Folder 868, Katherine S. Dreier Papers.
18 Man Ray, letter to Dreier, July 23, 1927. Box 30, Folder 868, Katherine S. Dreier Papers.
19 Duchamp, letter to Dreier, March 12, 1928. Box 12, Folder 318, Katherine S. Dreier Papers.
20 "My dear Miss Dreier....You know that in Hannover we have an association of abstract artists consisting of the names [Carl] Buchheister, [Rudolf] Jahns, [Ulrich] Nitschke, Schwitters, [Friedrich] Vordemberge-Gildewart, all of whom are familiar to you. At my suggestion, its chairman, Karl Buchheister, now plans to invite you to an informal lecture evening on May 9. I had thought that we might ask you to tell us and our circle, perhaps for half an hour or longer if you wish, something about the interest in new art in North America. If you happen to have with you photos of your work or of other American artists, it would be very nice to pass them around, but...it would suffice if you were to report

to us, in simple narrative and without a lot of preparation, of course, about the success of your efforts in America….We beg you to come have dinner with us with your friend Duchamp on Thursday, at least by six." Kurt Schwitters, letter to Dreier, April 26, 1929. Box 31, Folder 925, Katherine S. Dreier Papers. Trans. Russell Stockman.

21 Schwitters, letter to Dreier, June 27, 1927. Box 31, Folder 925, Katherine S. Dreier Papers. Trans. Russell Stockman.

22 Schwitters, letter to Dreier, November 25, 1936. Box 31, Folder 925, Katherine S. Dreier Papers. Trans. Russell Stockman. Schwitters coined the term MERZ to describe his artwork, and built his first *Merzbau*, an environmental construction in his home, in Hannover. From 1923 to 1932 he also published a periodical entitled *Merz*.

23 Schwitters, letter to Dreier, July 24, 1937. Box 31, Folder 926, Katherine S. Dreier Papers. Trans. Russell Stockman.

24 Duchamp, letter to Dreier, May 11, 1937. Box 12, Folder 322, Katherine S. Dreier Papers.

25 Duchamp, letter to Dreier, September 24, 1939. Box 12, Folder 323, Katherine S. Dreier Papers.

26 Dreier, letter to Duchamp, February 11, 1940. Box 12, Folder 323, Katherine S. Dreier Papers.

27 "The Sunday we spent together was indeed most enjoyable for me and Mr. Van Der Rohe and I too look forward to another such occasion." Karl Nierendorf, letter to Dreier, November 17, 1937. Box 27, Folder 788, Katherine S. Dreier Papers.

28 Dreier, letter to Nierendorf, May 23, 1938. Box 27, Folder 788, Katherine S. Dreier Papers.

29 Dreier, letter to Duchamp, June 13, 1938. Box 12, Folder 323, Katherine S. Dreier Papers.

30 Miriam Gabo, letter to Dreier, October 16, 1938. Box 14, Folder 377, Katherine S. Dreier Papers.

31 Dreier, letter to Theodore Sizer, director of the Yale University Art Gallery, July 3, 1942. Box 39, Folder 1127, Katherine S. Dreier Papers.

"Mr. Marcel Duchamp has safely arrived and had an amazing crossing. They had been promised safe passage by the belligerent nations and steamed under full light unharmed while ships to the right and left of them were torpedoed, a rather gruesome sensation since the number reported to them was fifteen. He arrived on Thursday the 25th and came up on Saturday for the week-end."

32 "Dear Man Ray:…I can't tell you how much we enjoy your large painting, 'The Promenade,' and how happy I am that you gave it to us for the Collection [in 1937].…What good times we used to have when we created the Société Anonyme, and how glad will be when it is safely established with its Catalogue and we write 'Fini.' Always with deep appreciation of the friendship that has lasted through all these years, believe me, Faithfully yours, Katherine S. Dreier, President." Dreier, letter to Man Ray, January 25, 1949. Box 30, Folder 868, Katherine S. Dreier Papers.

33 See, e.g., letter from John Storrs to Dreier, text at note 30 in my introductory essay to the present volume.

34 Ivo Pannaggi, letter to Dreier, November 14, 1947. Box 28, Folder 812, Katherine S. Dreier Papers.

35 Dreier, letter to Duchamp, September 3, 1946. Box 12, Folder 324, Katherine S. Dreier Papers.

36 "A letter from Campendonk tells me that he has heard from you and was very happy about it. Unfortunately, he, too, has been ill and, therefore, unable to answer it, but maybe by now you will have heard from him. He has passed through a very difficult period as almost all his paintings which were left in Germany have been destroyed through bombing or other means, and at present he apparently cannot yet send his newer work out of Holland as he is still considered an enemy alien. It seems incredible that our various governments are so stupid, and do not let the artists build up a friendship among nations." Dreier, letter to Schwitters, December 18, 1947. Box 31, Folder 926, Katherine S. Dreier Papers. "Dear Miss Dreier, I was glad that you telephoned about Schwitters. I arranged for another installment of the Museum scholarship to be sent to him and cabled Miss Thomas. Schwitters seems to have an amazing fund of tenacity and I hope it will bring him through this illness." Margaret Miller (curator at The Museum of Modern Art), letter to Dreier, January 7, 1948. Box 26, Folder 736, Katherine S. Dreier Papers. "Mietze darling, Schwitters died on January 8th — isn't it sad and today his exhibition opens. Somehow his death took it very out of me, for the last years of his life were so very sad and it just seem to be opening up again.…How much do I owe Lisa for the Vitamens she sent for me to Schwitters." Dreier, letter to Mary Dreier ("Mietze"), January 19, 1948. Box 41, Folder 1171, Katherine S. Dreier Papers.

37 Dreier, letter to Schwitters, November 13, 1946. Box 31, Folder 926, Katherine S. Dreier Papers.

38 Schwitters, letter to Dreier, April 18, 1947. Box 31, Folder 926, Katherine S. Dreier Papers. Trans. Russell Stockman.

39 "Dear Miss Dreier: Writing to you for the first time, I wished it was not such a sad happening I have to relate.…On January 8th — a week today — my father died quietly at Kendal Infirmary, to where he had been brought a little over a week before.…As you know, he had been seriously ill for quite some years — on and off." Ernst Schwitters, letter to Dreier, January 15, 1948. Box 31, Folder 921, Katherine S. Dreier Papers.

40 "What must you think of me for not writing you all winter.…I wanted to send you just a CARE package, but Marcel was so convinced that you would prefer to have sardines and herring and tuna fish preserved in oil, rather than a CARE package that it is only now that they have gone off to you — four boxes of sardines in oil, three tuna fish and three fillet of herring in oil.…I was sorry that both Marcel's and my long silence had worried you. I don't know what he is so busy about or whether it is that he has very little strength, for he is very thin — however, he walks with such firmness and vitality that I think he must be busy about some things of which he doesn't speak. At present he is deep in chess playing two days a week for more than two months to enable the judges to decide who will represent this club at a national or international tournament." Dreier, letter to Suzanne Duchamp, April 6, 1948. Box 12, Folder 327, Katherine S. Dreier Papers.

41 Dreier, letter to Duchamp, February 15, 1951. Box 12, Folder 324, Katherine S. Dreier Papers.

42 "I received this morning your telegram and the sad news postponing the visit to Milford.…Hope you can find a day next week (before Friday, any day) when I can go to Milford before I leave."

Duchamp, letter to Dreier, August 16, 1951. Box 12, Folder 324, Katherine S. Dreier Papers. "Came back last night after this very restful vacation.…I received your letter in Syracuse and was so happy to hear about your new nurse.…I will be happy to read a few words from you when you feel like writing." Duchamp, letter to Dreier, September 4, 1951. Box 12, Folder, 324, Katherine S. Dreier Papers.

43 Duchamp, letter to Dreier, October 4, 1951. Box 12, Folder 324, Katherine S. Dreier Papers.

44 Duchamp, letter to Dreier, January 15, 1952. Box 12, Folder 324, Katherine S. Dreier Papers.

45 See Duchamp, letter to Louise and Walter Arensberg, May 6, 1952, in *Affect/Marcel: The Selected Correspondence of Marcel Duchamp*, ed. Francis M. Naumann and Hector Obalk (London: Thames and Hudson, 2000), p. 313.

fig. 2
The Haven, Katherine S. Dreier's home in West Redding, Connecticut, c. 1942.

fig. 3
Katherine S. Dreier in her sitting room at The Haven, c. 1942.

fig. 4
The Haven, center hall, n.d. At the base of the staircase is Constantin Brancusi's *Yellow Bird* (*L'Oiseau d'or*, 1919).

had just resigned as director of the Division of Art at the Los Angeles Museum. The Country Museum would provide a permanent home for the Société Anonyme Collection, "combining Art in the home and the garden…a part of everyday life… brought into the lives of our rural community, who can come and see art at leisure …without undue exertion."[6] It would be an educational resource for local art students, including those at Yale. In addition to allowing the study of her own collection, it would provide temporary exhibitions, classes, lectures, and a library. As was her custom, Dreier wrote to Duchamp about her idea and received his advice and approval.[7] In February 1940 Dreier actually hired Hekking for a three-month period, assigning him the task of creating a brochure and finding sponsors for the Country Museum. Her idea — novel for its time — was that the sponsors would purchase The Haven for $125,000. (Dreier could not afford to donate it.) The museum would have a resident director and an annual budget of $30,000 for educational activities.[8]

Hekking's efforts to garner interest and capital for the venture proved fruitless. By the summer of 1940 he had formally withdrawn, already having begun to work on an expenses-only basis during the late spring. That September, while visiting a friend in New Haven, Hekking happened to call on Everett Victor Meeks, dean of the School of the Fine Arts at Yale. He broached the idea of the Country Museum with Meeks, who was cordial but unenthusiastic. Although unfamiliar with the contents of the Collection, Meeks was concerned about maintaining it in a physically unsafe dwelling. Since Dreier had already decided that Hekking was to be the director of the Country Museum once it was launched, the university's ability to control its operations would also be an issue. Finally, a time of looming war was a period of national uncertainty. All in all, Meeks stated, he was unable to commit the university to purchasing The Haven; he further doubted that any subscribers would be found to sustain the Country Museum.[9] Meeks politely invited Hekking to visit again — after The Haven was sold. Theodore Sizer, the director of the Yale Art Gallery and a long-standing colleague of Hekking's, was also present at this meeting. Writing to Dreier about the conversation, Hekking described Sizer as "a live wire."[10]

By the late winter of 1941 Dreier had accepted that the Country Museum scheme seemed to hold no promise. Undaunted and true to habit, she took matters into her own hands. Her friend Dr. Samuel Geiss Trexler, head of the Lutheran Synod, had given her an introduction to President Seymour of Yale. They met in early March. Expressing interest in Dreier's plan, Seymour urged her to present it to Sizer as soon as he returned from Australia, where he was working on a forthcoming exhibition. Dreier subsequently wrote to Seymour thanking him for his time and restating her belief that young people need to study present-day masters "first hand instead of…through colored slides…which would only be possible in a small museum and in the country where time is not so pressing."[11]

Sizer finally met with Dreier in June. He knew something of the quality of her collection and immediately expressed enthusiasm for her idea of "teaching Art Appreciation without Museum fatigue."[12] On the other hand, he readily saw the impracticality of trying to remake her sprawling New England estate into a safe space for exhibiting works of art and "an educational center for…the many preparatory schools in the area."[13] Mindful that the Yale Art Gallery had no twentieth-century teaching collection and owned only two newly arrived abstract paintings (George L. K. Morris's *Composition* [1938] and Charles Greene Shaw's *Plastic Abstraction* [1938]), Sizer quickly grasped the value of the Société Anonyme Collection as a teaching resource for art students.

End-of-term administrative duties and catch-up work after his long absence in Australia delayed Sizer's visit to The Haven until July. Afterward he sent a gracious

but to-the-point letter to Dreier: "May I thank you for your kindness…and for the privilege of seeing the extraordinarily fine collection of pictures which you brought together so intelligently years before abstract painting was generally understood or appreciated. I was unprepared, I must confess, to discover the extent and quality of the collection." In the same letter he distilled the heart of the situation:

> The whole thing boils down to a matter of cost: a suggested budget of $30,000 a year would mean an endowment of a million or a million and a half, which would be difficult if not impossible to secure in these abnormal times.…We have made a practice for years in encouraging the schools of New Haven…to use the facilities of the Gallery.…What we are attempting to do here closely parallels your exceedingly interesting proposal.[14]

Perhaps Sizer's peremptory summary of this proposal was precipitated by his eagerness to acquire the Collection. He subsequently regretted his directness, writing the next day to President Seymour that the "lady is difficult, but her collection is worth the expenditure of time and trouble."[15] At the same time, in a letter to Wilmarth S. Lewis, a member of the Yale Museum and Library Committee and chairman of the Yale Library Associates, he wrote,

> Were the lady to set no conditions we could afford to swallow a lot (& let a large portion of the collection lie dormant for better times)…but she (far smarter than superficially apparant [sic]) quite properly wants it used in all sorts of (interesting) ways — & we to pay the bill.…My laudable desire to find out…will probably result in losing a nice juicy fish right off the hook.…the lady…likes much attention — & you can load the compliments on with a trowel…so long as we land this fish.[16]

Lewis and Sizer punctuated the next weeks with several closely spaced visits to The Haven while maintaining a close correspondence with Dreier. Tactful and intuitive as to Dreier's own view of herself as an artist of ability, Lewis wrote to her that he found her collection "extraordinarily interesting," and hoped it would come to Yale "since the collection is…a teaching collection. It belongs in a great university where students…may have easy access to it."[17] In a letter to Dreier of August 4, Sizer offered for her consideration the argument that a "free and privately endowed university, such as Yale, unencumbered by governmental politics," would be a suitable repository for the Collection, while fireproofing The Haven would be costly.[18] Instead he proposed that Yale would receive from her, as her gift, the Collection of the Société Anonyme (as distinguished from her personal collection), and would accede to her terms that the Country Museum at The Haven, which Dreier still hoped to realize, would be permitted to borrow works from Yale for educational purposes. Sizer also emphasized that the Yale Art Gallery, as an educational institution, maintained a regular schedule of docent lectures and other programs for public and private regional schools and local community organizations. In that these activities resembled Dreier's stated plan for the Country Museum, they would fulfill her goals.

By August 7, 1941, Dreier had capitulated, with some qualifications. Yale would indeed receive as her gift the Collection of the Société Anonyme, which she agreed, for the time being, to separate from her private collection. It would also allow Frederick Hartt, whom she had hired in April and salaried as of July 1, to continue to catalogue those works now at Yale, at her expense.[19] She finally stipulated that Yale would be responsible for continuing the Société's teaching mission and lectures, reaffirming that the "Aim of the Société Anonyme — Museum of Modern Art — 1920 is *Educational.*"[20]

As legal co-owner and trustee with Duchamp of the Société Anonyme Collection, Dreier needed his consent, which he readily gave by telegram. He counseled her, however, to keep her private collection, thereby ensuring her future control of its content. The final legal papers for transfer of the Société Anonyme Collection to Yale were drawn up by the New Haven law firm of Wiggin and Dana on October 3, 1941, and within a few weeks the Yale Corporation formally accepted Dreier's collection, as recorded in its minutes of October 11, 1941. A few days later Dreier wrote to President Seymour:

> The Collection has been assembled, guarded and sent out on its mission during the past twenty-one years with so much love, in which many artists joined, that we are happy to have it where it will continue to do its work. We all tried to be true to our aim, incorporated in our name, The Société Anonyme, which was first of all to promote Art and not personalities, and, secondly, to spread an understanding of the new forms of Art which the coming era was creating. Therefore, it seems to both Mr. Duchamp and myself a very marvellous ending to have the Collection housed in perpetuity, where thousands of young people, from all over the country, may see and study these new forms. [These pictures] will revitalize…and create an inner moral courage and discipline.[21]

Dreier lost no time sending the Collection to New Haven. By October 22, 1941, Josephine Setze, the Art Gallery registrar, who had made several trips to West Redding to escort parts of the Collection, could confirm the safe arrival of a major part of the gift. The transfer was complete by the end of October, except for objects then on loan to other museums.

The same Corporation meeting that had formally accepted Dreier's gift also confirmed the appointment of young George Heard Hamilton as curator of modern art at the Yale Art Gallery. As the objects began to arrive, Hamilton was completing the final chapters of his dissertation at Yale. In a letter to Dreier, Sizer commented that his young colleague Hamilton was "elated" by the "quality and quantity of your benefaction." Hamilton's immediate enthusiasm pleased Dreier, who commented that he had quickly perceived the "richness of the Movement of Abstract Art and… the depth of expression which has been achieved."[22] Hamilton became the principal caretaker of the Société Anonyme Collection and the staff member who interacted most often with Dreier. He worked with her to complete the catalogue of the Collection, and, as its curator, dealt constantly with her demands about the display of Société Anonyme works in the Gallery.

With the acquisition of the Société Anonyme Collection the Yale Art Gallery filled an important gap in its holdings, becoming immediately significant among American museums for its art representative of the modern movement. Once the transfer was complete, Dreier pressed for an exhibition of the Collection, and on January 14, 1942, the Gallery opened *The Exhibition of the Collection of the Société Anonyme — Museum of Modern Art: 1920*, featuring 127 works by seventy-three artists.[23] The Collection filled the Gallery's major exhibition spaces on two floors — a tribute to Dreier and Duchamp, and to Sizer's recognition of the Collection's value as a "repository of contemporary and experimental works of art."[24] Visitor attendance and the schedule of public lectures for this exhibition must have pleased Dreier as well as Gallery board members and donors, who had felt some anxiety about the gift. In a letter to Dreier, the Art Gallery docent A. Elizabeth Chase wrote that during the exhibition's six-week run it had received 850 visitors per week, as compared with an average weekly attendance of between 350 and 550.[25] Most of all, the exhibition aroused

curiosity; students visited in "droves" to learn about the new art.[26] Sizer's words of the previous summer had come to fruition; for years to come, Dreier's collection would indeed "further the highly successful work of Miss Chase, much of which parallels Miss Dreier's scheme."[27]

In accord with the agreement between Dreier and Yale, the Gallery let the Collection's objects travel, lending them elsewhere as she wished. Works were shown not only in the Gallery but in Yale's libraries, lecture rooms, and offices.[28] Dreier herself lectured at many exhibitions of Société Anonyme works at the Yale Art Gallery.[29] The agreement also stipulated completion of the Collection catalogue, which remained a priority for Dreier. To assure wide distribution, Sizer suggested that the catalogue be simple and affordable to students. Hartt had begun work on the book but was drafted in April 1942, four months after Pearl Harbor. As curator of the Collection and Dreier's immediate liaison with the Art Gallery, Hamilton inherited the task of bringing the catalogue to fruition. Dreier's sense of urgency in completing the project often tried the patience of her Yale associates. The catalogue was distinguished for its time in that it addressed a collection amassed by artists and contained many texts written by artists: the biographies and commentary were written largely by Duchamp and Dreier.[30] Finally published, in 1950, the catalogue remains an invaluable resource for these texts.

In the spring of 1942 Dreier was still without a sponsor for her Country Museum. As Sizer had foretold the preceding fall, "her elaborate plans for a rural art center…

fig. 5
Katherine S. Dreier in the gallery of *The Exhibition of the Collection of the Société Anonyme — Museum of Modern Art: 1920*, the inaugural exhibition of the Collection at Yale, January 1942. To her left is her own *Two Worlds (Zwei Welten)* (1930). Archives, Yale University Art Gallery

[died] a natural death."[31] As far back as September 1941 he had hoped that Dreier might give her entire collection to Yale if the university was patient; he foresaw that she would be unable to run a community museum and would be obliged to sell The Haven. Ever hopeful that Yale might accept her "new educational plan" and receive her private collection at her death by taking on the running of the Country Museum, Dreier was deeply disappointed the following April [1942] when Sizer told her this would be impossible.[32] Sizer wrote Dreier that he had three wishes: that her collection have a scholarly, well-illustrated catalogue; that Yale receive her library of books and pamphlets that "document the collection"; and that her personal collection be "reunited with that of the Société Anonyme." This was his "great dream," for which he had "high hopes."[33] That Sizer was unable to accept the entire collection is unfortunate but understandable. It was wartime, and Gallery staff was preoccupied with safeguarding the Collection in the event of enemy attack. Funds and space at Yale were nonexistent; Yale's plans for completing the Art Gallery building had had to be postponed, and the future was utterly uncertain. Many of the Gallery staff had been drafted; Sizer himself was about to leave for military service. Dreier had no recourse but to retain her remaining art objects.

By 1946, Dreier had sold The Haven and moved closer to Yale. Her new home in Milford, Connecticut, was within easy reach of New Haven (figs. 6, 7); she could and did visit Yale often, ensuring that works from the Collection were well represented among the Gallery's installations and asking to rearrange objects according to her

fig. 6
Brancusi's *Leda* (1920) in the garden of Katherine S. Dreier's home in Milford, Connecticut, 1948. Visible through the window to the left is Marcel Duchamp's *Large Glass* (1915–23).

fig. 7
Katherine S. Dreier in the elevator of her home in Milford, 1948. Duchamp painted the exterior of the elevator to match the wallpaper in her hall.

current judgment. She kept close watch on the activities of the Société Anonyme and continued to promote interest in the organization's membership, occasionally trying to sponsor Société events in Yale's name, at times without even informing the university. She was still making additions to the Collection at Yale, usually initiating them herself, though she often consulted Duchamp. Sometimes she gave objects to Yale from her personal collection, which remained in her Milford home; sometimes she purchased works for it; sometimes she asked artists to donate a work to further shape the Collection at Yale. Other gifts she solicited from artists whom she wished to be represented in the Collection. At the time of the dissolution of the Société Anonyme, Inc., in 1950, Dreier had added thirty artists to the original 1941 gift.

Between the Yale University Art Gallery's 1942 exhibition and the exhibition it organized in December 1952 as a memorial for Dreier, six exhibitions at the Gallery drew largely on the Société Anonyme Collection. Four were major events in which Société objects figured prominently: *Duchamp, Duchamp-Villon, Villon*, 1945 (fig. 8); *Exhibition of Contemporary Sculpture: Objects and Constructions*, 1946 (fig. 9); *Exhibition of Painting and Sculpture by the Directors of the Société Anonyme since Its Founding, 1920–1948*, 1948, in honor of Dreier's seventieth birthday (fig. 10); and *Exhibition on the Occasion of the 30th Anniversary of the Société Anonyme*, 1950.[34] This last exhibition celebrated the dissolution of the Société Anonyme, a thirty-year old missionary of modern art that at this point had no further role (fig. 11). The catalogue on which Dreier and Duchamp had worked so hard, *The Collection of the Société Anonyme: Museum of Modern Art 1920*, was published three months later.

fig. 8
Duchamp, Duchamp-Villon, Villon, exhibition of artworks from the Société Anonyme Collection at the Yale University Art Gallery, March 1945. Installation view. Archives, Yale University Art Gallery

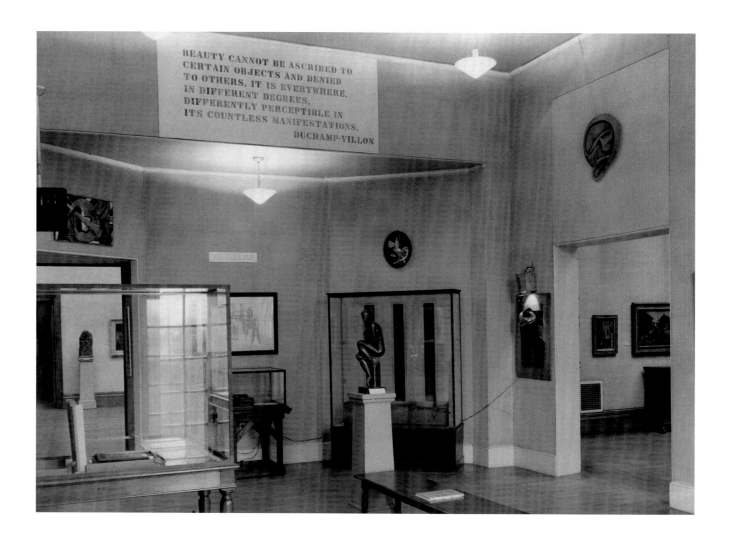

fig. 9

Bulletin of the Associates in Fine Arts at Yale University, April 1946, which served as the catalogue for *Exhibition of Contemporary Sculpture: Objects and Constructions*, p. 1. More than half of the artworks shown were either from Dreier's 1942 gift or came into the collection before her death in 1952. Archives, Yale University Art Gallery

fig. 10

Exhibition of Paintings and Sculpture by the Directors of the Société Anonyme since Its Founding, 1920–1948, 1948. Installation view. At right, in glass case: Naum Gabo, *Model of the Column* (c. 1928), *Model for Vertical Construction in Space with Ellipse* (1929), and *Variation of a Spheric Theme* (1936). Archives, Yale University Art Gallery

fig. 11 (below)

Celebration of the dissolution of the Société Anonyme and of the publication of a catalogue of the Collection, April 1950. Left to right: Mrs. Charles Seymour; Duchamp; Charles Seymour, president of Yale; Dreier; and Charles H. Sawyer, dean of the Art School and head of the Division of the Arts at Yale. Archives, Yale University Art Gallery

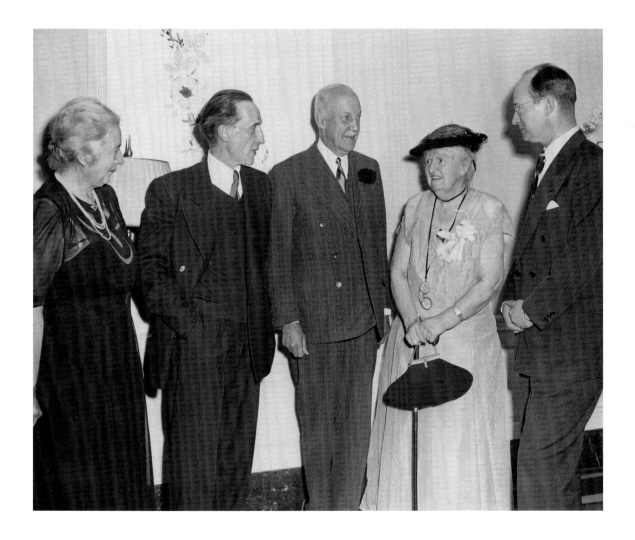

Dreier died in 1952, and the memorial exhibition was quickly organized to honor her achievements (fig. 12). From December 1952 until February 1953, visitors to the Gallery could see works of art from Dreier's personal collection as well as those already at Yale. This was the only time her own and the Société Anonyme collections were shown in their entirety. In addition to these exhibitions at Yale, requests came from museums throughout the country for loans from the Collection, making a clear statement that the educational activities of the Société Anonyme were being sustained with the same vigor that Dreier had envisioned in 1920.

At Dreier's death, her personal collection was in her Milford home. Some pieces had been sold over the years, but her mark as a collector had been preserved. She had favored the work of living artists, and although she was loyal to her friends, she had bought only works that resonated with her artistic instincts. After the memorial exhibition her collection was dispersed according to the terms of her will. Yale received seven objects that she probably felt belonged with the Société Anonyme Collection: Constantin Brancusi's *Yellow Bird* (1919; fig. 13), Dreier's own *Self-Portrait* (1911), Raymond Duchamp-Villon's *Seated Woman*

fig. 12
Cover of *In Memory of Katherine S. Dreier, 1877–1952*, the catalogue for the Yale University Art Gallery's memorial exhibition for Dreier on her death, December 1952. This exhibition was the only time her collection was shown in its entirety. Archives, Yale University Art Gallery

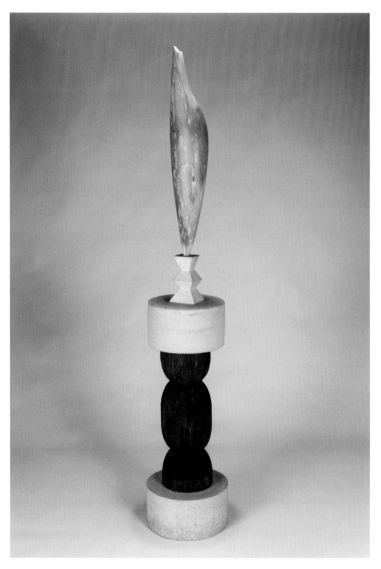

fig. 13
Constantin Brancusi. *Yellow Bird*, 1919. Yellow marble, limestone and oak base, Overall: 87¼ in. (221.6 cm)

(1914; fig. 14), Max Ernst's *Paris-Rêve* (1924–25; fig. 15), David Nestorovitch Kakabadzé's Z (c. 1925), John Storrs's *Dancer* (1918–20), and Jacques Villon's *Philosopher* (1930). As executor of Dreier's remaining estate, Duchamp made the choices about the dispersal of objects out-side the will according to his judgment of what she would have wished. His own *Tu m'*, commissioned by Dreier for a space above a bookcase in her personal study at The Haven, came to Yale, along with nearly three hundred other undesignated objects. The final tally of objects from both the Société Anonyme Collection and Dreier's now at Yale is more than one thousand artworks by 180 artists.

The presence of the Société Anonyme Collection at Yale not only enlarged the historical visibility of the Société Anonyme as the earliest American organization to promote the new art but also celebrated Dreier for her early recognition and understanding of modern art by living artists. The wide range of media, international choice of artists, and inclusion of examples of the principal movements of early-twentieth-century art in the Société Anonyme Collection mark it as a historic cornerstone of Yale's collection.

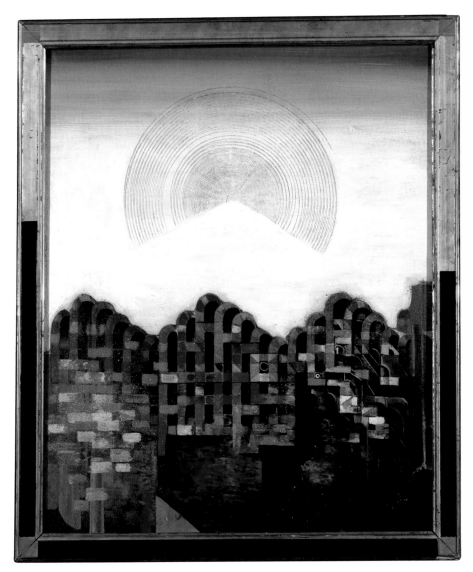

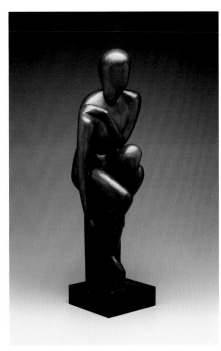

fig. 14
Raymond Duchamp-Villon. *Seated Woman (Femme assise)*. 1914. Bronze with black marble pedestal and base, 28 x 8 x 7⅛ in. (71.1 x 20.3 x 18.1 cm)

fig. 15
Max Ernst. *Paris-Rêve*. 1924–25. Oil on canvas, 25½ x 21¼ in. (64.8 x 54 cm)

Notes

The chronological history of the Société Anonyme that is the basis of this essay is drawn entirely from Robert L. Herbert, Eleanor S. Apter, and Elise K. Kenney, eds., *The Société Anonyme and the Dreier Bequest at Yale University: A Catalogue Raisonné* (New Haven: Yale University Press, 1984). I am grateful for this opportunity to revisit the pleasant years of scholarly opportunity provided to me by Professor Herbert and Ms. Apter, who invited me to join their endeavor.

1 President Charles Seymour, letter to Katherine S. Dreier, October 11, 1941. Box 61, Folder 534, Records of Charles Seymour as President of Yale University (RU 23), Manuscripts and Archives, Yale University Library.

2 The formal opening of the Société Anonyme preceded the opening of The Museum of Modern Art, under the directorship of Alfred H. Barr, Jr., by almost a decade. Barr and Dreier knew each other. Dreier valued each artist's work; Barr, the current art scene. See Sybil Gordon Kantor, *Alfred H. Barr, Jr., and the Intellectual Origins of The Museum of Modern Art* (Cambridge: MIT Press, 2002), pp. 111–17.

3 See, for example, Dreier, letter to Frederick Hartt, May 17, 1939. Hartt, a graduate student at the Institute of Fine Arts, New York University, was a friend of Dreier's to whom she wrote of the "intensity" of pain in her legs, adding that as one ages, details slip. Box 17, Folder 476, Katherine S. Dreier Papers/ Société Anonyme Archive, Yale Collection of American Literature, Beinecke Rare Book and Manuscript Library, Yale University.

4 "Somehow someone will…present a plan whereby art…sinks below the surface and acts as it should like a cake of yeast — fermenting — until the individual is the richer for it." Dreier, letter to Hartt, July 11, 1939. Box 17, Folder 476, Katherine S. Dreier Papers.

The twentieth-anniversary retrospective was *New Forms of Beauty 1909–1936: A Selection of the Collection of the Société Anonyme — Museum of Modern Art: 1920*, George Walter Vincent Smith Art Gallery, Springfield, Mass., November 9– December 17, 1939, and Wadsworth Atheneum, Hartford, Conn., January 4–February 4, 1940, with a catalogue by Dreier.

5 "Ever since Duchamp's Glass has been placed in the Library the House has become a museum which I must see that it is established before I die." Dreier, letter to Hartt, August 27, 1940. Box 17, Folder 476, Katherine S. Dreier Papers. "Marcel Duchamp's famous Glass is so a part of the house that it cannot be moved and hense [*sic*] turned my private dwelling into a public museum." Dreier, letter to Theodore Sizer, April 17, 1941. Box 39, Folder 1125, Katherine S. Dreier Papers.

6 Dreier, letter to William M. Hekking, July 26, 1936. Box 17, Folder 482, Katherine S. Dreier Papers.

7 Duchamp, letter to Dreier, August 8, 1939. Quoted in Herbert, Apter, and Kenney, *Société Anonyme*, p. 22.

8 See Liena Vayzman, "Katherine S. Dreier's Vision for a Country Museum: Integrating Avant-Garde Art and Modern Life in Rural Connecticut," *Yale University Art Gallery Bulletin*, 2002, pp. 51–61.

9 Everett Victor Meeks, letter to Carl A. Lohmann (secretary of Yale University), February 14, 1941. Box 61, Folder 534, Records of Charles Seymour as President of Yale University (RU 23).

10 Hekking, letter to Dreier, September 25, 1940. Box 17, Folder 476, Katherine S. Dreier Papers.

11 Dreier, letter to Seymour, n.d. [c. March 8, 1941]. Box 40, Folder 1142, Katherine S. Dreier Papers.

12 Dreier, letter to Seymour, July 26, 1941. Box 61, Folder 534, Records of Charles Seymour as President of Yale University (RU 23). Since his arrival at the Yale University Art Gallery, in 1928, Sizer had made a priority of keeping New Haveners apace with contemporary art seen in New York galleries. Loan exhibitions at the Gallery in the 1930s included Paul Klee, Giorgio de Chirico, living American artists, and modern art owned in New Haven. Sizer probably knew of Dreier's collection before he met her; he was certainly more familiar with its artists than either Meeks or Lohmann. He often visited New York, Hartford, and Boston galleries that showed contemporary art, and probably saw the Société Anonyme exhibition of 1939 at either its Springfield or its Hartford venue. See Eugene R. Gaddis, *Magician of the Modern: Chick Austin and the Transformation of the Arts in America* (New York: Alfred A. Knopf, 2000), pp. 318, 335–36.

13 Dreier, letter to Sizer, June 11, 1941. Box 39, Folder 1125, Katherine S. Dreier Papers.

14 Sizer, letter to Dreier, July 22, 1941. Box 39, Folder 1125, Katherine S. Dreier Papers. Henri Focillon was a visiting scholar and professor in the newly formed History of Art department at Yale and had a key role in shaping its curriculum. Dreier's gift complemented his book *La Vie des formes* (1934), translated into English (1942) by George Kubler, then a young professor in Yale's new department. Included in its curriculum was a course requirement for art history majors in twentieth-century art, for which Yale had no teaching collection. The arrival of the Société Anonyme Collection in late 1941 made a significant difference as a teaching resource.

15 Sizer, memorandum to Seymour, July 23, 1941. Box 61, Folder 534, Records of Charles Seymour as President of Yale University (RU 23).

16 Sizer, letter to Wilmarth S. Lewis, July 23, 1941. Box 61, Folder 534, Records of Charles Seymour as President of Yale University (RU 23).

17 Lewis, letter to Dreier, July 31, 1941. In another letter written the same day, Lewis wrote to Seymour of a visit to The Haven and Dreier's proposal: "Miss D. is, I suppose, a little mad, but it would be a great feather in our cap if we could get her collection." Box 61, Folder 534, Records of Charles Seymour as President of Yale University (RU 23).

18 Sizer, letter to Dreier, August 4, 1941. Box 39, Folder 1125, Katherine S. Dreier Papers. In the same letter, mindful of Yale's School of the Fine Arts, Sizer suggested to Dreier that a collection such as hers needed "to be kept alive by the addition…of similar creative work."

19 Once the collection had come to Yale, Dreier forwarded Hartt's salary to the university, which dispensed it to him.

20 Dreier, statement of her conditions for transfer of the Société Anonyme Collection to Yale University, draft of August 8, 1941, and Dreier, letter to Lewis,

August 8, 1941. Box 61, Folder 534, Records of Charles Seymour as President of Yale University (RU 23).

21 Dreier, letter to Seymour, October 14, 1941. Box 61, Folder 534, Records of Charles Seymour as President of Yale University (RU 23).

22 Sizer, letter to Dreier, October 22, 1941. Box 39, Folder 1125; Dreier, letter to Sizer, November 26, 1941. Box 39, Folder 1129, Katherine S. Dreier Papers.

23 At Sizer's urging, the Advisory Board of the Associates of the Yale Art Gallery published an extra issue of the *Bulletin*, the Art Gallery's periodic publication, as the catalogue of the first Société Anonyme exhibition, using it to inform members that the Gallery had adequate space to store and exhibit new gifts. On November 14, 1941, Sizer noted in a letter to Lewis, "I feel very strongly that if we do not let prospective donors know our intentions, we will lose a number of very important collections." Box 3, Folder L, MSG 453, Theodore Sizer Papers, Manuscripts and Archives, Yale University Library. The Art Gallery was planning to expand; objects in its collection were stored in several buildings on the campus, but the preceding spring the Yale Corporation had accepted the architect Philip Goodwin's plans for completing the 1928 building.

24 On November 29, 1941, acknowledging both Yale's need for the Société Anonyme Collection and the risk in taking it, Sizer wrote to Art Gallery Advisory Board member Walter Brewster, "I am anxious …to tell you about the Katherine Dreier situation and the acquisition of the collection of the Société Anonyme — a matter of some four hundred and fifty paintings, prints and pieces of sculpture. At one bound we have become an important repository of contemporary and experimental works of art. …This collection, some of which is rubbish and other portions of great importance, will do much to revitalize the situation.…I am sure we will be in for a lot of criticism." Box 1, Folder B, MSG 453, Theodore Sizer Papers.

25 A. Elizabeth Chase, letter to Dreier, n.d. School of the Fine Arts Papers, Manuscripts and Archives, Yale University Library, Box 4, Folder 17, YRG 18A, RU 189.

26 Sizer, letter to Lewis, January 23, 1942. Box 3, Folder L, MSG 453, Theodore Sizer Papers. Hartt told Chase that although the students were "a bit taken aback by the new expression, they are respectful and receptive." Hartt, letter to Chase, January 19, 1942. Box 12, Folder 477, Katherine S. Dreier Papers.

27 Sizer, memorandum to Seymour, July 23, 1941. Box 61, Folder 534, Records of Charles Seymour as President of Yale University (RU 23). Sizer had hired Chase in 1931 to develop educational programs for students in public and private schools, clubs, and community organizations throughout Connecticut.

28 Scarcely had the 1942 exhibition closed when Dreier wrote to Sizer asking how her pictures were to be hung, as this was "part of our agreement." Dreier, letter to Sizer, February 19, 1942. Box 12, Folder 477, Katherine S. Dreier Papers. In an earlier letter, from February 9, she had reminded Sizer that there was to be a room where her pictures could be rotated; she also liked the idea of rotating the Italian late-medieval pictures in the Jarves Col-

lection and those of the Société Anonyme. Box 39, Folder 126, Katherine S. Dreier Papers.

29 For a 1948 Yale University Art Gallery exhibition celebrating past and present directors of the Société Anonyme, Dreier presented one of three Trowbridge lectures, the other two lecturers being James J. Sweeney and Naum Gabo. The series was later published in Dreier, Sweeney, and Gabo, *Three Lectures on Modern Art* (New York: Philosophical Library, 1949).

30 Dreier and Duchamp, *Collection of the Société Anonyme: Museum of Modern Art 1920*, ed. George Heard Hamilton (New Haven: Yale University Art Gallery for the Associates in Fine Arts, 1950). Box 61, Folder 534, Records of Charles Seymour as President of Yale University (RU 23).

31 Sizer, memorandum to Seymour, September 22, 1941. Box 61, Folder 534, Records of Charles Seymour as President of Yale University (RU 23).

32 In a undated typed recapitulation of a conversation with Sizer perhaps in early August 1941, apparently an aide-mémoire for her use in the future, Dreier reconstructed their discussion about the terms of the gift to Yale: "Mr. Sizer said: Although no mention was made of your personal collection, I assume this is a part of the gift. The two supplement each other so well should be retained intact in perpetuity." Box 93, Folder 2369, Katherine S. Dreier Papers. As mentioned above, when Duchamp, as cotrustee with Dreier of the Société Anonyme, had given his approval for the transfer of the Collection to Yale, he had advised that her personal collection be kept aside.

33 Dreier continued to express disappointment that Yale could not accept the balance of objects not in the Société Anonyme Collection proper in 1942. Dreier, letter to Sizer, April 4, 1942. Sizer was especially interested in acquiring Dreier's library of books on modern art, enviable for its time; unfortunately it was dispersed at her death, and no inventory of its contents survives. Sizer, letter to Dreier, April 7, 1942. Both letters in Box 39, Folder 1126, Katherine S. Dreier Papers.

34 Referred to as the "Directors exhibition," the 1948 exhibition was re-created as closely as possible at the Yale University Art Gallery in the winter of 2002, a project organized by Jennifer R. Gross.

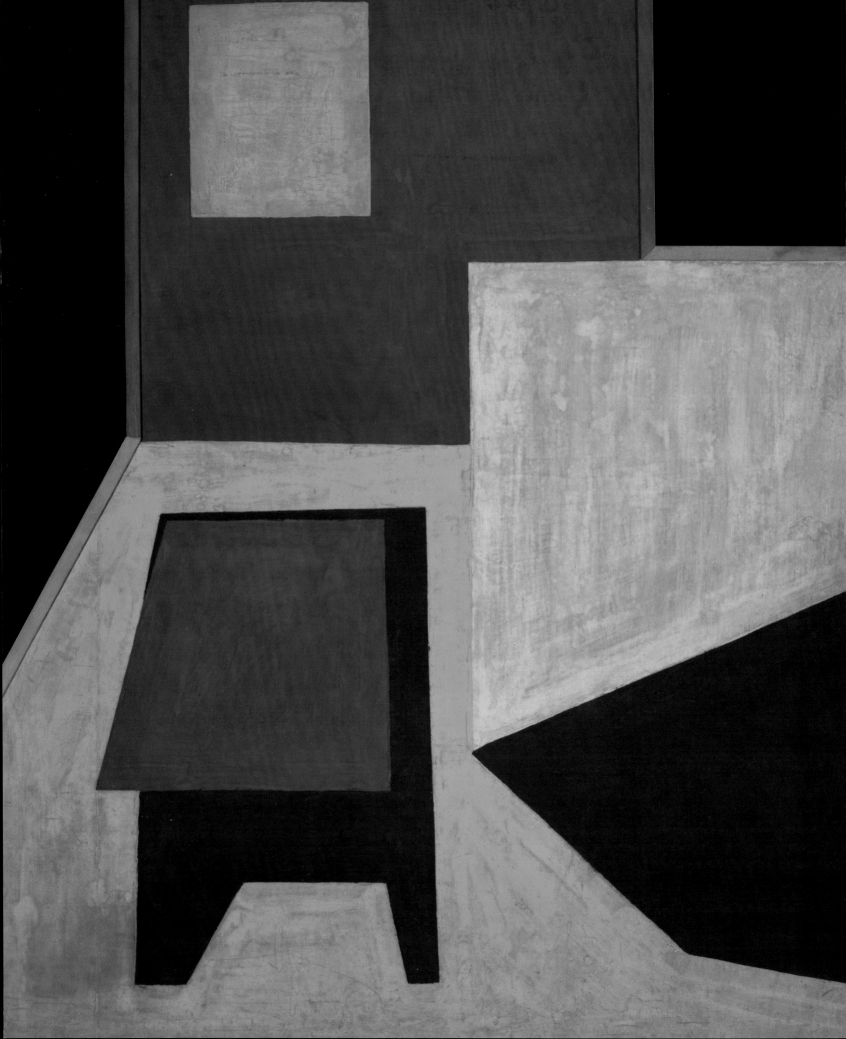

The Artists' View Sylvia and Robert Mangold on the Société Anonyme Collection

Jennifer R. Gross with Susan Greenberg

Sylvia Plimack Mangold and Robert Mangold were undergraduates at Yale in the decade that followed the Katherine S. Dreier Bequest and have been consistently active in the University's art community.

August 11, 2004

Jennifer Gross When I called about talking to you on the Société Anonyme, was there any artist or concept that leapt to your mind, whether from your experience of studying at Yale or just in general?

Sylvia Mangold Oh, Bob had to remind me what it was.

Robert Mangold We'd seen individual works, and we might have known vaguely what the Collection was, but I don't think we'd ever seen it as such.

JG You said earlier that John Covert jumped to your mind as an artist you recalled, with works like *Brass Band* [fig. 2].

RM That's true.

JG But when you both were here at Yale, the Société Anonyme was not an entity you knew about?

SM I was really moved by Duchamp's painting *Tu m'* [see fig. 3 in Bohan's essay in the present volume]. I wrote a poem about it and I was thrilled with it. But as much as *Tu m'* was influential for me, I didn't connect it with the Société Anonyme.

JG You just thought of it as a work by Marcel Duchamp. So the next question I wanted to ask you is irrelevant: what did you learn about the history of modernism through your exposure to the Société Anonyme? Really, you didn't — or at least you didn't recognize that you had. It was just that there were works in the Collection that you loved.

RM The works in the Art Gallery were important. I was reading books in the library on Surrealism and Dada, and taking classes that dealt with them, so seeing these works was reinforcement. I was sold on the art but I didn't know how it had gotten there.

JG So even though you studied with George Heard Hamilton, who was the first curator of the Société Anonyme Collection at Yale, the Société Anonyme as such didn't register in your mind. You'd been shown objects from the Collection but you had no idea what had brought them together.

SM Looking back, now that we've gone through a certain amount of history, the ambitions of the Société Anonyme are much more significant to us. The goals are important to us as artists at this point in our lives. Katherine Dreier writes about the relationship of idea to patent, and how the person who gets the recognition isn't necessarily the only person who conceived the idea — just the person closest to the news, in a way — and there are all these other people who reinforce the idea and contribute to it who are unknown. It's very nice that she wanted to keep them alive in this time capsule.

RM We recently went out to see *Beyond Geometry: Experiments in Form 1940s to 1970s*, at the Los Angeles County Museum of Art.

SM We lived through that time, so we know how true the show is to our experience.

RM What was really nice about the show was that it was inclusive rather than

fig. 1
Laszlo Peri. *Room (Space Construction) (Zimmer)*. 1920–21. Tempera on composition board, 39 x 30 in. (99.1 x 76.2 cm)

fig. 2
John Covert. *Brass Band.* 1919. Oil, cord, nails, and possibly tempera over gesso, on commercial pieced wood covered in cardboard, 26 x 23 ¹³/₁₆ in. (66 x 60.5 cm)

exclusive. It put up a lot of people's work. As that period is usually shown, you see just the highlights, or what the curators think are the highlights. What was interesting at LACMA was that there was a lot of work by people who aren't center stage right now. And it represented the individual artists well: you got a sense of Larry Weiner as someone who made these early paintings, and now we know the work that he's come to be recognized for.

SM There were others who weren't in the show, like Paul Mogenson.

RM His work was important. Bob Hout was another painter who showed a lot in those years. So the show could have been bigger and broader yet, but it was a good museum attempt. By being inclusive, bigger, and broader, it was much more true to the times.

JG Right, it represented that moment in history rather than the digested portion of the history that everyone has come to know. Something like that has been my experience in going through the Société Anonyme Collection again. There are no assumptions about individual merit. We haven't discovered many unrecognized master artists, but my whole perception of what the definition of modernism was back then, and of what the range of operation was, is much more clear.

SM I also wonder how much of the truth people really want.

JG Because we can only handle so much information anyway?

SM Looking at something in every area — it kind of takes away the esteem of something when you know too much truth about it. You read correspondence, say, and it humanizes people but it also demythologizes them. I think the recording of history tends not to want truth. I love the truth, but I get into a lot of trouble.

JG I think you've said clearly that for the Société Anonyme to have recorded the greater landscape of modernism, and held it in one place — it's comforting that that recognition can happen. You can only hope it can also take place for your generation of artists. But these not-so-well-known people who are now all together and seen as part of the same community: what is the relative merit of seeing them that way now?

RM When you're in a community of artists at a certain time, you go to each other's shows, visit each other's studios, you all exist on a somewhat equal basis, you're all involved in what's happening. You're obviously more connected and closer to some people's work than to others, but —

JG You're all doing the best you can.

RM Right. And there's a mutual respect. So that when you see all the Société Anonyme work, obviously Duchamp and Dreier and whoever else had to do with the selecting, but there was a kind of mutual respect among all of these people. Maybe as time goes by you think, "Well, what did they see in this person?" but at the time that person was a contributor, and we can't possibly know the enormity of that contribution. We have just one or two works to look at and say, "Well *I* don't see it that way," but in fact it was there and it contributed to the growth of everybody else.

SM When Bob was looking at that painting by Johannes Molzahn [fig. 3], he was looking at how the painting served Molzahn, and also at how it might act as an inspiration for himself — whether he could take something away from it and put it to use. The painting itself might not be so impressive, but Bob saw something in it.

JG The effort had a value.

RM As an artist, you grow from seeing all of your contemporaries' work. You go to the shows. You may think it isn't as good as the last, or something like that, but it's part of the whole evaluation, growth, visualization, intellectualization, and development that you go through as an artist. You learn to discern, you learn to pick out — you can't do that by yourself. You can't just be in your studio and do that; you have to be able to see other work. You measure what you're doing against it, think about what you're

doing in relation to it. So all of that work becomes important.

SM When you look at the Société Anonyme Collection, and you see work that's not so good, work that's medium, and work that's extraordinary, it does the same thing. This wide range of participation really is inspiring.

JG But if this unfiltered availability of work is inspirational to the artist, does that mean that art history is actually counterproductive for creativity? It's all been predigested. When artists study art in a museum, they only get a specific measure —

RM Yes. You don't get all Bob Dylan's albums, you get the greatest hits.

JG Right. And you can only learn so much from that.

SM I like that point a lot.

RM Whenever you can contain, encapsulate, a period with not just the stars, not just the people who were having grand exhibitions, but a fuller representation of what was going on, it gives you something very different from what you'd find anywhere else.

JG It's an exciting time for the Collection, because I believe that what Dreier and Duchamp set out to do is now being actually achieved. With this exhibition going on the road, this is the first time that the Société Anonyme is going forth as an entity, as they set it aside to go forth. The Collection is more than a thousand objects, and two hundred will be traveling. It's been sobering to comprehend how hard they worked for this. And they got very little support for their efforts. Even up to the very end, they were cynical about depositing the Société Anonyme legacy at Yale, because they had no hope for what the museum could do for them. Their instincts were initially correct; for a while the Collection was not well tended. But Yale did keep it together and now these works are preserved and can be seen, and no one's manipulated the selection to tell an art history. What Dreier and Duchamp did serves the practice of the artists, *all* of the artists, with great respect.

[*We are moving through the painting racks of the Collection.*]

RM Whose is that?

JG Laszlo Peri [see fig. 1]. Never heard of him, huh? Isn't that fabulous? You should be interested in this painting. I love this painting.

SM I do too.

JG It's 1920–21 and it's called *Room*.

RM That's a real find.

RM Is there more of his work?

JG Just a small work on paper.

RM And he was from where? Hungary?

JG And lived in England during the war.

SM You know, the good ones really pop out.

JG This is a painting by a Russian Cubist, Nadezhda Udaltsova [see fig. 15 in Tashjian's essay in the present volume]. You may have seen it.

Susan Greenberg It was in the show *Amazons of the Avant-Garde*, at the Guggenheim in 2000–2001.

JG I think young painters are going to love this one, by Jay Van Everen [fig. 4]. It's from the early twenties — doesn't it look like it was made yesterday in L.A.?

RM Yes, I think a lot of people will connect with it, in a way you do with work you never knew existed.

SG There's a nice Jacques Villon up here, *Color Perspective* [fig. 5].

RM I love that. I like his work.

SM The work that looks so good today is especially flat and frontal.

RM It could be our taste.

SM Well, you'd think I'd like the more illusionary pictures.

SG Like Juan Gris's *Newspaper and Fruit Dish* [1916; fig. 6]?

fig. 3
Johannes Molzahn. *Happening (Geschehen)*. 1919.
Oil and aluminum leaf on canvas, 55⅛ x 59⁵⁄₁₆ in.
(140 x 150.7 cm)

fig. 4
Jay Van Everen. *Abstraction* or *Lady in Abstract*.
c. 1921, reworked c. 1923–26. Oil on canvas, 36 x 50 in.
(91.4 x 127 cm)

fig. 5
Jacques Villon. *Color Perspective (Perspective colorée)*.
1922. Oil on canvas, 23¹¹⁄₁₆ x 36¼ in. (60.2 x 92.1 cm)

SM I know that's a really good painting, but I keep going back to the Villon. The color is so wonderful.

RM Villon was a great colorist. His paintings are modest, in a way, and very clean and clear and well thought out.

SG Oh, here are the Coverts.

RM He was one of my favorites. I remember seeing *Brass Band*.

SG It was up in the galleries?

RM I'm pretty sure it was. When I was a student I was very influenced by Stuart Davis, and Léger [fig. 7], so this kind of fit in — those almost industrial pipelike forms that fit together in a certain way.

SG Here's Louis Eilshemius [fig. 8].

fig. 6
Juan Gris. *Newspaper and Fruit Dish.* 1916. Oil on canvas, 36¹³/₁₆ x 24 in. (93.5 x 61 cm)

RM So he was in the Société Anonyme?

JG Yes, he was a fixture. He gave lectures and had a few one-person exhibitions. They even took his paintings to Europe.

SG Actually the first one-person exhibition the society did was his.

RM The paintings are wild, though. They're out of a time warp, some really strange world of its own.

JG And again, I think his peers admired him for his unique character.

RM It compares with the love of Rousseau in turn-of-the-century Paris. There was this innocent creativity, totally different from the professional world.

JG Are there any contemporary collections that emulate or are a modern variant on the conception of the Société Anonyme as an artists' initiative? You mentioned thinking that the democratic approach of Carol and Sol LeWitt's collection was reminiscent of the impulse of Dreier and Duchamp.

RM I think that's true. Wherever they went, wherever Sol had shows, he would come back with new artworks. And there's a broadness to Sol's approach to art anyway. The collection is not just Minimal, not just Conceptual — it spreads over a wide field of what's been happening. It covers a lot.

JG I also think a lot of the artists in the LeWitts' collection were untried in terms of the art world when they collected them. I assume they were responding to the passion of the individual whose work they were acquiring.

RM I think that's true. And you know, I guess the other collection you might think of in relation to the Société Anonyme would be Herbert and Dorothy Vogel's collection, which is now at the National Gallery in Washington. It started in the sixties and covers a broad period of time. Generally the works aren't gigantic; they tend to be smaller.

JG Did they collect your work?

RM Yes, quite a bit.

JG It's a phenomenal collection in the range of material and the depth —

RM They have hundreds of works. And they did it with very little money.

JG No money, yet the artists I know in that collection are very much inspired by the moral support they lent. Dorothy and Herb's constant enthusiasm for them was a real encouragement.

RM I think that's true. They followed the artists' careers, they considered them their friends —

JG And family too, I think, like the Société Anonyme. Thinking of both the LeWitts' and the Vogels' experience, it's worth comparing the art world of New York in the early seventies with the Société Anonyme period. At both times there was a sense of community. There wasn't a lot of money and there were pockets of democratic community support.

RM When we and most of the people we knew came into the art world, things didn't sell very easily. There wasn't a big market. But that allowed you to trade works, and it let people buy works for very little money. The art world is financially more stable now, which is good for the artists, but you lose that kind of —

JG Fluidity and dialogue.

SM Money is connected to art now in a way it never was before.

JG If there's really nothing like the Société Anonyme in existence today, is it because artists are better supported and there's no need for that kind of advocacy?

RM Well, I'm sure there are communities of artists around institutions of different kinds, people who live and teach in one place, but I don't think it's the same. But maybe I shouldn't say, because I'm not part of the younger art community. Maybe there's a kind of community of artists in, say, Brooklyn who support each other.

JG It's been my experience that because just living today is so expensive, people

fig. 7
Fernand Léger. Study for *The City* (Etude pour *La Ville*). 1919. Watercolor, gouache, ink, and graphite on paper, laid down on cardboard, 15 1/2 x 11 5/16 in. (39.4 x 28.7 cm)

fig. 8
Louis Michel Eilshemius. *Mountain Landscape*. c. 1914. Oil on paper, laid down on laminated cardboard, 8 7/8 x 8 3/4 in. (22.5 x 21.3 cm)

have to work so hard on maintaining and moving their own lives forward that they don't necessarily have that much time for the integrated community.

RM The idea of the career seemed so remote to us. We all knew we could be painters, sculptors, whatever it was we wanted to do. We knew that we could get a part-time job and we could do it. That was no problem. But the idea of having a career.... It wasn't that we didn't want to have shows, or be in the magazines, or any of that, but the idea seemed so remote, it wasn't foremost on one's screen. We thought, "Oh, wouldn't that be great?" or, "Wouldn't that be wonderful?"

JG I don't see the phenomenon of a group of artists who feel committed enough to their generation of artists that they make the effort to try to address the lack of understanding in America for their work. It's not a cause to which they want to put their efforts. Do you think it's cynicism that keeps anything like that from happening today?

RM Well, in the world in general there isn't the kind of resistance there used to be. There isn't the question "Is this art?" that was raised about Joyce's *Ulysses*. That doesn't exist today. Or, well, it may exist in Texas or the White House, but it doesn't exist on the broad scale. People accept Andy Warhol as a celebrity. Everybody knows who he is.

JG So it doesn't really come up as an option.

SM The thirties and forties were also a time that was politically charged with the ideas of socialism, the idea of sharing. There wasn't the disillusion we now have. That very idealistic spirit in the Société Anonyme, I don't know that there's such a thing today. If you tried to get something like that group going today, everyone would look at you suspiciously, thinking, "What's he going to get out of it?"

RM Thousands of people, maybe millions, go to the Venice Biennale or Documenta, and they see a lot of "cutting edge" work, wherever that is, and they aren't shocked by it; in fact, they're kind of blasé about it. They just think, "Ho hum, that's what artists are doing." There's no resistance. Sometimes I think resistance is good. I can remember doing work and if everybody came in and said they liked it I was immediately skeptical. There was this idea that if they liked it, if it was too easily liked, there had to be something wrong. There was the feeling in the Société Anonyme period that abstract art would change the world, and that socialism and communism would change the world. I don't think anybody really believes that democracy's going to change the world. We know what democracy's going to bring. It's not going to be any big surprise.

JG How about art?

RM I don't think there's any equivalent wave that people feel is really going to change the way people see life.

SM Well, you could look at good design. Good architecture changes people's lives, and so changes life. I think there's truth in that.

JG But how about painting and sculpture, which were more the focus of the Société Anonyme? Do we believe those things can change our lives?

RM I think you can go into a gallery, you can see a piece somewhere, and it'll stick with you. It can be something that you know is very important, visually and artistically. You can go into a museum and see a piece of Egyptian art, or a Piero della Francesca — see it once and it'll be in your head forever. That experience is always there, and it's a guiding experience that artists want their work to have. But the cumulative thing that you're talking about, the feeling about abstract art that it was new and was going to foster a better life, a more orderly, more aesthetically beautiful life, that somehow we were going to open up to something —

SM When people respond to art it does change them, but —

RM It's on an individual basis.

fig. 9
Marcel Duchamp. *Genre Allegory (Allégorie de genre)*. 1944. Collage, 12¹/₂ x 9⁷/₁₆ in. (31.8 x 24 cm)

SM People support creativity in their homes; there's more respect for art than there used to be.

JG There certainly is more art in people's homes, I think, more consciousness of aesthetics and its value. That was a major push of Dreier's, to bring modern art into the home. And there's definitely a broader appreciation for modernist design as an appealing aesthetic.

RM But at the time of the Russian Revolution, all those artists were on the inside of things. There was a sense that they were building a new country and that art was going to be a part of it. And there was a kind of idealism. It must have been a unique and wonderful situation. Everything was connected; there was this sense that in the new government, poetry, music, painting, design, and whatever were going to bring about a better way of life.

SM And there was the Bauhaus —

RM And Vienna. There were all these centers where designers and architects were coming together, and there was a sense of mission. You can go to any art school in the world today and I don't think you'll find that.

JG Another thing that Dreier was committed to, well into her sixties, was teaching, and the last suite of classes she taught was art appreciation for a girls' junior college here in Connecticut. She and Kandinsky wrote about aesthetics as a weapon against materialism in the Western world. They had a very heated correspondence, and Kandinsky wrote that everything would have to come to a negative point before we could rise out of the ashes culturally, and that America was one of the places where that might happen first, because materialism is so rampant here. So we'd self-combust, and then art would bear the hope of sort of reclaiming the cultural profile of the Western world.

RM I like that. I wish I believed it, but I like it.

JG So that kept her teaching. And when she couldn't even walk she wrote this letter in her late sixties saying, I am teaching these girls because I am trying to save them from the vice of American materialism.

RM Maybe we're still falling into the pit — materialism seems stronger worldwide than it's ever been.

SM We're so brainwashed. It's all about manufacturing objects to be acquired and then discarding them and acquiring again. And it's everywhere.

SG The Internet contributes, the fact that you can order anything you want, any time, anywhere.

JG Certainly it seems like art's become one of the ultimate material commodities.

RM I know, it's very depressing. I can't complain, but when you see the auction prices of contemporary art, it's shocking.

JG It's incomprehensible.

SM But that's not art's fault.

RM Well, it's not the artists' fault, but they're in this. We're in this society, we're part of it. We're no longer the bohemian fringe of society, we're right in the middle of it.

SM Well, but what about the need to make art? What about wanting to spend your days painting?

JG Is there anything that you saw in the Collection by an artist you knew that changed your mind or surprised you about their practice or their work? We didn't look at as many of the familiar artists as we did the unfamiliar artists.

SM Some of the art by Marcel Duchamp. That collage [*Genre Allegory*, 1944; fig. 9] was so graphic. And Kurt Schwitters, he becomes even more significant for those paintings we saw today, particularly *Merz 1003 (Peacock's Tail)* [see fig. 20 in Wilson's essay in the present volume], than he was for the collages I knew. I also enjoyed seeing the David Burliuk [fig. 10], because he was an influence for me very early on.

fig. 10
David Burliuk. *South Sea Fishermen.* 1921.
Oil on burlap, 42⁷⁄₈ x 68⁵⁄₈ in. (121.6 x 174.3 cm)

fig. 11
Marthe Donas. *Still Life with Bottle and Cup.* 1917.
Lace, sandpaper, cloth, netting, and paint on compo-
sition board, 20⅞ x 15³⁄₁₆ in. (53 x 38.6 cm)

RM I must say I probably didn't have a strong opinion of Jacques Villon, but what I saw was quite eye-opening for me.

JG Is there an artist you think deserves a little revival or revisiting?

RM Laszlo Peri. Some of the women would be interesting to revisit, like Marthe Donas [fig. 11]. I'd like to see more of her work.

SM Stefi Kiesler [fig. 12].

RM There's a richness of diversity that you probably wouldn't get in a book on the period. I'm kind of amazed that Duchamp would even tolerate a lot of this work, so somehow my vision of Duchamp, what I've learned about him, isn't correct. His and Dreier's view of that time had a bigger spread than what we normally see.

JG I don't think he did tolerate a lot of the work in the Collection, but what was included didn't matter to him as much as making sure certain things weren't excluded. As long as the things he felt were important were in there he was happy with the general spread, and actually worked for it. The collective built on the extreme difference between the aesthetics of Duchamp and Dreier, and of the other artists who advised them. They recognized that we all have biases, and that history naturally is biased, but they felt that by working cooperatively they could achieve a greater good.

SM Is there anyone you think should have been included who wasn't?

JG Gosh, I've never thought of it from that perspective. It's funny to think of it that way. I guess I'm sad that there's not a better representation of Stuart Davis. I definitely see that as a gap. I don't think it was strategic that the Americans got left out, I think it was the attrition of effort. They could only do so much. They desired the Collection to be broad ranging, but inevitably they got tired.

RM I also think the initial idea was, "Let's bring this art to America so the artists there can see it, so it can affect the art community there." They were bringing the art over first. Then only after that they were looking for the results of this collision of art.

JG Do you think Yale has lived up to the legacy of Société Anonyme in its stewardship of the Collection?

RM I guess I would say no, because I've never heard or seen enough of it. I've never seen it promoted or publicized or exhibited in the proper way.

SM Yale did keep it together.

RM A lot of institutions wouldn't have accepted the whole thing.

JG Well, I think that was an issue.

RM So I guess in a sense Yale fulfilled its obligation. I just think that in terms of educating the art community it would have been better if they'd shown the work more often.

JG Is there anything that would benefit the life of the Collection at Yale from here on out?

RM When I was in history classes here, we were given assignments to go write about a work in the museum. But I could imagine that if there was a room with this Collection, a changing group, students would get involved in some of these very obscure people, and would find it very exciting to open up their world instead of writing about somebody we all know.

SM Sometimes students don't necessarily want to do big paintings, they want to make intimate, modest, small-sized paintings. So they might want to look at that Eilshemius, at the things he does with the edge, where he paints around it and then has the ground showing and then paints these abstract landscapes with these tiny little figures —

JG A room like that would be liberating.

fig. 12
Stefi Kiesler. *Typo-Plastic*. c. 1925–30. Black and red typewriter ink, 10⅝ x 8¼ in. (27 x 21 cm)

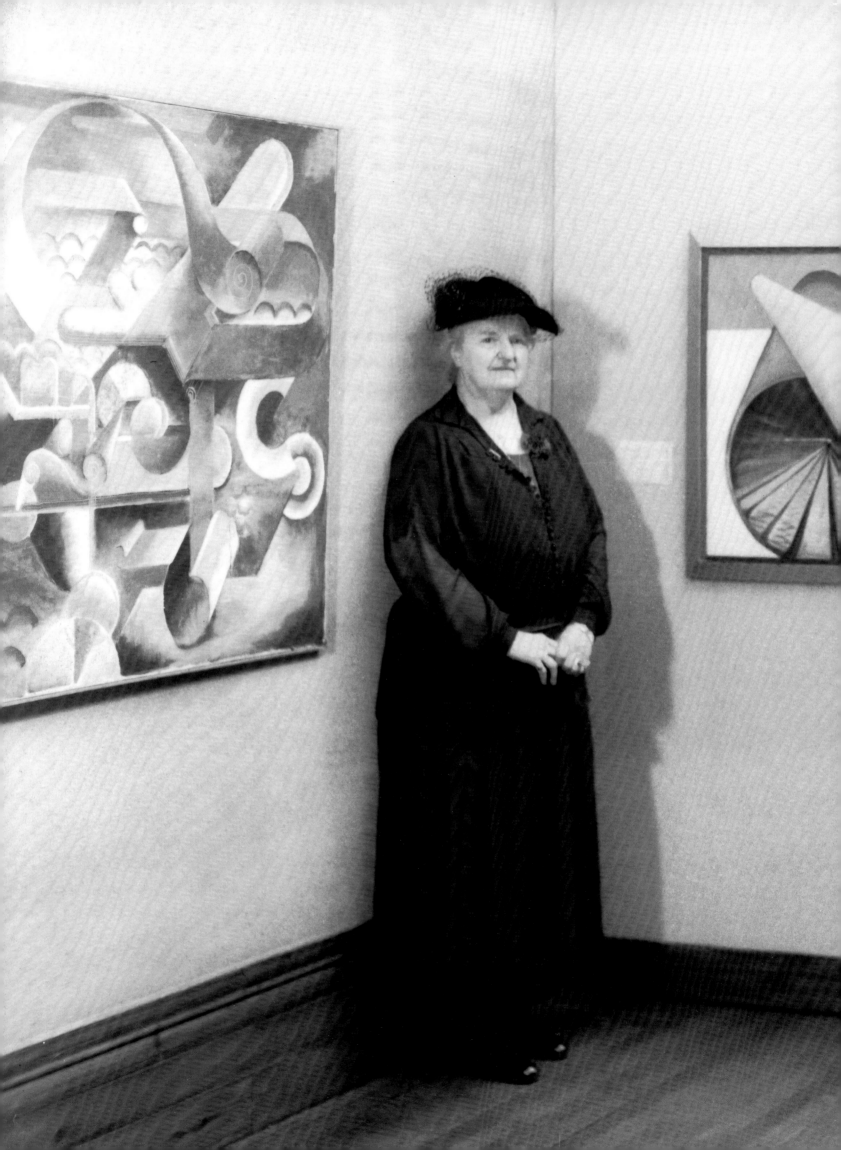

Artist Biographies

Susan Greenberg
Kristin P. Henry
Bryony W. Roberts

Katherine S. Dreier in the gallery of *The Exhibition of the Collection of the Société Anonyme—Museum of Modern Art: 1920*, the inaugural exhibition of the Collection at Yale, January 1942. To her left is her own *Two Worlds (Zwei Welten)* (1930). Archives, Yale University Art Gallery

Constantin Alajálov
AMERICAN, BORN RUSSIA (1900–1987)

Born in Bakou in 1900, Alajálov began making literary illustrations as a teenager in Rostov-on-the-Don. Such anecdotal genre scenes would characterize his murals and magazine covers (beginning with work for *The New Yorker* in 1926) throughout his career. After carrying out public and royal commissions in Russia and Constantinople, he emigrated to New York in 1923. Soon after his arrival he was introduced to Dreier, probably by Burliuk. In the United States, Alajálov produced graphic work with striking Constructivist-inspired geometry. He collaborated with Dreier and Christian Brinton on designing several Société Anonyme publications, notably *Modern Art*, the elaborate catalogue accompanying the 1926 *International Exhibition* at the Brooklyn Museum. KPH

Josef Albers
AMERICAN, BORN GERMANY (1888–1976)

Originally from Bottrop, Germany, Albers moved to Berlin in 1913. That year, despite having trained as a primary school teacher, he began to paint abstractions after seeing modernist art in Berlin galleries. He studied art in Berlin, Essen, and Munich, and in 1920 he began an apprenticeship at the Bauhaus. He soon became an instructor in materials and design at the Weimar school, then became a full professor when it moved to Dessau, working successively in glass, typography, and furniture design until the school closed in 1933. That year he emigrated with an invitation to teach at North Carolina's new Black Mountain College, where he began a lifelong relationship with Dreier. In 1950 he joined the Yale Art School as the head of the Department of Design. KPH

Alexander Archipenko
RUSSIAN, LIVED FRANCE AND UNITED STATES (1887–1964)

Archipenko was born in Kiev in 1887 and emigrated from Moscow to Paris in 1908. Beginning in 1910, he exhibited sculpture at the Salon des Indépendants and at avant-garde venues in Amsterdam, Berlin, Rome, New York, Budapest, and Prague. He established an art school in Paris in 1912, taught in Nice during the war, and moved to Berlin in 1921. His polychrome reliefs in "direct-carved" wood, plaster, and metal redefined sculptural form in the language of Cubism. In 1920 Dreier and Duchamp offered Archipenko his first one-man show in the United States. He settled in New York in 1923 and remained an active exhibitor and instructor, teaching in Woodstock, Los Angeles, and Chicago until his death. KPH

Harlequin and Woman. 1925. Oil on canvas, 38⅛ x 27¹³⁄₁₆ in. (96.8 x 70.7 cm).

Gate. 1936. Oil on masonite, 19½ x 20³⁄₁₆ in. (49.5 x 51.3 cm).

Woman (Metal Lady). 1923. Brass, copper, wood, and silver, 54⁵⁄₁₆ x 20¹¹⁄₁₆ x 3¾ in. (138 x 52.5 x 9.5 cm).

Torso-Navel. 1921. Oil on wood, 31⁹⁄₁₆ x 20⁹⁄₁₆ x 2⁹⁄₁₆ in. (80.1 x 52.2 x 6.5 cm).

Andante V. c. 1915–17. Oil on canvas, 30¹⁄₁₆ x 32 in. (76.3 x 81.3 cm).

Soccer Players (Fussballspieler). 1927–28. Pencil and gouache on paper, 17⁵⁄₁₆ x 13⅜ in. (43.9 x 34 cm).

Jean (Hans) Arp
FRENCH, BORN GERMANY (1886–1966)

Born in Strasbourg, Arp moved to Weimar in 1905. His brief stints of formal training in Cologne and Paris were followed by a period of self-exploration in Weggis, Switzerland. There he collaborated with the Moderner Bund movement and exhibited with the Blaue Reiter group at the invitation of Kandinsky. In 1915 he moved to Zurich and joined the Dada group, publishing poetry and producing diverse work in collage, lithography, and sculpture. In the mid-1920s he was associated with the Paris Surrealists, though he maintained his independence from artistic dogma and tradition. In 1949 he visited the Société Anonyme collection at Yale and donated *Torso-Navel* to it, along with a sculpture by his wife, Sophie Täuber-Arp, in appreciation of the collection's broad scope. KPH

Rudolf Bauer
GERMAN, LIVED UNITED STATES (1889–1953)

Bauer, a cartoonist turned nonobjective painter, joined Herwarth Walden's Der Sturm group in 1915. He exhibited regularly at Walden's Berlin gallery and taught at the Sturmschule with Heinrich Campendonk, Paul Klee, and Georg Muche. Deeply influenced by Kandinsky, Bauer made lively abstractions that express emotional experience through analogy to music. In 1929 he opened his private museum, Das Geistreich, where his longtime friend Hilla Rebay introduced him to Solomon R. Guggenheim, who was to be his principal patron throughout the 1930s. Bauer visited the United States in 1936–37, and in 1939, after being released from a German concentration camp through Guggenheim's intervention, he settled permanently in the New York–New Jersey area. Bauer abandoned painting in 1940 to prevent Guggenheim from acquiring all his future work through a disputed contract. KPH

Willi Baumeister
GERMAN (1889–1955)

Baumeister studied at the Stuttgart Kunstakademie from 1905 to around 1910. Drawn more to French art than to German, he visited Paris repeatedly after an extended stay in 1911. He was personally and artistically close to Léger, whose pure style and machine forms influenced his early figurative abstractions. Like Léger, he explored mural painting, typography, graphic art, and set design while painting prolifically. From 1911 to 1928 he lived mainly in Stuttgart, but he traveled widely in Europe, exhibiting in Berlin, Paris, Zurich, and Venice, as well as in São Paulo. After teaching at the Städel Kunstakademie in Frankfurt, Baumeister was denounced by the Nazi regime in 1933. He was made full professor at the Stuttgart Kunstakademie in 1946 and painted actively until his death. KPH

Umberto Boccioni
ITALIAN (1882–1916)

Boccioni studied for four years in Rome under the painter Giacomo Balla. He soon became close to Severini and met the painters Carlo Carrà and Luigi Russolo and the writer Filippo Tommaso Marinetti, the cofounders of Futurism in Italy, who wrote their manifesto in 1910. Beginning in 1912 the group held major exhibitions in Paris, London, Berlin, Munich, Amsterdam, and The Hague, with Boccioni—as skilled a writer and speaker as Marinetti—acting as the movement's lead organizer and apologist. He was a brilliant, dynamic draftsman and the only important Futurist sculptor. Boccioni lived successively in Paris, Russia, and Milan. After serving for one year with the Italian army in World War I, he was killed in a military accident at the age of thirty-four. KPH

Richard Boix
SPANISH, LIVED UNITED STATES (1890–1973)

Little of Boix's history is known. He was reportedly born in Spain and exhibited in Madrid and Havana; by 1920 he had moved to New York and joined the Société Anonyme. Boix seems to have worked primarily as a graphic artist. He made spare, lucid caricatures of Duchamp and Man Ray in the Société's inaugural year, and in 1921 adapted these drawings for a cartoon (now at The Museum of Modern Art, New York) commemorating the symposium "Psychology of Modern Art and Archipenko," organized by the Société Anonyme on February 16 that year. Speakers Man Ray, Dreier, Phyllis Ackerman, Christian Brinton, and Hartley appear in this cartoon with Duchamp, Stella, and Eilshemius as the *New York Dada Group*. KPH

Ilya Bolotowsky
AMERICAN, BORN RUSSIA (1907–1981)

Born in St. Petersburg, Bolotowsky left Russia after the Revolution and went first to Constantinople, then, in 1923, to the United States. From 1924 to 1930 he studied at the National Academy of Design, New York, making prize-winning paintings, figurative but semiabstract. He credited his conversion to full abstraction to his encounters with Russian Constructivists in 1929 and with Miró and Mondrian in 1933. After traveling to Europe in 1932, Bolotowsky worked for the WPA Federal Arts Program under Burgoyne Diller and produced several major public murals in the 1930s and 1940s. He lived in Alaska from 1942 to 1945, and from 1946 to 1948 he headed the Art Department at Black Mountain College, North Carolina. He taught for thirty years at colleges in Arizona, Wyoming, Wisconsin, and New York. KPH

Still Life: Glass and Siphon. c. 1914. Collage, gouache, and ink on cardstock, 12 1/16 x 8 3/16 in. (30.7 x 20.8 cm).

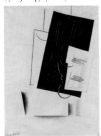

Caricature of Man Ray. 1920. Black ink on paper, 16 x 11 1/4 in. (40.6 x 28.6 cm).

Autumn. Study for mural, Men's Day Room, Chronic Diseases Hospital, Welfare Island, New York. 1940. Pencil and tempera on cardboard, 5 1/4 x 6 5/16 in. (13.3 x 16 cm).

Little French Girl (The First Step III). c. 1914–18. Oak, 48 5/8 x 5 3/8 x 9 1/4 in. Solomon R. Guggenheim Museum, N.Y. Gift, Estate of Katherine S. Dreier, 1953. 53.1332.

Black and White Collage (Verre et musique). 1913. Mixed media on laid Ingres paper, 28 11/16 x 18 3/4 in. (72.9 x 47.7 cm).

Autumn Chilliness. 1916. Oil on canvas, 27 5/8 x 27 1/2 in. (70.1 x 69.8 cm).

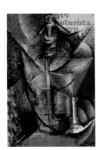

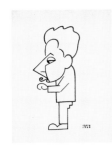

Constantin Brancusi
ROMANIAN, LIVED FRANCE (1876–1957)

Born in Hobitza, Brancusi studied at the Craiova school of arts and crafts until 1898 and graduated from the Bucharest school of fine arts in 1902. By 1904 he had arrived in Paris, where he met Auguste Rodin, whose offer of apprenticeship, however, he rejected. By the end of World War I, Brancusi had mastered the materials of stone, polished metal, and wood to create an exquisitely refined, radically simplified formal language. He exhibited regularly in Paris and Romania and was featured in the New York Armory Show in 1913. His first one-man show was at Stieglitz's Photo-Secession Gallery, New York, in 1914. Dreier most likely met Brancusi through Duchamp, in Paris, in November 1919, when she bought *Little French Girl*, a work she then included in the inaugural Société Anonyme exhibition in 1920. SG

Georges Braque
FRENCH (1882–1963)

Born in Argenteuil-sur-Seine, Braque spent most of his life in Paris. Early in his career he exhibited Fauvist paintings at the Salon des Indépendants. By 1909 he had befriended Picasso and was experimenting with Analytic Cubism, inspired by the work of Cézanne. Though initially rejected by the Salon d'Automne, Braque's Cubist paintings gained critical acclaim when shown at Daniel-Henry Kahnweiler's gallery in November 1908 and at the Cologne Sonderbund in 1912. In 1913, soon after making his first collages, he exhibited at the New York Armory Show and immediately impressed Dreier, who would feature his work in sixteen Société Anonyme exhibitions before 1930. BWR

Dora Bromberger
GERMAN (1871–1942)

Born in Bremen, Bromberger appears to have spent most of her life in her hometown. She studied in Munich for a few years and met Dreier there around 1920. Beginning in 1924 the Société Anonyme arranged for Bromberger's paintings to be exhibited in New York, for which the artist repeatedly thanked Dreier in the two women's correspondence. Her ambition to become a full-time painter was thwarted, however, by Nazi discrimination against Jewish artists. When Bromberger was denied exhibition space in Germany in the 1930s, Dreier purchased several works for the Société Anonyme collection to ease her financial burden. She died in Minsk, Russia, presumably in exile. KPH

Patrick Henry Bruce

AMERICAN, LIVED FRANCE (1881–1936)

After receiving academic training in Richmond
and New York, Bruce moved to Paris in 1904. He
painted conservatively until 1907, when he met
Gertrude and Leo Stein and, prompted by their
collection of radical art, enthusiastically embraced
modernism. In 1908 he enrolled in the Académie
Matisse and in 1912 he joined the circle of Robert
and Sonia Delaunay. Fascinated by the forms and
rhythms of modern dance, which he strove to
express through color, he reached artistic matu-
rity after World War I with his Compositions
series. Dreier purchased six of these paintings and
exhibited them repeatedly under the auspices of
the Société Anonyme. In 1933, isolated and
underappreciated, Bruce destroyed most of his
work and gave up painting. After three decades
abroad, he returned to New York, where he took
his own life. KPH

Composition I. 1916. Oil on canvas, 45⅝ x 34⅞ in.
(115.9 x 88.6 cm).

Carl Buchheister

GERMAN (1890–1964)

Born in Hannover, Buchheister abandoned formal
training after spending just six months at the Berlin
Kunstgewerbeschule. He served in World War I,
then returned to Hannover, an avant-garde center
where he met Schwitters, Lissitzky, van Doesburg,
Kandinsky, and Moholy-Nagy. By 1923 Buchheister
was exploring a curvilinear abstract style, which
he sharpened under the influence of Constructivist
theories espoused by his friends in the *gruppe k*.
He participated in several abstractionist collectives
before their suppression in the Nazi period, when
many of his Constructivist works were destroyed.
During World War II he painted landscapes and
portraits and served as a reserve officer, but when
peace returned he became a painting instructor
in Hannover and committed himself to reestablish-
ing abstract art in Germany. KPH

Red and Green Steps. 1925. Oil on canvas, 39 x 23 in.
(99.9 x 60.7 cm).

David Burliuk

AMERICAN, BORN UKRAINE (1882–1967)

A dynamic and sensational character, Burliuk was
a prominent member of the Russian Futurist move-
ment. With his showy earrings and trademark vests,
he was literally one of the most colorful figures in the
international avant-garde. Originally from Kharkov,
Ukraine, Burliuk studied art in Kazan, Odessa,
Munich, Paris, and finally Moscow, and subsequently
worked in as many cities. From 1910 to 1918 he
helped lead the Jack of Diamonds group, with whom
he published the manifesto "A Slap in the Face of
Public Taste" (1912) and made a seventeen-city Russ-
ian tour (1913–14) to promote modern art and poetry.
From 1920 to 1922 he traveled in Japan and the
South Pacific. The faceted geometry of Burliuk's
early modernist paintings gave way to figurative real-
ism after he emigrated to New York in 1922, and pas-
toral scenes in an impasto derived from van Gogh
dominate his late work. KPH

The Eye of God. 1923–25. Oil and sand on canvas,
39⅞ x 30¹⁄₁₆ in. (101.3 x 76.4 cm).

Big Bird (maquette). c. 1936. Painted sheet metal and
painted wire, 13¼ x 8¼ x 7¼ in. (33.7 x 21 x 18.4 cm).

Alexander Calder

AMERICAN (1898–1976)

Calder studied engineering at the Stevens Institute
for Technology in Hoboken, New Jersey, until 1919,
and then began to study art at the Art Students
League, New York, in 1923. In 1925, having become
a newspaper illustrator, he was assigned to cover
Barnum and Bailey's circus and subsequently cre-
ated a miniature sculptural circus of his own. On
moving to Paris in 1926, he showed animal sculp-
tures at the Salon des Indépendants and staged per-
formances with his circus in several galleries. In
1930 Calder joined the Abstraction-Création group
and met Arp, Mondrian, and Pevsner. He began
exhibiting "mobiles," as Duchamp named his mov-
ing sculptures, the following year. On his return to
New York, his increasingly monumental sculpture
progressed steadily toward his large-scale "stabiles"
of the 1960s and 1970s. BWR

Seated Nude. c. 1920. Oil on canvas, 15³⁄₁₆ x 17¹¹⁄₁₆ in.
(38.5 x 45 cm).

Heinrich Campendonk

GERMAN, LIVED NETHERLANDS (1889–1957)

Campendonk trained at the Krefeld arts and crafts
school and was closely associated with the cousins
Helmuth and August Macke, who introduced him to
Marc and Kandinsky in 1911. He joined the Blaue
Reiter group and participated in their first exhibition
the following year. Influenced by folk art and
Catholic mysticism, Campendonk designed murals,
stage sets, and stained glass, and was also an active
teacher. He lived in Seeshaupt and Krefeld but
exhibited mainly in Berlin's Der Sturm Gallery,
where he met Dreier in 1920. She arranged his first
one-artist show in the United States in 1925. He
was appointed a director of the Société Anonyme in
1923 and succeeded Kandinsky as second vice presi-
dent. In 1934 Campendonk fled Germany and settled
in the Netherlands. Although he continued to exhibit
in Germany after the war, he remained in Amster-
dam until his death. KPH

Man with Megaphone I (*Homme au mégaphone, Etude
I*). From designs for a mural in a cinema. 1926. Gouache
over graphite on paper, 13¾ x 9¾ in. (35 x 24.8 cm).

Otto Gustaf Carlsund

SWEDISH (1897–1948)

Born in Russia to Swedish and French parents,
Carlsund began his artistic training in Dresden in
1921. He then studied in Oslo, under Christian
Krogh, and in Paris, under Gösta Adrian-Nilsson,
before apprenticing himself to Léger and his
teaching partner Amédée Ozenfant. With Ozen-
fant's encouragement, Carlsund planned many
public and private murals throughout his career,
but none was completed. In the 1920s his work
passed through Cubist and Neoplasticist/Con-
structivist phases, and in 1929, with van Doesburg
and Jean Hélion, he founded the Art Concret
group. A major exhibition by that name in Stock-
holm in 1930 proved a commercial and critical
failure and effectively marked the end of Carl-
sund's career. KPH

Giorgio de Chirico
ITALIAN, BORN GREECE (1888–1978)

De Chirico lived in Athens, Munich, and Milan before moving to France in 1911. In Paris he produced his most important, original paintings — eerie landscapes that won the regard of Picasso, Guillaume Apollinaire, Braque, and Brancusi. He spent three years in military service during World War I and in 1918 moved to Rome, where he wrote the Metaphysical essay *Noi Metafisici* and worked with the Dadaists and Futurists. His first solo exhibition, in 1919, was a commercial failure, but he retained the loyal admiration of André Breton and the French Surrealists — who, however, deserted him after an exhibition of his increasingly classical canvases in Paris in 1925. De Chirico's work passed through Baroque and Neo-Metaphysical phases before his death, in Rome. BWR

John Covert
AMERICAN (1882–1960)

One of the most original American contributors to New York Dada, Covert studied art in Pittsburgh before enrolling at the Munich art academy in 1909. After three years in Germany and two in Paris, he returned to the United States a committed realist painter — until his introduction to the international avant-garde through the New York circle of his cousins Walter and Louise Arensberg, in 1915, when he immediately began to produce Cubist paintings and imaginative mixed media compositions. Covert helped found the Society of Independent Artists and introduced Dreier to the group in 1917. He participated regularly in Société Anonyme exhibitions after 1920. Unable to support himself financially, he abandoned painting in 1923 to join his family business, and offered four of his most important works to found the Société Anonyme collection. KPH

Jean Crotti
SWISS (1878–1958)

Crotti first studied painting in Munich, then in 1901 moved to Paris and continued his training at the Académie Julien. He exhibited regularly in Paris until 1915, when he moved to New York. There he met Duchamp and Picabia, joined the New York Dada group, and produced collages, mechanical drawings, and wire constructions. Returning to Paris in 1919, Crotti married Suzanne Duchamp, Marcel Duchamp's sister. Together they founded Tabu-Dada, a movement promoting spiritualized abstraction. In the 1930s and 1940s Crotti developed a stained glass process called *gemmaux* and used it to re-create paintings by well-known artists. Despite figuring in only three Société Anonyme exhibitions, he maintained a cordial lifelong correspondence with Dreier and gave *Composition* to the Collection in 1949. KPH

Metaphysical Interior. 1925. Oil on canvas, 27 15/16 x 21 5/8 in. (71 x 55 cm).

Vocalization. 1919. Oil and wooden dowels over commercial pieced wood covered in cardboard, 23 11/16 x 26 3/8 in. (60.2 x 67 cm).

Composition. 1925. Oil on canvas, 28 3/8 x 21 1/4 in. (72 x 54 cm).

Wall Decoration — The Risen Christ. c. 1918–20. Oil on burlap, 6 ft. 3 5/16 in. x 6 ft. 2 1/16 in. (191.3 x 188.1 cm).

Construction. 1940. Oil on wood and masonite, 24 x 24 x 3 1/16 in. (61 x 61 x 7.8 cm).

Simultaneous Composition (Composition simultanée). 1929. Oil on canvas, 19 3/4 x 19 13/16 in. (50.2 x 50.4 cm).

James Henry Daugherty
AMERICAN (1889–1974)

Daugherty, a native of North Carolina, studied briefly at the Corcoran Art School, Washington, D.C., in 1903 and subsequently trained under Hugh Breckenridge, William Merritt Chase, and, in London, Frank Brangwyn. Traveling abroad from 1905 to 1907, he visited Paris, Venice, Rome, and the Netherlands but did not explore modernism seriously until his return to the United States. In 1915 he met Arthur Burdett Frost, who introduced him to the color theories of Matisse and the Orphists and to the paintings of Bruce. Daugherty responded with abstract compositions investigating the dynamism of pure color. After the 1920s he concentrated on mural painting and children's-book illustrations, returning to color abstractions in the last decade of his life. KPH

Burgoyne Diller
AMERICAN (1906–1965)

Raised in Michigan, Diller moved to New York in 1928 and studied painting and lithography at the Art Students League. In the 1930s he directed projects at the WPA and worked as a mural painter for a series of federally funded art programs. His abstract murals, like his paintings, showed the influence of such European painters as Klee, Kandinsky, and Mondrian, as well as of the Constructivists and Suprematists. At Dreier's request, Diller organized "Group A" to stimulate discussions about abstract art. One of the WPA's few abstract muralists, he was temporarily suspended in 1941 because of an alleged Communist affiliation. Diller became an instructor at Brooklyn College in 1946 and a visiting critic at Yale University in 1953. BWR

Theo van Doesburg
DUTCH (1883–1931)

Van Doesburg was born Christiaan Emil Marie Küpper, in Utrecht, but adopted his stepfather's name at a young age. He left home at eighteen to be an artist and supported himself by copying paintings at the Rijksmuseum in Amsterdam. A self-taught painter, poet, and art critic, van Doesburg became a key figure in the De Stijl movement. He helped to found the magazine *De Stijl* in 1917 and collaborated closely with Mondrian. He was closely associated with the Bauhaus and participated in the German Dada movement with Schwitters and Tristan Tzara. His use of diagonal lines and his interest in architecture caused a break with Mondrian in the 1920s. In 1930 van Doesburg founded the magazine *Art Concret*, which focused on mathematics and measurement in art. BWR

Marthe Donas

BELGIAN (1885–1967)

Donas studied at the Antwerp art academy in 1902–3 and 1913–14. In 1916 she moved to Paris, where she studied at the Académie de la Grande Chaumière and the Académie Ranson. She also worked for a month in the studio of the painter André Lhote, who "converted" her, as she later wrote, to Cubism. Around 1918 she traveled to Nice, where she taught and painted portraits, and worked in the studio of Archipenko. After 1920 Donas exhibited in numerous avant-garde forums, including (under the name Tour Donas) Berlin's Der Sturm Gallery, where Dreier first saw her work, and with the Section d'Or group (1920–21) and at the Salon des Indépendants (1920, 1923). Until 1927 she exhibited her work extensively, primarily in Antwerp and Brussels. She resumed her career in 1948 and painted for the rest of her life. SG

Still Life with Profile of Pitcher. c. 1918–19. Oil on composition board, 23 ¹¹/₁₆ x 15 ¹³/₁₆ x ³/₄ in. (60.2 x 40.2 x 1.9 cm).

Arthur Garfield Dove

AMERICAN (1880–1946)

Raised in New York State, Dove studied at Hobart College and Cornell University before moving to New York in 1903 to work as a commercial illustrator. He undertook an extended trip to France from 1907 to 1909, and exhibited twice at the Salon d'Automne alongside the infamous Fauve artists. Upon his return to New York he met Stieglitz, who included his work in a show at the 291 gallery in 1910 and then gave him a solo show in 1912. Dove would continue to exhibit with Stieglitz well into the 1920s, and it was through his almost annual one-person exhibitions at Stieglitz's Intimate Gallery after 1926 that he met Duncan Phillips, his second patron. Dreier included Dove in her 1926 *International Exhibition* at the Brooklyn Museum. From 1933 to 1938, Dove lived in his native Geneva, New York, and after 1938 in Centerport, Long Island. BWR

Barnyard Fantasy. 1935. Oil on canvas, 30 ⁷/₈ x 23 ¹/₈ in. (78.4 x 58.8 cm).

Dorothea A. Dreier

AMERICAN (1870–1923)

Before her early death from tuberculosis, Dorothea Dreier was one of the primary funders of the newly established Société Anonyme. The Société featured her work in an unprecedented seven one-person shows spanning two decades in New York, Detroit, Philadelphia, and cities throughout Germany. Dreier considered the Scottish-born American painter Walter Shirlaw her most valuable teacher. He helped her to appreciate the nineteenth-century innovators she saw firsthand on regular trips to Europe between 1902 and 1920, at times accompanied by her younger sister, Katherine. Dorothea often remained abroad for extended periods, particularly in the Netherlands, and was profoundly influenced by Vincent van Gogh. Contemporaries described the keyed-up palette and heavy impasto of her later views of New York as a distinctively American expression of the new in art. KPH

New York: The Little Church Around the Corner. 1920. Oil on canvas, 27 ¹³/₁₆ x 19 ¹¹/₁₆ in. (70.6 x 50 cm).

Explosion. 1940–47. Oil on canvas, 24 ¹/₁₆ x 29 ¹⁵/₁₆ in. (61.1 x 76 cm).

Composition 140. 1936. Oil on canvas, 45 ¹/₄ x 34 ¹/₄ in. (115 x 87 cm).

In advance of the broken arm or *Snow Shovel.* 1945. Wood and galvanized-iron snow shovel, 48 x 18 x 4 in. (121.9 x 45.7 x 10.2 cm).

Katherine Sophie Dreier

AMERICAN (1877–1952)

Born in Brooklyn to a wealthy, socially progressive family of German immigrants, Dreier took private art lessons as a child before enrolling in the Brooklyn Art School in 1895 and training under painter Walter Shirlaw from 1903 to 1908. As a student in Europe in 1902–3, she saw collections of old master paintings, and her work under Shirlaw was fairly traditional. She was nonetheless receptive to more experimental art and cemented her commitment to modernism at the 1912 Sonderbund exhibition in Cologne. A Theosophist strongly influenced by the theories of Kandinsky, Dreier felt that a new era of spiritual art had begun. She devoted her life to promoting an international community of modern artists through the Société Anonyme, founded in 1920 with Duchamp and Man Ray. Dreier lived primarily in Connecticut from 1925 until her death. KPH

Werner Drewes

AMERICAN, BORN GERMANY (1899–1985)

Born in Canig, Drewes studied architecture and design in various schools before attending the Bauhaus, Weimar, in 1921, where he worked with Klee and Johannes Itten. After 1927 he studied at the Bauhaus, Dessau, with Kandinsky, who greatly influenced his subsequent work. In 1930 Drewes moved to the United States, where he participated in many exhibitions, including the *Four Painters* show organized by Dreier in 1936, which also featured herself, Albers, and Paul Kelpe. Drewes was a founding member of the American Abstract Artists association and became director of the Graphic Arts Project in 1940. He also held numerous teaching positions, including professorships at Columbia University (1936–40) and Washington University, St. Louis (1946–65). Drewes retired to Virginia. SG

Marcel Duchamp

AMERICAN, BORN FRANCE (1887–1968)

In 1904 Duchamp followed his two older brothers, Raymond Duchamp-Villon and Jacques Villon, from his native Normandy to Paris. There he studied painting at the Académie Julien in 1905. In 1912 he painted the definitive version of *Nude Descending a Staircase*, which he exhibited that year at the Section d'Or and in 1913, to much controversy, at the Armory Show in New York. It was also in 1913 that Duchamp rejected painting in favor of sculpture and began both to experiment with chance in his creative process and to appropriate found objects for his Readymades. Duchamp moved in 1915 to New York, where he met Dreier and the Arensbergs. Throughout his life he would continue to travel between New York and Paris. In 1920 Duchamp cofounded the Société Anonyme with Dreier and Man Ray. Duchamp remained Dreier's most vital partner in the ongoing work of the Société Anonyme. BWR

Suzanne Duchamp

FRENCH (1889–1963)

Suzanne Duchamp was the younger sister of Jacques Villon, Marcel Duchamp, and Raymond Duchamp-Villon. Born in Blainville, in Normandy, she began to study at the École des Beaux-Arts in Rouen in 1905. She participated in her brother Jacques's meetings in Puteaux and in 1914 exhibited with the Section d'Or. By 1916 she was living in Paris, where she exhibited at the Salon des Indépendants; in 1919 she married fellow artist Jean Crotti. Around this time her approach to art changed from a naturalistic to a Dadaist style. She met Dreier in November 1919, when the American artist visited the Duchamp family in Rouen. Dreier included her work in the 1926 *International Exhibition* at the Brooklyn Museum, and the two corresponded regularly until 1950. In her later work Duchamp returned to representational painting. SG

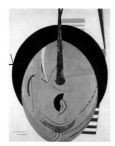

Accordion Masterpiece (Chef d'oeuvre accordéon). 1921. Oil, gouache, and silver leaf on canvas, 39⁵/₁₆ x 31⁷/₈ in. (99.8 x 80.9 cm).

Raymond Duchamp-Villon

FRENCH (1876–1918)

Pierre Maurice Raymond Duchamp was Marcel Duchamp's elder brother. In 1895 he moved to Paris with his brother Gaston (later called Jacques Villon) to study medicine, but left medical school in 1898, when he fell seriously ill. During his convalescence he began to make sculpture and eventually assumed the surname Duchamp-Villon. One of the few autodidacts to become a major sculptor, he debuted at the Société Nationale des Beaux-Arts in 1902 and exhibited annually at the Salon d'Automne from 1905 to 1913. In 1907 Duchamp-Villon's style began to shift from expressive modeling influenced by Auguste Rodin to smooth geometric forms with strongly articulated planes. By 1912, when he and Jacques were hosting a weekly salon for the Puteaux group, he was devoted to Cubism. His short career ended when he died of typhoid contracted as a medical officer in World War I. KPH

Parrot. 1913–14. Wood, 25³/₄ x 23¹¹/₁₆ x 2¹/₂ in. (65.4 x 60.2 x 6.3 cm).

Louis Michel Eilshemius

AMERICAN (1864–1941)

An eccentric painter-poet and the self-declared "Mightiest Mind and Wonder of the Worlds, Supreme Parnassian and Grand Transcendent Eagle of Art," Eilshemius achieved brief popularity in the mid-1920s thanks to avid promotion by the Société Anonyme. As a child he lived in Newark and attended boarding schools in Geneva and Dresden. After academic training in New York and Paris, he traveled in Europe, North Africa, and the South Pacific between 1892 and 1903, recording his responses in an abundance of unsold paintings and books published at his own expense. Duchamp "discovered" his naïve, dreamlike works at the Society of Independent Artists exhibition of 1917. A vogue developed for his work, but Eilshemius felt exploited by it and gave up painting by the early 1920s. He died impoverished and alone. KPH

The Concert Singer. c. 1910. Oil on paper, laid down on laminated chipboard, 18¹/₂ x 14 in. (47 x 35.6 cm).

The Factory (Die Fabrik). c. 1921. Oil on canvas, 25⁷/₈ x 32³/₁₆ in. (65.8 x 81.8 cm).

Adolf Erbslöh

GERMAN, BORN UNITED STATES (1881–1947)

Born in New York to German parents, Erbslöh moved to Wuppertal, Germany, at the age of six. The rugged landscape and steel mills of his childhood home would inspire the solid forms and pure colors of his paintings. He studied art at the Karlsruhe academy, then in 1904 moved to Munich to train under the Jugendstil painter Ludwig Heterich. In 1909 he was a cofounder of the Munich Neue Künstlervereinigung, the association from which Kandinsky would break away to found the Blaue Reiter group. Erbslöh remained committed to figurative painting; stylistically he was most indebted to van Gogh, Cézanne, and Alexei Jawlensky. In 1916 he joined the Munich Neue Sezession. He traveled throughout Germany and in Italy and South America, visited New York in the 1920s, then retired to a country home he purchased at Irschenhausen in 1934, after the Nazis had banned "decadent" Expressionist art. KPH

Anthropomorphic Figure (Plaster Man). 1930. Gouache on plaster over plywood, 27¹⁵/₁₆ x 21⁹/₁₆ x 1 in. (71 x 54.8 x 2.5 cm).

Max Ernst

GERMAN, LIVED FRANCE AND UNITED STATES (1891–1976)

As a college student in Bonn, Ernst studied philosophy and abnormal psychology, absorbing the writings of Nietzsche and Freud. He decided to become an artist after seeing the works of van Gogh, Cézanne, and Picasso at the 1912 Sonderbund exhibition in Cologne. He first exhibited at Der Sturm, Berlin, in 1913, and continued painting during military service in World War I. Ernst became a leader of the Dada movement in Cologne, but in his ideas he was closer to the Paris Surrealists, with whom he had only a tenuous relationship, since he disapproved of André Breton's leadership. He lived in Paris from 1922 to 1941 and spent twelve years in the United States, where he was briefly married to Peggy Guggenheim, before returning to France in 1953. He worked actively until his death. BWR

Abstraction. 1936. Gouache and watercolor, 17⁷/₈ x 11¹³/₁₆ in. (45.4 x 30 cm).

Oskar W. Fischinger

AMERICAN, BORN GERMANY (1900–1967)

After attending a technical school in Gelnhausen, Fischinger moved to Frankfurt to work as an engineer. Encouraged by the critic Bernhard Diebold to explore cinema, he began to make experimental abstract films, for which he invented his own equipment. He established a studio in Munich, then in 1926 relocated to Berlin. Commercial success in Germany led to animation opportunities in Hollywood, where he settled in 1936, but his independent working method clashed with the studio system. A visual purist, he insisted that musical accompaniment was no more than an aid to the audience, not a "text" to be illustrated by his animated abstractions. In 1937, needing work, Fischinger made his first paintings on canvas and brought them to New York. Impressed by these works, Hilla Rebay awarded him three successive Guggenheim grants to support his film projects. KPH

Naum Gabo

AMERICAN, BORN RUSSIA, LIVED GERMANY, FRANCE, AND ENGLAND (1890–1977)

Born Naum Neemia Pevsner, Gabo assumed his surname to distinguish himself from his elder brother, the Paris-based abstractionist Antoine Pevsner. Initially educated in Russia, he studied science and engineering in Munich from 1910 to 1914, but meanwhile attended Heinrich Wölfflin's art history lectures and frequented international exhibitions of avant-garde art. On the outbreak of World War I he moved to Oslo, where he made his first constructions in 1915. Two years later he returned to Russia and in 1920 wrote his "Realistic Manifesto," calling for a revolutionary art constructed of "space and time." He worked in Berlin, Paris, and London before settling in 1946 in Connecticut, where Dreier made him a director of the Société Anonyme the following year. KPH

Model of the Column. c. 1928, rebuilt 1938. Perspex and plastic on aluminum base, 10⅝ x 4⁷⁄₁₆ x 3¹⁵⁄₁₆ in. (27 x 11.3 x 10 cm).

Adeline Ravoux. 1890. Oil on fabric, 19¾ x 19⅞ in. (50.2 x 50.5 cm). The Cleveland Museum of Art. Bequest of Leonard C. Hanna, Jr. 1958.31.

Vincent van Gogh

DUTCH, LIVED FRANCE (1853–90)

Having worked with his brother Theo at the Goupil art gallery in its branches at The Hague, London, and Paris, van Gogh began painting seriously after a brief religious phase in which he served as an ascetic preacher. He was inspired by the work of Millet, Rembrandt, Rubens, and Delacroix. His life as an artist, made possible by Theo's support, was nomadic, unstable, and solitary. In each of his makeshift homes, van Gogh painted tirelessly and produced an astonishing quantity of work. His volatility and intense productivity increased with the onset of illness, probably related to syphilis, in his thirties, when his instability alienated his few artistic comrades, notably Gauguin. Overcome by depression, van Gogh shot himself in July 1890 and died two days later. BWR

Paul Gauguin

FRENCH (1848–1903)

Gauguin was born in Paris but spent his childhood in Lima, Peru. After traveling the world as a sailor, he returned to Paris in 1871 and worked for twelve years in the Paris stock exchange, meanwhile meeting Pissarro and Degas and exhibiting work in the fourth through eighth Impressionist exhibitions. In 1883 he left the stock exchange and devoted himself to painting, embracing an itinerant lifestyle in which he sought a primitive and untouched world. On expeditions to Martinique, Brittany, and Arles he spent time with Symbolist writers and with many artists, including Bernard and van Gogh. In 1891 he left France for Tahiti, where he remained until 1893. After revisiting Brittany in 1894, he left France for Tahiti permanently in 1895. BWR

Joys of Brittany (Joies de Bretagne). 1889. Zincograph, 8 x 8¹¹⁄₁₆ in. (20.3 x 22.1 cm).

Nighttime, Enigma, and Nostalgia. 1931–32. Black and brown ink on Strathmore white paper, 18³⁄₁₆ x 24⁵⁄₁₆ in. (46.3 x 61.7 cm).

Arshile Gorky

AMERICAN, BORN ARMENIA (1904–48)

Born Vosdanig Manoog Adoian, Gorky survived a tragic childhood. With his family he fled the Turkish massacres in Armenia, joined what is now described as a death march, and watched his mother die of starvation. After escaping to the United States, Gorky revisited these experiences in his artwork. He first lived in Boston, where he studied at the New School of Design and adopted a pseudonym. Moving to New York in 1925, he taught at the Grand Central School of Art and befriended John Graham, Willem de Kooning, and Stuart Davis. He exhibited with the Société Anonyme in 1931. After 1935 he painted murals for the WPA, then produced increasingly abstract work as an important member of the New York School. After being crippled in a car accident, Gorky committed suicide. BWR

Albert Gleizes

FRENCH (1881–1953)

With no formal training in art, Gleizes designed fabric in his father's Paris upholstery shop before exhibiting his first paintings in 1902. He helped found the Abbaye de Créteil, a utopian artists' community, in 1906, and befriended Henri Le Fauconnier, Robert Delaunay, and Léger. In 1912 he and Metzinger co-wrote an important book on Cubism. Gleizes grew close to the Duchamp-Villon family while collaborating on the 1912 Section d'Or exhibition, and he befriended Marcel Duchamp while living in New York in 1915–19. Guided by a deep social consciousness, Gleizes created abstractions meant to address essential human experience, and he wrote prolifically on art and society. After a year in Barcelona he settled in Saint-Rémy-de-Provence, where he converted to Catholicism in 1941 and experimented with the making of religious art until his death. KPH

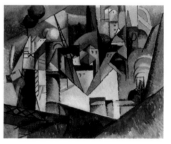

Landscape (Paysage). 1914. Oil on canvas, 28⅞ x 36⁵⁄₁₆ in. (73.3 x 92.3 cm).

Vox Humana. 1931. Oil and sand on canvas, 47 x 32¹⁄₁₆ in. (119.4 x 81.4 cm).

John D. Graham

AMERICAN, BORN RUSSIA (1881–1961)

Born Ivan Dombrovsky in Kiev, Graham lived in St. Petersburg and Romania and served in the Russian cavalry during World War I before emigrating to New York in 1920. Beginning in 1922, he studied painting with John Sloan at the Art Students League and exhibited at the Society of Independent Artists. In 1927 he met Duncan Phillips, his future patron, and legally changed his name to John Graham. Active in New York's Russian art community, Graham traveled extensively in Europe while maintaining close friendships with Dreier, David Smith, Gorky, and Stuart Davis. Graham's aesthetic theories, as expressed in his book *System and Dialectics of Art* (1937), and his conversations with Willem de Kooning, Smith, Jackson Pollock, and others made a key contribution to the rise of the New York School. BWR

Juan Gris
SPANISH, LIVED FRANCE (1887–1927)

In 1906 Gris emigrated from Madrid to Paris, where he initially supported himself by publishing illustrations in periodicals. Inspired by Picasso, he began painting in the Cubist style, but developed a uniquely precise and architectural approach. Gris exhibited at the Section d'Or and the Salon des Indépendants. He also designed theater and ballet sets but lived an impoverished life, surviving on the support of his dealers, Daniel-Henry Kahnweiler and Léonce Rosenberg. He reached his artistic peak between 1916 and 1919; his health then began to deteriorate, and he died at the age of forty. BWR

Alice Halicka
POLISH, LIVED FRANCE (1895–1975)

Born in Kraków, Halicka studied art in Munich in 1912 before traveling to Paris, where she studied at the Académie Ranson and married fellow artist Louis Marcoussis. From 1913 to 1918 she worked in a Cubist style, then turned her attention to illustration, the decorative arts, stage and costume design, and publicity. She traveled to the United States in the 1930s with assistance from Dreier, who shared her interest in music and dance. While in New York, Halicka designed the décor for George Balanchine's ballet *I Married an Angel* (1938). After Marcoussis's death, in 1941, Halicka devoted herself primarily to stewarding her husband's reputation. SG

Lawren Stewart Harris
CANADIAN (1885–1970)

After spending a year at the Toronto Art School in 1903–4, Harris traveled widely in Europe. He studied painting in Germany with Adolph Schlabitz, then returned to Canada in 1907 and worked as an illustrator. He lived mainly in Toronto, making frequent painting trips into the Canadian wilderness, before becoming the artist-in-residence at Dartmouth College from 1934 to 1938. A Theosophist (an interest he shared with Dreier), Harris helped to found the Transcendentalist Group of painters in Santa Fe, where he lived for two years before settling permanently in Vancouver in 1940. As painter, writer, and member of the Group of Seven, he was a pioneer of modern Canadian art. Harris's increasingly abstract work responded to the rugged geometry of his natural environment and modeled a new national aesthetic. KPH

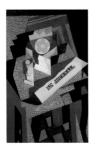

Newspaper and Fruit Dish (Journal et compotier). 1916. Oil on canvas, 36¹⁵/₁₆ x 24 in. (93.5 x 61 cm).

On the Beach. 1926. Oil on canvas, 22³/₁₆ x 29⁵/₁₆ in. (56.4 x 74.5 cm).

Abstraction, No. 3. c. 1934–37. Oil on canvas, 29⅛ x 36⅛ in. (74 x 92 cm).

Rubber Plant. 1920. Oil on canvas, 32 x 26 in. (81.3 x 66 cm).

Female Bust. 1920. Ink, watercolor, and pencil on paper, 13⅜ in x 11³/₁₆ in. (35.4 x 28.7 cm).

Sculpture. 1941–42. Oil and tempera on cheesecloth or muslin on masonite, 60 x 12 x 12 in. © 2005 Holtzman / Holtzman Trust c/o hcr@hcrinternational.com

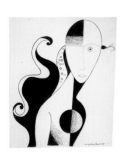

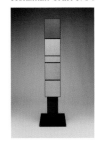

Marsden Hartley
AMERICAN (1877–1943)

Born in Maine, Edmund (Marsden) Hartley studied at the Cleveland School of Art before entering New York's Chase School in 1899. In 1900 he transferred to the National Academy of Design, where he would study for four years. In 1909 he met Stieglitz, who featured his landscapes at the 291 gallery that year and again in 1912. Hartley left for Paris in 1912 and would mostly remain abroad, in France and Germany, until 1930, although he returned to the United States during World War I, when he became actively involved with the Société Anonyme. In 1918–19 he also lived briefly in New Mexico, which provided the subject matter for a number of important paintings. In the 1930s and early 1940s Hartley wrote prolifically and traveled to paint in Mexico, Bermuda, and Nova Scotia. BWR

Angelika Hoerle
GERMAN (1899–1923)

Hoerle's training as an artist came through her brother, the painter Wilhelm Fick. After working briefly as a textile designer, she participated in the Cologne Dada exhibition at the Cologne Kunstverein in 1919. With Seiwert and others, she and her husband, the artist Heinrich Hoerle, were involved with the Dada review *Stupid 1,* and with related exhibitions and publications. Hoerle exhibited in the 1920s at the Nierendorf gallery in Cologne, where Dreier purchased her work. Her involvement in Cologne Dada was cut short by her early death from tuberculosis. SG

Harry Holtzman
AMERICAN (1912–87)

Born in New York, Holtzman in 1928 entered the Art Students League, where he met Diller, and in 1933–35 was assistant instructor under Hans Hofmann. In 1934 he became interested in the work of Mondrian, whom he visited in Paris and later helped to emigrate to the United States. (On Mondrian's death, in 1944, Holtzman served as the executor of his estate.) Through Diller, Holtzman became supervisor of abstract mural painters in New York as part of the WPA Federal Art Project in 1935. In 1936 he helped to establish the American Abstract Artists association. After 1950 he taught at Brooklyn College and at the State University of New York, Purchase. SG

Finnur Jónsson

ICELANDIC (1892–1993)

Jónsson first studied drawing, painting, and gold-smithery in 1915 in Iceland, where he continued his training in the winters while working as a fisherman in the summers. In 1919 he moved to Copenhagen to study drawing with Viggo Brandt and Carl Meier. Three years later he went to Dresden, met Kesting and Oskar Kokoschka, and enrolled at Der Weg, Kesting's school of modern art. Encouraged by Schwitters, Jónsson showed his work to Herwarth Walden, who exhibited eight pieces at his Berlin gallery Der Sturm in 1925. Dreier was Jónsson's sole exhibitor in the United States, beginning with the 1926 *International Exhibition* at the Brooklyn Museum, but she never met the artist and knew little of his subsequent career. Jónsson eventually abandoned his Cubist style and returned to painting traditional landscapes while teaching in Iceland from 1934 to 1950. KPH

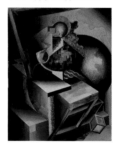

Woman at the Card Table. c. 1918–25. Oil and gold paint on burlap, 25¼ x 20⁵⁄₁₆ in. (64.1 x 51.6 cm).

Béla Kádár

HUNGARIAN (1877–1955)

Originally trained as a locksmith, Kádár decided to be an artist after visiting Paris in the late 1890s. He enrolled in the Budapest Academy of Fine Arts in 1902, then in 1910 traveled on foot to Paris and Berlin to see progressive art. Kádár also discovered Fauvism, Cubism, and Expressionism through artists in his native land. After embracing both modernism and folk art, he settled in Berlin and began exhibiting at Herwarth Walden's Der Sturm Gallery. Kádár enjoyed international success in the 1920s, and his Constructivist-influenced works were included in the Société Anonyme *International Exhibition* in Brooklyn in 1926. The Nazis condemned his work by including it in the *Entartete Kunst* (Degenerate art) exhibition in 1937. Kádár fled to Budapest, where he lived in poverty in the Jewish ghetto until his death. BWR

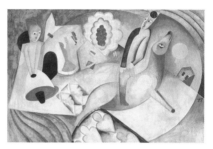

Separation (Trennung). c. 1920–24. Gouache over graphite on paper, 39³⁄₁₆ x 58⁷⁄₈ in. (99.5 x 149.5 cm).

David Kakabadzé

GEORGIAN (1889–1952)

Kakabadzé took drawing lessons near his hometown in Georgia before attending the University of St. Petersburg from 1910 to 1916. He was taking a degree in science but also studied painting, under L. Dimitriev Kavakzski. In 1919 he received a bursary from the Georgian government to train in Paris, where he remained until 1927, publishing essays on contemporary art while making increasingly abstract paintings and sculpture. Constrained by the Russian ban on abstraction when he returned to Georgia, Kakabadzé painted realistic city views and briefly designed stage sets. In 1948, because of his formalist background, he lost his teaching post at the Tbilisi art academy, and he died in obscurity. KPH

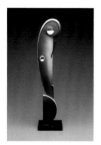

Z (The Speared Fish). c. 1925. Painted wood with metal and glass, 28⁷⁄₈ x 5⁵⁄₈ x 5¼ in. (73.4 x 14.3 x 14.6 cm) including base.

Improvisation No. 7 (Storm). 1910. Oil on pasteboard, 27⁹⁄₁₆ x 19³⁄₁₆ in. (70 x 48.7 cm).

Collage. 1923. Mixed media, graphite, ink, and wash on wove paper, 12 x 11³⁄₁₆ in. (30.5 x 28.4 cm).

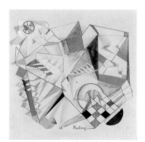

Composition 1. 1926. Oil on canvas, 51 x 25⁵⁄₈ in. (129.5 x 65.1 cm).

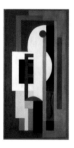

Wassily Kandinsky

RUSSIAN, LIVED GERMANY AND FRANCE (1866–1944)

A trained lawyer, Kandinsky moved to Munich in 1896 to study art at the Azbé school and the Munich academy. In 1901, as a painting student, he formed the Phalanx group. From 1909 to 1914 he lived near Munich, where he and Marc cofounded the Blaue Reiter group and he published his important essay *Concerning the Spiritual in Art* (1912). He returned to Moscow just before World War I and taught art there before accepting a post at the Bauhaus, Weimar, in 1922. Kandinsky followed the Bauhaus to Dessau in 1925 and again to Berlin in 1932. When the Nazis closed the Bauhaus, in 1933, he moved to a suburb of Paris, where he spent the rest of his life. BWR

Edmund Kesting

GERMAN (1892–1970)

Born in Dresden, Kesting studied at the Dresden academy and in 1919 founded his own art school, Der Weg, in the city. In the early 1920s he met Herwarth Walden, who would exhibit his Dada-like constructions and collages at the Berlin gallery Der Sturm. In the mid-1920s Kesting became interested in photography, and after World War II he taught film at the Deutschen Hochschule für Filmkunst in Berlin. Having encountered Kesting's work in 1926, through Der Sturm, Dreier included two pieces in the 1926 *International Exhibition* in Brooklyn, the only Société Anonyme show in which he was represented. SG

Ragnhild Keyser

NORWEGIAN (1889–1943)

After studying painting in her native Oslo from 1916 to 1919, Keyser moved to Paris, where she studied with André Lhote, Pedro Araujo, and Léger. She exhibited at a number of important Paris venues, including the Salon des Indépendants of 1923, the Galerie de l'Art d'Aujourd'hui in 1925, and the Indépendants again and the Galerie d'Art Contemporain in 1926. It was at the Indépendants exhibition of 1926 that Dreier saw her work, and she included three of Keyser's paintings in the Société's *International Exhibition* in Brooklyn later that year. Keyser returned to Norway in 1927, where she exhibited regularly in the 1930s. She died in Oslo. SG

Stefi Kiesler
AUSTRIAN, LIVED UNITED STATES (1900–1963)

After studying philology at the University of Vienna, Kiesler moved to Paris in 1924 with her husband, the architect and theater designer Frederick Kiesler, a member of the de Stijl group. In Paris she created her first typed drawings, or "Typo-Plastics," which she published in the magazine *De Stijl* under the pseudonym Pietro de Saga. Coming to New York in 1926, the Kieslers soon met Dreier, who was working on the Brooklyn *International Exhibition*. They maintained a close friendship with Dreier over the next several decades. After 1931 Stefi Kiesler held a position as a librarian at the New York Public Library. She worked for Dreier in the 1940s, conducting biographical research for the 1950 Société Anonyme catalogue. SG

Paul Klee
SWISS, LIVED GERMANY (1879–1940)

When Klee graduated from art school in Munich in 1902, he worked as a violinist and a music critic. He encountered modernist art on trips to Paris and Berlin and through his friendships with Kandinsky, Marc, and August Macke, who encouraged him to join the Blaue Reiter group in 1912. Between 1920 and 1931 Klee taught at the Bauhaus, in both Weimar and Dessau. His first solo exhibition in the United States was at the Société Anonyme in 1924, and he participated in the first Surrealist exhibition in Paris in 1925. He began to teach at the Düsseldorf academy in 1931 but was dismissed under the Nazi regime and returned to Switzerland, where he worked until his death. BWR

Erika Giovanna Klien
AUSTRIAN, LIVED UNITED STATES (1900–1957)

Klien studied art at the Vienna Kunstgewerbeschule with progressive educator Franz Cizek before becoming his assistant there in the mid-1920s. In 1926 she met Dreier, who was researching works for the Brooklyn *International Exhibition*. Klien went on to have a significant career as an art teacher. She worked at the Elizabeth Duncan School in Salzburg from 1927 to 1928, then, after emigrating to New York, at the Stuyvesant Neighborhood House, the New School for Social Research in the 1930s, the Dalton School, the Spence School, and finally the Walt Whitman School, where she was chairman of the art department until her death. SG

Typo-Plastic. c. 1925–30. Black and red typewriter ink, 10⅝ x 8¼ in. (27 x 21 cm).

Watercolor Sketch for "MA" (Aquarellskizze zu "MA"). 1922. Pencil, ink, and watercolor on paper, 11⁵⁄₁₆ x 8⅝ in. (28.6 x 21.8 cm).

Factory (geometrical abstraction). 1925. Graphite and black crayon on paper, 8¹⁵⁄₁₆ x 9 in. (22.7 x 22.9 cm).

Umbrella (La Parapluie). 1925. Watercolor and gouache on paper, 12⅜ x 9⁵⁄₁₆ in. (31.4 x 23.7 cm).

Female Torso (Weiblicher Torso). c. 1911–14. Cast stone, 45¼ x 18¾ x 12¾ in. (114.9 x 47.6 x 32.4 cm).

Man with Mandolin. 1916–17. Limestone, 30 x 10 x 11 in. (76.2 x 26 x 28.9 cm).

Fernand Léger
FRENCH (1881–1955)

Léger moved to Paris from Normandy in 1900 and worked as an architectural draftsman while studying at the École des Arts Décoratifs. In 1908 he met Archipenko, Chagall, Lipchitz, and Guillaume Apollinaire in La Ruche, the artists' studio building in Montparnasse. After 1910 he developed his own variant of Cubism, based on illusions of geometric solids. Léger exhibited in New York's Armory Show of 1913 before serving in World War I. When he returned from the fighting, he befriended Le Corbusier and Amédée Ozenfant and traveled extensively. He had a one-person show at the Société Anonyme in 1925 and returned to the United States at the start of World War II. He taught at Yale University and Mills College during the war but returned to Paris in 1945. BWR

Wilhelm Lehmbruck
GERMAN (1881–1919)

Lehmbruck began his artistic training at the Düsseldorf Kunstgewerbeschule at the age of fourteen. In 1905, under the auspices of the Düsseldorf academy, he traveled to Italy to study Roman sculpture. Two years later he visited Paris, where he met Aristide Maillol and Auguste Rodin; he settled in the city in 1910. Though known primarily as a sculptor, Lehmbruck also exhibited paintings and drawings and produced a number of influential etchings. His early classicizing style gradually shifted toward more individualized and often tragic figures, particularly after the start of World War I, when he had to leave France for Berlin. In increasing despair at his separation from the international artistic community in Paris, he committed suicide at the age of thirty-eight. KPH

Jacques Lipchitz
LITHUANIAN, LIVED FRANCE AND UNITED STATES (1891–1973)

Chaim Jacob Lipchitz left Lithuania for Paris at the age of eighteen, determined to become an artist. He enrolled at the Académie Julien, took private drawing and sculpture classes, and collected tribal sculpture. In 1912 Lipchitz moved into a Montparnasse studio adjacent to Brancusi's. His sculpture took a radical turn in 1914–15, when he produced his first mature Cubist works — thin cast bronzes, carved-stone works blending architectural and human forms, and massive planar sculptures in stone and bronze. During World War II Lipchitz fled to the United States, settling in Hastings-on-Hudson, New York, in 1947. Characterized by monumental proportions and epic themes, his more conservative American works reflect the demands of public commissions and his deepening social consciousness. KPH

El Lissitzky
RUSSIAN (1890–1941)

Lissitzky studied architectural engineering in Darmstadt before earning his architectural diploma in Moscow. A participant in the revival of Jewish culture, he was receptive to the Russian revolutions of 1917. In 1919 Chagall invited him to teach at the Art Labor Cooperative in Vitebsk, where he met Malevich and embraced geometric abstraction. He created his first *Proun* composition in Berlin in 1923. During a stay in Hannover, he completed lithographs for the *Victory over the Sun* portfolio and collaborated with Schwitters on his *Merz* publications. Lissitzky worked in a variety of media, including photography, architecture, typography, and exhibition design, and he was a pioneer of modern book design. He spent the last decade of his life in Moscow designing propaganda for the Communist government. BWR

Louis Lozowick
AMERICAN, BORN RUSSIA (1892–1973)

Born in Ludvinovka, Ukraine, in 1892, Lozowick studied at the Kiev Art Institute before moving to the United States in 1906. He trained with Leon Kroll at New York's National Academy of Design from 1912 to 1915, then graduated from Ohio State University in 1918. He traveled considerably, first across the United States, then to Europe, spending most of his time in Paris, Berlin, and Moscow, where he met Malevich, Vladimir Tatlin, and Alexander Rodchenko. On returning to New York, in 1924, Lozowick advocated Russian modernism. He teamed up with Dreier in 1925 to publish the pamphlet *Modern Russian Art* under the auspices of the Société Anonyme, and was active as a critic, artist, and lecturer until around 1930. He continued to make elegant precisionist lithographs until shortly before he died, in South Orange, New Jersey. SG

Kasimir Malevich
RUSSIAN (1878–1935)

Malevich arrived in Moscow to study art in 1905. He exhibited with the Moscow Association of Artists and later with the Jack of Diamonds group and the Union of Youth, where he met Vladimir Tatlin, Puni, and Popova. In 1927 he visited the Bauhaus in Dessau and became friendly with Walter Gropius and Moholy-Nagy. After the Russian Revolution of 1917, Malevich was an important teacher of art in the new society until 1930, when Stalin's government condemned his "bourgeois" ideas and interned him. His work after 1930 reflects the Soviet directive for artists' work in a social realist mode, and he died as a modernist hero forgotten in his own country. BWR

Victory over the Sun: Gravediggers (Sieg über die Sonne: Totengräber). 1923. One of ten color lithographs, sheet: 21½ x 18½ in. (54.5 x 47 cm).

City Shapes. 1922–23. Oil on composition board with canvas-textured surface, 18⅛ x 14¹⁵⁄₁₆ in. (46 x 38 cm).

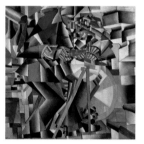

The Knife Grinder or *Principle of Glittering (Tochil'shchik Printsip Mel'kaniia).* 1912–13. Oil on canvas, 31⁵⁄₁₆ x 31⁵⁄₁₆ in. (79.5 x 79.5 cm).

Fish. 1926. Oil behind glass, wood frame by Pierre Legrain, 21½ x 15¹¹⁄₁₆ in. (54.6 x 39.8 cm).

Deer Isle, Maine: Stonington Waterfront, Two Movements. 1924. Watercolor and charcoal on paper, 14½ x 17½ in. (36.8 x 44.5 cm).

Nude Seated in an Armchair (Nu assis dans un fauteuil). 1922. Lithograph, 17¼ x 11 in. (43.8 x 28 cm).

Louis Marcoussis
POLISH, LIVED FRANCE (1878–1941)

Born in Warsaw as Louis Casimir Ladislas Markus, Marcoussis studied law before enrolling in the fine arts academy of Kraków. In 1903 he moved to Paris, where he studied at the Académie Julien and drew illustrations for fashion and humor magazines to support himself. He exhibited at the Salon d'Automne in 1905. In 1910 he was living in Montmartre, where, through Braque and Guillaume Apollinaire, he met Picasso and became interested in Cubism. Three years later he married Halicka. During a visit to Poland in 1919, Marcoussis was struck by behind-glass paintings that he saw there and undertook them himself until 1928. His etched book illustrations from the 1930s established his reputation. Marcoussis died at Cusset, near Vichy, France. SG

John Marin
AMERICAN (1870–1953)

Marin made his first watercolors in 1888, while touring the Midwest, initiating a lifelong practice of traveling to paint American landscapes. He worked as an architect in New Jersey between 1892 and 1897 before studying at the Pennsylvania Academy of the Fine Arts and then in New York at the Art Students League. After 1905 he traveled often to Paris, where he exhibited at the Salon des Indépendants and the Salon d'Automne. Marin met Stieglitz in Paris in 1909 and had his first one-person show at Stieglitz's 291 gallery in 1910. He moved to New York in 1911 but spent his summers painting the natural landscapes of Massachusetts, New York, Pennsylvania, and Maine. After Stieglitz's death, in 1946, Marin took over his gallery An American Place, working with his widow, Georgia O'Keeffe. BWR

Henri Matisse
FRENCH (1869–1954)

Matisse moved from Saint-Quentin to Paris in 1891 and studied with Gustave Moreau at the École des Beaux-Arts. After a successful exhibition at the official Salon in 1896, he became fascinated by the work of Cézanne and began to exhibit at the more progressive Salon des Indépendants and Salon d'Automne. He became friends with Derain, and in 1905 the two painters traveled to Collioure, in the South of France, where they developed Fauvism. While based in Paris, Matisse took trips to Munich, Morocco, Spain, and Russia. In 1917 he moved to Nice and filled his apartment with the screens, mirrors, and theatrical decorations that often appear in his paintings. He continued to work in a variety of media, including murals, book illustration, printmaking, sculpture, and stained glass, until his death. BWR

Roberto Matta Echaurren

CHILEAN (1911–2002)

Matta studied architecture in Santiago before moving to Paris in 1933 to work in the studio of Le Corbusier. In Paris he met the poets Federico García Lorca and Pablo Neruda. He then traveled to Berlin, St. Petersburg, Helsinki, Mexico, and, in 1936, London. He began painting seriously after meeting Picasso, Magritte, and Miró. Matta's drawings intrigued Salvador Dalí and André Breton, who invited him to join the Surrealist movement in 1937. Profoundly influenced by the work of Duchamp, he developed his own biomechanistic iconography and automatic techniques, which helped shape the New York School in the 1940s. After moving to Rome and then Paris, Matta lectured in Cuba, Egypt, Zambia, Tanzania, Peru, Chile, and Nicaragua. He spent the last years of his life in Paris. BWR

Konstantin Medunetsky

RUSSIAN (1889–c. 1935)

Born in Moscow, Medunetsky entered the city's Stroganov school of applied arts in 1914, specializing in stage design. He later attended SVOMAS, the state free art studios established after the Russian Revolution of 1917. In 1919 Medunetsky became a founding member of OBMOKHU, the society of young artists, which rejected traditional easel painting in favor of industrial and mechanical art. He exhibited his constructions alongside those of the brothers Georgii and Vladimir Stenberg at the Poets' Café in Moscow in 1921; the catalogue of this exhibition was the first printed declaration of Constructivist principles. In 1923 Medunetsky contributed to the *First Discussional Exhibition of Associations of Active Revolutionary Art* in Moscow. Before his death he returned to the theater and created costumes and sets. SG

Jean Metzinger

FRENCH (1883–1956)

Metzinger studied painting in Nantes and exhibited successfully in Paris before moving there in 1903. His early Paris work displays an interest in Neo-Impressionism and the Section d'Or group. He quickly befriended both camps of Cubist artists — Henri Le Fauconnier and Robert Delaunay on one side, Braque and Picasso on the other. In 1912, with his friend Gleizes, he wrote the seminal text *Du Cubisme*. He exhibited frequently at the Salon d'Automne and the Section d'Or while teaching with Le Fauconnier at the Académie de la Palette. After serving in World War I, he participated in the first Society of Independent Artists show in New York and in many Société Anonyme exhibitions. Late in life he returned to a modified realist painting style. BWR

Fabulous Race Track of Death (*Instrument Very Dangerous to the Eye*). c. 1941. Oil on canvas, 28 x 36 in. (71.1 x 91.4 cm).

Spatial Construction (formerly *Construction No. 557*). 1919. Tin, brass, painted iron, and steel on painted metal base, 18¹/₈ x 7 x 7 in. (46 x 17.8 x 17.8 cm).

The Port. 1920. Oil on canvas, 31¹⁵/₁₆ x 21⁵/₁₆ in. (81.1 x 54.1 cm).

Somersault (*Le Renversement*). 1924. Oil, pencil, charcoal, and tempera on canvasboard, 36³/₈ x 28¹¹/₁₆ in. (92.4 x 72.8 cm).

Crescents and Cross. c. 1921–23. Woodcut on paper, 18¹/₂ x 11⁵/₈ in. (47 x 29.5 cm).

Happening (*Geschehen*). 1919. Oil and aluminum leaf on canvas, 55¹/₈ x 59⁵/₁₆ in. (140 x 150.7 cm).

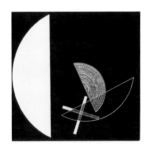

Joan Miró

SPANISH (1893–1983)

During his schooling in Barcelona, Miró was interested in Fauvism and poetry. After moving to Paris in 1923, he became friendly with the poets André Masson and Paul Éluard and collaborated with the Surrealists. He began making "dream paintings" in 1925 and participated in the Société Anonyme exhibition at the Brooklyn Museum in 1926. During World War II, Miró left Paris for Majorca and returned to Barcelona in 1942. He began experimenting in a variety of media, includ-ing sculpture, ceramics, murals, and graphics. Although his work had been much exhibited in New York, Miró did not visit the United States until 1947, when he became interested in Ameri-can abstract painting. In 1956 he moved to Palma, Majorca, where he lived until his death. BWR

László Moholy-Nagy

HUNGARIAN, LIVED GERMANY AND UNITED STATES (1895–1946)

After completing a law degree in Budapest, Moholy-Nagy began painting and drawing during his convalescence from wounds sustained in World War I. He committed himself to art in 1917 and associated with the radical MA group of artists in Szeged, Hungary. Moving to Berlin in 1920, he met Schwitters and Lissitzky through the Der Sturm group. He began teaching at the Bauhaus in 1923 but left after the resignation of Walter Gropius, in 1928. During the 1920s he experimented with photomontage and photography, in addition to designing sets for the state opera in Berlin. In the mid-1930s Moholy-Nagy worked in Amsterdam and London as a commercial designer before moving to Chicago, where he directed the New Bauhaus and founded the Institute of Design. BWR

Johannes Molzahn

AMERICAN, BORN GERMANY (1892–1965)

Molzahn spent his childhood in Weimar. From 1909 to 1914 he worked in Switzerland, where he met Baumeister, Oskar Schlemmer, and Otto Meyer-Amdern. After serving in World War I, he exhibited regularly at Der Sturm in Berlin. Molzahn published his "Manifesto of Absolute Expressionism" in 1919, declaring the work of art "a flaming mark of the ETERNAL." After teaching stints in Magdeburg and Breslau from 1923 to 1933, Molzahn was condemned by the Nazis' inclusion of his work in the *Entartete Kunst* (Degenerate art) exhibition of 1937. Dreier and Moholy-Nagy helped him to emigrate to the United States in 1938, and he taught in Seattle, New York, and Chicago for twenty years, becoming an American citizen in 1949. KPH

Piet Mondrian
DUTCH (1872–1944)

Mondrian moved from his native Amersfoort to Amsterdam in 1892 to study at the Rijksakademie. The city's Stedelijk Museum featured his early, naturalistic paintings in a major exhibition in 1909, the same year he joined the Theosophic Society. Influenced by Picasso and Braque, he experimented with Pointillism and then Cubism, and moved to Paris in 1912. During World War I he was stranded in the Netherlands, where he formulated his Neo-Plastic style of reduced colors and geometric shapes. He also helped found the review *De Stijl*, which encouraged abstraction in both the fine and the applied arts. Mondrian returned to Paris in 1919. In 1926 he participated in the Société Anonyme exhibition at the Brooklyn Museum. In 1938, as World War II approached, he fled to London, and then in 1940 to New York, where he joined the American Abstract Artists association. He died four years later. BWR

Composition with Yellow, Blue, Black and Light Blue. 1929. Oil on canvas, 19 ¹⁵/₁₆ x 19 ¹³/₁₆ in. (50.6 x 50.3 cm). © 2005 Mondrian/Holtzman Trust

Emil Nolde
GERMAN (1867–1956)

Born Emil Hansen in the village of Nolde, Germany, Nolde apprenticed as a woodcarver and furniture designer before studying painting in Munich, Karlsruhe, and Paris. In 1902 he settled in Berlin, where he emulated the work of Gauguin and van Gogh, and in 1906 he joined the Dresden Brücke group. His interest in primitive art and new subject matter grew through a trip to Asia and the South Seas in 1913 and 1914. In the 1920s and 1930s Nolde divided his time between his native northern Germany and Berlin, painting and working in various print media. In 1937 the Nazi government included his work in the *Entartete Kunst* (Degenerate art) exhibition, and four years later it forbade him to paint. He nevertheless continued to work, creating in particular the watercolor series "Unpainted Pictures," notable for their color and luminosity. BWR

Morning in the Flower Garden. 1918. Oil on canvas, 29 ⁵/₈ x 35 in. (75.3 x 88.9 cm).

Ivo Pannaggi
ITALIAN, LIVED NORWAY (1901–1981)

Pannaggi studied architecture in Florence and Rome until 1919, when he took up painting. Through the Bragaglia gallery in Rome, he and Vincino Paladini staged the dance performance *Ballo meccanico futurista* in 1922. A central figure in Italian Futurism from then on, Pannaggi co-wrote the "Manifesto dell'arte meccanica futurista" that same year and designed stage sets and puppets for avant-garde productions throughout the 1920s. Encountering Russian Constructivism at the Venice Biennale of 1924, he became committed to its purist ideal of harmony between people and their living environment. Rejecting a rising current of fascism among Italian artists, he moved to Germany in 1927 and traveled widely as a journalist and commercial artist before settling in Norway. After working there for thirty years as an architect, he returned to Italy, where he spent his last years. KPH

Geometric Function K 5% (Funzione geometrica K 5%). 1926. Gouache on paper, 12 ¹/₂ x 7 ¹⁵/₁₆ in. (31.8 x 20.1 cm).

Head (Tête). c. 1927–29. Oil on canvas, 38 ³/₈ x 32 in. (97.5 x 81.3 cm).

Georges Papazoff
BULGARIAN, LIVED FRANCE (1894–1972)

After fighting in the Balkan Wars against the Turks (1908–13), Papazoff settled in Prague to study art. In 1918 he moved to Munich, where he studied painting with Hans Hofmann. While living briefly in Berlin, he met the artists who exhibited at Herwarth Walden's Der Sturm Gallery and in 1924 he decided to devote himself to painting. After 1924 he lived in Paris and associated with the Surrealists but maintained his creative independence. Papazoff gained a following in Paris, and in 1926 he was included in the Société Anonyme's Brooklyn exhibition. After Duchamp introduced him to the New York art world, he exhibited regularly in the United States. BWR

Two Figures. Before 1930. Pencil, possibly transfer drawing, on paper, 18 ³/₄ x 13 in. (47.7 x 33 cm).

Hélène Perdriat
FRENCH (1894–1969)

A self-taught artist born in La Rochelle, Perdriat exhibited at the Modern Gallery, New York, in 1916 and 1918 and began to show work in Paris in 1919. She was a graphic artist and stage designer as well as a painter, creating the sets for Rolf de Maré's ballet *Marchand d'oiseaux*, and she also illustrated books, including editions of Flaubert's *Madame Bovary* and Colette's *Maison de Claudine*. Her work was popular in Paris and New York in the 1920s, probably the period in which Dreier acquired her work for the Société Anonyme Collection. After a much-derided solo exhibition in New York in 1930, Perdriat fell into obscurity. SG

Room (Space Construction) (Zimmer). 1920–21. Tempera on composition board, 39 x 30 in. (99.1 x 76.2 cm).

Laszlo Peri
HUNGARIAN, LIVED ENGLAND (1889–1967)

Peri grew up in Budapest, where he enrolled at the drama academy of the Hungarian avant-garde arts journal *MA* in 1917. He began to make Expressionist drawings while touring Czechoslovakia as an actor in 1918, then spent the next year contributing to *MA* from Vienna and Paris before settling in Berlin in 1919. There he met Moholy-Nagy, who encouraged him in the increasingly abstract style of his Space Constructions, or architecturally inspired paintings and prints. After practicing architecture for four years in Germany and possibly Russia in the 1920s, he began to sculpt social realist figures and to publish caricatures in a German Communist newspaper. He fled to London under political pressure in 1933, became a British subject in 1939, and spent the rest of his life making small-scale reliefs and commissioned sculptures for public spaces. KPH

Antoine Pevsner
RUSSIAN, LIVED FRANCE (1886–1962)

Born Anton Pevsner, the artist studied painting at the Kiev school of fine arts from 1902 to 1909, and then at the St. Petersburg Academy of Fine Arts. In 1911 he moved to Paris (where he became known as Antoine), absorbing Cubist and Futurist influences from a circle of artists including Amedeo Modigliani and Archipenko. After a year in Russia at the outbreak of World War I, Pevsner joined Naum Gabo, his younger brother, in Oslo from 1915 to 1917 and took up sculpture. The brothers then relocated to Moscow and joined the radical Russian art community. Pevsner taught at the Moscow academy, but in 1923, as the mood in Russia shifted, he left to settle permanently in Paris. In 1931 he cofounded the Abstraction-Création group, and in 1946 helped establish the Salon des Réalités Nouvelles. KPH

Suzanne Phocas
FRENCH (born 1897)

Born in Lille, the young Phocas lived in Greece and studied ancient art. She came to Paris during World War I, where she trained with the Swiss-French Nabi artist Félix Vallotton. In 1923 she became the student of the Cubist painter Jean Metzinger, whom she subsequently married. Phocas's naïve art, which borrowed forms from Cubism, created a unique visual language that appealed to many collectors of the time, including Dreier, who first saw her work during travel in Paris in preparation for the *International Exhibition* in Brooklyn in 1926. In the years ensuing, Phocas ceased painting to assist her husband. SG

Francis Picabia
FRENCH (1879–1953)

After successfully painting landscapes in an Impressionist style, Picabia began to explore abstract art and synesthetic theories around 1905. In 1910 he met Duchamp, whose sense of irony and iconoclastic approach resonated with his own rejection of artistic dogmas. He attended the 1913 Armory Show in New York and formed close relationships with Stieglitz and Marius de Zayas. With Duchamp and Man Ray, Picabia helped to establish New York Dada and quickly became a major figure in the international Dada scene, publishing several Dada journals, poems, and tracts. By 1920, however, he had denounced Dada, and in 1925 he moved to the Midi, where he returned to making figurative art. He spent his final years in Paris, where he resumed abstract painting and wrote poetry. KPH

The Dancer. 1927–28. Brass and celluloid, 31⅞ x 13½ x 11 in. (81 x 34.3 x 27.9 cm) including base.

Child with Dog. 1925–26. Oil on unprepared canvas, 29⅞ x 39⅜ in. (75.9 x 100 cm).

Universal Prostitution (*Prostitution universelle*). 1916–17. Black ink, tempera, and metallic paint on cardboard, 29⁵⁄₁₆ x 37¹⁄₁₆ in. (74.5 x 94.2 cm).

The Bath. 1905, Vollard edition of 1913. Drypoint on paper, 13⅜ x 11⁵⁄₁₆ in. (34 x 28.7 cm).

Painterly Architectonic. 1918. Gouache and watercolor with touches of varnish on paper, 11⁹⁄₁₆ x 9¼ in. (29.3 x 23.5 cm).

Suprematist Composition. c. 1920–21. Graphite, gouache, and ink on paper, 19 x 14 in. (48.3 x 35.6 cm).

Pablo Picasso
SPANISH, LIVED FRANCE (1881–1973)

Considered a child prodigy, Picasso had his first one-man exhibition at Els Quatre Gats in Barcelona at the age of sixteen. He executed the paintings of his Blue Period during short visits to Paris before moving there in 1904. He completed his canonical *Les Demoiselles d'Avignon* in 1907. Working closely with Braque, he pioneered Analytic and Synthetic Cubism, a collaboration broken when Braque left for military service in 1914. Picasso then worked with Jean Cocteau, Erik Satie, and Matisse on set designs for several ballets. He entered a classical period in 1921. During the Spanish Civil War he created many somber paintings, notably *Guernica*, made for the Spanish Pavilion at the 1937 Paris World's Fair. Picasso remained in Paris during World War II but left in 1955 to live in the South of France until his death. BWR

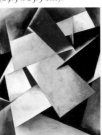

Liubov Popova
RUSSIAN (1889–1924)

Popova originally studied literature in Moscow but subsequently took private art lessons with Russian Impressionist painters. In 1912 she began to work with Vladimir Tatlin and gained her first exposure to the work of Picasso and Braque. After studying briefly with Metzinger and Henri Le Fauconnier in Paris in 1913, she adopted a Cubo-Futurist style. Popova exhibited for the first time with the Jack of Diamonds group in 1916 and joined Malevich's Suprematist group in 1916–17. She began to design theater sets and costumes in 1920, and lectured on her innovations in set design at the INKHUK school in 1922. Popova died of scarlet fever. BWR

Ivan Puni (Jean Pougny)
RUSSIAN, LIVED FRANCE (1892–1956)

Born in Kuokkala, Finland, Puni trained in Paris from 1910 to 1912. That year he settled in St. Petersburg, where he and his wife, the painter and writer Kseniia Boguslavskaia, established a studio that became a meeting place for avant-garde writers and artists. In 1914 he exhibited at the Salon des Indépendants in Paris. During World War I Puni organized the *Tramway* V and 0.10 Futurist exhibitions in St. Petersburg. In 1918 he was appointed to the fine-arts academies in both St. Petersburg and Vitebsk. In late 1920 he settled in Berlin, where he exhibited at Der Sturm; in 1924 he moved to Paris, where he remained for the rest of his life. SG

Man Ray
AMERICAN (1890–1976)

Man Ray was first exposed to modern art as a youth in New York, when he visited Stieglitz's 291 gallery and the Armory Show of 1913. Through his friendships with Duchamp and Walter Arensberg, he became a notable figure in the New York avant-garde and helped found the Society of Independent Artists. Man Ray was initially a painter and sculptor but began experimenting with photography in 1914. In 1920 he helped found the Société Anonyme. In 1921 he followed Duchamp to Paris, where he worked with Dadaists and Surrealists and had great success as a portrait, fashion, and experimental photographer. The next year he created his first Rayographs and published them in several periodicals. During World War II he moved to Los Angeles, then in 1951 returned to Paris, where he lived for the rest of his life. BWR

Odilon Redon
FRENCH (1840–1916)

As a youth in Bordeaux, Redon made charcoal drawings, etchings, and lithographs under the tutelage of local artists. In 1864 he left Bordeaux to study at the École des Beaux-Arts in Paris, where, lacking encouragement from his teachers, he found his inspiration in the Louvre and in his own imagination. After fighting in the Franco-Prussian War, Redon published several albums of lithographs dedicated to Edgar Allan Poe and Gustave Flaubert. He found support from the Symbolist writers through his deep friendship with Stéphane Mallarmé. His work rarely received critical acclaim, but after exhibiting more works than any other artist in the New York Armory Show in 1913, he gained the admiration of a new generation of painters. Late in life he retired to the country and painted primarily in watercolor until his death. BWR

Georges Ribemont-Dessaignes
FRENCH (1884–1974)

Born in Montpellier, Ribemont-Dessaignes abandoned academic instruction after briefly attending two Paris art schools from 1900 to 1901. He met Duchamp-Villon and Duchamp through the Puteaux group in 1909 but quit painting in 1912 for a hiatus during which he wrote poetry and plays attacking conventional morality. He was a Dadaist from 1918 until its decline, but both anticipated and outlasted the Dada movement with his spirited work. He returned to painting between 1917 and 1920, stimulated by Picabia's machine drawings, and regularly contributed to Dada exhibitions, publications, and festivals. He was a member of the Surrealist group from 1924 to 1929 and subsequently devoted himself to literary activity. KPH

Manikins. 1924. Rayograph, 11¹³/₁₆ x 9¹¹/₁₆ in. (30 x 24.6 cm).

And Beyond, the Astral Idol (Et Là-Bas, l'idole astrale, l'apothéose). 1891. Lithograph, 17³/₄ x 12³/₄ in. (45 x 31.7 cm).

Young Woman (Jeune femme). 1919. Oil on linen, 28¹⁵/₁₆ x 23³/₄ in. (73.5 x 60.4 cm).

Painting (formerly *Machine*). 1916. Oil on canvas, 30¹/₈ x 22³/₄ in. (76.5 x 57.8 cm).

Merz 316. Ische Gelb. 1921. Mixed media, 12⁵/₁₆ x 9³/₁₆ in. (31.2 x 23.4 cm).

The Workman (Der Arbeitsmann). 1920–22. Oil on unprimed plywood, 34⁷/₁₆ x 17¹/₄ in. (87.5 x 43.7 cm).

Morton Livingston Schamberg
AMERICAN (1881–1918)

Schamberg studied architecture before enrolling in the Pennsylvania Academy of the Fine Arts in 1903, when he met his lifelong friend Charles Sheeler. They shared a Philadelphia studio from 1906 on and made several trips to Europe together. During Schamberg's extended visits to Paris in 1906, 1908, and 1910, Walter Pach introduced him to Leo Stein's ideas and Sarah Stein's large Matisse collection. He became a Fauve-style colorist, and his contributions to the 1913 Armory Show also demonstrated an awareness of Cubism. Schamberg met Dreier and Duchamp through the circle of Walter and Louise Arensberg in 1916. That spring he organized the first major exhibition of modern art in Philadelphia and, inspired by Picabia, made the machine paintings that climaxed his short career. He died in the influenza epidemic of 1918. KPH

Kurt Schwitters
GERMAN, LIVED NORWAY AND ENGLAND (1887–1948)

Schwitters trained as a figurative artist and never abandoned academic painting, even after creating his renowned abstract assemblages. After World War I he exhibited his collages at Herwarth Walden's Der Sturm Gallery and participated in the Dada movement in Berlin. He coined the term *Merz* to describe his artwork and built the *Merzbau*, an environmental construction, in his home in Hannover. In subsequent years he wrote sound poetry, and between 1923 and 1932 he published the periodical *Merz.* Schwitters moved to Norway in 1937. After World War II began and Germany invaded Norway, he fled to England, where he spent seventeen months in internment camps before settling in the Lake District, where he died in exile. BWR

Franz Wilhelm Seiwert
GERMAN (1894–1933)

Seiwert lived in his hometown of Cologne for his entire life. A Marxist and antiwar activist, he contributed prints, drawings, and essays to the German leftist press from 1919 on. In 1923, disappointed by the Cologne Dada movement, he and Heinrich Hoerle cofounded the Gruppe progressiver Künstler, intending it to have a more revolutionary stance and to promote a society of human unity. The flat style, social themes, and worker protagonists of Seiwert's mature paintings and graphic works embody his Marxist ideal for art: unsentimental and concrete images dealing with the laws and structure of reality. Complications from a childhood injury caused Seiwert's early death. KPH

Victor Servranckx
BELGIAN (1897–1965)

Servranckx entered the Brussels Academy of Art in 1913 and spent four years there. He first exhibited his paintings in 1917 and by 1924 had earned a respected place in the avant-garde community through solo shows in Brussels and Bielfeld, Germany, and group shows in Paris. The clean lines and precise geometry of Servranckx's paintings, along with his less-known work in sculpture and furniture design, reveal the strong influence of Léger, Le Corbusier, and other proponents of the international machine aesthetic. In 1935 he designed the Belgian Pavilion headquarters at the Brussels Universal Exposition. While he continued to exhibit regularly in Paris, Servranckx spent his long career primarily in Belgium, where he was a highly regarded mural painter, educator, critic, and essayist. KPH

Walmar Shwab
SWISS (1902–DATE UNKNOWN)

Born Wladimir Schwab and raised in Switzerland and Mongolia, Shwab studied chemistry in Paris from 1920 to 1925 before turning to abstract painting. He was interested in the work of Léger, Gleizes, and particularly the paintings of Moholy-Nagy, whom he traveled to Germany to meet in 1927. In 1928 Shwab exhibited his paintings at Berlin's Der Sturm Gallery, where Dreier would acquire his work in 1930. In 1933 Shwab abandoned painting and returned to the study of chemistry, earning his doctorate in 1939. SG

Milly Steger
GERMAN (1881–1948)

After training in the studios of sculptors Karl Janssen in Düsseldorf and Georg Kolbe in Berlin, Steger worked under the patronage of industrialist Karl Ernst Osthaus in Hagen, where she completed sculpture for the municipal theater, schools, and town hall. Returning to Berlin in 1917, she became a member of Arbeitsrat für Kunst (Working council for art), an activist association of German artists and architects, and of the artist community the Freien Secession (Free secession), of which Kolbe was a chairman. Between 1922 and 1945 Steger participated in more than twenty-five exhibitions of the Akademie der Kunst in Berlin. The bombing of her home and studio there in November 1943 destroyed many works and documents concerning her career. SG

No. 46-1922: The Town. 1922. Oil on canvas, 28⁷/₁₆ x 38³/₈ in. (72.3 x 97.5 cm).

Construction 14. c. 1928. Oil on linen, 18¹¹/₁₆ x 46¹/₁₆ in. (47.5 x 117 cm).

Resurrection or *Memorial to Two Sisters.* c. 1918–23. Wood, height: 43¹¹/₁₆ in. (111 cm) including base.

Heads. 1925. Watercolor and gouache on paper, 11⁵/₁₆ x 8¹/₂ in. (28.7 x 21.6 cm).

The White Heron. 1918–20. Oil on canvas, 48¹/₁₆ x 29¹/₁₆ in. (122.1 x 73.8 cm).

Equivalent. 1924 or 1926. Gelatin silver print. Beinecke Rare Book and Manuscript Library, Yale University.

Käte Traumann Steinitz
GERMAN, LIVED UNITED STATES (1889–1975)

After studying drawing with Lovis Corinth in Berlin, Steinitz moved with her husband, Dr. Ernst Steinitz, to Hannover, where she met Schwitters in 1918. Together they founded the Aposs-Verlag, under which they published typographically new and progressive work, including two children's books, *Die Märchen vom Paradies* (1924) and, with the collaboration of van Doesburg, *Die scheuche Märchen* (1925). In 1928 Steinitz and Schwitters also collaborated on a comic opera, *Zusammenstoss.* She lived in New York from 1935 to 1942, then settled in Los Angeles in 1945, where she was chief curator of the Elmer Belt Library of Vinciana until her death. SG

Joseph Stella
AMERICAN, BORN ITALY (1877–1946)

Stella moved from Italy to the United States at the age of nineteen and briefly studied medicine before enrolling in art school in 1897. A precise but delicate draftsman, he was drawn to scenes of urban life and industrial landscapes. Influenced by work he saw in Italy and France between 1909 and 1912 — particularly that of the Italian Futurists, who shared his enthusiasm for motion and technology — Stella developed a sparkling, faceted modernist style. He met Dreier through the Society of Independent Artists around 1916, and she would become one of his most ardent supporters. Until he moved to Europe, in 1928, Stella was active in the Société Anonyme as an exhibitor, lecturer, and exhibition organizer. He moved between Paris, Naples, and New York, exhibiting intermittently until his death. KPH

Alfred Stieglitz
AMERICAN (1864–1946)

As a photographer, writer, gallerist, and publisher, Stieglitz was pivotal in promoting modern art and photography in the United States. Born in New Jersey, he studied mechanical engineering in Germany while independently exploring photography, starting in 1883. After returning to New York in 1891, he strengthened photography's status as a fine art as editor of the journal *Camera Notes* (1897–1902) and by organizing the first Photo-Secession exhibition, in 1902, when he began to publish *Camera Work.* In 1905, with the photographer Edward Steichen, Stieglitz founded the Little Galleries, at 291 Fifth Avenue. From the mid-1920s until his death he ran two additional galleries, the Intimate Gallery (1925–29) and An American Place (1929–46). BWR

John Henry Bradley Storrs
AMERICAN, LIVED FRANCE (1885–1956)

The son of a prosperous real estate developer and architect, Storrs began his artistic training in the United States before moving to Paris in 1911. There he worked with Auguste Rodin until the master's death, in 1917. Storrs's sculpture of the early 1920s focused on the figure and was influenced by Rodin and Cubism. After 1923 he sculpted works inspired by architecture, especially the skyscrapers of New York and Chicago, which he visited often between 1927 and 1939, and after 1930 he emulated the forms of industrial machinery and tools. Storrs was in France at the outbreak of World War II and was imprisoned for six months in a concentration camp in 1939. He lived as an expatriate in Mer, France, until his death. SG

Machine Form. 1920. Ink on paper, 12⅝ x 9½ in. (32.1 x 24.1 cm).

Sophie Täuber-Arp
SWISS (1889–1943)

After studying textile design in St. Gall, Switzerland, and in Germany, Täuber moved to Zurich in 1915 and began to produce abstract or what she called "concrete" paintings. She was also active in Zurich's Dada group from 1916 to 1919, particularly in their performances at the Cabaret Voltaire. From 1916 to 1929 she was a professor of textile design at the school of applied arts in Zurich. In 1921 she married the French sculptor, painter, and poet Jean Arp, with whom she moved in 1929 to the town of Meudon-val-Fleury, just outside Paris. Her most important commission, the interior design of the Café de l'Aubette in Strasbourg, was completed in 1927–28 but was destroyed by the Nazis in the early 1940s. A member of many artists' alliances in Switzerland and France, Täuber-Arp also published the modern art journal *Plastique* in 1937–38. SG

Turned Wood Sculpture (*Sculpture en bois tourné*). 1937. Lathe-turned wood, height: 15⁵⁄₁₆ in. (38.9 cm).

Joaquín Torres-García
URUGUAYAN (1874–1949)

Born in Uruguay, Torres-García studied at the Escuela Oficial de Bellas Artes and at the Academia Baixas in Barcelona, where he was part of the bohemian milieu of the cafe Els Quatre Gats, along with Picasso and Julio González. In 1920 he moved to New York to manufacture sculptured wooden toys. During this time he also produced paintings of cityscapes in a flat geometric style, two of which Dreier acquired after meeting him in 1920. In 1926 Torres-García moved to Paris, where he met van Doesburg and Mondrian and developed the theory of Universal Constructivism, for which he is best known. Returning to Montevideo in 1934, he formed the Asociación de Arte Constructivo, which spread ideas about modern art throughout Latin America. In 1943 he founded the Taller Torres-García (Torres-García school), where artists worked collectively on murals, architecture, sculpture, and crafts. SG

New York Street Scene. 1920. Oil and collage on academy board coated in gray paint, 18 x 23¹⁵⁄₁₆ in. (45.7 x 60.8 cm).

At the Piano. 1915. Oil on canvas, 42 x 35¹⁄₁₆ in. (106.7 x 89 cm).

Nadezhda Udaltsova
RUSSIAN (1886–1961)

While studying at the art school of Konstantin Yuon and Ivan Dudin in Moscow, Udaltsova met fellow artist Popova, with whom she traveled to Paris in 1912. During her year in Paris, Udaltsova worked with Cubists Metzinger, Henri Le Fauconnier, and André Dunoyer de Segonzac, who would influence her subsequent work after her return to Moscow in 1913. She soon became closely involved with the Moscow avant-garde and showed in their major exhibitions, making her debut at the fourth Jack of Diamonds exhibition in 1914. In 1918 she collaborated with Alexander Rodchenko, Malevich, and others on the newspaper *Anarkhiia* (Anarchy). In the 1920s and 1930s she contributed to many international exhibitions, and had a solo exhibition in 1945 at the Moscow Union of Soviet Artists. SG

Composition, 1923. 1923. Gouache on paper, 10¹³⁄₁₆ x 8½ in. (27.4 x 21.5 cm).

Georges Valmier
FRENCH (1885–1937)

Valmier grew up in Paris and received traditional art training at the École des Beaux-Arts. He moved to Montmartre in 1908. Valmier did not investigate Cubism, however, until he met Gleizes during his service in World War I. After the war, Valmier developed an elegant interpretation of Cubism and was represented by Léonce Rosenberg. After 1928 the inspiration for his work came increasingly from spiritual and cosmic ideas. He joined the Abstraction-Création group in 1931 but suffered a physical collapse in 1932 that hindered his painting. In the 1920s and 1930s he designed many theater sets and costumes and painted commissioned panels for Rosenberg's dining room. He left his final suite of murals, for the Paris World's Fair of 1937, unfinished at his death. BWR

Abstraction or *Lady in Abstract.* c. 1921, reworked c. 1923–26. Oil on canvas, 36 x 50 in. (91.4 x 127 cm).

Jay Van Everen
AMERICAN (1875–1947)

Van Everen trained in architecture at Cornell University, from which he graduated in 1897. He then studied art at a number of New York art schools, including the Art Students League, the New York School of Art, the National Academy of Design, the Art Alliance, and Cooper Union. After early work as an illustrator, designer, and muralist, he turned to the problem of color in modern painting in 1917 through a friendship with Daugherty. It was probably around this time, between 1918 and 1920, that he met Dreier, who often exhibited his works with the Société Anonyme in the 1920s. Van Everen continued his series of color studies influenced by Mayan, Aztec, and Oriental art into the 1930s before turning to book illustration in his final years. SG

Jacques Villon

FRENCH (1875–1963)

Villon was the eldest child of the artistic Duchamp family. As an adolescent he learned engraving from his grandfather in Rouen, and he continued to make prints when he moved to Paris in 1895. By 1912 Villon was painting seriously and participating in the regular meetings of the "Puteaux" or "Passy" Cubists, which included his three artistic siblings and Gleizes, Metzinger, Léger, Picabia, and Guillaume Apollinaire. After four years of military service in World War I, Villon began to explore a flatter, more abstract Cubist style. He worked in relative obscurity until the late 1940s, when his Cubist paintings won new admiration in France. Villon also produced several important illustrated books in the decade before his death. BWR

The Jockey. 1924. Oil on canvas, 25$^{7}/_{16}$ x 50$^{7}/_{16}$ in. (64.6 x 128.1 cm).

The Island of Peace. c. 1918–19. Oil on canvas, 41$^{1}/_{8}$ x 38 in. (104.5 x 96.5 cm).

Heinrich Johann Vogeler

GERMAN (1872–1942)

Born in Bremen, Vogeler moved to Düsseldorf in 1890 at the age of eighteen. Dissatisfied with his instructors, he interrupted his studies at the Düsseldorf Kunstakademie with extended visits to Belgium, Italy, and Paris. In 1894 he joined Fritz Overbeck's art colony at Worpswede, where he created architectural designs and Pre-Raphaelite-inspired book illustrations. Vogeler and his brother Franz founded the Worpswede Werkstätte in 1908, producing Arts and Crafts–style furniture until Heinrich was drafted to fight in World War I. After the war he began to promote the Bolshevist ideas he had encountered on the Russian front and to campaign for a communist Germany. In 1931 he settled in Russia, where he worked on propaganda paintings and architectural commissions. He was interned in a wartime prison camp in 1941 and died there the following year. KPH

Also in Exhibition

Alexander Archipenko *Woman (Metal Lady)*. 1923. Brass, copper, wood, new silver, paint, 54 5/16 x 20 11/16 x 3 3/4 in. (138 x 52.5 x 9.5 cm)

Carl Buchheister *Red and Green Steps.* 1925. Oil on canvas,
39 x 23 in. (99.9 x 60.7 cm)

Alexander Calder *Fourth Flurry '48.* 1948. Painted sheet metal and wire,
6 ft. 8 in. x 6 ft. 4¹/₂ in. (203.2 x 194.3 cm)

Heinrich Campendonk *Pastoral Scene.* c. 1920. Oil on wood, 37¹/₂ x 23¹/₁₆ in. (95.2 x 58.5 cm)

Heinrich Campendonk *The Red Cat (Die rote Katze).* 1926. Oil on canvas, 29⁵/₈ x 33⁷/₁₆ in. (75.3 x 85 cm)

Arthur Garfield Dove *Sunrise III* (formerly *Sunset No. 3*). 1936–37. Wax emulsion and oil on canvas partly coated in gesso, 25 x 35¹/₁₆ in. (63.5 x 89.1 cm)

Marcel Duchamp *Rotary Glass Plates (Precision Optics)*, also known as *Revolving Glass (Rotative plaque verre [Optique de précision])*. 1920. Painted glass and iron with electric motor, 65¼ x 62 x 38 in. (165.7 x 157.5 x 96.5 cm)

Marcel Duchamp *Rotoreliefs (Optical Disks)*, also known as *Play Toys*. 1935. Six disks printed on each side in offset color lithography, in circular holder consisting of two black plastic rings, each disk diam. 9¹³⁄₁₆ in. (25 cm)

Marcel Duchamp *Box in a Valise (Boîte-en-valise)*. 1942–43. Leather valise containing miniature replicas and color reproductions, 4⅛ x 14⅞ x 16⅛ in. (10.5 x 37.8 x 41 cm)

Suzanne Duchamp *Accordion Masterpiece (Chef d'oeuvre accordéon)*. 1921. Oil, gouache, and silver leaf on canvas, 39⁵⁄₁₆ x 31⅞ in. (99.8 x 80.9 cm)

Louis Michel Eilshemius *Ferryboat at Night.* c. 1910–13. Oil on cardboard,
8⅜ x 11 in. (21.3 x 27.9 cm)

Naum Gabo *Model of the Column* (formerly *Model for Glass Fountain*). c. 1928,
rebuilt 1938. Perspex and plastic on aluminum base, 10⅝ x 4⁷/₁₆ x 3¹⁵/₁₆ in.
(27 x 11.3 x 10 cm)

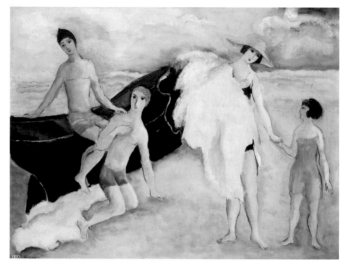

John Graham *Vox Humana*. 1931. Oil and sand on canvas, 47 x 32¹/₁₆ in. (119.4 x 81.4 cm)

Alice Halicka *On the Beach*. 1926. Oil on canvas, 22³/₁₆ x 29⁵/₁₆ in. (56.4 x 74.5 cm)

Lawren Stewart Harris *Abstraction, No. 3*. c. 1934–37. Oil on canvas, 29¹/₈ x 36¹/₈ in. (74 x 92 cm)

Angelika Hoerle *Female Bust*. 1920. Ink, watercolor, and pencil on paper, 13³/₈ x 11³/₁₆ in. (35.4 x 28.7 cm)

Angelika Hoerle *Head with Sign, Hand, Wheel, and Auto Horn*. 1922. Graphite on paper, c. 13½ x 11½ in. (34.3 x 29.2 cm)

Angelika Hoerle *Tree and Wall*. 1922. Graphite on paper, 17⁵/₁₆ x 13 in. (43.6 x 33 cm)

David Kakabadzé Z (*The Speared Fish*). c. 1925. Painted wood with metal and glass, 28⁷/₈ x 5⁵/₈ x 5³/₄ in. (73.4 x 14.3 x 14.6 cm) including base

Wassily Kandinsky *The Waterfall*. 1909. Oil on pasteboard, 27⁹/₁₆ x 38³/₈ in. (70 x 97.5 cm)

Wassily Kandinsky *Multicolored Circle (Mit Buntem Kreis)*. 1921. Oil on canvas, 54⁷/₁₆ x 70⁷/₈ in. (138.2 x 180 cm)

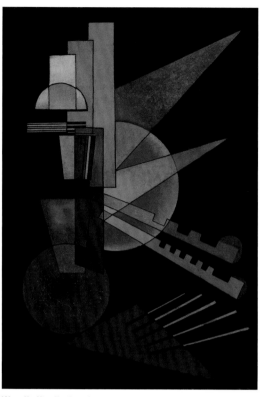

Wassily Kandinsky *Abstract Interpretation (Abstrakte Deutung)*. 1925. Oil on composition board, 19¹/₂ x 13⁵/₈ in. (49.5 x 34.6 cm)

Wassily Kandinsky *Small Yellow (Kleines Gelb)*. 1926. Oil on composition board, 16⁵/₁₆ x 12¹¹/₁₆ in. (41.5 x 32.3 cm)

Paul Klee *Autumn Flower (Herbstblume)*. 1922. Oil on canvas with blue watercolor (or ink) border, laid down on cardboard mat, 16¹¹/₁₆ x 13¹/₂ in. (42.5 x 34.4 cm)

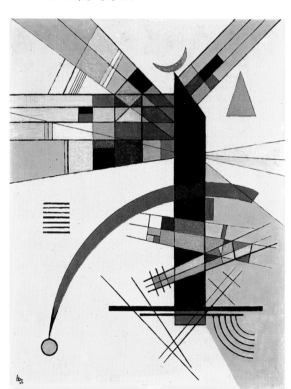

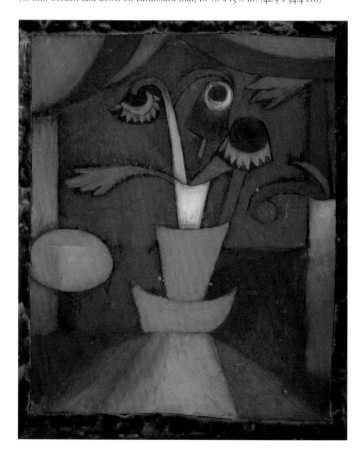

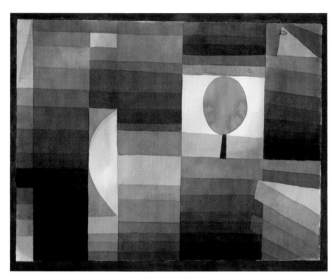

Paul Klee *The Herald of Autumn (green/violet gradation with orange accent)* (*Der Bote des Herbstes [grün/violette Stufung mit orange Akzent]*). 1922. Watercolor and pencil on laid Ingres paper, 10³/₈ x 13 in. (26.5 x 33.1 cm)

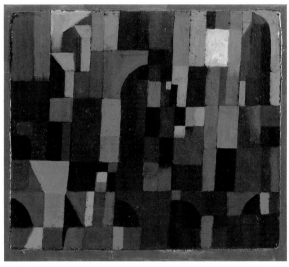

Paul Klee *Red/Green Architecture (yellow/violet gradation)* (*Architektur rot/grun [gelb/violette Stufung]*). 1922. Oil on canvas with red watercolor border, laid down on cardboard mat, 14¹⁵/₁₆ x 16⁷/₈ in. (37.9 x 42.9 cm)

Erika Giovanna Klien *Factory (geometrical abstraction).* 1925. Graphite and black crayon on paper, 8¹⁵/₁₆ x 9 in. (22.7 x 22.9 cm)

Erika Giovanna Klien *The Train.* 1925. Graphite, crayon, and watercolor on paper, laid down on tag board, 7 x 11³/₄ in. (17.8 x 29.8 cm)

Erika Giovanna Klien *Abstraction.* 1926. Aqueous paint, either gouache or size, on fine weave linen, 39½ in. x 6 ft. 6¼ in. (100.3 x 198.8 cm)

Erika Giovanna Klien *Rhythm of Movement: Figure (Bewegungs-Rhytmus Figur).* 1926. Charcoal on paper, laid down on tag board, 17½ x 9⁹⁄₁₆ in. (44.5 x 24.5 cm)

Fernand Léger *Composition No. VII.* 1925. Oil on canvas mounted on aluminum, 52⁵/₁₆ x 36³/₁₆ in. (132.9 x 91.9 cm)

John Marin *Deer Isle, Maine: Stonington Waterfront, Two Movements.* 1924. Watercolor and charcoal on paper, 14¹/₂ x 17¹/₂ in. (36.8 x 44.5 cm)

Roberto Matta Echaurren *Fabulous Race Track of Death* (*Instrument Very Dangerous to the Eye*). c. 1941. Oil on canvas, 28 x 36 in. (71.1 x 91.4 cm)

Joan Miró *Somersault* (*Le Renversement*). 1924. Oil, pencil, charcoal, and tempera on canvasboard, 36³/₈ x 28¹¹/₁₆ in. (92.4 x 72.8 cm)

Hélène Perdriat *Two Women*. n.d. Etching on paper, composition: 2⁷/₈ x 1⁷/₈ in. (7.3 x 4.8 cm), sheet: 12¹/₁₆ x 10³/₁₆ in. (30.7 x 25.8 cm)

Antoine Pevsner *The Dancer*. 1927–28. Brass and celluloid, 31⁷/₈ x 13¹/₂ x 11 in. (81 x 34.3 x 27.9 cm) including base

Ivan Puni *Suprematist Drawing* 3. c. 1920–21. Graphite, gouache, and ink on paper, 24⁷/₁₆ x 18³/₄ in. (62 x 47.6 cm)

Man Ray *Web*. 1922. Rayograph mounted on white wove paper, 9⅜ x 7 in. (23.8 x 17.8 cm)

Man Ray *Ships*. 1924. Rayograph mounted on white wove paper, 10 x 13 in. (25.4 x 33 cm)

Man Ray *Revolving Doors*. 1926. Ten color screenprints, each sheet 22 x 15 in. (56 x 39 cm) with slight variations

III

IV

V

VI

VII

VIII

IX

X

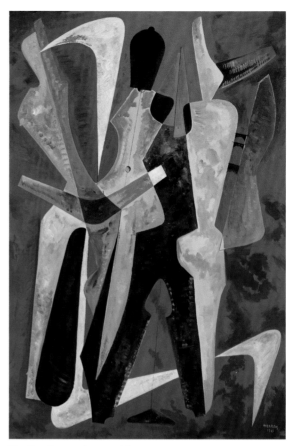

Man Ray *Promenade*. 1941. Oil on canvas, 60 x 40¼ in. (152.4 x 102.2 cm)

Morton Schamberg *Painting* (formerly *Machine*). 1916. Oil on canvas, 30⅛ x 22¾ in. (76.5 x 57.8 cm)

Kurt Schwitters *Monument to the Artist's Father*. c. 1922–23. Painted plywood, 49¹⁵⁄₁₆ x 10½ x 16¹⁄₁₆ in. (126.9 x 26.6 x 40.8 cm)

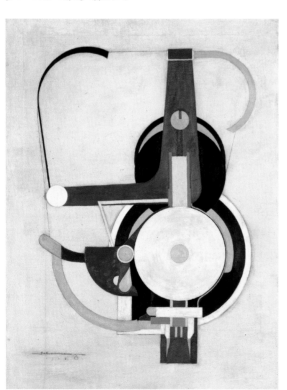

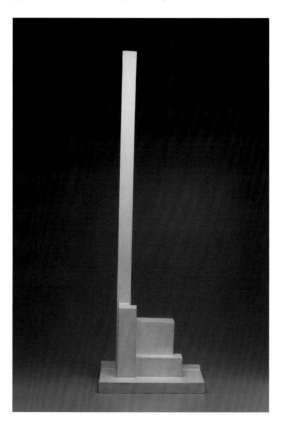

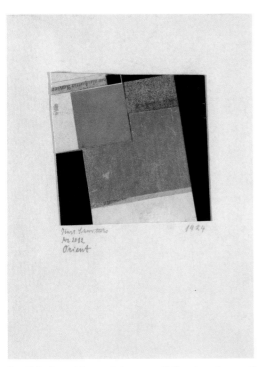

Kurt Schwitters *Mz 2012 Orient.* 1924. Collage in various media, 7⁵/₁₆ x 5³/₈ in. (18.5 x 13.7 cm)

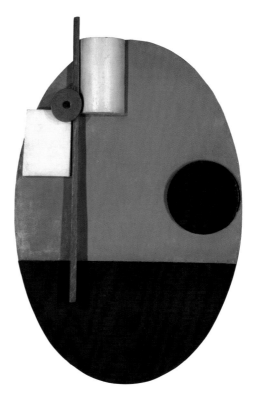

Kurt Schwitters *Oval Construction.* 1925. Wood, plywood, nails, and paint, 45⁷/₈ x 29¹/₂ x 5³/₈ in. (116.5 x 75 x 13.6 cm)

Kurt Schwitters *Carnival.* 1947. Collage of various reproductions and papers, 10⁹/₁₆ x 7¹⁵/₁₆ in. (26.9 x 19.9 cm)

Kurt Schwitters *Collage: Best Wishes for K S Dreier! (Collage: Für K S Dreier Viel Freude!)* (detail). 1937. Collage, 5¹⁵/₁₆ x 3¹³/₁₆ in. (15.1 x 9.7 cm)

Käte Traumann Steinitz *Heads*. 1925. Watercolor and gouache on paper, 10^{1}/$_{16}$ x 10^{1}/$_{4}$ in. (25.6 x 26.1 cm)

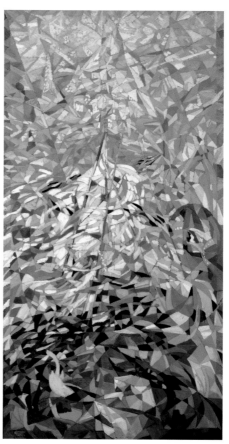

Joseph Stella *Spring* or *The Procession*. c. 1914–16. Oil on canvas, 6 ft. 3^{5}/$_{16}$ in. x 40^{3}/$_{16}$ in. (191.3 x 102.1 cm)

John Storrs *Untitled* (*The Dancer*). 1918–20. Polychromed terra-cotta, 4^{3}/$_{4}$ x 4^{1}/$_{4}$ x 3 in. (12.1 x 10.8 x 7.6 cm)

Jacques Villon *Still Life (Déjeuner, La Table servie, Nature morte)*. 1912–13. Oil on burlap, 35 x 45¹¹/₁₆ in. (88.9 x 116.1 cm)

Exhibition Checklist

All works are in the collection of the Yale University Art Gallery unless otherwise indicated.

Constantin Alajálov
AMERICAN, BORN RUSSIA, 1900–1987

Harlequin and Woman. 1925. Oil on canvas, 38 1/8 x 27 13/16 in. (96.8 x 70.7 cm). Gift of Collection Société Anonyme, 1941.324

Josef Albers
AMERICAN, BORN GERMANY, 1888–1976

Gate. 1936. Oil on masonite, 19 1/2 x 20 3/16 in. (49.5 x 51.3 cm). Gift of Collection Société Anonyme, 1941.325

Alexander Archipenko
RUSSIAN, LIVED FRANCE AND UNITED STATES, 1887–1964

Woman (Metal Lady). 1923. Brass, copper, wood, new silver, paint, 54 5/16 x 20 11/16 x 3 3/4 in. (138 x 52.5 x 9.5 cm). Gift of Katherine S. Dreier to the Collection Société Anonyme, 1948.207

Jean (Hans) Arp
FRENCH, BORN GERMANY, 1886–1966

Bird Man. 1921. c. 1920. Painted wood, 11 7/16 x 8 1/4 in. (29 x 20.9 x 6.5 cm). Gift of Katherine S. Dreier to the Collection Société Anonyme, 1948.208

Torso-Navel. 1921. Oil on wood, 31 9/16 x 20 9/16 x 2 9/16 in. (80.1 x 52.2 x 6.5 cm). Gift of Katherine S. Dreier to the Collection Société Anonyme, 1950.47

7 Arpaden von Hans Arp. 1923. Print portfolio. Cover; title page; 1: *Mustache-hat (Schnurrhut)*; 2: *The Ocean (Das Meer)*; 3: *A Navel (Ein Nabel)*; 4: *Navel Bottle (Die Nabelflasche)*; 5: *Mustache-clock (Schnurruhr)*; 6: *Egg Whisk (Eierschlager)*; 7: *Arabian Eight (Arabische Acht)*. Lithographs, each 17 5/8 x 13 1/4 in. (44.8 x 38.9 cm). Gift, Estate of Katherine S. Dreier, 1953.6.137.a–i

Rudolf Bauer
GERMAN, LIVED UNITED STATES, 1889–1953

Andante V. c. 1915–17. Oil on canvas, 30 1/16 x 32 in. (76.3 x 81.3 cm). Gift of Collection Société Anonyme, 1941.333

Willi Baumeister
GERMAN, 1889–1955

Soccer Players (Fussballspieler). 1927–28. Pencil and gouache on cream-colored wove paper removed from drawing album, 17 5/16 x 13 3/8 in. (43.9 x 34 cm). Gift of Collection Société Anonyme, 1941.345

Umberto Boccioni
ITALIAN, 1882–1916

Still Life: Glass and Siphon. c. 1914. Collage, gouache, and ink on cardstock, 12 1/16 x 8 3/16 in. (30.7 x 20.8 cm). Gift of Collection Société Anonyme, 1941.353

Richard Boix
SPANISH, LIVED UNITED STATES, 1890–1973

Study for *Caricature of Marcel Duchamp.* 1920. Blue ink, graphite, wash, and green crayon on paper, 13 x 8 1/2 in. (33 x 21.6 cm). Gift, Estate of Katherine S. Dreier, 1953.6.16

Caricature of Marcel Duchamp. 1920. Black ink on paper, 11 1/2 x 15 in. (29.2 x 38.1 cm). Gift, Estate of Katherine S. Dreier, 1953.6.17

Study for *Caricature of Man Ray.* 1920. Brush, black ink, pencil on brown wrapping paper, 13 1/2 x 11 in. (34.3 x 27.9 cm). Gift, Estate of Katherine S. Dreier, 1953.6.14

Caricature of Man Ray. 1920. Brush and black ink, 16 x 11 1/4 in. (40.6 x 28.6 cm). Gift, Estate of Katherine S. Dreier, 1953.6.15

Ilya Bolotowsky
AMERICAN, BORN RUSSIA, 1907–81

Autumn. Study for mural, Men's Day Room, Chronic Diseases Hospital, Welfare Island, New York. 1940. Pencil and tempera on cardboard, 5 1/4 x 6 5/16 in. (13.3 x 16 cm). Gift, Estate of Katherine S. Dreier, 1953.6.167

Sailing. Study for mural, Men's Day Room, Chronic Diseases Hospital, Welfare Island, New York. 1940. Pencil and tempera on cardboard, 5 1/4 x 6 11/16 in. (13.3 x 17 cm). Gift, Estate of Katherine S. Dreier, 1953.6.168

Constantin Brancusi
ROMANIAN, LIVED FRANCE, 1876–1957

Little French Girl (The First Step III). 1914–18. Oak, 48 5/8 x 9 3/8 x 9 1/4 in. (123.5 x 23.8 x 23.5 cm). Solomon R. Guggenheim Museum, New York. Gift, Estate of Katherine S. Dreier, 1953.53.1332

Yellow Bird (L'Oiseau d'or). 1919. Yellow marble with limestone-and-oak base, height: 36 1/4 in. (92 cm), circumference: 20 1/2 in. (52.1 cm), overall height including base: 7 ft. 3 1/4 in. (221.6 cm). Bequest of Katherine S. Dreier, 1952.30.1

Georges Braque
FRENCH, 1882–1963

Black and White Collage (Verre et musique). 1913. Graphite, black chalk/charcoal, white chalk, and painted black paper (brown wove paper brushed with black water-based pigment/ink) on laid Ingres paper, 28 11/16 x 18 3/4 in. (72.9 x 47.7 cm). Gift of Katherine S. Dreier to the Collection Société Anonyme, 1949.138

Dora Bromberger
GERMAN, 1871–1942

Autumn Chilliness. 1916. Oil on canvas, 27 5/8 x 27 1/2 in. (70.1 x 69.8 cm). Gift, Estate of Katherine S. Dreier, 1953.6.233

Patrick Henry Bruce
AMERICAN, LIVED FRANCE, 1881–1936

Composition I. 1916. Oil on canvas, 45 5/8 x 34 7/8 in. (115.9 x 88.6 cm). Gift of Collection Société Anonyme, 1941.368

Carl Buchheister
GERMAN, 1890–1964

Red and Green Steps. 1925. Oil on canvas, 39 x 23 in. (99.9 x 60.7 cm). Gift of Collection Société Anonyme, 1941.374

David Burliuk
AMERICAN, BORN UKRAINE, 1882–1967

The Eye of God. 1923–25. Oil and sand on canvas, 39 7/8 x 30 1/16 in. (101.3 x 76.4 cm). Gift of Collection Société Anonyme, 1941.378

Alexander Calder
AMERICAN, 1898–1976

Big Bird (maquette). c. 1936. Painted sheet metal and painted wire, 13 1/4 x 8 1/4 x 7 1/4 in. (33.7 x 21 x 18.4 cm). Gift, Estate of Katherine S. Dreier, 1953.6.2

Fourth Flurry '48. 1948. Painted sheet metal and wire, 6 ft. 8 in. x 6 ft. 4 1/2 in. (203.2 x 194.3 cm). Gift of Katherine S. Dreier to the Collection Société Anonyme, 1948.298

Heinrich Campendonk
GERMAN, LIVED NETHERLANDS, 1889–1957

Pastoral Scene. c. 1920. Oil on wood, 37 1/2 x 23 1/16 in. (95.2 x 58.5 cm). Gift of Collection Société Anonyme, 1941.382

Seated Nude. c. 1920. Oil on canvas, 15 3/16 x 17 11/16 in. (38.5 x 45 cm). Gift, Estate of Katherine S. Dreier, 1953.6.8

The Cloistered Life. 1921. Oil on canvas, 48 7/16 x 37 5/8 in. (123.1 x 95.6 cm). Gift of Collection Société Anonyme, 1941.384

Interior with Head and Still Life (Innenraum mit Kopf und Stilleben) (formerly *Déjeuner [Breakfast]*). 1921. Oil on canvas, 26⅝ x 39³/₁₆ in. (67.7 x 99.5 cm). Gift of Collection Société Anonyme, 1941.381

The Woodcarver. 1924. Oil on canvas, 27¹⁵/₁₆ x 34¹/₁₆ in. (71 x 88.2 cm). Gift of Collection Société Anonyme, 1941.383

The Red Cat (Die rote Katze). 1926. Oil on canvas, 29⅝ x 33⁷/₁₆ in. (75.3 x 85 cm). Gift of Collection Société Anonyme, 1941.380

Cartoon for a Mural Commemorating the Return of Schneidemühl to the German Nation. 1928–30. Ink, watercolor, and gouache on paper squared up in pencil, 41⅛ x 68⅞ in. (104.4 x 175 cm). Gift of Katherine S. Dreier to the Collection Société Anonyme, 1946.64

Otto Gustaf Carlsund
SWEDISH, 1897–1948

Brown Operator (L'Opérateur brun). 1926. Gouache over graphite on light tan paper, 14⁵/₁₆ x 9⅝ in. (36.4 x 24.4 cm). Gift of Collection Société Anonyme, 1941.394. This and following from a series of designs for a mural in a cinema.

Man with Megaphone I (Homme au mégaphone, Etude I). 1926. Gouache over graphite on light tan paper, 13¾ x 9¾ in. (35 x 24.8 cm). Gift of Collection Société Anonyme, 1941.395

The Green Machine (Machine verte). 1926. Gouache, 13¾ x 9³/₁₆ in. (34.9 x 23.3 cm). Gift of Collection Société Anonyme, 1941.396

Musician I (Musicien 1). 1926. Gouache over graphite on light tan paper, 14⅜ x 6¾ in. (36.5 x 17.2 cm). Gift of Collection Société Anonyme, 1941.397

Actors (Les Acteurs). 1926. Gouache over graphite on light tan paper, 14⅜ x 6¹¹/₁₆ in. (36.5 x 17 cm). Gift of Collection Société Anonyme, 1941.398

Musician II (Musicien 2). 1926. Gouache over graphite on light tan paper, 14⁵/₁₆ x 6⁵/₁₆ in. (36.4 x 16.1 cm). Gift of Collection Société Anonyme, 1941.399

Red Machine (Machine rouge). 1926. Gouache over graphite on light tan paper, 14⁵/₁₆ x 9¹⁵/₁₆ in. (36.4 x 24.9 cm). Gift of Collection Société Anonyme, 1941.400

Gray Operator (Opérateur gris). 1926. Gouache over graphite on light tan paper, 14⁵/₁₆ x 9½ in. (36.4 x 24.2 cm). Gift of Collection Société Anonyme, 1941.402

Giorgio de Chirico
ITALIAN, BORN GREECE, 1888–1978

Metaphysical Interior. 1925. Oil on canvas, 27¹⁵/₁₆ x 21⅝ in. (71 x 55 cm). Gift of Collection Société Anonyme, 1941.423

John Covert
AMERICAN, 1882–1960

Brass Band. 1919. Oil, cord, nails, and possibly tempera over gesso, on commercial pieced wood covered in cardboard, 26 x 23¹³/₁₆ in. (66 x 60.5 cm). Gift of Collection Société Anonyme, 1941.411

Vocalization. 1919. Oil and wooden dowels over commercial pieced wood covered in cardboard, 23¹¹/₁₆ x 26⅜ in. (60.2 x 67 cm). Gift of Collection Société Anonyme, 1941.413

Jean Crotti
SWISS, 1878–1958

Composition. 1925. Oil on canvas, 28⅜ x 21¼ in. (72 x 54 cm). Gift of Katherine S. Dreier to the Collection Société Anonyme, 1949.174

James Henry Daugherty
AMERICAN, 1889–1974

Wall Decoration — The Risen Christ. c. 1918–20. Oil on burlap, 6 ft. 3⁵/₁₆ in. x 6 ft. 2¹/₁₆ in. (191.3 x 188.1 cm). Gift of Collection Société Anonyme, 1941.419

Burgoyne Diller
AMERICAN, 1906–65

Construction. 1940. Oil on wood and masonite, 24 x 24 x 3¹/₁₆ in. (61 x 61 x 7.8 cm). Gift of Katherine S. Dreier to the Collection Société Anonyme, 1950.52

Composition #21. 1945. Oil on canvas, 36½ x 42⅛ in. (92.7 x 107 cm). Gift of Katherine S. Dreier to the Collection Société Anonyme, 1946.37

Theo van Doesburg
DUTCH, 1883–1931

Simultaneous Composition (Composition simultanée). 1929. Oil on canvas, 19¾ x 19¹³/₁₆ in. (50.2 x 50.4 cm). Gift of Katherine S. Dreier to the Collection Société Anonyme, 1941.209

Marthe Donas
BELGIAN, 1885–1967

Still Life with Bottle and Cup. 1917. Lace, sandpaper, cloth, netting, and paint on composition board, 20⅞ x 15³/₁₆ in. (53 x 38.6 cm). Gift of Collection Société Anonyme, 1941.429

Still Life with Coffee Pot. c. 1917–18. Oil on composition board, 20⁵/₁₆ x 15 in. (51.6 x 38.1 cm). Gift of Collection Société Anonyme, 1941.430

Still Life with Profile of Pitcher. c. 1918–19. Oil on composition board, 23¹¹/₁₆ x 15¹³/₁₆ x ¾ in. (60.2 x 40.2 x 1.9 cm). Gift of Katherine S. Dreier to the Collection Société Anonyme, 1941.428

Arthur Garfield Dove
AMERICAN, 1880–1946

Barnyard Fantasy. 1935. Oil on canvas, 30⅞ x 23⅛ in. (78.4 x 58.8 cm). Gift of Duncan Phillips, B.A. 1908, to the Collection Société Anonyme, 1949.85

Sunrise III (formerly *Sunset No. 3*). 1936–37. Wax emulsion and oil on canvas partly coated in gesso, 25 x 35¹/₁₆ in. (63.5 x 89.1 cm). Gift of Katherine S. Dreier to the Collection Société Anonyme, 1949.3

Dorothea A. Dreier
AMERICAN, 1870–1923

Dutch Woman Seated. c. 1908. Watercolor on paper, 20½ x 15¾ in. (52 x 40.2 cm). Gift of Société Anonyme, 1941, 1941.435

Katherine Sophie Dreier
AMERICAN, 1877–1952

Two Worlds (Zwei Welten). 1930. Oil on canvas, 28¼ x 36⅛ in. (71.8 x 91.7 cm). Gift of Collection Société Anonyme, 1941.438

40 Variations. 1937. Colored ink (au pochoir) over lithograph, sheet: 11⅞ x 8½ in. (30.2 x 21.6 cm). Gift of Collection Société Anonyme, 1941.440a&b

Explosion. 1940–47. Oil on canvas, 24¹/₁₆ x 29¹⁵/₁₆ in. (61.1 x 76 cm). Gift of Katherine S. Dreier to the Collection Société Anonyme, 1950.1

Werner Drewes
AMERICAN, BORN GERMANY, 1899–1985

Composition 140. 1936. Oil on canvas, 45¼ x 34¼ in. (115 x 87 cm). Gift of Collection Société Anonyme, 1941.442

Marcel Duchamp
AMERICAN, BORN FRANCE, 1887–1968

Cemetery of Uniforms and Liveries, No. 2, also known as *The Bachelors and Nine Malic Moulds (Cimitière des uniformes et livrées No. 2).* 1914. Pencil and watercolor on paper, 26 x 39⁵/₁₆ in. (66 x 99.8 cm). Gift of Katherine S. Dreier to the Collection Société Anonyme, 1948.311

Tu m'. 1918. Oil on canvas, bottle brush, three safety pins, and one bolt, 27½ in. x 9 ft. 11⁵/₁₆ in. (69.8 x 303 cm). Gift, Estate of Katherine S. Dreier, 1953.6.4

Rotary Glass Plates (Precision Optics), also known as *Revolving Glass (Rotative plaque verre [Optique de précision])*. 1920. Painted glass and iron with electric motor, 65¼ x 62 x 38 in. (165.7 x 157.5 x 96.5 cm). Gift of Collection Société Anonyme, 1941.446a–c

Rotoreliefs (Optical Disks), also known as *Play Toys*. 1935. Six disks printed on each side in offset color lithography, in circular holder consisting of two black paper rings, each disk diam. 9¹³/₁₆ in. (25 cm). Gift of Collection Société Anonyme, 1941.447

Color model for reproduction of "Cemetery of Uniforms and Liveries, No. 2" (Coloriage pour le "Cimitière des uniformes et livrées No. 2"). 1938. Photographic reproduction, 8⅛ x 12⅛ in. (21.1 x 31.3 cm). Gift, Estate of Katherine S. Dreier, 1953.6.349

Box in a Valise (Boîte-en-valise). 1942–43. Leather valise containing miniature replicas and color reproductions, 4⅛ x 14⅞ x 16⅛ in. (10.5 x 37.8 x 41 cm). Gift, Estate of Katherine S. Dreier, 1948.102

Pocket Chess Set. 1943. Leather pocket chessboard, celluloid pieces, and pins in black leather wallet, closed: 6½ x 4½ x ½ in. (16.5 x 11.4 x 1.3 cm), open: 6½ x 8¾ x ¼ in. (16.5 x 22.2 x 0.6 cm). Gift, Estate of Katherine S. Dreier, 1953.6.221

Genre Allegory (Allégorie de genre). 1944. Collage, 12½ x 9⅞ in. (31.8 x 24 cm). Gift, Estate of Katherine S. Dreier, 1953.6.350

In advance of the broken arm or *Snow Shovel*. 1945 (replica of the lost original of 1915). Wood and galvanized-iron snow shovel, 48 x 18 x 4 in. (121.9 x 45.7 x 10.2 cm). Gift of Katherine S. Dreier to the Collection Société Anonyme, 1946.99

To Katherine Dreier, Knight of the Société Anonyme. 1951. Birthday card. Graphite on paper, 6 x 4⁵/₁₆ in. (15.6 x 12 cm). Gift, Estate of Katherine S. Dreier, 1953.6.43

Suzanne Duchamp
FRENCH, 1889–1963

Accordion Masterpiece (Chef d'oeuvre accordéon). 1921. Oil, gouache, and silver leaf on canvas, 39⁵/₁₆ x 31⅞ in. (99.8 x 80.9 cm). Gift of the artist to Collection Société Anonyme, 1949.173

Raymond Duchamp-Villon
FRENCH, 1876–1918

Parrot. 1913–14. Wood, 25¾ x 23¹¹/₁₆ x 2½ in. (65.4 x 60.2 x 6.3 cm). Gift of Collection Société Anonyme, 1941.449

Seated Woman (Femme assise). 1914. Bronze, with black marble pedestal and base, 28 x 8 x 7⅛ in. (71.1 x 20.3 x 18.1 cm) including base. Bequest of Katherine S. Dreier, 1952.30.7

Louis Michel Eilshemius
AMERICAN, 1864–1941

The Concert Singer. c. 1910. Oil on paper, laid down on laminated chipboard, 18½ x 14 in. (47 x 35.6 cm). Gift of Collection Société Anonyme, 1941.452

Ferryboat at Night. c. 1910–13. Oil on cardboard, 8⅜ x 11 in. (21.3 x 27.9 cm). Gift, Estate of Katherine S. Dreier, 1953.6.9

New York Harbor, after 1913. Oil on cardboard, 8⁹/₁₆ x 16 in. (21.7 x 40.6 cm). Gift, Estate of Katherine S. Dreier, 1953.6.10

Mountain Landscape. c. 1914. Oil on paper, laid down on laminated chipboard, 8⅞ x 8¾ in. (22.5 x 21.3 cm). Gift of Collection Société Anonyme, 1941.451

The Pool. c. 1920. Oil on printed sheet of music paper, laid down on laminated chipboard, 10¹¹/₁₆ x 13⅝ in. (27.1 x 34.6 cm). Gift of Collection Société Anonyme, 1941.450

Adolf Erbslöh
GERMAN, BORN UNITED STATES, 1881–1947

The Factory (Die Fabrik). c. 1921. Oil on canvas, 25⅞ x 32³/₁₆ in. (65.8 x 81.8 cm). Gift of Collection Société Anonyme, 1941.453

Max Ernst
GERMAN, LIVED FRANCE AND UNITED STATES, 1891–1976

Paris-Rêve. 1924–25. Oil on canvas, 25½ x 21¼ in. (64.8 x 54 cm). Bequest of Katherine S. Dreier, 1952.30.5

Anthropomorphic Figure (Plaster Man). 1930. Gouache on plaster over plywood, 27⁵/₁₆ x 21⁹/₁₆ x 1 in. (71 x 54.8 x 2.5 cm). Gift of Collection Société Anonyme, 1941.454

Oskar W. Fischinger
AMERICAN, BORN GERMANY, 1900–1967

Abstraction. 1936. Gouache and watercolor, 17⅞ x 11¹³/₁₆ in. (45.4 x 30 cm). Gift of Collection Société Anonyme, 1941.473

Naum Gabo
AMERICAN, BORN RUSSIA, LIVED GERMANY, FRANCE, AND ENGLAND, 1890–1977

Model of the Column. c. 1928, rebuilt 1938. Perspex, transparent plastic coated with unidentified black substance, plastic on aluminum base, 10⅝ x 4⅞ x 3¹⁵/₁₆ in. (27 x 11.3 x 10 cm). Gift of Collection Société Anonyme, 1941.474

Paul Gauguin
FRENCH, 1848–1903

Joys of Brittany (Joies de Bretagne). 1889. Zincograph, 8 x 8¹¹/₁₆ in. (20.3 x 22.1 cm). Gift of Collection Société Anonyme, 1941.475

Albert Gleizes
FRENCH, 1881–1953

Landscape (Paysage). 1914. Oil on canvas, 28⅞ x 36⁵/₁₆ in. (73.3 x 92.3 cm). Gift of Collection Société Anonyme, 1941.485

Vincent van Gogh
DUTCH, LIVED FRANCE, 1853–90

Adeline Ravoux. 1890. Oil on fabric, 19¾ x 19⅞ in. (50.2 x 50.5 cm). The Cleveland Museum of Art, Bequest of Leonard C. Hanna, Jr., 1958.31

Arshile Gorky
AMERICAN, BORN ARMENIA, 1904–48

Nighttime, Enigma, and Nostalgia. 1931–32. Black and brown ink on Strathmore white paper, 18³/₁₆ x 24⁵/₁₆ in. (46.3 x 61.7 cm). Gift of Collection Société Anonyme, 1941.487

John D. Graham
AMERICAN, BORN RUSSIA, 1881–1961

Vox Humana. 1931. Oil and sand on canvas, 47 x 32¹/₁₆ in. (119.4 x 81.4 cm). Gift of Collection Société Anonyme, 1941.488

Zeus. 1941. Oil on canvas, 29⅞ x 23⅞ in. (75.9 x 60.6 cm). Gift from the estate of Katherine S. Dreier to the Collection Société Anonyme, 1953.6.128

Juan Gris
SPANISH, LIVED FRANCE, 1887–1927

Newspaper and Fruit Dish (Journal et compotier). 1916. Oil on canvas, 36¹³/₁₆ x 24 in. (93.5 x 61 cm). Gift of Collection Société Anonyme, 1941.489

Alice Halicka
POLISH, LIVED FRANCE, 1895–1975

On the Beach. 1926. Oil on canvas, 22³/₁₆ x 29⁵/₁₆ in. (56.4 x 74.5 cm). Gift of Collection Société Anonyme, 1941.496

Lawren Stewart Harris
CANADIAN, 1885–1970

Abstraction, No. 3. c. 1934–37. Oil on canvas, 29⅛ x 36⅛ in. (74 x 92 cm). Gift of Katherine S. Dreier to the Collection Société Anonyme, 1950.42

Marsden Hartley
AMERICAN, 1877–1943

Rubber Plant. 1920. Oil on canvas, 32 x 26 in. (81.3 x 66 cm). Gift of Collection Société Anonyme, 1941.500

Angelika Hoerle
GERMAN, 1899–1923

Female Bust. 1920. Ink, watercolor, and pencil on paper, 13³/₈ in x 11³/₁₆ in. (35.4 x 28.7 cm). Gift of Collection Société Anonyme, 1941.502

Tree and Wall. 1922. Graphite on paper, 17³/₁₆ x 13 in. (43.6 x 33 cm). Gift of Collection Société Anonyme, 1941.503

Head with Sign, Hand, Wheel, and Auto Horn. 1922. Graphite on paper, c. 13¹/₂ in. x 11¹/₂ in. (34.3 x 29.2 cm). Gift of Collection Société Anonyme, 1941.504

Harry Holtzman
AMERICAN, 1912–87

Sculpture. 1941–42. Oil and tempera on cheesecloth or muslin, laid down on masonite, 60 x 12 x 12 in. (152.4 x 30.5 x 30.5 cm). Gift of the artist to the Collection Société Anonyme, 1950.112

Finnur Jónsson
ICELANDIC, 1892–1993

Woman at the Card Table. c. 1918–25. Oil and gold paint on burlap, 25¹/₄ x 20⁵/₁₆ in. (64.1 x 51.6 cm). Gift of Collection Société Anonyme, 1941.510

Béla Kádár
HUNGARIAN, 1877–1955

Separation (Trennung). c. 1920–24. Gouache over graphite on paper, 39³/₁₆ x 58⁷/₈ in. (99.5 x 149.5 cm). Gift of Collection Société Anonyme, 1941.511

David Kakabadzé
GEORGIAN, 1889–1952

Z (The Speared Fish). c. 1925. Painted wood with metal and glass, 28⁷/₈ x 5⁵/₈ x 5³/₄ in. (73.4 x 14.3 x 14.6 cm) including base. Bequest of Katherine S. Dreier, 1952.30.2

Wassily Kandinsky
RUSSIAN, LIVED GERMANY AND FRANCE, 1866–1944

The Waterfall. 1909. Oil on pasteboard, 27⁹/₁₆ x 38³/₈ in. (70 x 97.5 cm). Gift of Collection Société Anonyme, 1941.529

Improvisation No. 7 (Storm). 1910. Oil on pasteboard, 27⁹/₁₆ x 19³/₁₆ in. (70 x 48.7 cm). Gift of Collection Société Anonyme, 1941.527

Multicolored Circle (Mit Buntem Kreis). 1921. Oil on canvas, 54⁷/₁₆ x 70⁷/₈ in. (138.2 x 180 cm). Gift of Collection Société Anonyme, 1941.528

Abstract Interpretation (Abstrakte Deutung). 1925. Oil on composition board, 19¹/₂ x 13⁵/₈ in. (49.5 x 34.6 cm). Gift of Collection Société Anonyme, 1941.526

Small Yellow (Kleines Gelb). 1926. Oil on composition board, 16⁵/₁₆ x 12¹¹/₁₆ in. (41.5 x 32.3 cm). Gift of Collection Société Anonyme, 1941.525

Edmund Kesting
GERMAN, 1892–1970

Collage. 1923. Pleated and folded white wove papers, brown wove kraft paper, fine wove beige fabric, sandpaper with black chalk, coarse black woven fabric net, beige open-weave fabric net, graphite, ink, and wash on wove paper, 12 x 11³/₁₆ in. (30.5 x 28.4 cm). Gift of Collection Société Anonyme, 1941.530

Ragnhild Keyser
NORWEGIAN, 1889–1943

Composition 1. 1926. Oil on canvas, 51 x 25⁵/₈ in. (129.5 x 65.1 cm). Gift of Collection Société Anonyme, 1941.531

Stefi Kiesler
AUSTRIAN, LIVED UNITED STATES, 1900–1963

Typo-Plastic. c. 1925–30. Black and red typewriter ink, 10⁵/₈ x 8¹/₄ in. (27 x 21 cm). Gift of Collection Société Anonyme; Gift of Frederick Kiesler, 1941.667

Typo-Plastic. c. 1925–30. Red and black typewriter ink, 10⁵/₈ x 8¹/₄ in. (27 x 21 cm). Gift of Collection Société Anonyme; Gift of Frederick Kiesler, 1941.668

Typo-Plastic. c. 1925–30. Black and red typewriter ink, 10⁵/₈ x 8¹/₄ in. (27 x 21 cm). Gift of Collection Société Anonyme; Gift of Frederick Kiesler, 1941.669

Typo-Plastic. 1925–30. Black and red typewriter ink, 10⁵/₈ x 8¹/₄ in. (27 x 21 cm). Gift of Collection Société Anonyme; Gift of Frederick Kiesler, 1941.670

Paul Klee
SWISS, LIVED GERMANY, 1879–1940

Abstract (Red/green gradation with some cinnabar in vertical format) (Abstrakt [rot/grüne Stufung mit etwas Zinnobar im Hochformat]). 1921. Watercolor with black ink border, 12³/₁₆ x 8⁷/₁₆ in. (31 x 21.5 cm). Gift of Collection Société Anonyme, 1941.535

Red/Green Architecture (yellow/violet gradation) (Architektur rot/grün [gelb/violette Stufung]). 1922. Oil on canvas with red watercolor border, laid down on cardboard mat, 14¹⁵/₁₆ x 16⁷/₈ in. (37.9 x 42.9 cm). Gift of Collection Société Anonyme, 1941.533

Autumn Flower (Herbstblume). 1922. Oil on canvas with blue watercolor (or ink) border, laid down on cardboard mat, 16¹¹/₁₆ x 13¹/₂ in. (42.5 x 34.4 cm). Gift of Collection Société Anonyme, 1941.534

The King of All Insects (Der König alles Ungeziefers). 1922. Sepia ink and watercolor on laid Ingres paper, 13³/₄ x 11¹/₄ in. (34.8 x 28.4 cm). Gift of Collection Société Anonyme, 1941.536

The Herald of Autumn (green/violet gradation with orange accent) (Der Bote des Herbstes [grün/violette Stufung mit orange Akzent]). 1922. Watercolor and pencil on laid Ingres paper, 10³/₈ x 13 in. (26.5 x 33.1 cm). Gift of Collection Société Anonyme, 1941.537

Foundation (Grundfeste). 1922. Watercolored oil-transfer drawing on rough watercolor paper with red-brown watercolor (or ink) border, 11³/₁₆ x 14³/₄ in. (28.4 x 37.7 cm). Gift of Collection Société Anonyme, 1941.538

Ingenious Star Container (Kunstvoller Sternehälter). 1922. Watercolored oil-transfer drawings, laid down on cardboard, 13³/₈ x 17⁵/₁₆ in. (34 x 44 cm). Gift of Collection Société Anonyme, 1941.539

Watercolor Sketch for "MA" (Aquarelleskizze zu "MA"). 1922. Pencil, ink, and watercolor on paper, 11⁵/₁₆ x 8⁵/₈ in. (28.6 x 21.8 cm). Gift of Collection Société Anonyme, 1941.540

Erika Giovanna Klien
AUSTRIAN, LIVED UNITED STATES, 1900–1957

Factory (geometrical abstraction). 1925. Graphite and black crayon on paper, 8¹⁵/₁₆ x 9 in. (22.7 x 22.9 cm). Gift, Estate of Katherine S. Dreier, 1953.6.52

The Train. 1925. Graphite, crayon, and watercolor on paper, laid down on tag board, 7 x 11³/₄ in. (17.8 x 29.8 cm). Gift, Estate of Katherine S. Dreier, 1953.6.53

Abstraction. 1926. Aqueous paint, either gouache or size, on fine weave linen, 39¹/₂ in. x 6 ft. 6¹/₄ in. (100.3 x 198.8 cm). Gift of Katherine S. Dreier to the Collection Société Anonyme, 1946.69

Rhythm of Movement: Figure (Bewegungs-Rhytmus Figur). 1926. Charcoal on paper, laid down on tag board, 17¹/₂ x 9⁹/₁₆ in. (44.5 x 24.5 cm). Gift, Estate of Katherine S. Dreier, 1953.6.48

Rhythm of Movement (Bewegungs Rhytmus). 1926. Charcoal on paper, laid down on gray tag board, 17¹/₄ x 9³/₈ in. (43.8 x 23.9 cm). Gift, Estate of Katherine S. Dreier, 1953.6.49

Fernand Léger
FRENCH, 1881–1955

Study for *The Disk* (Etude pour *Le Disque*). 1918. Watercolor on pale green wove paper, 14¹/₈ x 11¹/₈ in. (35.8 x 28.3 cm). Gift of Collection Société Anonyme, 1941.543

Study for *The City* (Etude pour *La Ville*). 1919. Watercolor, gouache, ink, and graphite on paper, squared up, laid down on cardboard, 15 1/2 x 11 5/16 in. (39.4 x 28.7 cm). Gift of Collection Société Anonyme, 1941.544

Ladder. 1923. Watercolor and pencil on paper, laid down on cardboard, 10 5/16 x 12 11/16 in. (26.2 x 32.2 cm) (irreg.). Gift of Collection Société Anonyme, 1941.545

Composition No. VII. 1925. Oil on canvas mounted on aluminum, 52 5/16 x 36 3/16 in. (132.9 x 91.9 cm). Gift of Collection Société Anonyme, 1941.542

Umbrella (*La Parapluie*). 1925. Watercolor and gouache on paper, 12 3/8 x 9 5/16 in. (31.4 x 23.7 cm.). Gift of Collection Société Anonyme, 1941.546

Wilhelm Lehmbruck
GERMAN, 1881–1919

Female Torso (*Weiblicher Torso*). c. 1911–14. Cast stone, 45 1/4 x 18 3/4 x 12 3/4 in. (114.9 x 47.6 x 32.4 cm). Gift, Estate of Katherine S. Dreier, 1953.6.5

Jacques Lipchitz
LITHUANIAN, LIVED FRANCE AND UNITED STATES, 1891–1973

Man with Mandolin. 1916–17. Limestone, 30 x 10 x 11 in. (76.2 x 26 x 28.9 cm). Gift of Collection Société Anonyme, 1941.547

El Lissitzky
RUSSIAN, 1890–1941

Victory over the Sun (*Sieg über die Sonne*). 1923. Portfolio of ten color lithographs (two with collage), each 21 1/8 x 17 15/16 in. (53.5 x 45.5 cm), in album, 21 1/2 x 18 1/2 in. (54.5 x 47 cm):

The Machinery (*Teil der Schaumaschinerie*). Gift, Estate of Katherine S. Dreier, 1953.6.229 B

Announcer (*Ansager*). Gift, Estate of Katherine S. Dreier, 1953.6.229 C

Sentinel (*Posten*). Gift, Estate of Katherine S. Dreier, 1953.6.229 D

Anxious Ones (*Ängstliche*). Gift, Estate of Katherine S. Dreier, 1953.6.229 E

Globetrotter (*in Time*) (*Globetrotter* [*in der Zeit*]). Gift, Estate of Katherine S. Dreier, 1953.6.229 F

Sportsmen (*Sportmänner*). Gift, Estate of Katherine S. Dreier, 1953.6.229 G

Troublemaker (*Zankstifter*). Gift, Estate of Katherine S. Dreier, 1953.6.229 H

Old Man (*Head Two Paces Behind*) (*Alter* [*Kopf 2 Schritt hinten*]). Gift, Estate of Katherine S. Dreier, 1953.6.229 I

Gravediggers (*Totengräber*). Gift, Estate of Katherine S. Dreier, 1953.6.229 J

New Man (*Neuer*). Gift, Estate of Katherine S. Dreier, 1953.6.229 K

Proun 99. c. 1923–25. Water-soluble and metallic paint on wood, 50 13/16 x 39 in. (129 x 99.1 cm). Gift of Collection Société Anonyme, 1941.548

Louis Lozowick
AMERICAN, BORN RUSSIA, 1892–1973

City Shapes. 1922–23. Oil on composition board with canvas-textured surface, 18 1/8 x 14 15/16 in. (46 x 38 cm). Gift of the artist to the Collection Société Anonyme, 1950.8

Kasimir Malevich
RUSSIAN, 1878–1935

The Knife Grinder or *Principle of Glittering* (*Tochil'shchik Printsip Mel'kaniia*). 1912–13. Oil on canvas, 31 5/16 x 31 5/16 in. (79.5 x 79.5 cm). Gift of Collection Société Anonyme, 1941.553

Louis Marcoussis
POLISH, LIVED FRANCE, 1878–1941

Fish. 1926. Oil behind glass, wood frame by Pierre Legrain, 21 1/2 x 15 11/16 in. (54.6 x 39.8 cm). Gift of Collection Société Anonyme, 1941.556

John Marin
AMERICAN, 1870–1953

Deer Isle, Maine: Stonington Waterfront, Two Movements. 1924. Watercolor and charcoal on paper, 14 1/2 x 17 1/2 in. (36.8 x 44.5 cm). Gift of Katherine S. Dreier to the Collection Société Anonyme, 1949.82

Henri Matisse
FRENCH, 1869–1954

Nude Seated in an Armchair (*Nu assis dans un fauteuil*). 1922. Lithograph on paper, 17 1/4 x 11 in. (43.8 x 28 cm). Gift of Collection Société Anonyme, 1941.558

Roberto Matta Echaurren
CHILEAN, 1911–2002

Fabulous Race Track of Death (*Instrument Very Dangerous to the Eye*). c. 1941. Oil on canvas, 28 x 36 in. (71.1 x 91.4 cm). Gift of Collection Société Anonyme, 1941.559

Konstantin Medunetsky
RUSSIAN, 1889–c. 1935

Spatial Construction (formerly *Construction No. 557*). 1919. Tin, brass, painted iron, and steel on painted metal base, 18 1/8 x 7 x 7 in. (46 x 17.8 x 17.8 cm) (including base). Gift of Collection Société Anonyme, 1941.562

Jean Metzinger
FRENCH, 1883–1956

The Port. 1920. Oil on canvas, 31 15/16 x 21 5/16 in. (81.1 x 54.1 cm). Gift of Collection Société Anonyme, 1941.565

Joan Miró
SPANISH, 1893–1983

Somersault (*Le Renversement*). 1924. Oil, pencil, charcoal, and tempera on canvasboard, 36 3/8 x 28 11/16 in. (92.4 x 72.8 cm). Gift of Collection Société Anonyme, 1941.572

László Moholy-Nagy
HUNGARIAN, LIVED GERMANY AND UNITED STATES, 1895–1946

Crescents and Cross. c. 1921–23. Woodcut on paper, 18 1/2 x 11 5/8 in. (47 x 29.5 cm). Gift of Collection Société Anonyme. 1941.575

Planes and Beams. c. 1921–23. Woodcut on paper, 9 1/8 x 11 11/16 in. (23.2 x 29.7 cm). Gift of Collection Société Anonyme, 1941.580

Intersecting Planes. 1923–24. Woodcut on paper, 9 1/8 x 11 11/16 in. (23.2 x 29.7 cm). Gift of Collection Société Anonyme, 1941.576

Abstraction. 1923–24. Woodcut on paper, 17 7/16 x 11 13/16 in. (44.3 x 30 cm). Gift, Estate of Katherine S. Dreier, 1953.6.59

G 5. 1926. Oil and pencil on galalith, 16 9/16 x 20 3/4 in. (42 x 52.7 cm). Gift of Collection Société Anonyme, 1941.573

Johannes Molzahn
AMERICAN, BORN GERMANY, 1892–1965

Happening (*Geschehen*). 1919. Oil and aluminum leaf on canvas, 55 1/8 x 59 5/16 in. (140 x 150.7 cm). Gift of Collection Société Anonyme, 1941.587

Piet Mondrian
DUTCH, 1872–1944

Composition with Yellow, Blue, Black and Light Blue. 1929. Oil on canvas, 19 15/16 x 19 13/16 in. (50.6 x 50.3 cm). Gift of Collection Société Anonyme, 1941.603

Fox Trot B. 1929. Oil on canvas, 17⁷/₈ x 17⁷/₈ in. (45.4 x 45.4 cm). Gift of Collection Société Anonyme, 1941.604

Fox Trot A. 1930. Oil on canvas, 30¹³/₁₆ x 30¹³/₁₆ in. (78.2 x 78.3 cm). Gift of the artist to the Collection Société Anonyme, 1942.355

Emil Nolde
GERMAN, 1867–1956

Morning in the Flower Garden. 1918. Oil on canvas, 29⁵/₈ x 35 in. (75.3 x 88.9 cm). Gift of Collection Société Anonyme, 1941.614

Ivo Pannaggi
ITALIAN, 1901–81

Architectonic Function 3U (Funzione architettonica 3U). c. 1925–26. Oil on canvas, 59¹/₁₆ x 35⁷/₁₆ in. (150 x 90 cm). Gift of Collection Société Anonyme, 1941.616

Geometric Function K 5% (Funzione geometrica K 5%). 1926. Gouache on paper, 12¹/₂ x 7¹⁵/₁₆ in. (31.8 x 20.1 cm). Gift, Estate of Katherine S. Dreier, 1953.6.61

Georges Papazoff
BULGARIAN, LIVED FRANCE, 1894–1972

Head (Tête). c. 1927–29. Oil on canvas, 38³/₈ x 32 in. (97.5 x 81.3 cm). Gift of M. Henri-Pierre Roché for the Collection Société Anonyme, 1949.6

Hélène Perdriat
FRENCH, 1894–1969

Two Figures. Before 1930. Pencil, possibly transfer drawing, on paper, 18³/₄ x 13 in. (47.7 x 33 cm). Gift, Estate of Katherine S. Dreier, 1953.6.100

Two Women. n.d. Etching on paper, composition: 2⁷/₈ x 1⁷/₈ in. (7.3 x 4.8 cm), sheet: 12¹/₈ x 10¹/₄ in. (30.78 x 25.0 cm). Gift, Estate of Katherine S. Dreier, 1953.6.260

Laszlo Peri
HUNGARIAN, LIVED ENGLAND, 1889–1967

Room (Space Construction) (Zimmer). 1920–21. Tempera on composition board, 39 x 30 in. (99.1 x 76.2 cm). Gift of Collection Société Anonyme, 1941.627

Antoine Pevsner
RUSSIAN, LIVED FRANCE, 1886–1962

The Dancer. 1927–28. Brass and celluloid, 31⁷/₈ x 13¹/₂ x 11 in. (81 x 34.3 x 27.9 cm) including base. Gift of Collection Société Anonyme, 1941.629

Suzanne Phocas
FRENCH, BORN 1897

Child with Dog. 1925–26. Oil on unprepared canvas, 29⁷/₈ x 39³/₈ in. (75.9 x 100 cm). Gift of Collection Société Anonyme, 1941.631

Francis Picabia
FRENCH, 1879–1953

Universal Prostitution (Prostitution universelle). 1916–17. Black ink, tempera, and metallic paint on cardboard, 29⁵/₁₆ x 37¹/₁₆ in. (74.5 x 94.2 cm). Gift of Collection Société Anonyme, 1941.635

Midi (Promenade des anglais). c. 1923–26. Oil, feathers, macaroni, and leather on canvas in snakeskin frame by Pierre Legrain, 21³/₄ x 39¹/₄ in. (55.3 x 99.7 cm). Gift of Collection Société Anonyme, 1941.634

Pablo Picasso
SPANISH, LIVED FRANCE, 1881–1973

The Bath. 1905, Vollard edition of 1913. Drypoint on paper, 13³/₈ x 11⁵/₁₆ in. (34 x 28.7 cm). Gift of Collection Société Anonyme, 1941.636

Liubov Popova
RUSSIAN, 1889–1924

Painterly Architectonic. 1918. Gouache and watercolor with touches of varnish on paper, 13³/₁₆ x 9¹³/₁₆ in. (33.5 x 24.9 cm). Gift, Estate of Katherine S. Dreier, 1953.6.91

Painterly Architectonic. 1918. Gouache and watercolor with touches of varnish on paper, 11⁹/₁₆ x 9¹/₄ in. (29.3 x 23.5 cm). Gift, Estate of Katherine S. Dreier, 1953.6.92

Ivan Puni (Jean Pougny)
RUSSIAN, LIVED FRANCE, 1892–1956

Suprematist Drawing 6. c. 1920–21. Graphite, gouache, and ink on paper, 19¹/₂ x 12¹/₂ in. (49.5 x 31.8 cm). Gift of Collection Société Anonyme, 1941.645

Suprematist Composition. c. 1920–21. Graphite, gouache, and ink on paper, 19 x 14 in. (48.3 x 35.6 cm). Gift of Collection Société Anonyme, 1941.646

Suprematist Drawing 3. c. 1920–21. Graphite, gouache, and ink on paper, 24⁷/₁₆ x 18³/₄ in. (62 x 47.6 cm). Gift of Collection Société Anonyme, 1941.647

Man Ray
AMERICAN, 1890–1976

L'Impossibilité Danger/Dancer. 1972. Photolithograph, 23³/₈ x 15³/₁₆ in. (59.3 x 38.5 cm)

Three Heads (Joseph Stella and Marcel Duchamp). 1920. Gelatin silver photograph with paper collage mounted on red poster board, 11¹/₈ x 8 in. (28.3 x 20.3 cm) with mat. Gift, Estate of Katherine S. Dreier, 1953.6.208

Portrait of Marcel Duchamp. 1920–21. Gelatin silver print, 14¹/₂ x 11 in. (36.8 x 27.9 cm). Gift, Estate of Katherine S. Dreier, 1953.6.181

Lampshade. 1921. Painted tin, metal rod, wing bolt, square bolt, and round metal flange screwed to round wood base, 45³/₈ x 3¹/₁₆ in. (115.3 x 7.7 cm). Gift, Estate of Katherine S. Dreier, 1953.6.1

Web. 1922. Rayograph mounted on white wove paper, 9⁵/₁₆ x 10⁷/₈ in. (23.7 x 27.6 cm). Gift of Collection Société Anonyme, 1941.648

Feather. 1922. Rayograph mounted on white cardboard, 11¹¹/₁₆ x 9³/₈ in. (29.7 x 23.8 cm). Gift of Collection Société Anonyme, 1941.650

Manikin. 1923. Rayograph on paper, 9⁵/₁₆ x 7 in. (13.7 x 17.8 cm). Gift of Collection Société Anonyme, 1941.649

Spiral. 1923. Rayograph mounted on white cardboard, 11¹¹/₁₆ x 9³/₈ in. (29.7 x 23.8 cm). Gift of Collection Société Anonyme, 1941.654

Manikins. 1924. Rayograph, 11¹³/₁₆ x 9¹¹/₁₆ in. (30 x 24.6 cm). Gift of Collection Société Anonyme, 1941.659

Ships. 1924. Rayograph mounted on white wove paper, 10 x 13 in. (25.4 x 33 cm). Gift of Collection Société Anonyme, 1941.661

Sugar Loaves. 1925. Rayograph mounted on black wove paper, 9¹/₄ x 11⁵/₈ in. (23.5 x 29.5 cm). Gift of Collection Société Anonyme, 1941.658

Letters: PGSJOMC. 1925. Rayograph mounted on white cardboard, 11⁵/₈ x 9¹/₄ in. (29.5 x 23.5 cm). Gift, Estate of Katherine S. Dreier, 1953.6.102b

Revolving Doors. 1926. Ten color screenprints, each sheet 22 x 15 in. (56 x 39 cm) with slight variations. Gift, Estate of Katherine S. Dreier, 1953.6.56 1a–j, 2a–j

Promenade. 1941. Oil on canvas, 60 x 40¹/₄ in. (152.4 x 102.2 cm). Gift of the artist to the Collection Société Anonyme, 1948.97

Odilon Redon
FRENCH, 1840–1916

And Beyond, the Astral Idol (Et Là-Bas, l'idole astrale, l'apothéose). 1891. Lithograph on paper, 17³/₄ x 12³/₄ in. (45 x 31.7 cm). Gift of Collection Société Anonyme, 1941.663

Georges Ribemont-Dessaignes
FRENCH, 1884–1974

Young Woman (Jeune femme). 1919. Oil on linen, 28¹⁵/₁₆ x 23³/₄ in. (73.5 x 60.4 cm). Gift of Collection Société Anonyme, 1941.665

Morton Livingston Schamberg
AMERICAN, 1881–1918

Painting (formerly *Machine*). 1916. Oil on canvas, 30⅛ x 22¾ in. (76.5 x 57.8 cm). Gift of Collection Société Anonyme, 1941.673

Kurt Schwitters
GERMAN, LIVED NORWAY AND ENGLAND, 1887–1948

Merz 316. Ische Gelb. 1921. Beige and brown wove papers (some with black, red, and yellow letterpress printing), newspaper fragments, ticket stubs, blue papers with gold printing, yellow- and pink-painted white wove papers, and white wove paper with pink pattern, 12⁵⁄₁₆ x 9³⁄₁₆ in. (31.2 x 23.4 cm). Gift, Estate of Katherine S. Dreier, 1953.6.71

Merz 369, "tto." 1922. Collage in various media, 9⅛ x 6⁷⁄₁₆ in. (23.2 x 16.3 cm). Gift, Estate of Katherine S. Dreier, 1953.6.72

Monument to the Artist's Father. c. 1922–23. Painted plywood, 49¹⁵⁄₁₆ x 10½ x 16¹⁄₁₆ in. (126.9 x 26.6 x 40.8 cm). Gift, Estate of Katherine S. Dreier, 1953.6.7

Merz 1003 (Peacock's Tail) (Merz 1003 [Pfauenrad]). 1924. Oil and wood on composition board, 28⅝ x 27¹³⁄₁₆ in. (72.7 x 70.6 cm). Gift of Collection Société Anonyme, 1941.680

Merz 2012 Orient. 1924. Collage in various media, 7⁵⁄₁₆ x 5⅜ in. (18.5 x 13.7 cm). Gift, Estate of Katherine S. Dreier, 1953.6.73

Oval Construction. 1925. Wood, plywood, nails, and paint, 45⅞ x 29½ x 5⅜ in. (116.5 x 75 x 13.6 cm). Gift of Katherine S. Dreier to the Collection Société Anonyme, 1948.210

Relief with Red Segment (Relief mit rotem Segment). 1927. Oil and wood on plywood, 29½ x 24⅝ x 1¹⁵⁄₁₆ in. (75 x 62.5 x 5 cm). Gift of Collection Société Anonyme, 1941.678

Collage: Best Wishes for KS Dreier! (Collage: Für KS Dreier Viel Freude!). 1937. Collage, 5¹⁵⁄₁₆ x 3¹³⁄₁₆ in. (15.1 x 9.7 cm). Gift, Estate of Katherine S. Dreier, 1953.6.196

Carnival. 1947. Collage of various reproductions and papers, 10⁹⁄₁₆ x 7¹³⁄₁₆ in. (26.9 x 19.9 cm). Gift, Estate of Katherine S. Dreier, 1953.6.76

Collage: To KS Dreier for Her 70th Birthday. 1947. Tempera over printed paper, laid down on cardstock, 6⅛ x 4¹⁵⁄₁₆ in. (15.6 x 12.6 cm). Gift, Estate of Katherine S. Dreier, 1953.6.195

Franz Wilhelm Seiwert
GERMAN, 1894–1933

The Workman (Der Arbeitsmann). 1920–22. Oil on unprimed plywood, 34⁷⁄₁₆ x 17¼ in. (87.5 x 43.7 cm). Gift of Collection Société Anonyme, 1941.683

Victor Servranckx
BELGIAN, 1897–1965

No. 46-1922: The Town. 1922. Oil on canvas, 28⁷⁄₁₆ x 38⅜ in. (72.3 x 97.5 cm). Gift of Collection Société Anonyme, 1941.684

Walmar Shwab
SWISS, 1902–DATE UNKNOWN

Construction 14. c. 1928. Oil on linen, 18¹¹⁄₁₆ x 46¹⁄₁₆ in. (47.5 x 117 cm). Gift of Collection Société Anonyme, 1941.676

Milly Steger
GERMAN, 1881–1948

Resurrection or *Memorial to Two Sisters.* c. 1918–23. Wood, height: 43¹¹⁄₁₆ in. (111 cm) including base. Gift of Katherine S. Dreier to the Collection Société Anonyme, 1946.97

Edward Steichen
AMERICAN, 1879–1973

Portrait of Katherine S. Dreier. 1907. Platinum print on paper, 9¾ x 9⅝ in. (24.8 x 24.5 cm). Gift of Katherine S. Dreier to the Collection Société Anonmye, 1942.217.1

Käte Traumann Steinitz
GERMAN, LIVED UNITED STATES, 1889–1975

The Pine Trees. 1921–22. Gouache, watercolor, crayon, and pencil on paper, 6 x 9⅛ in. (15.3 x 23.2 cm). Gift of Collection Société Anonyme, 1941.688

Heads. 1925. Watercolor and gouache on paper, 10¹⁄₁₆ x 10¼ in. (25.6 x 26.1 cm). Gift, Estate of Katherine S. Dreier, 1953.6.121

Joseph Stella
AMERICAN, BORN ITALY, 1877–1946

Spring or *The Procession.* c. 1914–16. Oil on canvas, 6 ft. 3⁵⁄₁₆ in. x 40³⁄₁₆ in. (191.3 x 102.1 cm). Gift of Collection Société Anonyme, 1941.692

Brooklyn Bridge. 1918–20. Oil on canvas, 7 ft. ¾ in. x 6 ft. 4⅝ in. (215.3 x 194.6 cm). Gift of Collection Société Anonyme, 1941.690

The White Heron. 1918–20. Oil on canvas, 48¹⁄₁₆ x 29¹⁄₁₆ in. (122.1 x 73.8 cm). Gift of Collection Société Anonyme, 1941.691

Study for New York Interpreted. 1920–22. Watercolor and gouache on paper, 10⅞ x 19¹¹⁄₁₆ in. (27.7 x 50 cm). Gift, Estate of Katherine S. Dreier, 1953.6.82

Flower and Butterfly. c. 1920–30. Crayon and graphite on paper, 14⅛ x 11¼ in. (35.9 x 28.6 cm). Gift, Estate of Katherine S. Dreier, 1953.6.77

Flower and Butterfly. c. 1920–30. Crayon and graphite on paper, 14⅛ x 9⅛ in. (35.9 x 23.2 cm). Gift, Estate of Katherine S. Dreier, 1953.6.78

Flowers. c. 1920–30. Crayon and pencil on paper, 11 x 11 in. (27.9 x 27.9 cm). Gift, Estate of Katherine S. Dreier, 1953.6.80

Flowers. c. 1920–30. Crayon and pencil on paper, 28½ x 22½ in. (72.5 x 57.2 cm). Gift, Estate of Katherine S. Dreier, 1953.6.81

Alfred Stieglitz
AMERICAN, 1864–1946

Equivalent. 1924 or 1926. Gelatin silver print. Beinecke Rare Book and Manuscript Library, Yale University

Equivalent. 1925. Gelatin silver print. Beinecke Rare Book and Manuscript Library, Yale University

Equivalent. 1926. Gelatin silver print. Beinecke Rare Book and Manuscript Library, Yale University

John Henry Bradley Storrs
AMERICAN, LIVED FRANCE, 1885–1956

Untitled (The Dancer). 1918–20. Polychromed terra-cotta, 4¾ x 4¼ x 3 in. (12.1 x 10.8 x 7.6 cm). Bequest of Katherine S. Dreier, 1952.30.3

Machine Form. 1920. Ink on paper, 12⅝ x 9½ in. (32.1 x 24.1 cm). Gift of Collection Société Anonyme, 1941.693

Seated Figure. c. 1920. Ink, with corrections in white paint, on paper, sheet: 8⅞ x 6⅛ in. (22.5 x 15.6 cm). Gift of Collection Société Anonyme, 1941.694

Sophie Täuber-Arp
SWISS, 1889–1943

Turned Wood Sculpture (Sculpture en bois tourné). 1937. Lathe-turned wood, height: 15⁵⁄₁₆ in. (38.9 cm). Gift of Jean Arp in memory of Sophie Täuber-Arp, 1950.48

Joaquín Torres-García
URUGUAYAN, 1874–1949

New York Street Scene. 1920. Oil and collage on academy board coated in gray paint, 18 x 23⁵/₁₆ in. (45.7 x 60.8 cm). Gift of Collection Société Anonyme, 1941.723

Nadezhda Udaltsova
RUSSIAN, 1886–1961

At the Piano. 1915. Oil on canvas, 42 x 35¹/₁₆ in. (106.7 x 89 cm). Gift of Collection Société Anonyme, 1941.725

Georges Valmier
FRENCH, 1885–1937

Composition (No. 7888). c. 1922–23. Gouache on paper, 9¹³/₁₆ x 7 in. (24.9 x 17.9 cm). Gift of Collection Société Anonyme, 1941.732

Composition, 1923. 1923. Gouache on paper, 10¹³/₁₆ x 8½ in. (27.4 x 21.5 cm). Gift of Collection Société Anonyme, 1941.733

Jay Van Everen
AMERICAN, 1875–1947

Abstraction or *Lady in Abstract*. c. 1921, reworked c. 1923–26. Oil on canvas, 36 x 50 in. (91.4 x 127 cm). Gift of Mrs. Jay Van Everen to the Collection Société Anonyme, 1948.294

Jacques Villon
FRENCH, 1875–1963

Still Life (Déjeuner, La Table servie, Nature morte). 1912–13. Oil on burlap, 35 x 45¹¹/₁₆ in. (88.9 x 116.1 cm). Gift of Collection Société Anonyme, 1941.742

In Memoriam. 1919. Oil on burlap, 51¹/₁₆ x 32¹/₁₆ in. (129.7 x 81.5 cm). Gift of Collection Société Anonyme, 1941.741

Color Perspective (Perspective colorée). 1922. Oil on canvas, 23¹¹/₁₆ x 36¹/₄ in. (60.2 x 92.1 cm). Gift of Collection Société Anonyme, 1941.745

The Jockey. 1924. Oil on canvas, 25⁷/₁₆ x 50⁷/₁₆ in. (64.6 x 128.1 cm). Gift of Collection Société Anonyme, 1941.746

Heinrich Johann Vogeler
GERMAN, 1872–1942

The Island of Peace. c. 1918–19. Oil on canvas, 41¹/₈ x 38 in. (104.5 x 96.5 cm). Gift of Collection Société Anonyme, 1941.796

Additional artists

Annot
Ernst Barlach
Charles Barnes
Ella Bergmann-Michel
Lothar Blankenburg
Albert Bloch
Sándor Bortnyik
Gottfried Brockmann
Douglas Edwin Brown
Mario Carreño
Leon Carroll
Marc Chagall
Serge Charchoune
József Csáky
Fortunato Depero
André Derain
Gerardo Dottori
Alexander Davidovich Drewin
Christof Drexel
Friedrich Adolf Dreyer
Friedel Dzubas
Lyonel Feininger
Conrad Felixmüller
Oskar Fischer
James A. Fitzsimmons
Herbert Garbe
Paul Gaulois
Fritz Glarner
Anne Goldthwaite
Gustave Gwozdecki
Jacoba van Heemskerck
Karl Herrmann
Lily Uhlmann Hildebrandt
Rudolf Jacobi
Alexei Jawlensky
Walter Kamys
Ernst Ludwig Kirchner
Käthe Kohlsaat
Adriaan Lubbers
Antonio Marasco
Franz Marc
Ewald Mataré
Jan Matulka
Carlo Mense
G.M. [Georg Meyer?]
Robert Michel
Georg Muche
Heinrich Nauen
Otto Nebel
Ruby Warren Newby
Emile Nicolle
Paul Outerbridge, Jr.
Hermann Max Pechstein
Holmead Phillips
Marjorie Phillips
Hermann Post
Enrico Prampolini

Wallace Putnam
Robert Reid
Hans Richter
Karl Peter Röhl
Ralph M. Rosenborg
Raphael Sala
Louis Schanker
Hugo Scheiber
Karl Schmidt-Rottluff
Georg Schrimpf
Martel Schwichtenberg
Gino Severini
Walter Shirlaw
Fritz Stuckenberg
Léopold Survage
Arnold Topp
Maria Uhden
Nicholas Vasilieff
Walther Wahlstedt
Abraham Walkowitz
Max Weber
Magnus Zeller

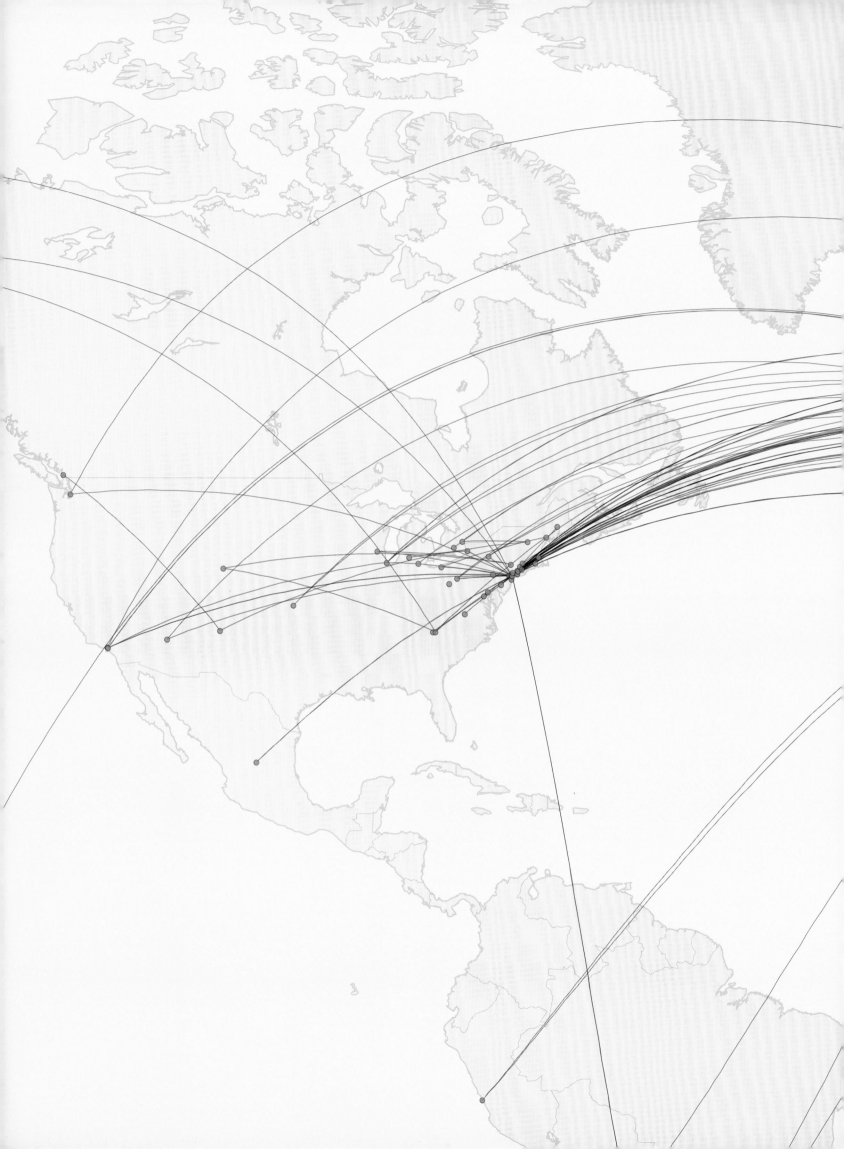

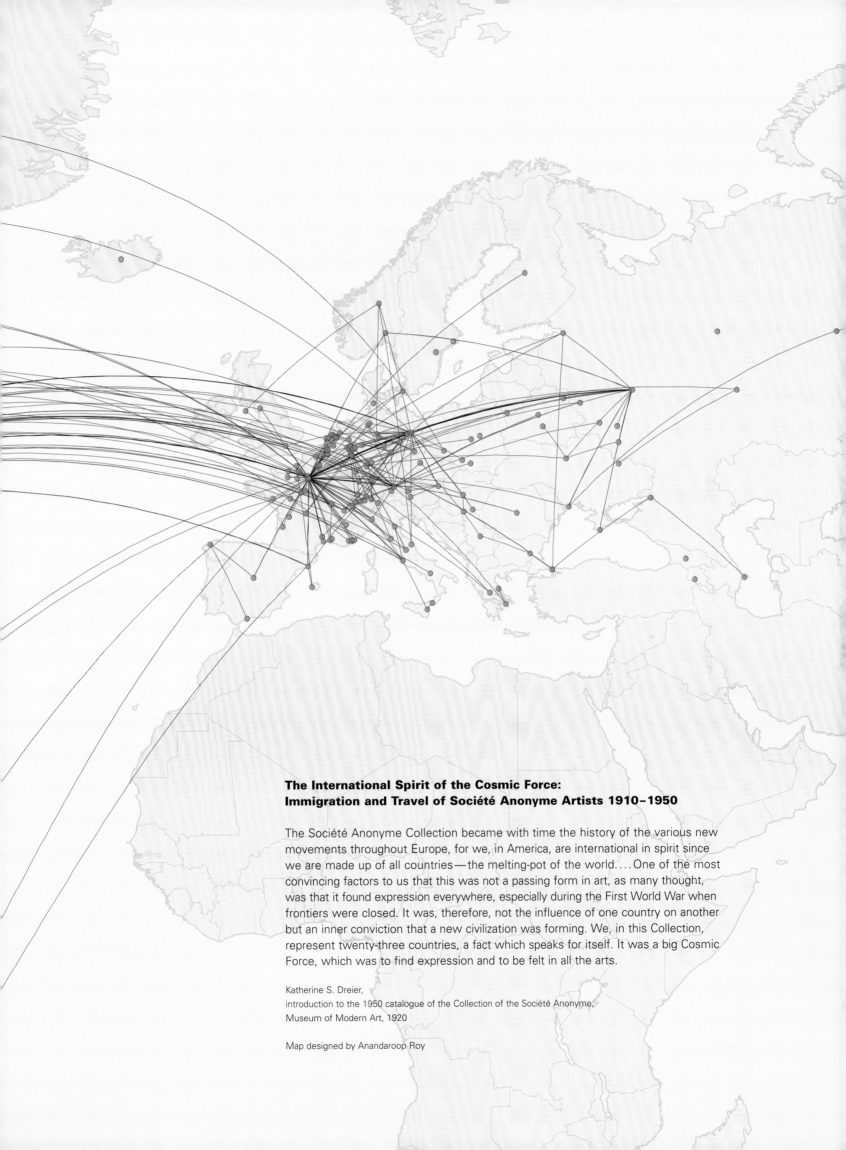

**The International Spirit of the Cosmic Force:
Immigration and Travel of Société Anonyme Artists 1910–1950**

The Société Anonyme Collection became with time the history of the various new
movements throughout Europe, for we, in America, are international in spirit since
we are made up of all countries—the melting-pot of the world.... One of the most
convincing factors to us that this was not a passing form in art, as many thought,
was that it found expression everywhere, especially during the First World War when
frontiers were closed. It was, therefore, not the influence of one country on another
but an inner conviction that a new civilization was forming. We, in this Collection,
represent twenty-three countries, a fact which speaks for itself. It was a big Cosmic
Force, which was to find expression and to be felt in all the arts.

Katherine S. Dreier,
introduction to the 1950 catalogue of the Collection of the Société Anonyme,
Museum of Modern Art, 1920

Map designed by Anandaroop Roy

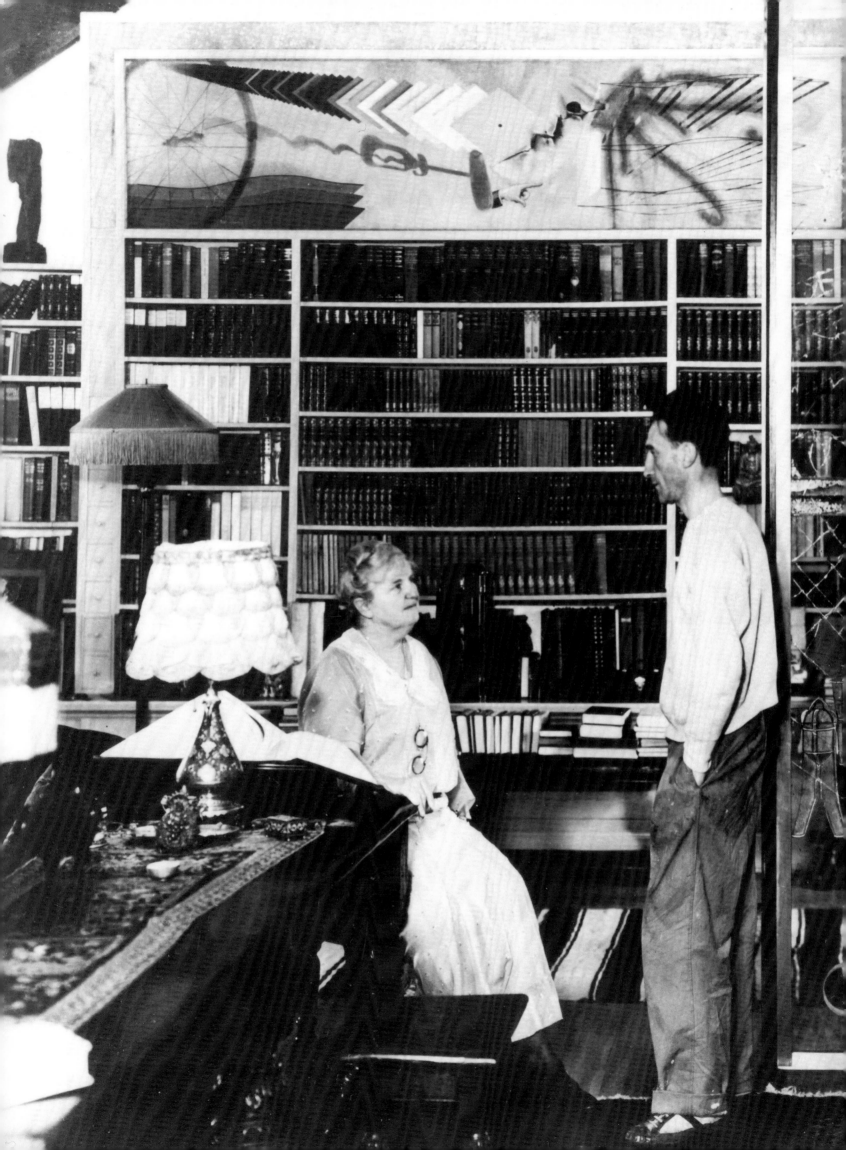

Selected Readings

Altshuler, Bruce. *The Avant-Garde in Exhibition: New Art in the 20th Century*. Berkeley: University of California Press, 1994.

Barr, Alfred H., Jr. *Cubism and Abstract Art*. New York: Museum of Modern Art, 1936.

Bohan, Ruth L. *The Société Anonyme's Brooklyn Exhibition: Katherine Dreier and Modernism in America*. Ann Arbor: UMI Research Press, 1982.

Cohen-Solal, Annie. *Painting American: The Rise of American Artists, Paris 1867 – New York 1948*. Translated by Laurie Hurwitz-Attias. New York: Alfred A. Knopf, 2001.

Corn, Wanda. *The Great American Thing: Modern Art and National Identity, 1915 – 1935*. Berkeley: University of California Press, 1999.

Davidson, Abraham A. *Early American Modernist Painting, 1910 – 1935*. New York: Harper and Row, 1981.

Dickerman, Leah, ed. *The Dada Seminars*. New York: Distributed Art, 2005.

Dreier, Katherine S. *Three Lectures on Modern Art*. New York: Philosophical Library, 1949.

——— . *Western Art and the New Era: An Introduction to Modern Art*. New York: Brentano's, 1923.

Dreier, Katherine S., and Marcel Duchamp. *Collection of the Société Anonyme: Museum of Modern Art 1920*. Edited by George Heard Hamilton. New Haven: Yale University Art Gallery, 1950.

Duchamp, Marcel. *Affect / Marcel: The Selected Correspondence of Marcel Duchamp*. Edited by Francis M. Naumann and Hector Obalk. Translated by Jill Taylor. London: Thames and Hudson, 2000.

Foster, Stephen C., ed. *Dada / Dimensions*. Ann Arbor: UMI Research Press, 1985.

Greenough, Sarah, ed. *Modern Art and America: Alfred Stieglitz and His New York Galleries*. Washington, D.C.: National Gallery of Art and Bulfinch Press, 2000.

Hartley, Marsden. *Adventures in the Arts: Informal Chapters on Painters, Vaudeville, and Poets*. New York: Boni and Liveright, Inc. 1921. (Reprinted New York: Hacker, 1972.)

Herbert, Robert L., Eleanor S. Apter, and Elise K. Kenney, eds. *The Société Anonyme and the Dreier Bequest at Yale University: A Catalogue Raisonné*. New Haven: Yale University Press, 1984.

Joselit, David. *Infinite Regress: Marcel Duchamp, 1910 – 1941*. Cambridge: MIT Press, 1998.

Kachur, Lewis. *Displaying the Marvelous: Marcel Duchamp, Salvador Dali, and Surrealist Exhibition Installations*. Cambridge: MIT Press, 2001.

Kantor, Sybil Gordon. *Alfred H. Barr, Jr., and the Intellectual Origins of the Museum of Modern Art*. Cambridge: MIT Press, 2002.

Lynes, Russell. *Good Old Modern: An Intimate Portrait of The Museum of Modern Art*. New York: Atheneum, 1973.

Naumann, Francis M. *New York Dada, 1915 – 1923*. New York: Abrams, 1994.

Naumann, Francis M., and Beth Venn. *Making Mischief: Dada Invades New York*. New York: Whitney Museum of American Art, 1996.

Platt, Susan Noyes. *Modernism in the 1920s: Interpretations of Modern Art in New York from Expressionism to Constructivism*. Ann Arbor: UMI Research Press, 1985.

Man Ray. *Self Portrait*. Boston: New York Graphic Society, 1963.

Sanouillet, Michel, and Elmer Peterson, eds. *Salt Seller: The Writings of Marcel Duchamp (Marchand du Sel)*. New York: Oxford University Press, 1973.

Sawelson-Gorse, Naomi, ed. *Women in Dada: Essays on Sex, Gender, and Identity*. Cambridge: MIT Press, 1998.

Société Anonyme (the First Museum of Modern Art, 1920 – 1944): Selected Publications. 3 vols. New York: Arno Reprints, 1972.

Tashjian, Dickran. *A Boatload of Madmen: Surrealism and the American Avant-Garde, 1920 – 1950*. New York: Thames and Hudson, 1995.

——— . *Skyscraper Primitives: Dada and the American Avant-Garde, 1910 – 1925*. Middletown, Conn.: Wesleyan University Press, 1975.

Tuchman, Maurice, Judi Freeman, and Carel Blotkamp. *The Spiritual in Art: Abstract Painting, 1890 – 1985*. Los Angeles: Los Angeles County Museum of Art, and New York: Abbeville, 1986.

Zayas, Marius de. *How, When, and Why Modern Art Came to New York*. Edited by Francis M. Naumann. Cambridge: MIT Press, 1996.

Contributors

Ruth L. Bohan is associate professor of art history at the University of Missouri, St. Louis. She is author of *The Société Anonyme's Brooklyn Exhibition: Katherine Dreier and Modernism in America* (UMI Research Press, 1982) and served as contributing editor for *The Société Anonyme Collection and the Dreier Bequest at Yale University: A Catalogue Raisonné*, edited by Robert L. Herbert, Eleanor S. Apter, and Elise K. Kenney (Yale University Press, 1984). Her forthcoming book is *Looking into Walt Whitman, American Art, 1850–1920* (Pennsylvania State University Press, 2006).

Susan Greenberg is Horace W. Goldsmith Assistant Curator of Modern and Contemporary Art at the Yale University Art Gallery. She has written on Camille Corot for the journal *Art History* and was a contributor to *Edgar Degas: Defining the Modernist Edge*, edited by Jennifer R. Gross (Yale University Art Gallery, 2003), as well as author of *A Selection of French Impressionist Paintings from the Yale University Art Gallery* (Yale University Art Gallery, 2003).

Jennifer R. Gross is the Seymour H. Knox, Jr., Curator of Modern and Contemporary Art at the Yale University Art Gallery. She is also a lecturer in the art history program and a visiting critic at the Yale School of Art. Among her recent publications are essays in *Rachel Whiteread,* edited by Chris Townsend (Thames and Hudson, 2005) and Karen Tsujimoto and Jennifer R. Gross, *The Way Things Are: The Art of David Ireland* (University of California Press, 2004), and she was editor of *Edgar Degas: Defining the Modernist Edge* (Yale University Art Gallery, 2003).

David Joselit is professor of art history at Yale University. He is author of *Infinite Regress: Marcel Duchamp, 1910–1941* (MIT Press, 1998) and *American Art Since 1945* (Thames and Hudson, 2003). He is preparing a book on television, video art, and media activism, and he writes frequently about contemporary art and culture.

Elise K. Kenney is gallery historian and archivist for the Yale University Art Gallery. She is one of three editors of *The Société Anonyme Collection and the Dreier Bequest at Yale University: A Catalogue Raisonné* (Yale University Press, 1984).

Sylvia Plimack Mangold and **Robert Mangold** are esteemed contemporary artists and alumni of Yale University. They both received B.F.A. degrees from Yale in 1961, and Robert Mangold went on to earn his M.F.A. in 1963. They have been active alumni at the university, Sylvia serving as a senior critic in the School of Art Graduate Program in the Department of Painting, 1994–2002, and Robert as a Governing Board member of the Yale University Art Gallery from 1999 to the present.

Dickran Tashjian is professor emeritus of art history at the University of California, Irvine. A recipient of a Guggenheim Memorial Fellowship and a National Endowment for the Humanities senior fellowship, he is the author of several books, including, with Ann Tashjian, *Memorials for Children of Change: The Art of Early New England Stonecarving* (Wesleyan University Press, 1974); *Skyscraper Primitives: Dada and the American Avant-Garde, 1910–1925* (Wesleyan University Press, 1975); *Joseph Cornell: Gifts of Desire* (Grassfield Press, 1992); and *A Boatload of Madmen: Surrealism and the American Avant-Garde, 1920–1950* (Thames and Hudson, 1995).

Kristina Wilson is assistant professor of art history at Clark University. She is the author of *Livable Modernism: Interior Decorating and Design During the Great Depression* (Yale University Press, 2004).

Index

Photograph Credits